Eating America: Crisis, Sustenance, Sustainability

GDAŃSK TRANSATLANTIC STUDIES IN BRITISH AND NORTH AMERICAN CULTURE

Edited by Marek Wilczyński

VOLUME 7

PETER LANG
EDITION

Justyna Kociatkiewicz / Laura Suchostawska / Dominika Ferens (eds.)

Eating America:
Crisis, Sustenance, Sustainability

Bibliographic Information published by the Deutsche Nationalbibliothek
The Deutsche Nationalbibliothek lists this publication in the Deutsche Nationalbibliografie; detailed bibliographic data is available in the internet at http://dnb.d-nb.de.

Library of Congress Cataloging-in-Publication Data
Eating America : Crisis, Sustenance, Sustainability / Justyna Kociatkiewicz, Laura Suchostawska, Dominika Ferens (eds.).

 pages cm. -- (Gdansk Transatlantic Studies in British and North American Culture ; Volume 7)

 Includes index.

 ISBN 978-3-631-64662-5

1. American literature--History and criticism. 2. Food in literature. 3. Crisis in literature. 4. Consumption (Economics) in literature. 5. Moral conditions in literature. 6. Food habits--United States. I. Kociatkiewicz, Justyna, editor. II. Suchostawska, Laura, editor. III. Ferens, Dominika, 1964- editor.

 PS121.E28 2014

 810.9'355--dc23

2014023729

Typesetting and formatting by Ireneusz Kuboń
This publication is sponsored by the Embassy of the United States

ISSN 2192-6018
ISBN 978-3-631-64662-5 (Print)
E-ISBN 978-3-653-04153-8 (E-Book)
DOI 10.3726/ 978-3-653-04153-8

© Peter Lang GmbH
Internationaler Verlag der Wissenschaften
Frankfurt am Main 2015
All rights reserved.
Peter Lang Edition is an Imprint of Peter Lang GmbH.
Peter Lang – Frankfurt am Main · Bern · Bruxelles · New York · Oxford · Warszawa · Wien

This publication has been peer reviewed.

www.peterlang.com

Preface

"Crisis" seems to be one of the most popular words nowadays. Whether the subject is economics, politics, social attitudes, culture, or nature, sooner or later the reference to crisis –the critical point, the turning point – is made. In American studies, the discussion may focus on the role of the United States as a country that has had a tremendous influence on the contemporary condition. Its long-lasting economic and cultural hegemony, now apparently waning with the ascendance of Asian countries, raises a number of questions: Has America been – literally and metaphorically – eating, appropriating, exploiting, and molding the world (including American indigenous nations) in its own image, or has it been eaten, appropriated, and exploited as a (frequently criticized or disdained) source of ideas, ideology, and knowledge? What is the relation between the ecological crisis and America's consumerist economy and its practices (for example, in the areas of food production and consumption, the use of natural resources, mass tourism)? What is America's role in the ongoing crisis of modernity? And, if the crisis continues, where are the sources of sustenance?

This volume of essays addresses a number of issues related to crisis and that which seems directly connected to it as both its cause and consequence: eating. Eating may be understood as consuming, an absorption and digestion that sustains life. But it may also be read as consumerism, greedy acquisition that leads to indigestion. In both interpretations, the neutral and the critical one, eating relates to assimilation, internalization of the external, which is at once potentially sustaining and destructive. The contributors to this volume treat the problem of eating and crisis either literally or metaphorically, analyzing film, literature, TV series, various expressions of popular culture, lifestyles, history and ecology. American culture, or perhaps the American civilization, provides the connecting thread.

The Introduction to the volume is a promise of the multifarious nature of the contents, offering a historical survey of the trope of eating and digesting in colonial America. It is followed by a section devoted to the discussion of class- or ethnicity-motivated attitudes to food and eating as signifiers that may be interpreted from the political and moral perspective. The second section comprises papers on various dimensions and types of media, asking questions concerning ways in which the media relate to consuming, devouring, and digesting. The third section displays the open nature of scholarly investigations of crisis in literature: crisis is the central theme here, but the authors apply the term to divergent issues, including socially involved contemporary poetry, the poetics of crisis, the images of the Great Depression, the links between eating and war and

eating and apocalypse, America's being indigestible to contemporary immigrants, and cannibalism as a trope in many critiques of the American status quo. The fourth section offers the literal and metaphorical treatment of sustenance and its cultural significance which makes it impossible to limit sustenance to basic life-supporting nourishment. The last section focuses on the problem of sustainability, the strategies and techniques used to protect and ensure survival in the contemporary United States.

The editors of the volume would like to thank the Embassy of the United States for generously sponsoring this publication. Additional costs were covered with the financial assistance of the Department of English Studies, University of Wrocław. Special thanks go to Elżbieta Cesarska for her invaluable help in all matters administrative.

<div style="text-align: right">

Justyna Kociatkiewicz

Laura Suchostawska

Dominika Ferens

</div>

Contents

Zbigniew Białas
Introduction: Prolegomena to any Future History of Indigestion in America....................9

Part One: Food for Thought

Tomasz Basiuk
Tarte aux pommes, or, Delicacies Morally Good for You ...21

Małgorzata Poks
Voluntary Simplicity and Voluntary Poverty: Alternatives to Consumer Culture............35

Aneta Dybska
The Battle over Squash and Beans: Food Justice Activism in a Polarized City53

Part Two: Consuming Culture

Justyna Wierzchowska
Consuming the Artist, Consuming the Image: Marina Abramović 2001 MOCA Gala
Controversy ..71

Zofia Kolbuszewska
An Abject Guide to America: CSI Lab Autopsy and Stomach Contents as an (Ironic)
Index of Interiorizing the Global and the Local ..81

Agata Zarzycka
Unhappy Meals: Fast Food and the Crisis of the Underground in
American Goth-themed Fiction and Graphic Novels..93

Oskar Zasada
Devouring Heroism: An Archetype Crisis in American Pop Culture.............................105

Part Three: Crisis

Elisabeth A. Frost
Performing Witness: The New Documentary Poetics ..119

Jacek Partyka
Writing of Crisis and Crisis of Writing: Charles Reznikoff's *Testimony* (1934)............131

Joseph Kuhn
The Pale Horseman: Crisis in the Fiction of Katherine Anne Porter..............................143

Marta Koval
Indigestible America and the Crisis of Multiculturalism in
Aleksandar Hemon's Fiction ...155

8　　　　　　　　　　　　　　　　　　Contents

Anna Gilarek
Humanity in Crisis: Man-made Apocalypse in Margaret Atwood's *Oryx and Crake*
and *The Year of the Flood* ..163

Dominika Bugno-Narecka
Food (and) War in *Gravity's Rainbow* ...177

Agnieszka Kaczmarek
Eating Itself to Death: The USA as Seen by McCarthy and Twain.............................187

Part Four: Sustenance

Paulina Ambroży
"Resistance Is the Opposite of Escape": Still Life as Sustenance in the Poems of
Wallace Stevens and Gertrude Stein..203

Veronika Hofstätter
"Twas very hard to get down their filthy trash": Investigating Food and Crisis in
Mary Rowlandson's Captivity Narrative (1682) ..215

Małgorzata Martynuska
Consuming Latinidad: Mexican Foodways in Maria Ripoll's *Tortilla Soup* (2001)229

Part Five: Sustainability

Jerzy Kamionowski
"Steam-driven cannibals ... claim us flesh eaters,– wish we were": Black Sustainability
through the Voice in African American Poetry on the Middle Passage239

Laura Suchostawska
Thoreau and the Indians, or a Crisis of the American Ideals of the
Wild and Wilderness ..255

Francesca de Lucia
Marching through Wilderness: Relating to the Environment in an Italian American
Perspective..267

Dominika Ferens
Between Taste and Interest: Reading Asian American Literature in the Age of Food
Literacy...277

About authors..297

Introduction: Prolegomena to any Future History of Indigestion in America

Zbigniew Białas

There are, basically speaking, two major models of the body and its boundaries. One – that of a classical man, an eccentric detached body, "a walker in the world but apart from it" (Solnit 21), the classic image of the finished, self-sufficient man. The borderlines separating him from the outside world are sharply defined. On the other hand, there is the grotesque man, incomplete, open, not separated from the rest of the world by boundaries but blending with it - the body outgrowing itself and transgressing its own limits.[1] The latter is, of course, a Bakhtinian approach. Bakhtin maintains that at the time of the Renaissance bodies could not yet be considered for themselves; they still transgressed the limits of their isolation. The caesura seems to be the epoch of great geographical discoveries. The formula of the classical man cannot be maintained in all seriousness because whatever acts of the bodily drama do take place – whether before the discovery of America or after it – they take place on the confines of the body and the outer world.[2] Travel, colonisation, an encounter with the new world, just like any other encounter, are primarily contracts between the traveller's body and what is beyond it. There are different theories in relation to it, but whichever theory we wish to adopt, eating is a case in point - here the external world gains entry into the body. In the act of eating and digesting, the body most obviously transgresses its own limits. Bakhtin pointed this out succinctly: "[the body] swallows, devours, rends the world apart, is enriched and grows at the world's expense. The encounter of man with the world, which takes place inside the open, biting, rending, chewing mouth [is where] man tastes the world, introduces it into his body, makes it part of himself" (Bakhtin 281). In fact the situation is much more complex because it entails not only the question of the "input" of the world into the body but also, just as importantly, the "output" of the body into the world.

We should perhaps start from the very first literary representations of travel. One of the most famous travellers in Western culture was also a notorious liar and trickster; although fictitious, he was nevertheless formidably myth-forming. Odysseus, confronted with the Cyclops' monstrous body, denies his own corporeality, his flesh-ness. "Nobody is my name, Nobody they call me," insists

1 See: Bakhtin, *Rabelais and His World*, pp. 23-25.
2 See for example Bakhtin, p. 317.

Odysseus frantically, answering the Cyclops' impatient question.[3] The shift from Ὀδυσ[σεύς] to Οὖτις is more than cosmetic – it is indeed life-saving. "Nobody is slaying me by guile and not by force," roars the blinded Polyphemos, denying a *body's* participation in the process of his mutilation (Homer, *The Odyssey,* trans. Murray/ Dimock 345). Soon after, Odysseus temporarily withdraws under a *no-human-body* when in a successful attempt at escaping, he hides his cunning self beneath the mass of Polyphemos' favourite ram. This example illustrates not only the obvious truth that the paradigm of travelling, survival, sustenance and the centrality of flesh has its roots in ancient times, but also the fact that the traveller's body – whether hotly denied or not, whether saved or eaten - remains at the very core of the representational enterprise of travel writing. That Odysseus denies the somatics of travelling is understandable because he wants to save his body from being devoured. This is, however, lost on the Cyclops, who is not sufficiently intelligent to understand that no "body" equals no "meat": "Nobody will I eat last among his comrades" (Homer, *The Odyssey,* trans. Murray/Dimock 343),[4] brags the monster and it remains an empty threat, as, indeed, it must. One may note that somewhat as a by-product, the Cyclops rather than Caliban emerges in the frontline of the long array of native cannibals that people latter-day literary representations.

At Europe's other end, after many centuries and the discovery of a few new continents, in Jonathan Swift's *Gulliver's Travels,* Lemuel Gulliver, reconciling two opposing careers, is both a rather benign Polyphemos-figure in the country of Lilliput and an Odysseus-figure in the country of Brobdingnag. Swift intro-

3 Homer, *The Odyssey*, Book Nine, as translated by A. T. Murray and revised by George E. Dimock, Vol. 1, p. 343. The original 1919 Murray translation offered: "Noman is my name, Noman do they call me", Vol. 1, p. 343. There are over thirty translations of *The Odyssey* into English. The older editions, whether in poetry or prose, rather uniformly use versions of "Noman." Alexander Pope, for example, writes: "Noman is my name," p. 131, although there is a footnote explaining that: "The original is *Utis*, that is, in nobody, like *Utopia*, nowhere," p. 131; those translating the word as "Noman" include William Cullen Bryant: "Noman is my name," p. 191; S. H. Butcher and A. Lang: "Noman is my name," p. 145; George Herbert Palmer: "My name is Noman," p. 135; Samuel Butler: "My name is Noman," p. 112; T. E Shaw [Lawrence of Arabia]: "My name is No-man," p. 230; Albert Cook: "Noman is my own name," p. 123. The new translations favour "nobody" over "noman." Robert Fitzgerald: "My name is Nohbdy," p. 156; Robert Fagles' translation follows the new trend: "Nobody - that's my name," p. 223. There are numerous controversies surrounding the meaning of the name Ὀδυσσεύς. Cf. G. E. Dimock, Jr. "The Name of Odysseus" in: Harold Bloom, ed., *Odysseus/Ulysses*, pp. 103-118.

4 It is "meat" in Robert Fitzgerald's translation: "Nohbdy's my meat, then, after I eat his friends," p. 156.

duces an explorer whose body - at times treading upon the ground and at other times being trodden upon – in effect becoming a field - is almost always out of proportion when judged against the worlds he is exploring. In a comparable literary culture representing European dogmas of the Enlightenment we encounter yet another travelling charlatan. The historical figure of Baron Karl Friedrich Hieronymus von Münchhausen (1720 - 1797), when turned into the hero of a *Volksbuch,* highlights the fate of the body perhaps even more forcibly than do the combined figures of Odysseus and Gulliver.[5] Both in Raspe's and in Bürger's versions Baron von Münchhausen, "Gulliver Revived," becomes a caricature of his real-life counterpart, reflecting the travellers' obsessions and fabrications, the mutations of the body in motion, and the ardent denial of bodily limits and limitations in effect, a prime illustration of somatic monumentalism. Indeed, gargantuan illustrations adorn most editions of the book, both official and pirated. In other words, the traveller's own body – eating, eaten, treated as potential food, a potential field, or treading upon other creatures' fields, when represented in writing, when immobilised in the midst of this contract, somewhat like Keats' figures on the surface of the Grecian urn, is not only and not necessarily a somatic construction. It is a symbolic construct that enters into a relation with the surrounding world, and the nature of this multifaceted alliance – if alliance it is – forms, in the widest sense, the main theme of this essay.

How does this relate to the discovery/invention of America?

Well, the beginning is gruesome. A decomposing body eaten away by elements, being devoured by the world and losing the battle with it is symbolically responsible for Western Europe's discovery/invention of America, although not necessarily in a way that accords with common perceptions. Not just one body, but to be more exact – *two* human bodies. Or, to be yet more exact, two dead and floating human bodies. When towards the end of the 15th century two corpses, the features of which indicated a race of unknown men, were thrown by the currents of the Atlantic upon the coast of the Azores, the drifting cadavers attracted the attention of Christopher Columbus and prompted him to believe in the existence of unknown western regions. Alexander von Humboldt refers to

5 The comparison to Gulliver is historically warranted. One of the London editions of Münchhausen's adventures was entitled: *Gulliver Revived or, the Vice of Lying Properly Exposed: Containing Singular Travels, Campaigns, Voyages and Adventures... by Baron Munchausen.* Cf. also Rudolph Erich Raspe's 1785 English version: *Baron Munchausen's Narrative of his Marvellous Travels and Campaigns in Russia,* and Gottfried August Bürger's 1786 *Wunderbare Reisen zu Wasser und zu Lande, Feldzüge und lustige Abenteuer des Freiherrn von Münchhausen, wie er dieselben bei der Flasche im Zirkel seine Freunde zu erzählen pflegt.* See also: Wm. A. Little, *Gottfried August Bürger,* esp. pp. 191-195.

this incident early in the first volume of his *Personal Narrative of Travels to the Equinoctial Regions of the New Continent*, although he does not explain how one could recognise the features of the bodies as those of an unknown race after they had been floating in the sea for such a long time (Humboldt 59). Even if we slightly over-interpreted D. H. Lawrence's puzzling remark from *Studies in Classic American Literature* that "a white man decomposing is a ghastly sight" (Lawrence 141), a remark that suggests, if indirectly, that there is a racial difference in the aesthetics of bodily decomposition; even if – prompted by this very remark – we concluded that the decomposing drifting bodies were not ghastly, and therefore not those of white people, the resulting deduction would still seem somewhat tenuous.

Today we know that Columbus was a cheat who forged maps in order to prove that Africa extended to the south more than it did and thus to facilitate the financing of his voyages westward; we also know to what extent he was driven by Hermetic beliefs in predestination; therefore it is only the symbolical, not the historical value of the incident that is important for our purpose.[6] There is, however, a deeper rationale as to why it makes sense to use such illustrative stories. Since the time of Columbus, travellers' discourse has abounded in anecdotes. They are, according to Stephen Greenblatt, principal products of a given culture's representational technology, "mediators between the undifferentiated succession of local moments and a larger strategy toward which they can only gesture (Greenblatt 3). One of my self-imposed tasks is to signal how those isolated flashes indicate larger strategies.

A history of indigestion, and a history of indigestion in America specifically, remains to be written. Such a history would need to focus not only on questions of nourishment but also on questions of taste. Taste, again, creates problems. It is a sense and, like other senses, it provides a primary form of input into our mental system. Through taste we encounter aspects of the physical world and at the same time the language of taste is the language of aesthetics and social sciences. Although cooking and eating were not included in the realm of fine arts when the concept developed in the seventeenth century, today a poetics, psychology, politics and philosophy of food exists. One thinks of such issues as eating culture and the culture of eating, eco-critical attitudes to food, eco-feminist criticism, or postcolonial readings of devouring/devoured cultures. One

6 For some of the more blatant lies by Columbus see e.g. Arthur Davies, "Behaim, Martellus and Columbus," pp. 451-459. For an exposition of Columbus' idea of divine predestination see Djelal Kadir, *Columbus and the Ends of the Earth: Europe's Prophetic Rhetoric as Conquering Ideology.* One of the canonical studies on the invention rather than the discovery of America is Tzvetan Todorov's The Conquest of America: *The Question of the Other [La Conquete de l'Amerique: la question de l'autre*; 1982].

could investigates culinary politics rather than culinary culture. Or: one could investigate eating habits and social history. There do exist analyses of problematic relations between food and the understanding of nationhood (Sidney W. Mintz); there are studies of immigrant cuisine, from the sociolinguistic perspective one can locate ethnic boundaries by analysing e.g. talk of food itself. Food choice frequently delineates boundaries between communities, and the experience of eating encounters may either [1] corroborate existing sentiments or [2] help negotiate between cultures. For instance there are studies of nineteenth century German critique of American culinary habits where, on the one hand the texts that are analysed offer an example of condescension from the vantage point of European high-culture standards, and on the other hand reveal to what extent and how uneasily the element of race creeps in when German writers are confronted with the Black servant - a necessary component of the American eating spectacle (Heike Paul).

Focusing on the socio-political, one encounters analyses of late eighteenth and early nineteenth novels where female protagonists use food as an instrument of social power (Lahiri's *Interpreter of Maladies*, Divakaruni's *The Mistress of Spices,* as well as films like *Mississippi Masala*). Looking at literary representation of food from the semiotic and the political standpoint, critics often undertake an analysis of what food represents in extra-literary terms and what food signifies for members of today's various diasporas that try to define themselves culturally and politically. Important questions are asked: what work is performed by food metaphors and how do they unleash their polysemic potential, what parallels can be drawn between food and language as ethnic signs. Various authors stress aspects of culinary syncretism, whereby a new quality arises from an instance of cultural convergence.

One might also be tempted to disentangle the "Hungry Gaze": delineating the relationship between the visual and the kitchenesque. The field is promising not only because we all suffer from *le regard deja codé.* It is promising because – especially in the context of food - the metaphorical devouring, voracious eye itself has special power: if misapplied, it becomes the principal organ of mastery, penetration and takeover.

It is a separate world in itself to interpret religious aspects of culinary practices, or psychological insights dealing for example with eating disorders.

All these cannot be tackled here. Therefore, I decided to choose, from among the myriads examples of human omnivorousness only a few extreme cases that occur on the periphery of the digestible in a very early period of American history and are related in Alexander von Humboldt's *Personal Narrative* and the *Journals* of the Lewis and Clark expedition. This choice lets me add the concept of motion to the concept of digestion.

Edmund Husserl, in his essay "The World of the Living Present and the Constitution of the Surrounding World External to the Organism" emphasises the very performance of motion as a major cognitive act through which the mobile self experiences and understands its unity in opposition to the rest of the world. The outside is equated with the "beyond-the-body" *no-man,* the genuine *Οὖτις* in relation to which the travelling body, held together by bones, muscles and skin, continually changes its position and, by doing so, convinces itself of its oneness and uniqueness.

Remarking on what other people eat, the traveller records the extremes of what can be consumed and makes an indirect statement on what he would not consider fit for his own body. Further, he comments, if indirectly, on what disgusts him, what would result in his own body's revolt, the convulsion, the retching, the vomiting – i.e. the abjected.

To what extent is the food which is lodged in the mobile body part of that self?

Of all the passages that Humboldt devotes to bizarre dietary habits, perhaps the two most marginal ones (from opposite sides of the spectrum) can be found in the Fifth Volume: geophagy (eating earth) and anthropophagy. Humboldt maintains that Otomac Indians, when hungry, swallow "prodigious quantity of earth" as their principal food or, more precisely-- clay baked in the fire without the addition of anything organic, whether oily or farinaceous (Humboldt 641). The absorption of food normally results in the expulsion of the digested organic matter, whereas, in the case of geophagy "without additives of anything organic" the injected object is, in the end, the abjected object. In other words, the input remains the input at the output, and bodily processes appear to be purposeless, when, at the end of the process, waste is almost the same as food. Traditionally, in most mythologies and systems of symbolic representations, it is the earth that swallows man up and then gives birth and renews. Analysing at length symbolic contacts with earth as the element that devours and brings forth in the process, Bakhtin talks of "degradation." To degrade, according to him, is to bury, to let the body or part of the body be swallowed in order to bring forth an improved, renewed quality by means of lower bodily strata (Bakhtin 21, 88). Geophagy inverts and ridicules common symbolic language, it nullifies its optimistic, regenerative basis. On the one hand, geophagy is an attempt to defy the universality of "degradation." It also symbolically manifests the native's desire to absorb the constitutive matter of the landscape; it expresses the craving to incorporate the land. This desire is not alien to the traveller but the ground is. Thus, the traveller's revolt against geophagy is both a revolt of the body that accepts the universality of "degradation" and a sign of envy.

On the other hand, geophagy degrades digestion, and, hence, it is a sign of the monstrous. It suggests a theoretical scenario that could easily have been imagined by Baron Münchhausen or Lemuel Gulliver. Where would the traveller travel if all the land was eaten up, or worse still, eaten up and abjected? There is, potentially, a limit to triumphalism in Bakhtin's style. When he says that an eating man's encounter with the world is an act of victory because he devours the world without being devoured himself, and the limits between the man and the world are erased to man's advantage (Bakhtin 281), one should not forget that:

1. the victorious body receives the defeated world and is renewed only if eating is accompanied by digestion. There is no renewal, and therefore no victory, in the case of geophagy,

2. geophagy is not only a sign of defeat but also a sign of the monstrous because it is, potentially, a destructive act in the sense of eating up one's own habitat. Tendencies to incorporate are frequently destructive and there is good reason why in the psychoanalytic view incorporation is suspect.[7]

Humboldt gives the example of several cases and theorises that in torrid zones there are many individuals who have an "inordinate and almost irresistible desire of swallowing . . . fat clay, unctuous, and exhaling a strong smell" (Humboldt 644). Geophagy was reported in New Caledonia and Peru, among natives on the coasts of Guinea, among slaves in Martinique, and on the island of Java, where women ate clay in order to grow thin; they lost their appetite in the process and became, in today's parlance, anorexic. Humboldt relates all those instances and finds geophagy an object worthy of research, but cannot find a uniform explanation for "granivorous habits" (Humboldt 648-652). Although in the Lewis and Clark journals geophagy is not mentioned directly, Clark does attribute some of the bodily sufferings afflicting the Nez Perces to the fact that they eat their food with sand (Humboldt 373).

Anthropophagy is a much more intricate issue. When the input into the human body is the fragmented human body itself, monstrosity is located within the hint of self-annihilation because the body that can digest the body is potentially self-annihilating. Humboldt insists that the stories of West Indian cannibalism were exaggerated in early reports, but he also insists that anthropophagy is a fact, albeit a regrettable and marginal one (Humboldt 426). Even if the idea of flirting with cannibals remained only Melville's fancy when he presented Ishmael and Queequeg in one bed there would already be interesting possibilities

7 Bruno Bettelheim, *The Uses of Enchantment: The Meaning and Importance of Fairy Tales*. This reference after the Polish translation: *Cudowne i pożyteczne: O znaczeniach i wartościach baśni*, trans. by Danuta Danek, p. 9.

for interpretation, as hosts of existing analyses amply demonstrate. But this idea surpasses fiction. Winwood Reade, for example, a traveller to whom the very map of Africa resembled a woman, described his flirtations with cannibal maidens of Dahomey. Making advances to cannibals was an act of endangering one's body. Not only could it be fragmented but also incorporated through the cannibal maiden's orifices. It could be digested and abjected at the end of the process, however, having blended at least partly with, or having nourished, the very maiden. And no matter whether the girl is a cannibal or not; flirting with the idea that one is flirting with a cannibal seems to come from the repertoire of sado-masochism and bondage. It requires an anti-surficial attitude toward the somatic, insomuch as cannibalism entails the idea of the body as a dangerous orifice (Reade 54, 383).[8] The fusion of the devouring and the devoured body, as well as the borderlines between the image of the body and food, are fascinating issues and they have received a lot of critical attention.[9]

In a sense one could also argue that geophagy is related to digestive laziness, and the question of laziness crops up because it is a key issue in all representations related to travel and exploration. Some critics maintain that even Clark's frequent resort to rewriting Lewis' impressions is indicative of laziness. Extensive travel is an exercise in repetitive acts and the boredom of everyday chores. For days on end landscapes tend to be similar, and motion requires the repetition of almost the same gestures. To give sense to all this discouraging motion, those who travel need to denigrate the culture of non-motion (i.e., indolence). In philosophy this strain starts perhaps with Aristotle, who was said to have lectured while walking, and it progresses more or less continually through the ranks of philosophers like Jean-Jacques Rousseau, who admitted in *Confessions* that he could only meditate while moving about,[10] via revolutionaries like John Thelwall, whose book *The Peripatetic* appeared around the time of both expeditions in 1793,[11] up to Friedrich Nietzsche, who - had he written earlier - would have provided all travellers not only with a telos but also with wisdom. "*Sit* as

8 However, there are other possibilities, not dangerous to the traveller. Contemporary ascetic Aghori monks from Benares in India eat the bodies of dead men, but do not kill for food. See: Richard Rudgley, p. 57.

9 One of the most influential studies on the fusion of the devouring and the devoured body can be found in Bakhtin's *Rabelais and His World*, but in recent years one can observe a new wave of critical interest in the question of cannibalism. An extensive bibliography can be found, for example, in Geoffrey Sanborn, *The Sign of the Cannibal: Melville and the Making of a Postcolonial Reader*.

10 "I can only meditate when I am walking. When I stop, I cease to think; my mind only works with my legs," qtd. in Solnit, *Wanderlust*, p. 14.

11 "I pursue my meditations on foot," qtd. in Solnit, *Wanderlust*, p. 14.

little as possible," proclaimed Nietzsche in *Ecce Homo*; "give no credence to any thought that was not born outdoors while one moved about freely - in which the muscles are celebrating a feast, too" (Nietzsche 239-240). No doubt that would have delighted all explorers, justifying their efforts as intellectual feats. It would have delighted Clark, offering him a noble reason to rely on rewriting Lewis' entries as a sure method of eliminating too much sitting, although some critics excuse Clark by suggesting that the strategy of rewriting was to provide a copy of the journal in case of sudden loss.

Motion, non-laziness, the very act of geometrically distancing oneself from where one was at a previous moment – all these are measures of the journey's continuity and success. In a limited sense, applied geometry and applied vectoriality are directly related to food absorption, abjection and refuse. We need to acknowledge that in recent psychoanalytical criticism a somewhat related direction has developed, most evident in the later works of Julia Kristeva. We can adapt Kristeva's argument on the essentiality of "abjected matter," by which she would define anything "from finger clippings to faeces, all that we must shed, and from which we must distance ourselves, in order to be." (Burgin 117). There is an obvious practical side to it when the concept is applied to the activity of travelling, as the shedding and the distancing is a "staying alive" tactic, and Kristeva's "in order to be" becomes equivalent to "in order to survive" and "in order to proceed."

This essay, resignedly inspired by the logic of the body and the food metaphor, must end with a note on "decomposition." On the one hand, I would not like to create an impression that I propose an apology of refuse, rot, putrefaction and decay, neither do I attempt to familiarise disgust. On the other hand, the traveller's body, regardless of time, place, gender or the amount of fictitiousness involved in representation, consistently gestures towards a tragic formula and there is no optimistic synthesis on offer. If I closed such Prolegomena "compositionally", I would end with a methodological lie. Wishing neither to mourn nor to celebrate the decomposition of the flesh in the context of the colonisation of America, we should bear in mind that in the times of such expeditions as those undertaken and described by Humboldt or Lewis and Clark, the last, unrepresented act of the drama of eating is when wild animals feast on the choicest offal when human toils are over.

Works Cited

Bakhtin, Mikhail. *Rabelais and His World*, trans. Hélène Iswolsky. Bloomington: Indiana University Press, 1984.

Bettelheim, Bruno. *Cudowne i pożyteczne: O znaczeniach i wartościach baśni [The Uses of Enchantment: The Meaning and Importance of Fairy Tales].* Trans. Danuta Danek. Warszawa: Państwowy Instytut Wydawniczy, 1985.

---. *The Uses of Enchantment: The Meaning and Importance of Fairy Tales.* New York: Vintage Books, 1977.

Bloom, Harold, ed. *Odysseus/Ulysses.* New York, Philadelphia: Chelsea House Publishers, 1991.

Bürger, Gottfried August. *Wunderbare Reisen zu Wasser und zu Lande, Feldzüge und lustige Abenteuer des Freiherrn von Münchhausen, wie er dieselben bei der Flasche im Zirkel seine Freunde zu erzählen pflegt.* 1786.

Burgin, Victor. "Geometry and Abjection." *Abjection, Melancholia and Love: The Work of Julia Kristeva.* Eds. John Fletcher and Andrew Benjamin. London: Routledge, 1990. 104-123.

Davies, Arthur. "Behaim, Martellus and Columbus." *The Geographical Journal* 143.3 (Nov. 1977): 451 - 459.

Fletcher, John and Andrew Benjamin, eds. *Abjection, Melancholia and Love: The Work of Julia Kristeva.* London: Routledge, 1990.

Greenblatt, Stephen. *Marvelous Possessions: The Wonder of the New World.* Oxford: Clarendon, 1992.

Gulliver Revived or, the Vice of Lying Properly Exposed: Containing Singular Travels, Campaigns, Voyages and Adventures in Russia, the Caspian Sea, Iceland, Turkey, Egypt, Gibraltar, up the Mediterranean, on the Atlantic Ocean, and through the Centre of Mount Aetna, into the South Sea. Also An Account of a Voyage into the Moon and Dog Star, with Many Extraordinary Particulars Relating to the Cooking Animals in those Planets, which are there Called the Human Species. By Baron Munchausen. London: Printed for C. & G. Kearsley, Fleet Street, 1793.

Homer. *The Odyssey,* trans. William Cullen Bryant. Boston: Houghton, Mifflin and Co., 1891.

---. trans. S. H. Butcher and A. Lang. New York: Macmillan, 1895.

---. trans. Samuel Butler. Roslyn, NY: Walter J. Black, 1944.

---. trans. Albert Cook. New York: Norton, 1974.

---. trans. Robert Fagles. New York: Viking, 1996.

---. trans. Robert Fitzgerald. Garden City: Anchor Books, 1963.

---. trans. A.T. Murray. London: Heinemann, 1919.

---. trans. A.T. Murray, revised by George E. Dimock. Cambridge, Mass.: Harvard University Press, 1995.

---. trans. George Herbert Palmer. Boston: Houghton, Mifflin and Co., 1921.

---. trans. Alexander Pope. New York: The American News Company, 1882.

---. trans. T. E Shaw [Lawrence of Arabia]. New York: Oxford University Press, 1957.

Humboldt, Alexander von. *Personal Narrative of Travels to the Equinoctial Regions of the New Continent During the Years 1799 - 1804 by Alexander de Humboldt and Aime Bonpland; with maps, plans &c., written in French by Alexander de Humboldt, and translated into English by Helen Maria Williams,* Vols. I & II, third edition. London: Longman, 1822; Vol. III and Vol. IV, second edition, 1825; Vol. V, 1821; Vol. VI, 1826; Vol. VII, 1829.

Kadir, Djelal. *Columbus and the Ends of the Earth: Europe's Prophetic Rhetoric as Conquering Ideology.* Berkeley: University of California Press, 1992.

Lawrence, D. H. *Studies in Classic American Literature.* New York: Penguin, 1977.

Little, Wm. A. *Gottfried August Bürger.* New York: Twayne Publishers, 1974.

Nietzsche, Friedrich. „*On the Genealogy of Morals/Ecce Homo,* ed. and trans. Walter Kaufmann. New York: Vintage Books, 1989.

Reade, W. Winwood. *Savage Africa: Being the Narrative of a Tour in Equatorial, Southwestern and Nortwestern Africa.* 1864. New York: Johnson Reprint Corporation, 1967.

Rudgley, Richard. *Alchemia kultury: od opium do kawy* [*The Alchemy of Culture: Intoxicants in Society*]. trans. Ewa Klekot. Warszawa: Państwowy Instytut Wydawniczy, 2002.

Raspe, Rudolph Erich. *Baron Munchausen's Narrative of his Marvellous Travels and Campaigns in Russia.* 1785. London: Harrap, 1985.

Sanborn, Geoffrey. *The Sign of the Cannibal: Melville and the Making of a Postcolonial Reader.* Durham and London: Duke University Press, 1998.

Solnit, Rebecca. *Wanderlust: A History of Walking.* Harmondsworth: Penguin, 2000.

The Adventures of Baron Munchausen. New York: Illustrated Editions Company, n.d.

Todorov, Tzvetan. *The Conquest of America: The Question of the Other* [La Conquête de l'Amerique: la question de l'autre; 1982], trans. Richard Howard. New York: Harper, 1992.

Part One: Food for Thought

Tarte aux pommes, or, Delicacies Morally Good for You

Tomasz Basiuk

In his 1957 *Mythologies*, Roland Barthes applied his critical acumen to an analysis of the myths that prevail in the popular discourse about food. Following Gaston Bachelard, Barthes speaks about the mythology of milk, cheese, wine, and steak, and comments on "ornamental cookery," by which he means something like the "fiction" of ostentatious consumption addressed to the working class, such as he imagines the readers of *Elle* magazine to be (79-80). At the risk of repeating his observations in a trite manner, I will distill from Barthes's insights these abstract principles: (1) certain foods are healthier than others, and (2) certain food choices are more sophisticated than other food choices. In the present era of ecology, it seems necessary to add one more precept: (3) certain food choices are morally superior to other food choices. (While some might argue that certain foods are simply tastier than others, I leave this point out as necessarily moot, on the *de gustibus non disputandum* principle.) This paper investigates how these three tenets overlap in some contemporary writings about food. Close attention is paid to the way in which that distinction—in the sense of judgments about taste that have class ramifications for social strata, as shown by Pierre Bourdieu—plays a part in writings about healthy eating and about making morally sound food choices.

Remarks will be offered on a leaflet distributed by Mercy for Animals, an NGO, which recommends the vegetarian/vegan diet, and on three examples of reportage: selected coverage in the *New Yorker*, published between 2002 and 2012, of the continuing battle against raw milk products in the US; William Foster Wallace's "Consider the Lobster" (2005), a report from an annual lobster festival in Maine that was originally commissioned by *Gourmet* magazine; and Jonathan Safran Foer's *Eating Animals* (2009), which combines argument and investigative reporting to weigh the pros and cons of eating meat. The latter three examples all zero in on one of the three abstracted tenets—coverage of the raw milk debate focuses on food safety and nutritional facts, Wallace appears at first to ponder the alleged elegance of lobster fare, and Foer asks about the morality of eating animals—but their concerns overlap and thus the boundaries between these strands of their argument are blurred. That a class-based sense of distinction is detectable in the *New Yorker* coverage of *fromages au lait cru* is unsurprising. That Wallace talks about lobsters being scavengers as the reason why lobster meat was traditionally consumed by the poor before he switches to a terrifying description of a lobster being boiled—in an attempt to persuade read-

ers that a lobster's reactions are indicative of something akin to human feelings—is obviously intended to reinforce his attempt to turn people off lobster meat. More surprising is that Wallace returns, in a manner that might seem obsessive, to the hoary question of class. Foer's detailed investigation of how animals intended for human consumption are raised and slaughtered is at least somewhat sympathetic to slow food and to selective meat eating, even though refraining from eating meat is his preferred option. He seems to be addressing a contemporary leisure class, its members joined at the hip (for hipsterism), their common identity a particular combination of moral and class-related attitudes and styles. Thus, while the *New Yorker* uses sophistication to bolster its argument for raw milk and cheeses made from raw milk, Wallace calls on a class-related sense of distinction to undermine readers' notion that eating lobster is sophisticated, and Foer imagines his readers as modern-day sophisticates who intuitively grasp that locally cured ham is superior to mass-produced meatloaf.

In all the examples, a class-based argument about distinction—about keeping good company and having a sophisticated palate—plays a major if sometimes unacknowledged role, also when the explicit argument is about health and the moral aspects of nutrition. These examples seem to illustrate a broader discursive tendency: neither a health-based nor a moral argument about food choices functions independently of a class-based argument about distinction. An argument about distinction, also in those cases where class categories are inexplicit, is biased in favor of symbolic upward mobility internalized by the writers and projected onto the readers. This rhetorical gesture is an instance of hegemonic manipulation, even when it is well intended and favorably received.

Conspicuously absent from most arguments for a healthier diet and for morally preferable food solutions is any question of financial burden. Mass-produced food is typically less expensive than small-farm grown and locally processed food. It may be that new consumption patterns adopted by sections of the middle class, including young urbanites, will eventually spark broader change in the food industry that will ultimately benefit the less privileged consumers. As it is, however, the change being advocated is imagined as occurring top-down.

A somewhat analogous insight has recently been voiced, in an altogether different context, by Gayatri Chakravorty Spivak. In an interview with Cathy Caruth, published in the *PMLA* in 2010, Spivak discusses her teaching at Columbia as working for epistemological change because, under the current distribution of power, the poor must be helped by the rich: "I want to understand the mechanics of why the problems of the poor must be solved by good rich people. The good rich people are obliged to take money from bad rich people, and much of the money goes back to the bad rich people. The beggars receive some mate-

rial help but remain beggars" (1024). This question reverberates in my analysis of writings about healthy and morally sound nutritional choices.

Example 1

In a leaflet titled *25 Reasons to Try Vegetarian*, distributed in 2013 by Mercy for Animals, a non-governmental organization promoting vegetarian and vegan diets,[1] four types of "reasons to try vegetarian" are listed: a reduction in animal suffering, health benefits to the individual and to the human community at large ("To keep antibiotics working"), a reduced burden on the natural environment, such as less carbon dioxide emissions, and, somewhat surprisingly, the assurance that pursuing these dietary recommendations will put one in good company. "You'll be in good company" is the leaflet's penultimate claim (number twenty-four), and its justification reads: "Some of the world's greatest thinkers and humanitarians have recognized the moral importance of a vegetarian diet, including: Albert Einstein, Jane Goodall, Plutarch, Cesar Chavez, Pythagoras, Buddha, Leonardo da Vinci, Mahatma Gandhi, Mary Shelley and Coretta Scott King." Included on the same page is a quote from Henry David Thoreau's *Walden* (1854), which prophesies the advent of vegetarianism: "I have no doubt that it is part of the destiny of the human race, in its gradual improvement, to leave off eating animals." The following (and last) page of the leaflet reinforces Thoreau's moral prophecy and adds to the "good company"—in however an inappropriate way—by quoting Anne Frank: "How wonderful it is that nobody need wait a single moment before starting to improve the world."

The claim about being in good company seems unrelated to the other types of argument, which are directly linked to sustainability and to moral issues. Nonetheless, health-based, environmental, and humanitarian arguments function in conjunction with an aspirational argument—"You'll be in good company"— suggesting that being vegetarian or vegan is linked to distinction, in the sense given this term by Bourdieu. In this and the following examples I wish to sug-

1 The distinction between a vegetarian and a vegan diet is blurred in the leaflet: under a section title "The Vegetarian 4 Food Groups" are listed: Fruit, Vegetables, Beans & Lentils, and Whole Grains. No dairy products are included. Under the heading "Vegetarian health" one finds this assertion: "It's easy to get enough protein on a well-balanced vegan diet," as well as a further recommendation: "Humans have no need for cow's milk." The leaflet also calls upon arguments related to animal well-being, though they are not always presented as claims for veganism, e.g., "The vast majority of egg-laying hens spend their lives packed into tiny wire cages so small they can't even spread their wings."

gest that among arguments about nutritional choices and dietary habits an argument about distinction is routinely included.

Example 2

My second example concerns the limited availability of unpasteurized milk and raw milk products in the United States. A website dedicated to raw milk and raw milk products (raw-milk-facts.com) lists these facts: 29 states allow the sale of raw milk (in most of these states such sales are limited to direct trade between the farmer and the consumer). Some of these states allow sales of properly labeled raw milk in stores (Arizona, Utah, California, Washington). Some other states allow certain kinds of intermediaries, for instance, Massachusetts allows buying clubs, while North Dakota allows herdshares. These state-by-state regulations change.

Rules on the sale of raw milk cheese also vary but, in any case, the FDA requires raw milk cheese to be aged for at least 60 days. An official FDA website lists "Food Facts," which include the assertion that unpasteurized milk, cream, yoghurt (including frozen yoghurt), ice cream, and pudding, as well as soft cheeses such as Brie, Camembert, and Mexical-style soft cheeses such as Queso Fresco, Panelo, Asadero, and Queso Blanco are "unsafe to eat" if they have been made from unpasteurized milk (FDA website). The FDA provides a seemingly detailed explanation for these recommendations:

> Milk and milk products provide a wealth of nutrition benefits. But raw milk can harbor dangerous microorganisms that can pose serious health risks to you and your family. According to an analysis by the Centers for Disease Control and Prevention (CDC), between 1993 and 2006 more than 1500 people in the United States became sick from drinking raw milk or eating cheese made from raw milk. In addition, CDC reported that unpasteurized milk is 150 times more likely to cause foodborne illness and results in 13 times more hospitalizations than illnesses involving pasteurized dairy products. (FDA website)

The data cited in the FDA explanation should give us a pause, however. The incidence of 1500 people becoming ill in thirteen years, or just over a hundred per year, seems low in a country of more than three hundred million. Moreover, the vast discrepancy between the likelihood of being ill from consuming raw milk or a raw milk product and hospitalization resulting from such illness suggests that less than ten percent of those incidents of illness are sufficiently serious to make hospitalization necessary. In other words, only about ten or so people are hospitalized every year because they consumed raw milk or a raw milk product.

Not surprisingly, given the rather unconvincing justification of the FDA position, there has been a movement among knowledgeable consumers in the US to make raw milk and raw milk products commercially available. In some cases, consumers have defied both the FDA and state regulators by seeking out illegal suppliers of raw milk and raw milk products. Burhkard Bilger described this phenomenon in a 2002 *New Yorker* article "Raw Faith." There was subsequent coverage of the raw milk and raw milk cheese debate in the *New Yorker* between 2004 and 2012. This coverage mentions nutritional facts about raw milk and raw milk products, indicating that important health advantages are to be garnered from consuming both raw milk and its products. While the health risk which these foodstuffs may pose are also discussed, emphasis is placed on risk management and on the desirable extent of state interventionism. The coverage also emphasizes that raw milk products, and especially raw milk cheeses, just taste better than those made from pasteurized milk. Raw milk cheeses are thus compared to luxury products such as wine and to recreational drugs. They are also seen as a birthright in some European countries. The coverage thus mixes health-based argument (which it couches in terms of a discussion of manageable risk) with an argument about distinction.

In the 2002 article, Bilger explains the historical context for FDA's recommendation:

> well into the last century, raw milk was a prime breeding ground for tuberculosis and typhoid. Consequently, the Food and Drug Administration has required that all store-bought milk be pasteurized... and, since 1947, that all raw-milk cheeses be aged for at least sixty days. (310)

This latter requirement severely limits the choices available to cheese lovers: "Like many of the world's finest cheeses, Mont d'Or can't be sold in America; by the time the cheese has reached sixty days, it has dissolved into a puddle" (313). Bilger combines this argument about the gourmet palate with an argument about a healthy diet by quoting a fromager's claim: "It's one of the perverse ironies of FDA policy that raw milk cheese is actually better for us than pasteurized: easier to digest and better at fending off contaminants" (315).

In weighing arguments for and against raw milk and cheese, Bilger holds that there is room on the American food market for small-scale, specialized production of these foodstuffs alongside the mass-processed produce made from pasteurized milk, whose safety from bacterial contamination is simpler to ensure:

> Cheesemaking will always be an industrial business in America.... There's no mar-
> gin for holding raw milk in a tanker while it crosses South Dakota, no guarantee that
> one sloppy farmer won't taint a thousand cheeses when his milk is mixed in at the
> factory. The real question... is where to make exceptions. Should an American
> cheesemaker be able to make a Mont d'Or if her standards are high enough? (319)

In Bilger's view, the possibility of raw milk and its products being contaminated
with bacteria should lead to questions of risk management rather than serve as
cause for outright prohibition: "It comes down to defining reasonable risk. ...
Raw shellfish causes fifty times as many illnesses as cheese, yet diners have
learned to live with that risk" (320).

The comparison to raw fish is especially telling. Although Bilger does not
expand on this point, there is no FDA-recommended ban on raw fish despite the
substantially higher health risks it poses. The absence of a ban on raw fish sales,
which might have been applied seasonally because hot weather is conducive to
bacterial contamination, is not for lack of trying. Reporting on the FDA's failure
to install such a ban some five years ago, one journalist wrote: "The FDA has
moved to limit oyster sales in summer months to curb bacterial infections that
can be lethal. This initiative was blocked by lobbyists and legislators because it
would eliminate jobs" (Zajac). Both in the case of a ban on some artisanally
produced raw milk cheeses and in the case of an absence of a ban on rawfish
sales, the underlying reasons are likely linked to industry interests and lobbying,
and not simply due to medical science.

Bilger reports that cheese lovers and those seeking access to raw milk and
raw milk products have sometimes found ways to circumvent the limitations
imposed by officials: "The existence of a raw-milk underground has long been
an open secret to certain epicures" (313). Such illegal trade has not gone unno-
ticed by the FDA, whose agents track down cheesemakers and tradesmen defy-
ing the ban. Bilger describes his meeting with a disheartened fromager who has
switched professions out of concern that he and others like him were being pur-
sued by the government: "when I tracked down the cheesemaker in question
he'd gone on to computer programming. ... 'You just can't live like that,' he
said. 'You can't be an outlaw forever'" (313-314).

Two years later Frederick Kaufman expounded on the raw milk under-
ground in another piece in the *New Yorker*, in which he suggestively sketched
a scene whose setting is "a Hell's Kitchen basement ... [as] Manhattan's first
shipment of raw milk-unpasteurized, unlicensed, unhomogenized, and illegally
transported across state lines [is being] delivered to the members of a private
raw-milk coven." An emphasis on defiance is reinforced in later reports. Writing
in 2012, Dana Goodyear draws a clear analogy between the fight for raw milk

cheese and that for the legalization of marijuana: "Even before James Stewart, the leader of the milk-trafficking gang known as the Rawesome Three, hired an attorney from one of the top marijuana-defense firms in Los Angeles, the analogy was plain: raw milk has become the new pot." Goodyear's piece was illustrated with Chris Buck's satirical photographs of models posing as FDA agents on an organic dairy farm in Fresno, California. These photographs mock the federal agents' "men in black" image by portraying them as being on the lookout for raw milk and as apprehending a calf, which they appear to be protecting from exposure to its mother's raw milk.

In summary, the *New Yorker* coverage of the raw milk controversy is informed by the following assumptions, only some of which are clearly articulated. The artisanal product tastes better than the mass-produced variant. It is also healthier (easier to digest), while its production is likely to be more humane to animals. Furthermore, it is *in better taste*, as comparisons to wine and frequent invocations of Europe suggest. An unspoken correlate of this last point it is that artisanal raw milk cheese is more expensive than its mass produced counterpart, which is made from pasteurized milk.

Example 3

The aspirational, taste-based argument is far more clearly articulated in "Consider the Lobster," a 2004 piece by David Foster Wallace, commissioned by the *Gourmet* magazine, in which Wallace reports on the Maine Lobster Festival. Somewhat unexpectedly, Wallace presents the lobster as an overgrown, scavenger insect:

> The name 'lobster' comes from the Old English *loppestre*, which is thought to be a corrupt form of the Latin word for locust combined with the Old English *loppe*, which meant spider.... [Lobster is] an aquatic arthropod of the class Crustacea, which comprises crabs, shrimp, barnacles, lobsters, and freshwater crayfish.... [A]trthropods are... insects, spiders, crusteceans, and centipedes/millipedes, all of whose main commonality, besides the absence of a centralized brain-spine assembly, is a chitinous exoskeleton composed of segments.... The point is that lobsters are basically giant sea insects...they are garbagemen of the sea, eaters of dead stuff... and sometimes one another. (237)

Given this genetic and environmental provenance, it is easy to understand that "[u]p until sometime in 1880s... lobster was literally low-class food, eaten only by the poor and the institutionalized" (237). While lobster meat was very cheap, it was considered of such poor quality as to be deemed unsuitable for quotidian

consumption: "feeding lobsters to inmates more than once a week... was thought to be cruel and unusual, like making people eat rats" (238).

Our present situation is the reverse. Limited availability of lobster nowadays has made it more expensive and also more prestigious to eat. "Now, of course, lobster is posh... the seafood analog to steak" (238). Prolonged and intense catching of lobster has reduced the average size and age of any one specimen available today, resulting in a change of the way that lobster is eaten. As Wallace explains, lobsters can live up to one hundred years and weigh up to thirty pounds. Unlike today, "premodern lobster was cooked dead and then preserved" (238). Lobster, taken eaten out of a can, was easy to consume. While Wallace does not comment on this difference, one reason why the contemporary experience of eating lobster is far removed from the "premodern" way is because it is far more difficult to extricate meat from a smaller specimen. An analogous difference is articulated in Bourdieu's comment on the adverse relationship between eating fish and lower-class masculinity: "in the working classes, fish tends to be regarded as unsuitable food for men, not only because it is a light food, insufficiently 'filling'... but also because... it is one of the 'fiddly' things which... has to be eaten... with restraint, in small mouthfuls, chewed gently" (190).

Another difference, one elaborated by Wallace, is that "we now prefer our lobsters fresh" (240), and not taken out of a can. "A detail so obvious that most recipes don't even bother to mention it is that each lobster is supposed to be alive when you put it in the kettle... it's the freshest food there is" (242). The freshness of the meat is clearly linked to its high price and, simultaneously, to the prestige of eating lobster.

The manner of cooking lobster, which consists of boiling a live specimen to ensure its complete freshness, raises the ethical point that is Wallace's primary focus: "So here is a question that's all but unavoidable...: Is it all right to boil a sentient creature alive just for our gustatory pleasure?" (243). This ethical question is first considered with reference to the lobster's nervous system. This strategy is in fact adopted by the Lobster Festival organizers, who have apparently anticipated some people's unease in this respect. An leaflet distributed at the Festival, called *Test Your Lobster IQ*, reads in part (quoted by Wallace): "The nervous system of a lobster is very simple, and is in fact most similar to the nervous system of a grasshopper. It is decentralized with no brain. There is no cerebral cortex, which in humans is the area of the brain that gives the experience of pain" (245). Wallace partly corroborates this claim: "Pain reception is known to be part of a much older and more primitive system of nocireceptors and prostaglandins that are managed by the brain stem and thalamus. On the other hand, it is true that the cerebral cortex is involved in what's variously

called suffering, or the emotional experience of pain" (245-6). However, Wallace then calls upon another argument to claim that lobsters are being made to suffer when boiled live:

> There happen to be two main criteria that most ethicists agree on for determining whether a living creature has the capacity to suffer and so has genuine interests that it may or may not be our moral duty to consider. One is how much of the neurological hardware required for pain-experience the animal comes equipped with.... The other criterion is whether the animal demonstrates behavior associated with pain. (248)

There is no question in Wallace's mind that a lobster being boiled live "demonstrates behavior associated with pain":

> However stuporous a lobster... it tends to come alarmingly to life when placed in boiling water. If you're tilting it from a container into the steaming kettle, the lobster will sometimes try to cling to the container's side or even to hook its claws over the kettle's rim like a person trying to keep from going over the edge. Even if you cover the kettle and turn away, you can usually hear the cover rattling and clanking as the lobster tries to push it off.... The lobster...behaves very much as you or I would behave if we were plunged into boiling water.... A blunter way to say this is that the lobster acts as if it's in terrible pain. (247-8)

This anthropomorphic argument, admittedly suggestive, is clearly intended to turn readers off lobster meat, or at the very least cause them to abandon the dark habit of boiling a sentient creature for mere gustatory pleasure.

Indeed, Wallace concludes with a prophecy—which is simultaneously an indictment, analogous to that pronounced by Thoreau—and which he phrases as a question, albeit rhetorical: "Is it possible that future generations will regard our present agribusiness and eating practices in much the same way we now view Nero's entertainments or Mangele's experiments?" (253). Somewhat disturbingly, this reference to experiments conducted in Nazi camps recalls the exploitative use made of Anne Frank in my first example.

Given the high moral ground Wallace occupies, it is surprising that his seemingly uncompromising rhetoric is nonetheless easily reconciled with a more pragmatic weighing of the pros and cons of cooking lobster live as soon as he invokes the apparently far greater evils of big industry. Tucked away in one of his numerous footnotes is a speculative assertion about the causal association between the contemporary custom of cooking your own lobster live, on site, and

the food industry's seeming inability to streamline and otherwise manage the process to its commercial advantage: "Morality-wise, let's concede that this cuts both ways. Lobster-eating is at least not abetted by the system of corporate factory farms that produces most beef, pork, and chicken" (247). In a manner that reiterates the *New Yorker*'s coverage of the raw milk and cheese debacle, in which arguments about health concerns and risk management merge freely with assertions about taste and, hence, about distinction, Wallace has no difficulty combining highfalutin ethical claims with a preference for the artisanal over the mass produced (a preference unexamined in his essay), and moreover, he does so without paying any attention to the cost differentials involved.

Quite logical in the context, though no less astonishing for this, is Wallace's undisguised contempt for the poor. He emphasizes that the Festival is a popular rather than an elegant food event, and his disappointment at this resounds throughout the piece: "the Maine Lobster Festival's democratization of lobster comes with all the massed inconvenience and aesthetic compromise of democracy" (239). The inconvenience is largely due to the small town being unsuited to hosting the event. It encompasses inferior accommodation and such details as the limited availability of cars for hire. Perhaps least excusably, "aesthetic compromise" encompasses the food experience. In lieu of handsomely set restaurant tables there are

> ... rows of long institutional tables at which friends and strangers alike sit cheek by jowl, cracking and chewing and dribbling. It's hot... and the smells... are strong and only partly food-related. It is also loud.... The suppers come in styrofoam trays, and the soft drinks are iceless and flat... the utensils are plastic (there are none of the special long skinny forks for pushing out the tail meat, though a few savvy diners bring their own). Nor do they give you near enough napkins... not to mention the people who've somehow smuggled in their own beer in enormous aisle-blocking coolers. (239)

> The folks who attend the Maine Lobster Festival cannot be relied upon to class up their act. Wallace describes them as a mob—the *hoi polloi*: "crowds of people slapping canal-zone mosquitoes as they eat deep-fried Twinkies and watch Professor Paddywhack, on six-foot stilts in a raincoat with plastic lobsters protruding from all directions on springs, terrify their children" (240).

In short, Wallace would like his *Gourmet* readers to grasp, before they might venture to the Festival themselves, that, as he quaintly puts it, "It's not for everyone" (240). In the hands of a writer of Wallace's dexterity, this simple state-

ment acquires an appropriately self-ironic double meaning. It is, indeed, accompanied by its very own footnote, in which Wallace elaborates on this doubling by discussing the difference, which is entirely class-based, between the two locations where he finds himself, that is, the town where he eats versus the town where he stays:

> In truth, there's a great deal to be said about the difference between working-class Rockland and the heavily populist flavor of its festival versus comfortable and elitist Camden with its expensive view and shops given entirely over to $200 sweaters and great rows of Victorian homes converted to upscale B&Bs. And about these differences as two sides of the great coin that is US tourism. Very little of which will be said here, except to amplify the above-mentioned paradox [It's not for everyone] and to reveal your assigned correspondent's own preferences. (240)

In thus commenting on the Festival—alongside his discussion of the history of lobster fare—Wallace attempts to deploy middle-class snobbery to persuade members of that class to forego eating lobster. His other arguments are the bluntly anthropomorphic description of a lobster's behavior when boiled live and his unexamined disapproval of "the system of corporate factory farms." Many of his arguments are thus class-based, though not always explicitly so, as in the decidedly negative portrayal of working-class vacationing habits ("I have never understood why so many people's idea of a fun vacation is to don flip-flops and sunglasses and crawl through maddening traffic to loud, hot, crowded tourist venues" 240, fn. 6).

Example 4

Jonathan Safran Foer's *Eating Animals*, which deftly combines reportage and essay, is no less philosophic than Wallace's consideration of the lobster. Foer uses Wallace's argument about higher brain functions which enable understanding to make a point about cruelty, rather than about suffering. He thus turns the cognitive argument around, pointing it at people as eaters instead of animals as fare.

> It's often said that nature, "red in tooth and claw," is cruel. I heard this again and again from ranchers, who tried to persuade me that they were protecting their animals from what lay outside the enclosures.... But nature isn't cruel. And neither are the animals that kill and occasionally even torture one another. Cruelty depends on

an understanding of cruelty, and the ability to choose against it. Or to choose to ig-
nore it. (53)

Foer's book is based on interviews and on-site visits, some of which are both
clandestine and illegal. For example, he compares an artisan slaughterhouse and
a husbandry-based hog farm, where he had been made welcome, to industrial
farms, which he could only access by sneaking inside, with the aid of more ex-
perienced animal-rights activists, under the cover of night. Besides cruelty to
animals, Foer's argument focuses on health and ecology, two concerns which he
ascribes in part to having recently become a father. And then, an argument about
distinction is also used, however tacitly, at numerous points in the book.

Foer's discussion focuses on the big industry, whose presence looms in all
my examples:

> In 1967, there were more than a million hog farms in the country. Today there are a
> tenth as many, and in the past ten years alone, the number of farms raising pigs fell
> by more than two-thirds. (Four companies now produce 60 percent of hogs in Amer-
> ica.) (162)
> Less than 1% of the animals killed for meat in America come from family
> farms. (201)

Foer clearly prefers husbandry farms to the industrial kind. The former are far
less cruel toward animals and they produce foodstuffs of superior quality. Even
so, Foer finds slaughtering animals disturbing also at husbandry farms, and he
doubts that killing them can be entirely painless or stress-free. In one instance,
he excuses himself from tasting meat at an artisanal slaughterhouse he visits,
although he likes the people running it. He thus indicates his preference for
a vegetarian and perhaps a vegan diet without declaring this preference or at-
tempting to justify it.

Like the other writers discussed herein, Foer speaks from a position of rela-
tive economic privilege, suggested by his almost complete disregard for the dif-
ferential cost of artisanal versus mass-produced food. He is implicitly addressing
a "hip" reader, who is likely to agree that artisanal food is better than mass-
produced—because it is healthier, more ecological, better tasting and in better
taste—without complaining about the higher cost.

There is little question that the poor are most likely to be affected by damage
to the environment and by the poor quality of the food they consume. On the one
hand, they are more likely to live in areas contaminated by industrial develop-
ment, so that even their drinking water may be compromised. On the other, they

are unlikely to be able to afford artisanally produced cheese, meat from husbandry farms, etc. While Foer does not voice his discontent with the poor quite so openly as Wallace, he does seem to ignore these circumstantial differences as though they were inconsequential for himself and his projected readers.

In conclusion

The seeming disregard for the underprivileged implicit in the emphasis on distinction prevalent in these examples, more or less haphazardly chosen, demands some kind of explanation. This is so because all these positions—no matter how diverse their actual arguments against consuming animals and animal produce, for raw milk and cheese, against boiling sentient creatures but even more adamantly against the food industry which does not boil sentient creatures, and for husbandry farms as the lesser evil—are voiced by the cultural left. What is the likely justification for something that must otherwise seem mere snobbery? It seems that although the economic side of food production is scarcely being addressed in these examples, and although the economics of consumption are conspicuously left out, one *could* argue that the changes in consumption and production patterns that these examples promote might be slow to start but, once they have unfolded, the economies of scale would make locally produced, artisanal fare more affordable than it is now. And so, what seems like the snobbery of the few could eventually be transformed into the wellbeing of many.

Perversely, it would seem, the authors of the leaflet, the *New Yorker* writers, Wallace, and Foer all subscribe to a trickle-down logic whereby privilege starts at the top and eventually penetrates downward. As Spivak has put it in another context: "I want to understand the mechanics of why the problems of the poor must be solved by good rich people." The statement echoes Spivak's earlier, well-known complaint in "Can the Subaltern Speak?" that "white men are saving brown women from brown men" (284). To call on Marx: those who cannot represent themselves must be represented. But then, Spivak's more recent remark about how the poor may and may not be helped seems more pessimistic than her earlier statement, perhaps because it focuses more directly on redistribution rather than on representation: "The beggars receive some material help but remain beggars." In the positions I have summarized, the poor may not be beggars but they are reduced to waiting for the crumbs to fall.

Works Cited

Barthes, Roland. *Mythologies*. 1957. Translated from the French by Richard Howard and Annette Laversby. New York: Hill and Wang, 2012. Print.

Bilger, Burhkard. "Raw Faith." *Secret Ingredients. The New Yorker Book of Food and Drink*. Ed. by David Remnick. New York: The Modern Library, 2008. 309-322. Originally published in *The New Yorker* in 2002. Print.

Bourdieu, Pierre. *Distinction. A Social Critique of the Judgement of Taste*. Translated from the French by Richard Nice. Cambridge, MA: Harvard University Press, 1984. Print.

Buck, Chris. Untitled photographs. *The New Yorker* (April 30, 2012). Online: www.newyorker.com. Web. 30 Jan. 2014.

Caruth, Cathy. Interview with Gayatri Chakravorty Spivak. *PMLA* 125.4 (October 2010): 1020-1026. Online: http://www.mlajournals.org/toc/pmla/125/4. Web. 30 Jan. 2014.

The Food and Drug Administration (FDA) website. Online: www.fda.gov. Web. 30 Jan. 2014.

Foer, Jonathan Safran. *Eating Animals*. London: Hamish Hamilton (Penguin), 2009. Print.

Goodyear, Dana. "Raw Deal." *The New Yorker* (April 30, 2012). www.newyorker.com. Web. 30 Jan. 2014.

Kaufman, Frederick. "Psst! Got Milk?" *The New Yorker* (November 29, 2004). Online: www.newyorker.com. Web. 30 Jan. 2014.

Mercy for Animals. *25 Reasons to Try Vegetarian*. Leaflet.

Raw Milk Facts. www.raw-milk-facts.com. Web. 30 Jan. 2014.

Spivak, Gayatri Chakravorty. *Critique of Postcolonial Reason. Toward a History of the Vanishing Present*. Cambridge, MA: Harvard University Press, 1999. Print.

Wallace, David Foster. "Consider the Lobster." *Consider the Lobster and Other Essays*. New York, Boston, London: Back Bay Books (Little, Brown and Company), 2006: 235-254. Originally published in *Gourmet* (August 2004). Print.

Zajac, Andrew. "Raw Feelings in Louisiana over Oyster Ban." *Los Angeles Times* (Nov. 14, 2009). Online: http://articles.latimes.com/2009/nov/11/nation/na-oysters11. Web. 30 Jan. 2014.

Voluntary Simplicity and Voluntary Poverty: Alternatives to Consumer Culture
Małgorzata Poks

Voluntary Simplicity

Even a brief survey of the numerous websites advocating lives of voluntary simplicity suffices to impress the browser with the popularity of downsizing in mature capitalist societies.[1] Amitai Etizoni, American sociologist and founder of the Communitarian Network, attributes the spectacular career of simplicity to our increasing awareness of the undesirable effects of intensive consumerism combined with a rising concern for the quality of life. In an essay published in 2003 for a collection entitled *Voluntary Simplicity: Responding to Consumer Culture*, Etizoni estimated that over 20% of Americans were "contingent workers" (part-time, temporary, or contract workers), and warned that, with increasing numbers of minors and the elderly working to meet the rising costs of living, the country was "heading back toward an earlier age, that of rawer capitalism" ("Introduction" 3). In a post-affluent society, claims Etizoni, voluntary simplicity offers a welcome alternative to the treadmill of advanced capitalism, an opportunity to drop out of the rat race to live a more humane life attuned to communal, environmental, and spiritual needs. Spanning a whole spectrum of attitudes from selective downshifting through minimalism to the Simple Living Movement, voluntary simplicity attracts those whose most basic needs have been secured and who are searching for other sources of satisfaction and meaning beyond consumerism (17-18).[2]

"Simplicity has been and remains an ethic" of those "free to choose their standard of living," concurs David Shi, a prominent historian of the movement (*The Simple Life* 7). His first important book on the subject, *The Simple Life: Plain Living and High Thinking in American Culture* (published in 1985), traces the "fluctuating popularity and underlying continuity" of an ethic brought to American shores by Puritans and other early, religiously-motivated settlers. The

1 Simplicityinstitute.org or simplicitycollective.com are among the most important websites.

2 The simplifiers most interesting from the perspective of this article belong to the "holistic simplifiers," who come with their own coherently articulated philosophy and readjusted life-patterns. Sociologists see in them the seeds of a new culture. Duane Elgin, for example, speculated that once it developed into a social movement, voluntary simplicity would be able to permanently change the nature of the American Dream ("Voluntary Simplicity" 23).

importance of simplicity was then reinforced by the patrician simplicity and civ-
ic humanism of the Age of Reason, writes Shi; it was also embraced by Ameri-
can transcendentalists who were concerned with "being" rather than "having,"
rediscovered by countercultural movements of 1950s-1960s, and invoked by
icons of simple living in times of crisis, such as the two world wars or the eco-
nomic depression of the 1930s. All in all, simplicity has been a "refreshing and
therapeutic alternative to the hedonistic demands of consumer culture" (*The
Simple Life* 6), admits Shi.

Based on notions of sufficiency and simplicity, this countercultural lifestyle
was most famously exemplified by Henry David Thoreau's two-year "experi-
ment in living" on the shores of Walden pond. To this day his battle-cry "simpli-
fy, simplify" (*Walden* 89) resounds in the lives of American simplifiers, home-
steaders, tax-resisters, anarcho-primitivists, and other countercultural radicals
who have embraced simple living as part of more integrated, nonviolent life-
styles. In his article for the *Encyclopedia of Religion and Nature*, radical Chris-
tian Ched Mayers makes an important link between simple living and resistance
to the military-industrial complex, pointing to the revolutionary potential of al-
ternative economic systems based on sustainable choices, social justice, and co-
operation. Choosing voluntary simplicity means sharing "some of the risks and
precarious circumstances with everyone who lives on a low income" and simul-
taneously opposing the systems that perpetuate violence, injustice, and social
inequalities. "By participating in such alternatives," continues Mayers, "you live
the revolution in values that is necessary for peace with justice."

In 1985 David Shi pronounced the failure of voluntary simplicity as a socie-
tal ethic (278). But since the publication of his book, the overworked American
has become the overspent American[3] and the latter has started to downsize. With
the combined effects of economic and ecological crises, voluntary simplicity is
now becoming an important cultural force, a new movement which provides the
coordinates of a new social order. "How Times Have Changed" is how Duane
Elgin entitled the introduction to the revised edition of his 1977 book *Voluntary
Simplicity: Towards a Way of Life that Is Outwardly Simple, Inwardly Rich*. By
2010 Elgin could safely claim that simplicity had moved to the cultural main-
stream. No longer limited to individuals and families experimenting with sus-
tainable living, the phenomenon rapidly spread to include "eco-villages, co-
housing communities, transition towns, state-level initiatives, federal programs,

3 Labor economist Juliet B. Schor published two important books on consumption patterns
 in America: *The Overworked American: The Unexpected Decline of Leisure* (New York:
 Basic Books, 1993) and *The Overspent American: Why We Want What We Don't Need*
 (New York: Harper Perennial, 1999).

and global agreements." This seismic shift (Elgin's phrase) is best encapsulated by the change of rhetoric: rather than "downshifting" - giving up on luxuries and reducing consumption - simplicity is now associated with "upshifting," or moving beyond consumerism towards more balanced, healthier, and integrated lifestyles.

The term voluntary simplicity was introduced by Richard Gregg (1885-1974), a lawyer working with the trade unions, a leading theorist of nonviolence, and one of the first Americans to introduce Gandhi's teachings to non-Indian audiences. His visits to India to study Gandhian methods of initiating social change resulted in the publication of *The Power of Non-Violence* in 1934 and enabled the author to make powerful connections between non-violence and simplicity of life in *The Value of Voluntary Simplicity* published two years later, in 1936. Invoking founders of the world's great religions and such moral authorities as Francis of Assisi, Mohandas Gandhi, or Leo Tolstoy, all of whom practiced voluntary simplicity and advocated nonviolence, Gregg claims that in its essence the term refers to an inner detachment, which allows its practitioners to focus all their energy on what they consider most essential in life (24). Needless to add, in his opinion the most essential values are qualitative and spiritual rather than quantitative and materialistic. Reducing life to the level of basic needs helps to realize what the necessities of life are, to grow detached from mere wants, and to adopt a consistently "other"-centered attitude regardless of the personal cost involved. In essence, Gregg's understanding of voluntary simplicity is not unlike Henry David Thoreau's definition of "living deliberately," whereby one is to free him- or herself from the tyranny of wants and obey "the higher Law" of conscience. It could hardly have been otherwise since Gandhi - the chief source of inspiration for Gregg - was influenced by Thoreau, especially by his essay on "Civil Disobedience."

> In his first approach to the subject, Richard Gregg defined voluntary simplicity as singleness of purpose, sincerity and honesty within, as well as avoidance of exterior clutter, of many possessions irrelevant to the chief purpose of life. It means an ordering and guiding of our energy and our desires, a partial restraint in some directions in order to secure greater abundance of life in other directions. It involves a deliberate organization of life for a purpose. (4)

Enumerating the various implications of simplicity for economic, political, personal, and social life, Gregg concluded, however, that "simplicity alone is not enough" (30) for a permanent change in human values and attitudes to take place. What he called for was the integration of voluntary simplicity with

"a thoroughgoing program of non-violence as a method of persuasion to social change" (31).

In modern America a widespread interest in simple living can be traced back to the impact of the Great Depression. While in the prosperous 1920s those advocating simplicity as a counter-ethos to the spectacular consumption of the jazz age were few (e. g., Edward Bok or the Borsoldis), the 1930s made a virtue out of necessity. David Shi writes:

> The devastating effects of the depression called into question the whole ethos of the consumer culture. For millions of Americans the dream of unlimited prosperity based on eternal credit had proven illusory, and they searched frantically for new leadership and new ideas. The desperate conditions created by the economic crisis called for desperate solutions, and there was no lack of proposals and panaceas. (232)

On the one hand, the American authorities attempted to revive the Jeffersonian ideal of simplicity, albeit by the use of Hamiltonian means. On the other, diverse groups advocated a return to agrarian values as a way out of the crisis. But while the Southern Agrarians, with their manifesto *I'll Take My Stand*, were mostly nostalgic and utopian, Ralph Borsoldi's promotion of subsistence farming seemed much more pragmatic. A neo-Jeffersonian, a follower of economist Henry George and an early proponent of the back-to-the-land movement Bolton Hall, by 1920 Borsoldi had become discouraged with "helping big corporations to get bigger" (qtd. in Shi 227); he moved with his wife to a seven-acre homestead in the state of New York. Producing their own food, they lived the Thoreauvian version of the good life. Unlike Thoreau, though, the Borsoldis did not renounce technology and other basic comforts. In 1936 Ralph Borsoldi established the School of Living to promote homesteading methods among city dwellers; he also founded several Georgian[4] farming communities in the Northeast (Shi 241). In the face of his compatriots' growing dependency on federal aid, Borsoldi claimed that "the real basis for economic and social stability," as Shi puts it, "was not Social Security but a population with access to productive land" (242).

In depression-hit America it was, however, Scott Nearing (1883-1983) that most famously put the gospel of subsistence and self-sufficiency into practice. His description of the good life he and his wife Helen led as subsistence farmers, *Living the Good Life: How to Live Simply and Sanely in a Troubled World* (pub-

4 Economist Henry George (1839-1897) believed that people should own what they create and that land is the common property of all humanity.

lished in 1954), is credited with starting the massive back-to-the-land movement in the countercultural 1960s. Scott Nearing had been a radical economist, socialist activist, and pacifist before he bought his first farm in Vermont in 1932. "I chose homesteading as a way of life under United States right wing pressures in the 1930s" (210), wrote the rebel, disappointed with the American Way of Life which preached Christian love of one's neighbor while exploiting the weak and neglecting the needy; which was built on rampant competitiveness destructive to the social fabric; and which financed wars when people were dying of starvation (Nearing, *The Making of a Radical* 202). Justifying his decision to withdraw from western civilization, Nearing highlighted his mission to cultivate a new way of life in the midst of corruption, much like monks in the Dark Ages had done (Lynd xii). The "good life" Scott and Helen lived for the next fifty years combined hard manual work with contemplation, creative work, and political activism - they were especially engaged in furthering the cause of peace and social justice. Being holistic simplifiers, the Nearings were not afraid to renounce modern technology, including electricity and running water. Scott would cut down trees and split wood for cooking and heating; Helen would knit and sew; both cultivated fruits and vegetables for their meals. Moreover, like many later followers of the simple life, they felt that simplicity requires nonviolence and that nonviolence should be extended to include all living organisms. In her book *Simple Cooking for the Good Life*, Helen regretted not being able to live without harming at least plants, and advocated using "the less sentient forms of life for sustenance." Ultimately, as she believed, people "should widen the range of human feeling until it encompasses all life!" (54).

Voluntary Poverty

What looked like the stirrings of a new culture came to a halt in the prosperous 1980s and 1990s, which saw a big return of consumer spending. Consumerism started to be equated with patriotism[5] while increased consumer spending qualified as helping the country's economy. As a result, such holistic simplifiers as

5 On consumerist.com one can see an advertisement of an expensive pair of shoes which reads: "Ask not what your country can do for you. Ask 'Can I get this shoe in a size seven?'" In a North Carolina shopping mall the ad was accompanied by a sign that read: "It's time for you to do your part to stimulate the economy. And there's no better way to kick the economy up a notch than with a really great pair of pumps. Or a new flat screen TV. Or a fabulous bag. Or whatever you've been dying to get your hands on! So don't delay. CELEBRATE THE STIMULUS. TREAT YOURSELF TO SOMETHING SPECIAL TODAY!" Ben Popken, "Mommy Needs A New Pair of Stimulus Shoes." consumerist.com. June 12, 2008. December 9, 2013.

the Nearings are nowadays far outnumbered by selective simplifiers or plain downshifters. Yet, a plethora of books devoted to simplicity continues to be published, and simple living websites and simplicity circles mushroom. The reason for this is that simplicity has become fashionable - it is a marker of status and middle-class identity - and co-opted by the market. John Michael Greer, the president of the Ancient Order of Druids in America and author of *The Wealth of Nature: Economics as if Survival Mattered* (2011), complains that most followers of simple lifestyles would not risk the loss of status that the real move beyond the money economy requires. "None can be an impartial or wise observer of human life but from the vantage ground of what we shall call voluntary poverty," argued Thoreau in Walden. Greer agrees, regretting that "[t]he founders of the modern movement of 'voluntary simplicity' backed away uncomfortably from the noun in Thoreau's phrase, and thereby did themselves and their movement a huge disservice; it's all too easy to turn 'voluntary simplicity' into a sales pitch for yet another round of allegedly simple products at fashionably high prices" (Greer, "How Not to Play the Game"). An organic gardener and expert on self-sufficiency, Greer believes true homesteading or the urban variety of the simple life are more akin to monasticism. Greer's pessimism about western civilization, which he believes has entered the age of scarcity industrialism, has made him turn to monasticism for a model of cultural and economic survival. Inspired by the history and mission of medieval monasteries, which preserved Roman culture through the time of cultural collapse, or the ancient monasteries of the Far East, which cultivated high culture through times of war and barbarism, Greer promotes extreme simplicity in the Thoreauvian sense of the term - as a precondition to pursue higher goals (*The Wealth of Nature* 242-43).

Christian Anarchism and Voluntary Poverty

This was and continues to be the attitude of a loose constellation of radical American activists and anarchists inspired by the Sermon on the Mount who, at the time of the Great Depression and onwards, lived lives of voluntary poverty, outside the rules of the market, in an attempt to build a new society within the shell of the old. The remaining part of this article will focus on Peter Maurin and Dorothy Day, co-founders of the Catholic Worker movement. Seeking the ideal of a sustainable community engaged permanently in acts of solidarity and civil disobedience on behalf of the oppressed, the founders of the Catholic Worker movement and other "angelic troublemakers"[6] following in their footsteps

6 A phrase used by Bayard Rustin with reference to people of conscience who put their lives on the line to change unjust social and political systems. Bayard Rustin, along with Henry David Thoreau and Dorothy Day, is a central character in Anthony Terrance

demonstrated the viability of radically Christian, post-consumerist lifestyles in times of economic, political, and social crises.

As documented in *The Fear of Beggars: Stewardship and Poverty in Christian Ethics*, the emergence of the Christian mendicant movement coincided with the beginning of the money economy. Serving as a critique of social inequalities, the voluntary poverty embraced by the 13th century Franciscan or Dominican order was in fact a form of "economic anarchy" (Johnson 214) and put charity and the gift at the center of human relations. An entirely new social order, based on sharing and compassion, became possible. In a felicitous turn of phrase, the author, Kelly S. Johnson, calls the voluntary begging of Francis of Assisi "a form of economic unilateral disarmament" (214). As will soon emerge, not only did the Christian anarchists discussed in this article make the vital connection between economic anarchy - through the practice of voluntary poverty – and the disarmament of the heart, but they also struggled for literal disarmament and the abolition of nuclear weapons. Inspired by the words of Jesus: "Whatever you have done to the least of these, you have done to me" (Mt. 25:40) they embraced radical nonviolence, not infrequently applying the phrase "the least of these" to animals as well as humans and, consequently, advocating vegetarianism as "the only diet for a peacemaker."[7]

Depression America and Voluntary Poverty: The Catholic Worker Movement

Nineteen-twenty nine was a dramatic year for the western world. In America the interwar decade of spectacular corruption, crime, and a hedonistic search for new forms of enjoyment ended with an equally spectacular bankruptcy of the Dream: the Stock Market Crash initiated the most severe economic crisis of the

Wiley's upcoming book *Angelic Troublemakers: Religion and Anarchism in America*, to be published by Bloomsbury Publishing in 2014.

7 Some scholars argue that most early Christians were vegetarians and that meat-eating was not officially allowed until the fourth century, when the church embraced Constantine and the Roman Empire. Then, just as Christians rejected Jesus' nonviolence and devised the heresy of the so-called "just war theory," they deliberately approved meat-eating. Jesuit priest and activist John Dear wrote an article entitled "The Only Diet for a Peacemaker Is the Vegetarian Diet." In an extended version of that article, the pamphlet *Christianity and Vegetarianism*, Dear quotes famous vegetarians to prove the connection between abstention from eating meat and nonviolence. Thus, Albert Einstein is quoted to have said: "Nothing will benefit human health and increase [our] chances for survival as much as the evolution to a vegetarian diet" (15); and Leonardo da Vinci claimed: "The time will come when [people] ... will look upon the murder of animals as they now look upon the murder of men [and women]" (16).

20th century. The affluent society was transformed into a society of desperate beggars, bankrupts, and suicides almost overnight.

In France, the response to the economic crisis came in the form of personalism, a philosophical movement launched by Emmanuel Mounier, which stressed the dignity of work and the human person vis-à-vis the impersonality of market forces. His famous diagnosis of the state of affairs - "On the altar of this sad world there is but one god, smiling and hideous: the Bourgeois" (Mounier 17-18) - was followed by his refutation of modern solipsism as the chief cause of the crisis. "I love, therefore I am; therefore being is and life has value" (23), declared Mounier, calling for a communitarian revolution based on notions of solidarity with the poor, social justice, and personal responsibility for the transformation of the world. Peter Maurin, an undocumented alien of French origin, started to spread personalist ideas in the USA. A war draft resister, homesteader in Canada, and former member of the Christian Brothers religious order, in 1911 Maurin entered the USA, where he taught French and did manual work. In the 1920s he moved to upstate New York and became "an itinerant philosopher and handyman" (Ellis, "Peter Maurin" 19). A year into the depression, at the age of 53, Maurin took literally the evangelical counsels of perfection and renounced all his property, along with his social status, and adopted a life of activism and voluntary poverty. "When he came to New York City to speak at street corners," writes Marc H. Ellis, "he came as a poor man and slept in Bowery[8] hotels" ("Peter Maurin" 18).

What he preached was a three-point program for the transformation of the social order. First, in the midst of the Great Depression, Peter Maurin used to repeat: "there is no unemployment on the land" (qtd. in Zwick, "Why Not Canonize"). He envisaged a social order based on cooperative and largely self-sufficient farming communes. An early proponent of the green revolution, he was ahead of his time in his advocacy of "growing what you eat and eating what you grow." Moreover, the farming communes, which he called "agronomic universities," were to give meaningful work to the jobless and introduce city dwellers to the simple life oriented toward spiritual values. His philosophy of sustainable agriculture stemmed from the realization that, in the words of Brian Terrell, "the root of the poverty and despair in our culture is in our alienation from the land. The skid row soup line and the devastation of war he traced back to the ruined farmstead. Peter admitted to being a radical and reminded us that the word 'radical' comes from the Latin word 'radix,' meaning 'root'" (9).

8 In 1930 it was an impoverished and disreputable area of New York.

Second, what every commune needed was a house of hospitality to carry out the corporal and spiritual Works of Mercy.[9] Maurin's ideal was charity as practiced in the early church: in self-giving love and at a personal sacrifice. Studying the lives of the saints, he became convinced of the revolutionary potential of that practice; he knew that, in the words of Mark and Louise Zwick, "living the gospel was a unique way of changing the social order" (*The Catholic Worker Movement* 32).

Third, community centers were to hold roundtable discussions for "the clarification of thought" (Mounier's phrase). Maurin believed the discussions would help promote the social program of the church and initiate action. With the social encyclicals of the popes - *Rerum Novarum* (1891) and *Quadragesimo Anno* (1931) - and the French Catholic Revival in full bloom, he insisted that the Catholic tradition provided an even stronger criticism of bourgeois capitalist society than did Marxism (Maurin, *Catholic Radicalism*, 12, 49- 50).

Speaking at street corners, Peter seemed rather otherworldly to most casual listeners. Not, however, to Dorothy Day. The two met in December 1932. This is how Day recollects that year:

> We were in the third year of the depression. Roosevelt had just been elected President. Every fifth adult American – twelve million in all – was unemployed. ... In New York long bedraggled breadlines of listless men wound along city streets. On the fringes, by the rivers almost every vacant lot was a Hooverville, a collection of jerry-built shanties where the homeless huddled in front of their fires. (qtd. in Forest 96)

In 1932 Dorothy Day, a former bohemian dedicated to the pursuit of social justice and assistant editor of the radical magazine *Masses*, was a single mother and a devout Catholic convert making her living out of journalism. In November she was in Washington to cover the Communist-inspired Hunger March of 600 unemployed Americans. As a Catholic she felt utterly useless to the cause. "She had a religious faith and social conscience, but no community," comments her later collaborator Jim Forest (99). A few days later she found Peter Maurin waiting for her in her New York apartment. The seeds of the Catholic Worker

9 The corporal works of mercy:"To feed the hungry; To give drink to the thirsty; To clothe the naked; To harbour the harbourless; To visit the sick; To ransom the captive; To bury the dead." The spiritual works of mercy: "To instruct the ignorant; To counsel the doubtful; To admonish sinners; To bear wrongs patiently; To forgive offences willingly; To comfort the afflicted; to pray for the living and the dead." ("Corporal and Spiritual Works of Mercy.")

movement were sown. Based on Maurin's three-C program: "cult, culture, and cultivation," within the next five months the Catholic Worker launched a radical paper to promote a new social order, one based on the Sermon on the Mount. [10]

Entitled *The Catholic Worker*, the monthly paper made its debut on May Day, 1933. As the editorial specified: "The first number of *The Catholic Worker* was planned, written and edited in the kitchen of a tenement on 15th Street, on subway platforms, on the 'El', on the ferry. There is no editorial office, no over-head in the way of telephone or electricity, no salaries paid" (qtd. in Forest 3). As for the printing cost of the first 2,500 copies, it was met mostly from Dorothy Day's savings, including what she saved by not paying gas and electricity bills on time (Forest 3). The price was penny-a-copy, but many copies were distribut-ed free of charge. The circulation of *The Catholic Worker* rose rapidly in the succeeding years and reached 190 000 by 1938 (Roberts 180). The community started to develop, with its first House of Hospitality established in the slums of New York, and a series of, mostly short-lived, farming communes sprouting at an uneven pace. Timothy Miller, a historian of communal living in America, claims that the dozen Catholic Worker farms established in the 1930s "func-tioned in a manner reminiscent of the Little Landers and other small-scale sub-sistence agricultural community projects" (144). Miller further praises the Workers for building "a decentralized grassroots movement run by those who participated in it ... Far from building up substantial assets, the Workers barely managed to keep the most essential bills paid" (144). Serving the needs of "the least of these," they challenged the pre-Concillar Roman Catholic Church to live up to its creed. [11]

Many members of the movement followed a vegetarian diet, the rural farms providing fruits and vegetables for their immediate needs. And they never econ-omized on the poor. To the victims of evictions, taking place on a daily basis in the slum area, they offered hospitality or rent vouchers and sought landlords

10 Blessed are the poor in spirit, for theirs is the kingdom of heaven. Blessed are those who mourn, for they shall be comforted. Blessed are the meek, for they shall inherit the earth. Blessed are those who hunger and thirst for righteousness, for they shall be satisfied. Blessed are the merciful, for they shall receive mercy. Blessed are the pure in heart, for they shall see God. Blessed are the peacemakers, for they shall be called sons of God. Blessed are those who are persecuted for righteousness' sake, for theirs is the kingdom of heaven. Blessed are you when others revile you and persecute you and utter all kinds of evil against you falsely on my account" (Mat. 5, 3-10a).

11 Another notable Christian lay movement was launched in Canada by the Russian émigré Catherine Doherty (1896–1985). In 1932 she gave up all her possessions, lived among the poor in Toronto and established a Friendship House to feed the hungry and educate the poor. In 1937 she founded the first American Friendship House in Harlem as an inter-racial charity center.

willing to accept them. On the quality of food served, Tom Cornell,[12] the current associate editor of *The Catholic Worker*, said: "Nothing but the best." Dorothy herself commented: "What a delightful thing it is to be boldly profligate, to ignore the price of coffee and to go on serving good coffee and the finest bread to the long line of destitute who come to us" (qtd. in Forest 133).

The movement grew rapidly and soon its members found themselves feeding up to 1,500 people every day. Dorothy estimated that between 1935 and 1938 Catholic Workers provided night lodging for almost 49 300 homeless (qtd. in Forest 131). Founded on a belief "in an economy based on human needs, rather than profit motive" (Day, "Beyond Politics"), the community required the adoption of voluntary poverty from its members. As Day explained: "Love of brother [or sister] means voluntary poverty, stripping one's self, putting off the old man [or woman], denying one's self. It also means nonparticipation in those comforts and luxuries which have been manufactured by the exploitation of others" (*On Pilgrimage* 247). An important model for her and Maurin was Francis of Assisi, who married Lady Poverty and changed the way the society of his times thought about war and economic structures. Committed to Peter Maurin's idea of building a society "where it is easier for people to be good" (qtd. in Day, "On Pilgrimage - September 1973"), members of the Catholic Worker accepted no salaries for their work, contributing everything they earned to meeting the needs of the poor; they renounced private property, lived together in great simplicity, and wore donated clothes. Having spent much time in prison for acts of civil disobedience, they did not forget about visiting the prisoner, that most "neglected Work of Mercy" (Day, qtd. in Zwick, *The Catholic Worker Movement* 40); spoke out against racism; and provided hospitality to the stranger regardless of their race long before the Civil Rights era.

Convinced that in the America of his day the Afro-Americans were most hard-hit by the Depression, Peter Maurin believed a Catholic Worker interracial center should be opened in Harlem. Despite the explosive social and economic situation, Maurin, "bearing wrongs patiently" as the Gospels advised, established a Harlem storefront in 1934 in a donated, bare-walled house. Apart from providing information on racial equality, social justice, and the social program of the church, he and his helpers took care of the immediate needs of the community and also gave free French and arts and crafts classes to the poor. The experiment was extremely dangerous, though, and the center had to be closed within a year (Ellis, "Peter Maurin" 32-35).

12 Tom Cornell led the first protest against the Vietnam War on July 16, 1963, which started with only two people from the *Catholic Worker* and grew to 250 in the next ten days.

Solidarity with the poor, whom Maurin called "God's Ambassadors" (7), led Catholic Workers to renounce jobs that contributed to the misery and degradation of others (jobs in advertising, insurance companies or banks, and the arms industry) and take up various forms of nonviolent protest against social and political injustices. In 1936, the time of the Spanish Civil War, Dorothy Day embraced unconditional pacifism and called for a "disarmament of the heart."[13] Her unqualified pacifism caused a barrage of criticism during World War II; sales of the Catholic Worker hit rock bottom; the movement lost its popularity, which was regained at the dawn of the Vietnam era.

Catalysts for Change in the Civil Rights and the Cold War Era

Maurin and Day's insistence on practicing Works of Mercy at a personal sacrifice served as an implicit critique of government-sponsored social services programs. From their Christian anarchist perspective, both co-founders of the movement saw the personal cost involved in the process of helping the poor as transforming the way one sees the world. Dan McKanan comments: "seeing Christ in guests who are often unpleasant or abusive helps Catholic Worker to recognize the human dignity of the soldiers, police officers, generals, and politicians who are often the target of their protests" (10). Far from shouting slogans or abuse, picketing Workers frequently engaged their opponents in conversations, attempting to explain the rationale behind their protests. Long before Martin Luther King, Jr.'s call to hate evil but love the evil-doer as a person conditioned to do wrong by circumstances beyond his or her control, Dorothy Day and her followers had been attempting to transform the world by loving the neighbor and the enemy in a radical Christian fashion.

In addition to her numerous duties and responsibilities as the leader of the Catholic Worker, Dorothy Day took an active interest in the efforts of other groups that tried to follow communitarian gospel ideas. Frequently on the road visiting Catholic Worker centers, supporting nonviolent initiatives all over the country, and accepting numerous invitations to speak, in 1957 Dorothy paid a two-week visit to a beleaguered interracial community in the Deep South. Established in 1942 in Americus, Georgia, the Koinonia Christian farming community attempted to live the radical gospel call to universal brother- and sisterhood through its commitment to nonviolence, racial equality, simple living, sharing of resources, and stewardship of the land. At the beginning of the Civil Rights struggles, its members were threatened with acts of physical violence and

13 Two decades later Martin Luther King was to advocate the "weapon of love" and promote spiritual purification as a prerequisite for any direct action.

there was an ongoing economic boycott of its produce. In her regular *Catholic Worker* column entitled "On Pilgrimage" Dorothy describes how she shared in the work of the community and how she was shot at for the first time in her life while keeping a night watch with another member of the group. About Koinonia she has words of the highest praise:

> The entire way of life of the community – the firm foundation of non-ownership, is a challenge to the capitalist system of America. If others followed the example of Clarence Jordan – if priests and ministers throughout the country set out with their flocks, to build up a new society within the shell of the old by the hard labor of their hands, an oasis where there would be common ownership and the responsibilities which went with that common ownership, the problems of tenant farming, share-cropping, day labor, peonage, destitution, debt, and so on, would be solved, for Negro, for white, for Mexican, for Puerto Rican, for all. There would be less absentee ownership, corporation farming. There would be the farming commune envisaged by Peter Maurin as a solution to unemployment, old age, sickness, alienation of all kinds. ("On Pilgrimage - May 1957").

In addition to Day and Maurin, there was Ammon Hennacy (1893-1970), a member of the Catholic Worker between 1952 and 1960, who deserves credit for contributing significantly to the movement. Patrick G. Coy calls him "a Midwestern radical, born and bred on the decentralized egalitarian tradition that so marked the plains, prairies, and small towns of America's heartland in the latter 1800s through to the Depression era" (140). At 16 Ammon had been an active member of the Socialist Party. He was confirmed in his embrace of vegetarianism by reading Upton Sinclair's *The Jungle*, and discovered the radical Christian message of the Sermon on the Mount while serving time in Atlanta penitentiary for his anti-conscription campaign and refusal to register for wartime draft in 1917. Tolstoy and Gandhi completed his transformation into a Christian anarchist and a non-violent revolutionary. Upon release from prison, Hennacy homesteaded in a self-built hut in the Wisconsin woods, "waging Tolstoy's green revolution" (Coy 149). Fired from the dairy where he had been working for organizing a strike of dairy workers, in 1931 he became a full-time social worker, resisted the war draft and resigned his job as a result, refused to pay his income taxes for 1942, took up day-labor in agriculture to avoid paying the newly instituted withholding tax, annually picketed the IRS offices and federal buildings at tax time, took up regular fasts on the anniversary of the bombing of Hiroshima, for people on the Death Row, and in protest of nuclear armaments.[14] On the

14 His longest fast lasted 40 days.

whole, as Coy phrases it, "precious few embraced voluntary poverty as seriously and wholeheartedly as he" (167).

Inspired by Dorothy Day's work, he was baptized into the Roman Catholic Church and joined the Catholic Worker House of Hospitality in New York. Helping Dorothy Day to feed and welcome the poor, Hennacy led the movement into a more radical involvement in nonviolent direct actions. One of their greatest successes was a six-year protest against the compulsory air defense drills introduced by the State of New York in 1955. Believing the drill to be a preparation for total war, and opposing the idea of nuclear deterrence, Hennacy, Day, and other nonviolent protesters remained gathered in City Hall Park at the time the sirens sounded. Despite arrests and jail sentences, the yearly protests continued until 1961, when New York finally abandoned its civil defense drills. The protesters had won. Although ultimately Ammon Hennacy distanced himself from the Catholic Church and departed from St. Joseph's House of Hospitality, he continued to wage Dorothy Day's revolution of the heart from the Joe Hill House of Hospitality he established in Utah in 1961 and named after a labor activist executed by the state.

Such a scenario was far from exceptional with countless young radicals who came within the orbit of Dorothy Day's Catholic Worker. Inspired by her example, they nevertheless often diverged from her Christian anarchism or her absolute commitment to nonviolence. The legendary peace activists Philip and Daniel Berrigan, for example, known as "rebel priests," became alienated from Dorothy Day in 1968 by breaking into the offices of the Catonsville draft board and burning draft cards with homemade napalm. Their intention was to save the lives of Americans eligible for military service and attract public attention to the atrocities of the war in Vietnam. What Day disapproved of, however, was the destruction of property this action entailed.

But while the Berrigans continued to fight in the same "camp," another notable Catholic Worker, Michael Harrington, switched from Christianity to Marxism and secular socialism. Having joined Dorothy Day's movement in his early twenties and served as editor of *The Catholic Worker* between 1951-53, by the end of the 1950s Harrington had learned enough about poverty to write a groundbreaking book, *The Other America: Poverty in the United States* (published in 1962), which drew his compatriots' attention, including that of two presidents - J.F. Kennedy and Lyndon Johnson - to the "invisible" poor. Dan McKenan is not alone in tracing the subsequent War on Poverty waged by the Johnson administration to the years "its principal architect," Michael Harrington, spent in the New York House of Hospitality (11).

A New Society Within the Shell of the Old

Historian Anne Klejment praises Dorothy Day for "creating a spiritual foundation for American Catholics to engage in nonviolent direct action in pursuit of justice in labor relations, international peace, and the dignity of the most marginalized human beings" (67). But Klejment co-credits the Mexican-American union organizer and nonviolent Catholic resister César Chávez with being another "vital catalyst which invited further lay involvement and a new appreciation of the Beatitudes and the Works of Mercy" (67). Indeed, Day's participation in the United Farm Workers' picket in California in 1973, organized by Chávez, resulted in her last arrest, at the age of 76. On July 30th, Day arrived in San Francisco to take part in the 50th Anniversary of the War Resister's International. As news of the massive strikes of lettuce and grape workers and their equally massive arrests reached her, she decided: "César Chávez' union of Farm Workers has everything that belongs to a new social order, so my path was clear. I had come to picket where an injunction was prohibiting picketing, and I would spend my weeks in California in jail, not at conferences" ("On Pilgrimage - September 1973"). Arrested with many others for refusing to leave the place of protest, she spent ten days on an "industrial camp" surrounded by riot fencing. Day concluded the September "On Pilgrimage" column with a prayer to Pope John, a *campesino* by birth, to watch over the strikers and to "[h]elp make a new order wherein justice flourishes, and, as Peter Maurin, himself a peasant, said so simply, 'where it is easier to be good.'"

Day, Hennacy, and other Catholic Workers continued their nonviolent protests against war and other acts of conscience throughout their lives. Believing poverty and social inequality to be the source of violence, they concentrated all their efforts on alleviating the needs of the poor and the marginalized and changing the unjust social system. Liberated from distracting preoccupations by the adoption of voluntary poverty, they were in the forefront of all important struggles: they supported Dr. King's Civil Rights Movement; spoke with great force against military conscription; picketed nuclear plants; and called on all Americans to oppose the pro-war policies of the state. Their example inspired countless other "angelic troublemakers" to continue the fight for a new world within the shell of the old well beyond the death of Dorothy Day in 1980.

The home page of the Karen House Catholic Worker of St. Louis claims that currently there are more than 185 Catholic Worker communities, which "remain committed to nonviolence, voluntary poverty, prayer, and hospitality for the homeless, exiled, and hungry. Catholic Workers continue to protest injustice, war, racism, and violence of all forms" ("About the Catholic Worker"). Member of Karen House, Patrick G. Coy, reflecting on the all-too familiar view of "soci-

etal castoffs relegated to wearing and collecting castoffs" (1) on the streets of the city, arrives at the unavoidable conclusion: such scenes prove "the continued need for the radical and ... timely vision of the Catholic Worker movement" where "the spiritual world is not subordinated to the material" (1). Another Catholic Worker and long-time peace activist, Brian Terrell, rightly sees the Catholic Worker as "a revolutionary movement, one that recognizes that when we pray 'your will be done on earth as it is in heaven,' we are radically breaking with the status quo, committing ourselves to turning the world upside down, to a whole different order of things" (8).

Works Cited

"About the Catholic Worker." *karenhousecw.org.* Web. 12 December 2013.

"Corporal and Spiritual Works of Mercy." *Catholic Encyclopedia. Catholic Online.* Web. 15 Dec. 2013.

Coy, Patrick G. "The One Person Revolution of Ammon Hennacy." *A Revolution of the Heart: Essays On the Catholic Worker.* Ed. Patrick G. Coy. Philadelphia: Temple UP. 1988: 134-176. Print

Curren, Eric. " Voluntary Poverty - it Could Save Your Life, But What a Hard Sell." *Transition Voice.* 8 July 2011. *transitionvoice.com.* Web. 7 Dec. 2013.

Day, Dorothy. "Beyond Politics." *The Catholic Worker.* November 1949, 1,2,4. *The Catholic Worker Movement.* Web. 12 December 2013.

---. *On Pilgrimage.* 1948. Grand Rapids, Michigan: William B. Eerdmans Pub. 1999. Print.

---. "On Pilgrimage - May 1957." *The Catholic Worker.* May 1957, 3, 6. *The Catholic Worker Movement.* Web. 15 Dec. 2013.

---. "On Pilgrimage - September 1973." *The Catholic Worker.* September 1973, 1, 2, 6. *The Catholic Worker Movement.* Web. 15 Dec. 2013.

Dear, John. *Christianity and Vegetarianism: Pursuing the Nonviolence of Jesus.* Norfolk, Va: PETA, 1990. *jesusveg.com.* 10 September 2013. Web. Dec. 15, 2013.

Elgin, Duane and Arnold Mitchele. "Voluntary Simplicity." *The Co-Evolution Quarterly.* Summer 1977. *duaneelgin.com.* Web. 10 Dec. 2013.

Elgin, Duane. "How Times Have Changed." Introduction to revised edition of *Voluntary Simplicity: Toward a Way of Life That Is Outwardly Simple, Inwardly Rich.* New York: William Morrow & Co, 2010. *duaneelgin.com.* Web. 10 Dec. 2013.

Ellis, Mark H. *Peter Maurin: Prophet in the Twentieth Century.* Wipf & Stock Publishers, 2010. Print.

---. "Peter Maurin: To Bring the Social Order to Christ." *A Revolution of the Heart: Essays On the Catholic Worker.* Ed. Patrick G. Coy. Philadelphia: Temple UP. 1988: 15-46. Print.

Etizoni, Amitai. "Introduction. Voluntary Simplicity - Psychological Implications, Societal Consequences." *Voluntary Simplicity: Responding to Consumer Culture.* Eds. Daniel Doherty, Amitai Etizoni. Lanham: Rowman & Littlefield, 2003: 1-25. Print.

Forest, Jim. *All Is Grace: A Biography of Dorothy Day*. New York: Maryknoll, 2011.

Greer, John Michael. "How Not to Play the Game." *The Archdruid Report. thearchdruidreport.blogspot.com*. 26 June 2011. Web. 7 December 2013.

---. *The Wealth of Nature: Economics as if Survival Mattered*. New Society Publishers. 2011. Print.

Gregg, Richard. *The Value of Voluntary Simplicity*. Wellington, Pennsylvania: Pendle Hill, 1936. Scribd Inc. 2013. *scribd.com*. Web. 15 Dec. 2013.

Johnson, Kelly S. *The Fear of Beggars: Stewardship and Poverty in Christian Ethics*. Cambridge: Wm. B. Eerdmans Publishing, 2007. Print.

Klejment, Anne. "Dorothy Day and César Chávez: American Catholic Lives in Nonviolence." *U.S. Catholic Historian* 29.3 (2011): 67-90. *Project MUSE*. Web. 28 Dec. 2013.

Lynd, Staughton. Foreword. *The Making of a Radical: A Political Autobiography*. By Scott Nearing. Chelsea, Vermont: Chelsea Green Publishing. 1972. x-xiii. Print.

McKanan, Dan. *The Catholic Worker After Dorothy: Practicing the Works of Mercy in a New Generation*. Collegeville, Minnesota: Liturgical Press, 2008. Print.

Maurin, Peter. *Catholic Radicalism: Phrased Essays for the Green Revolution*. New York: Catholic Worker Books, 1949. Print.

Meyers, Ched. "Anarcho-Primitivism and the Bible." *Encyclopedia of Religion and Nature*. Continuum, 2005. Web. 15 Dec. 2013.

Miller, Timothy. *The Quest for Utopia in Twentieth-Century America. Vol. 1: 1900-1960*. Syracuse, New York: Syracuse UP, 1998. Print.

Mounier, Emmanuel. *A Personalist Manifesto*. Trans. monks of St. John's Abbey. New York, 1938. Print.

Nearing, Helen. *Simple Food for the Good Life: Random Acts of Cooking and Pithy Quotations*. 1980. Chelsea, Vermont: Chelsea Green Publishing, 1999. Print.

Nearing, Scott. *The Making of a Radical: A Political Autobiography*. 1972. Chelsea, Vermont: Chelsea Green Publishing, 2000. Print.

Popken, Ben. "Mommy Needs a New Pair of Stimulus Shoes." *consumerist.com*. 9 Dec., 2013. Web. Dec. 15, 2013.

Roberts, Nancy L. *Dorothy Day and The Catholic Worker*. Albany: State of New York Press, 1984. Print.

Shi, David. *The Simple Life: Plain Living and High Thinking in American Culture*. Athens, Georgia: U. of Georgia P., 1985. Print.

Terrell, Brian. "Radically Rooted in the Land." *The Roundtable*. Spring 1996: 8-9. Karen Catholic Worker House. *karenhouse.org*. Web. 12 December 2013.

Thoreau, Henry David. *Walden*. London & New York: The Walter Scott Publishing Co., 1886. Print.

Zwick, Mark and Louise. *The Catholic Worker Movement: Intellectual and Spiritual Origins*. Mahwah, New Jersey: Paulist Press, 2005. Print.

---. "Why Not Canonize Peter Maurin, Co-Founder with Dorothy Day of the Catholic Worker Movement." *Houston Catholic Worker*. Vol. XXX. No. 3. May-July 2010. *Casa Juan Diego. cjd.org*. Web. 15 Dec. 2013. Print.

The Battle over Squash and Beans: Food Justice Activism in a Polarized City

Aneta Dybska

Healthy, sustainable, affordable, produced by unexploited workers, physically accessible, and culturally adequate—these are the attributes of good food. It is under the banner of "good food" that in 2010 the Mayor of Los Angeles Antonio Villaraigosa commissioned a report on a new regional food system. Entitled "Good Food for All Agenda," it addresses economic, social and environmental considerations, combining a vision of ecological sustainability with local agricultural development. A regional non-profit organization, the Los Angeles Food Policy Council (LAFPC), is responsible for the implementation of those food policy goals. It convenes stakeholders from a range of sectors, socio-economic backgrounds, and locations. This collaboration involves strong citizen participation and is geared towards building a sustainable food system as much as developing policy recommendations towards systemic change. As laid out in the report, the good food policy is driven by economic considerations, namely, developing a food infrastructure, creating incentives for micro-enterprise development (small family-owned farms), offering green jobs training, as well as boosting regional demand for good food. Yet, the growth of a good food-based regional economy along with a commitment to fair worker practices serves the larger purpose of enacting social justice in the underserved areas of Los Angeles county,[1] most affected by structural inequalities of race and class. The report stipulates that the good food initiatives would entail converting convenience stores[2] into healthy food retailers, attracting supermarkets, encouraging healthy

1 Apart from Central Los Angeles, the following regions belong to Los Angeles County: Westside Cities, San Fernando Valley, Santa Clarita Valley, Antelope Valley, San Gabriel Valley, Gateway Cities, and South Bay.

2 Also known as a corner store or mom-and-pop store, the convenience store is a small retail establishment that carries a range of products such as groceries, alcohol, soft drinks, newspapers, and cigarettes. The choice is often limited and the food sold is highly processed. The mark-up on the prices is higher than at supermarkets (chain stores) since convenience stores buy in smaller quantities at higher prices. But customers pay for the convenience of shopping near the home. Starting from the 1970s, many convenience stores in South Central were run by Korean immigrants who came to the U.S. in the post-Civil Rights era and bought businesses where they could afford them, i.e. in poor, disinvested neighborhoods. As Edward T. Chang notes, a major source of conflict that emerged between black patrons and Korean merchants was rooted in cultural difference, ignorance of each other's histories (race relations in the U.S.), and misunderstandings

food street vending, promoting farmers markets, and broadening access to community gardens ("Building a Healthy Food System"). This policy is a huge step forward towards food justice: rather than alleviating the effects of food insecurity with the federal Food Stamps Program,[3] it engages low-income communities in the production, distribution and consumption of healthy and affordable food, increases food literacy, and empowers them to make informed food choices.

This paper uses the South Central L.A. Farm as a case study that elucidates grassroots-level interventions in the socio-spatial inequalities in Los Angeles that preceded the Good Food for All regional policy. Like many post-industrial regions across the U.S., the Los Angeles metropolitan area has been the center stage of demographic shifts and economic restructuring—factors that have significantly shaped the city's policies of growth and competitiveness in the global economy. A polarized city since its inception, only recently has Los Angeles become preoccupied with ecological sustainability and strategies of mitigating the socio-economic and spatial inequalities experienced by its diverse body of inhabitants. Prior to that, initiatives like the South Central L.A. Farm would have been precariously dependent on the global flows of capital and the exchange value of land. I therefore treat urban agriculture as a lens through which food justice and food justice activism can be seen as creating avenues for greater social equity. This research is driven by the following questions: Why is it important to talk about fairness through the prism of food? What tensions and conflicts can arise when the commons in the city's food deserts become privatized with little consideration for the social, economic, nutritional and public health costs? How does community gardening among low-income ethnic minorities translate into greater socio-spatial justice? And finally, in what way can micro projects like the South Central Farm trigger a thorough restructuring of the food system at the regional and national scale?

South Los Angeles (formerly South Central Los Angeles), a working class and minority region of the City of Los Angeles, stands out as a "food swamp" dotted with unhealthy food retail outlets and fast food franchises as well as a "food desert" where access to fresh and healthy food is severely limited.[4] The

concerning rules of appropriate behavior. Those conflicts culminated in the 1992 Rodney King riots, when many Korean-owned businesses were burnt down and looted. For a detailed discussion, see Edward T. Chang, "New Urban Crisis: Korean-African American Relations."

3 The program's official name today is the Supplemental Nutrition Assistance Program (SNAP).

4 The USDA defines a food desert as a "low income census tract where a substantial number of residents have low access to a grocery store." The poverty rate in low-income are-

region of 51 sq miles, while holding the most densely populated neighborhoods, is home to only 5 out of the city's 42 community gardens (as of 2011). This surprisingly low number of urban gardens in a "landscape of need" (Longcore et al. 2) and scarcity of greenery bears witness to the planning of LA as an extended city—a continuous suburban tract with no civic realm except for the beaches, the mountains, and the desert (Weinstein 31).

The South Central L.A. Farm at 41st Street and Alameda, established on 14 acres (5.6 ha) of vacant land zoned as industrial, has become an internationally notorious example of the city's pro-growth agenda thanks to Scott Hamilton Kennedy's 2008 Oscar-nominated documentary The Garden. Until its demolition in 2006, the community garden had operated for 13 years and served 150 poor Latino families, mostly immigrant farmers, as a source of fresh, healthy, and culturally relevant produce. The fact that the New Economy of the post-industrial era relies on the mass influx of unskilled immigrants from the global South who take up low-paid agricultural and service jobs, has led to the emergence of a substantial number of working poor who today constitute 40 per cent of Los Angeles's population; they live in the densely populated ring around the core of downtown Los Angeles (Soja 114-121), in neighborhoods such as South Central.

Only recently, however, has urban gardening become part and parcel of the Los Angeles municipal policy of mitigating hunger and malnutrition in impoverished, disinvested neighborhoods, mostly inhabited by low-income immigrants from Central and South America. The socio-economic polarization of Los Angeles expresses itself in the unequal spatial distribution of public green areas and unequal access to healthy food. That food deserts are, in part, a consequence of suburbanization seems to be common knowledge. When middle-class consumers moved to suburban locations, grocery chain stores followed them in pursuit of higher profits, away from the downtown low-income, minority populations, thus radically limiting the latter's access to affordable, fresh, and nutritious food (Morales 151-152). This is visible in the distribution of supermarkets: black neighborhoods have three times fewer supermarkets than white areas, and Latino neighborhoods two times fewer supermarkets than whites. As regards convenience stores, their number in South Central is twice as high as in other regions of Los Angeles County ("Good Food for All" 70, 73). But apart from being a corollary of suburban and regional growth, food deserts are also localized symptoms of the transnationalization and deregulation of the market, as well as the globalization of labor, production, and capital.

as is at least 20 per cent and at least 33 of the census tract's population live farther than a mile from a grocery store or a supermarket ("Food Deserts").

During World War II and in the post-war era, the industrial growth of Los Angeles went hand in hand with the western migration of Southern blacks who became the city's well-paid, skilled workforce. Though they earned decent incomes in the defense industries, residential discrimination confined them to racially segregated neighborhoods south of Los Angeles's Downtown (South Central: Jefferson Park, West Adams, Watts, as well as the cities of Inglewood, Compton, and Long Beach). By the time of the 1965 Watts riots, a violent six-day race rebellion in South Los Angeles, 80 per cent of Los Angeles County's 6 million inhabitants were predominantly white, with African Americans as the largest minority (11.6 per cent). According to U.S. Census Bureau statistics, those numbers have changed radically. As of 2012, 10 million people lived in Los Angeles County. While African Americans continue to be a minority (9.3 per cent), Hispanics and Latinos comprise 48 per cent of the population. Many are immigrant Mexican farmers who have settled in traditionally black inner-city neighborhoods such as South Los Angeles. That Los Angeles County has a significant Latino population results from the region's restructuring in the 1980s and 1990s, when large segments of white and African American working-class residents left for the suburbs or migrated to the Southern states in search of better job opportunities. Also, in the last few decades, Southern California has undergone an economic shift from largely industrial to corporate agricultural, effecting large-scale displacement on both sides of the U.S.-Mexican border. This shift was linked to Mexico's internal restructuring processes that gave an unfair advantage to the global food corporations which pushed small-farm holders, i.e. campesinos, off their land, sending them north in search of work. Ironically, as Sandy Brown and Christy Getz observe, working as waged laborers on California's farms, some of those Mexican immigrants depend for their livelihood on the same agribusiness that they were dispossessed by (122). Others settled in the Los Angeles metropolitan area and work in the service industry—a precarious existence. The 2000 U.S. Census Bureau statistics for Central Alameda, a neighborhood that was home to South Central Farm, are illustrative of this trend. The neighborhood had one of the largest population densities in the city of Los Angeles and the county (18,760 people per square mile): Latinos, most of them born in Mexico, comprised 84.5 per cent of the population,[5] compared to 13 per cent of African Americans.

Almost three decades after the Watts riots, the acquittal of white police officers who had brutally assaulted Rodney King, an African American man, ignited the 1992 Los Angeles Riots. The Rodney King Riots, as they are most frequently referred to, became a multiracial rebellion that was not limited to

5 For more data on South Central, go to the Mapping LA project of the *Los Angeles Times*.

a single neighborhood or racial/ethnic group. That the riot spread all over the Los Angeles metropolitan area, as Mike Davis has noted, was more than a reaction to police violence or Korean storeowners' increased commercial presence in deprived black neighborhoods. Although the tensions gave rise to inter-racial violence,[6] the riots were visibly an uprising of the poor —"a postmodern equivalent to traditional bread riots" (Davis). It was only in the aftermath of the 1992 riots that labor-community activism emerged as a way of channeling working-class disillusionment with the government's inept efforts to instigate change (Soja 143). Anchored in demands for democratic participation, equity and justice, local grassroots coalitions addressed such issues as: affordable housing, access to public services, immigrant rights, and education. All these demands naturally stemmed from an increased awareness that inequalities played themselves out spatially and should be targeted from the local community level (133).[7]

The South Central L.A. Farm, a community-gardening project established in 1992, expanded the political range of localized initiatives, with their explicit focus being on increasing food access among impoverished populations of color living inside food deserts. The farm was initially a reformist anti-hunger measure expected to result in increased food security, defined by the UN Food and Agriculture Organization as "exist[ing] when all people, at all times, have physical, social and economic access to sufficient, safe, and nutritious food to meet their dietary needs and food preferences for an active and healthy life" (FAO, 1996).

Determined to mitigate the economic deprivation and frustration that had recently found expression in the riots, the city leased a vacant lot to impoverished immigrant Latino volunteers[8] under the stewardship of the Los Angeles Food

6 To read about the interracial aspect of the riots, go to John Lie and Nancy Abelmann, "The 1992 Los Angeles Riots and the Black-Korean Conflict."

7 This coalition building, as Soja explains, was informed by close linkages with university activists, most significantly with Urban Planning scholars from UCLA (144).

8 Dean Kuipier, an *LA CityBeat* journalist, wrote in 2005 that "The families who work these plots are all chosen to receive one because by USDA standards they are impoverished, and use them to augment their household food supply. These are survival gardens" (qtd. in Philpott, "Neoliberalism at the Garden Gate"). In the light of this passage, we may infer that there were more volunteers than land available; on the other hand, the 350 lots were divided among just 150 families, a fact that may indicate that the lot assignment was not competitive after all.

Bank, a private non-profit charitable organization responsible for distributing food to the needy (*The Garden*).[9]

Sited in a largely industrial region of Los Angeles with few green public spaces, the South Central L.A. Farm constituted a viable alternative to charity food distribution (e.g. food pantry, food bank). Soon after its inception, the garden became a self-governed entity, a grassroots project modeled on the *ejido* system, a system of state-owned land management widely used throughout much of the 20th century in Mexican villages. As Garret M. Broad observes, the system prevents any form of land commodification, either for individual or collective purposes (30). Although divided into lots worked by individual families and managed by way of direct democratic participation, such land is not subject to the logic of exchange and functions as a village commons. Thus, the garden evolved into a progressive project embedded in the food justice discourse and activism. As Eric Holt-Giménez explains, the food justice agenda addresses socio-spatial injustices by promoting citizen involvement and more equitable and democratic business models. Such sustainable small-scale initiatives as community gardens, farmers markets, or community-supported agriculture (CSA) are believed to have a transformative potential, especially in underserved low-income communities (323). Designed as a well-tested alternative to the reformist food bank and food aid programs, the lease of the then public land increased the gardeners' food self-reliance as well as enabling the local production and consumption of culturally adequate produce. On top of ensuring food security, the gardeners worked to alleviate the socio-spatial and economic disadvantages of race, class, and immigrant status. The gardeners—many of them undocumented,[10] with a family income averaging $1,500 per month— grew enough produce to satisfy a third of their food demand (Lebuhn). Having depended on the land at home, they were able to use the farming skills they had carried with them across national borders. Apart from enriching their diets with fresh, nutritional food from their indigenous cultures in Mexico and Central America, they used the garden to celebrate their ethnic heritage. As social anthropologist Devon Peña

9 In 2009, around one million (one in ten) of Los Angeles county residents relied on emergency food assistance provided by the Los Angeles Regional Foodbank via food pantries, soup kitchens, and shelters ("Good Food for All Agenda" 70).

10 I use the term "undocumented" rather than "illegal." The latter term was contested during the April 2006 mass protests of immigrant groups aimed at re-defining the bureaucratic language of state exclusion. The protesters, many of them immigrants, insisted they were members of indigenous diasporas. Devon Peña informs us that one of the Spanish language banners sent the message: "No somos ilegales, somos obreros transnacionales" ("We are not illegal, we are transnational workers"). See Devon Peña's "Toward a Critical Political Ecology of Latina/o Urbanism."

observes, rife among the Mesoamerican communities in the Los Angeles region, such "places [are] infused with the extension of memories of difference in which homeland identities are anchored in conscious diasporic strategies for 'dwelling' in and reinhabiting transnational spaces" ("Toward" 2). Countering the logic of neoliberal planning and deterritorialization as a precondition for growth, the South Central L.A. Farm was an expression of vernacular urbanism involving what Peña calls a "transnationalization of a sense of space" ("Farmers" 3). Through the farm, the Latino families made a connection between their indigenous cultures and the immediate physical environment.[11] Dean Kuipers, journalist for *Los Angeles CityBeat*, recognized the garden's culture-specific biodiversity and economic function, calling it a "survival garden" quite unlike other "tiny weekend projects in the city with a few tomatoes and California poppies."

> The 330 spaces here are large, 20 X 30 feet, many of them doubled- and tripled-up into larger plots, crammed with a tropical density of native Mesoamerican plants – full-grown guava trees, avocados, tamarinds, and palms draped in vines bearing huge pumpkins and chayotes, leaf vegetables, corn, seeds like chipilin grown for spice, and rank upon rank of cactus cut for nopales. . . (qtd. in Philpott, "Neoliberalism at the Garden Gate")

When the vacant trash-hewn lot that stood for the neighborhood's decay and decline turned into a beautiful green space in an industrial food desert, the garden also became a source of pride.

Yet, when it comes to the stability and persistence of urban gardening projects, they may turn out to be precariously contingent on the capital's constant need to expand and deterritorialize the commons. This is exactly what happened to the South Central L.A. Farm. Due to intricate land ownership issues and the eventual sale of the land into private hands, the largest community garden in the U.S. fell short of becoming an immutable part of the local and sustainable food infrastructure. Initially hailed as a panacea to the problems created by the market and the roll-back of the welfare state, this "veritable Mesoamerican agroecological landscape renowned for a world-class ethnobotanical collection" (Peña, "Toward" 4) eventually succumbed to the logic of capitalist accumulation.

This was not the first time that the vacant lot became a contested space. In the late 1980s the private developer Ralph Horowitz had sold the lot to the city under eminent domain. The city planned to build a trash incinerator on the site,

11 In the industrial era in England, Germany and the U.S., as well as Poland, community gardens were established to facilitate rural migrants' transition to the urban environment, and to ease economic deprivation.

but due to successful community resistance against the project as an instance of environmental racism waged by African American Juanita Tate and the Concerned Citizens of South Central L.A., the investment never came to fruition. The land lay fallow until 1992, when the municipality, in cooperation with the Los Angeles Food Bank, allocated the land for a Latino community garden. In the meantime, the lot's value appreciated due to the city's investment in the rail infrastructure that made the garden's location on the Alameda Corridor strategic: linking the ports of Los Angeles and Long Beach with the Pacific Rim and the transcontinental rail network, the Alameda Corridor had the potential to attract business activity with the desired job creation for the local population and to yield long-term tax revenues for the city (Lebuhn).[12] When in 2003 Horowitz successfully reclaimed the land for light industrial uses, a controversy over moral vs. legal rights to the land ensued. The decision motivated the gardeners' protracted civil disobedience under the slogan "Aqui Estamos y No Nos Vamos!" They refused to give up the land until June 2006 when the city officials finally recognized the developer's legal right to the land.[13] Despite garnering unusual levels of media exposure and support from dozens of environmental groups, grassroots groups, civil rights activists, politicians, and Hollywood celebrities,[14] the farmers were forcibly removed from the site and the garden's rich and unique plant life was bulldozed.[15]

This case finds resonance in urban planner Nathan McClintock's words that "urban agriculture's physical location is often largely a function of land value," depending on the phase of business cycles. While in times of economic reces-

12 This is how Tom Philpott describes the farm's strategic location: "The garden lies conveniently near the Alameda Corridor, a $2.4 billion city project designed to facilitate the flow of goods shipped into the Los Angeles and Long Beach ports through the metropolitan area. Since its completion in 2002, big-box retailers have scrambled to build warehouses in South Central." ("Neoliberalism at the Garden Gate").

13 Here is how the South Central L.A. farmers argued their case in a letter to Antonio Villaraigosa, Mayor of Los Angeles, upon receiving an eviction notice on March 1, 2006: "As citizens and tax payers of the City of Los Angeles we are outraged that the city of LA settled a speculative lawsuit with Mr. Horowitz. Even after Judge W. Crispo had ruled three times against Horowitz, the city officials conceded to give the land back to Horowitz for a mere 5.1 million dollars, extremely under the fair market value, since in 1994 it had been sold" for 13.3 million dollars.

14 Among the supporters were Julia Butterfly Hill, John Quigley, Daryl Hannah, Joan Baez, Willie Nelson, Ralph Nader, and Danny Glover.

15 For details of the violent eviction and the history of the South Central Farm go to: "LA Planning Commission Must Heed South Central LA Community Concerns" by Tezozomoc, one of the South Central LA Farm leaders, as well as Scott Hamilton Kennedy's documentary *The Garden* (2008).

sion, urban agriculture may be supported as not interfering in the exchange uses of land, McClintock argues, during an economic upturn, it may be seen as a "hindrance to development." If we apply those macro-economic insights to our analysis, it will become clear as the South Central L.A. Farm "represents the simultaneous outgrowth of and reaction to crises of capital" (15).

Interestingly, South Central Farmers Feeding Families, a grassroots organization created to fight for the continued use of the garden lot for the public good, framed their protest in a way that resonated with the up-to-date activist and government discourses on food security and sustainability, and which, in different circumstances, would have given any applicant for a gardening project the upper hand in securing government grants. Their familiarity with officialese is aptly demonstrated in a wide-circulation letter of support addressed to Mayor Villaraigosa. Among the benefits highlighting the garden's diverse functions, they enumerate: community development, training in democratic participation and leadership, engaged civic life, the educational and cultural value of the farm as a site of cultural exchange and ethnic heritage, food security and entrepreneurial skills, health and nutrition.[16]

What happens when land as a precondition for food security and food justice disappears? "In the politics of impossibility you win by losing," says Tezozomoc, a leader and representative of South Central LA Farmers.[17] After the eviction in 2006, the farmers shifted their activity to an 85-acre-farm in Buttonwillow, Kern Country, CA, which they received through a generous donation. Of the original farmers only a few participate in the South Central Farmers' Cooperative today.[18] They run a Community-Supported Agriculture (CSA) farm with 1,500 members, but they also sell their organic, pesticide-free, heirloom fruits and vegetables at a number of farmers' markets in Los Angeles and Kern Coun-

16 See for example, "South Central Farmer's Community Garden Under Attack! Send Your Letter Today!" For a general discussion of the civic aspects of urban gardening, go to Bethany Rubin Henderson and Kimberly Hartsfield's "Is Getting into the Community Garden Business a Good Way to Engage Citizens in Local Government?"

17 Tezozomoc, "Renewing Our Community's Agricultural Life From Loss in South Central Los Angeles." Next to Rufina Juarez, Tezozomoc is featured in *The Garden* as a South Central L.A. Farm leader and representative. He is winner of the 2013 Growing Green Food Justice Award given by the Natural Resources Defense Council (NRDC), an international non-profit environmental group, for actions contributing to building sustainable food systems.

18 A handful of the original farmers, apparently in conflict with the farm leaders, relocated early on to a new gardening site under high-voltage lines in Watts.

ty.[19] At Buttonwillow, the farmers have successfully used the market to establish more equitable relations between food producers and consumers; despite operating in a neoliberal economic milieu, they successfully incorporate redistributive justice policies into their business model, since profits are not their top priority. Next to providing affordable and healthy produce to families living in food deserts,[20] they use sliding scale pricing—a differential pricing of shares, charging more prosperous members/buyers a higher price ($20-25) per a weekly box of produce to subsidize low-income members/buyers ($15). Unsold fruit and vegetables are donated to churches, homeless shelters and rehabilitation centers ("Putting Down Organic Roots"). They also partner with community-development organizations in low-income communities of color to enhance start-up opportunities related to organic agriculture, and offer educational outreach about healthy food choices.[21]

While this ending turns the South Central Farmers' ordeal into a well-crafted success story, we have to bring to the foreground the role of private capital in re-starting the food project in a new location. Land donation, being a voluntary act of distributive justice, is indeed consistent with the neoliberal logic that holds that the market will offer a solution to the social problems it engenders. Much as the market can, literally, prepare the ground for local struggles against food injustice, it can equally quell those impulses without consideration for the social costs involved. All of this is true for the South Central Farm. Therefore, more radical thinkers see such micro-level endeavors as urban gardening in a different light. They sound the alarm that urban agriculture has been made subservient to the goals of the neoliberal state (Mayer 365) and co-opted by the region's growth agenda and competitiveness in the global economy. Urban gardening, they observe, produces "spaces of neoliberal governmentality" which conveniently shift the burden of economic downturns and the social ramifications thereof onto the individuals who, as subjects of power, buy into the self-improvement agenda of the state as a prerequisite of a re-connection with nature, without questioning the legitimacy of the state or locating their personal transformation in a redesign of power relations (Pudup 1230).

19 This means that one can become a stakeholder in the CSA for a fixed fee and enjoy delivery of fresh in-season produce on a regular basis in return for supporting a local farm and participating in the sustainable food system.

20 To read about Ralph's, a chain grocer that recently withdrew from a South Central community, go to "Residents Rally Today to Protest Closure of Yet Another Grocery in South L.A."

21 The South Central Farmers' Health and Education Fund (SCFHEF), a non-profit organization, makes the farmers' food literacy activities and entrepreneurial support possible.

Is there an approach that would allow us to reconcile the progressive and radical perspectives so that one would not discredit the other? David J. Hess seems to have an answer:

> community gardening operates in a neoliberal political environment, but it would be a distortion to claim that this type of localism is an expression of neoliberalism. Rather, community gardening presents a coherent vision of how to link the goals of local sovereignty, sustainability, and distributive justice, and it does so by constantly working with (and occasionally against) governments to demand greater support, including the use of public lands for gardens. (156)

This view is shared by sociologist Josée Johnston, who frames food justice as a counter-hegemonic power struggle. Going beyond the Marxist understanding of power as a top-down process of domination and class oppression, we can see power as spread throughout the social body, as diffused social relations exercised in multiple locations by multiple agents. Drawing on Michel Foucault's notion of capillary power,[22] Johnston sees small-scale food justice projects as dispersed points of resistance that can effectively challenge the profit-oriented logic and cultural dominance of corporate food systems at the micro-level. Yet the counter-hegemonic practices that decommodify food, land, labor, and culinary knowledge, regardless of how successful they might be locally, fall short of being transformative at the macro scale.[23] Since power relations are heavily skewed in favor of international food corporations, supported by state and international regulatory bodies (such as the WTO), they can re-instate their cultural dominance by making public policy concessions to appease the demands of the subordinate groups, or else, commodify the nascent counter-cultural "culinary impulses" (Johnston 32).[24] Thus, lasting large-scale alternatives cannot be effective unless governments support food justice projects with social policies (33).

22 Power that permeates regional and local institutions, different forms of micro power. Foucault defines capillary power as follows: "the mechanisms of power, I am thinking rather of its capillary form of existence, the point where power reaches into the very grain of individuals, touches their bodies and inserts itself into their actions and attitudes, their discourses, learning processes and everyday lives" (*Power/Knowledge* 39).

23 The other key aspect of transformation can also involve creating alternative post-consumer needs and visions of life, e.g. reconciling consumer sovereignty with sustainability, for example by eating strawberries when they are in season.

24 *Whole Foods Market* can be an example of how organic production on an industrial scale can, in fact, compete with the pricier sustainable food initiatives by appealing to consumer sovereignty and sidestepping the issue of social justice or environmental sustainability (Johnston 30).

One such endeavor is supporting farmers' markets with wireless terminals that accept EBT (Electronic Benefit Transfer) debit cards, or food stamps. In this way, the federal government promotes better access to healthy food among food-aid recipients nationwide. Another recent public health measure, the Fruit and Vegetable Prescription Program (FVRx), is also worth paying attention to. Conceived as a partnership between local food system advocates and healthcare providers, this community health program sets out to promote healthy eating and fight diet-related diseases such as obesity and type 2 diabetes among children in food deserts. By way of redeeming a fruit and vegetable prescription (a coupon valued at $1or $2 per day per person), participants have weekly access to in-season fresh, locally grown fruit and vegetables.[25] Both are instances of biopower that, in the process of ensuring more equitable food access and supporting sustainable food economies,[26] rather than international food corporations and big box retailers such as Wal-Mart, make an investment in a healthy and nourished public.

A similar outcome is stipulated by The Los Angeles "Good Food for All" agenda, which insists on more effective use of federal aid programs (SNAP funds) to increase the availability of fresh produce in supermarkets, at farmers' markets, or from mobile vendors, but also to decrease fast food consumption in low-income neighborhoods and communities of color. Driven by public health concerns, among others, this solution foregrounds economic empowerment as a prerequisite for achieving food justice. Building the necessary food infrastructure would stimulate employment but also, at the consumption end, create conditions for low-income residents to spend their food dollars (estimated at $113 million per year) locally,[27] and thus prevent the leakage of food dollars outside their neighborhood. But the good food agenda, apart from being a measure to boost the local economy, insists that federal, state, and local funds and incentives (below-market rate loans and grants) should be available in the first place to "responsible food retailers" that employ locally, pay a living wage, and offer health benefits; in other words, the ones that "lift up their employees and their surrounding communities" (72).

It seems, then, that if pursued as planned and implemented with the federal funds, this comprehensive state-level program of building a green economy in the Los Angeles region may offer a structural response to food injustice. Yet none of these measures would have been adopted without fierce battles over

25 See "Fruit & Vegetable Prescription Program."

26 By USDA estimates, every dollar spent in food stamps generates $1.84 in local economic activity. See "Good Food for All," 69.

27 This number pertains to five underserved communities in the county.

squash and beans like that of the Latino immigrant farmers at the South Central Farm. Like many less publicized community gardening initiatives, the South Central farmers used urban agriculture as a platform to voice their demands for food justice and as a tool of economic and social empowerment.

Works Cited

Broad, Garret M. "Ritual Communication and Use Value: The South Central Farm and the Political Economy of Place." *Communication, Culture & Critique* 6.1 (2013): 20-40. Print.

Brown, Sandy, and Christy Getz. "Farmworker Food Insecurity and the Production of Hunger in California." *Cultivating Food Justice: Race, Class, and Sustainability.* Eds. Alison Hope Alkon and Julian Agyeman. Cambridge, Mass.: MIT Press, 2011. 121-146. Print.

"Building a Healthy Food System for Los Angeles, Strategic Priorities 2012-2013." Good Food Office, Los Angeles, Ca. PDF file.

Chang, Edward T. "New Urban Crisis: Koran-African American Relations." *Koreans in the Hood: Conflict with African Americans.* Ed. Kwang Chung Kim. Baltimore: The Johns Hopkins University Press, 1999. 39-59. Print.

Davis, Mike. Interview by Lance Selfa. *Socialist Worker* 1992. *socialistworker.org*. Web. 12 Jan. 2014.

Foucault, Michel. *Power/Knowledge: Selected Interviews and Other Writings, 1972-1977.* Ed. Colin Gordon. New York: Vintage Books, 1980. Print.

"Food Deserts." *usda. gov.* Agricultural Marketing Service, United States Department of Agriculture. Web. 10 Jan. 2014.

"Fruit &Vegetable Prescription Program." *wholesomewave.org.* Web. 10 Jan. 2014.

The Garden. Dir. Scott Hamilton Kennedy. Black Valley Films, 2008. Film.

"The Good Food a for All Agenda: Creating a New Regional Food System for Los Angeles." Los Angeles Food Policy Council. Jul. 2010. PDF file.

Henderson, Bethany Rubin, and Kimberly Hartsfield. "Is Getting into the Community Garden Business a Good Way to Engage Citizens in Local Government?" *National Civic Review* 98.4 (Winter 2009): 12-17. Print.

Hess, David J. *Localist Movements in a Global Economy: Sustainability, Justice, and Urban Development in the United States.* Cambridge, Mass.: MIT Press, 2009. Print.

Holt-Giménez, Eric. "Food Security, Food Justice, or Food Sovereignty? Crises, Food Movements, and Regime Change." *Cultivating Food Justice: Race, Class, and Sustainability.* Eds. Alison Hope Alkon and Julian Agyeman. Cambridge, Mass.: MIT Press, 2011. 309-330. Print.

Johnston, Josée. "Counter-hegemony or Bourgeois Piggery? Food Politics and the Case of FoodShare." *The Fight Over Food: Producers, Consumers, and Activists Challenge the Global Food System.* Eds. Wynne Wright and Gerrad Middendorf. Rural Sociological Society's Rural Studies Series and Pennsylvania State Press, 2007. PDF file.

Lebuhn, Henrik. "Entrepreneurial Urban Politics and Urban Social Movements in Los Angeles: The Struggle for Urban Farmland in South Central." *eurozine.com*. 2006. Web. 14 Jan. 2014.

Lie, John, and Nancy Abelmann. "The 1992 Los Angeles Riots and the Black-Korean Conflict." *Koreans in the Hood: Conflict with African Americans*. Ed. Kwang Chung Kim. Baltimore: The Johns Hopkins University Press, 1999. 75-87. Print.

Longcore, Travis, Christine Lam, Mona Seymour and Alina Bokde. "LA Gardens: Mapping to Support a Municipal Strategy for Community Gardens." University of Southern California GIS Research Laboratory Research Report. Feb. 2011. Web. 10 Jan. 2014.

"Mapping LA." *latimes.com*. 2009. Web. 12 Jan. 2014.

Mayer, Margit. "The 'Right to the City' in the Context of Shifting Mottos of Urban Social Movements." *City: Analysis of Urban Trends, Culture, Theory, Policy, Action* 13.2-3 (2009): 362-374. Print.

McClintock, Nathan. "Radical, Reformist, and Garden-Variety Neoliberal: Coming to Terms with Urban Agriculture's Contradictions." *Local Environment: The International Journal of Justice and Sustainability* (2013): 1-25. Print.

Morales, Alfonso. "Growing Food *and* Justice. Dismantling Racism through Sustainable Food Systems." *Cultivating Food Justice: Race, Class, and Sustainability*. Eds. Alison Hope Alkon and Julian Agyeman. Cambridge, Mass.: MIT Press, 2011. 149-176. Print.

Peña, Devon. "Farmers Feeding Families: Agroecology in South Central Los Angeles." Keynote Address, The National Association for Chicana and Chicano Studies. March 4, 2006. Washington State University, Pullman, WA. PDF file.

---. "Toward a Critical Political Ecology of Latina/o Urbanism." *acequiainstitute.org*. PDF file.

Philpott, Tom. "Neoliberalism at the Garden Gate." *counterpunch.org*. 16 March 2006. Web. 13 Jan. 2014.

Pudup, Mary Beth. "It Takes a Garden: Cultivating Citizen-subjects in Organized Garden Projects." *Geoforum* 39 (2008):1228-1240. Print.

"Putting Down Organic Roots in Buttonwillow." *BakersfieldExpress.org*. 14 June 2010. Web. 12 Jan. 2014.

"Residents Rally Today to Protest Closure of Yet Another Grocery in South L.A." *la.streetsblog.org*. 13 June 2013. Web. 13 Jan. 2014.

Soja, Edward. *Seeking Spatial Justice*. Minneapolis: University of Minnesota Press, 2010. Print.

"South Central Farmer's Community Garden Under Attack! Send Your Letter Today!" *nwrage.org*. Web. 13 Jan. 2014.

South Central Farmers Feeding Families. Letter to Mayor Antonio Villairaigosa. March 2, 2006. *fromthewilderness.com*. PDF file.

Tezozomoc. "LA Planning Commission Must Heed South Central LA Community Concerns" by, one of the South Central LA Farm Leaders." *Huffingtonpost.com*. 10 Jul. 2013. Web. 12 Jan. 2014.

---. "Renewing Our Community's Agricultural Life From Loss in South Central Los Angeles." *Huffingtonpost.com*. 8 Ap. 2013. Web. 13 Jan. 2014.

Weinstein, Richard S. "The First American City." *The City: Los Angeles and Urban Theory at the End of Twentieth Century.* Eds. Allen J. Scott and Edward W. Soja. Berkeley: University of California Press, 1996. 22-46. Print.

Part Two: Consuming Culture

Consuming the Artist, Consuming the Image: Marina Abramović 2001 MOCA Gala Controversy

Justyna Wierzchowska

The Museum of Contemporary Art in Los Angeles (MOCA) was founded in 1980 and is the only museum in Los Angeles devoted entirely to contemporary art, that is art created after 1940, both European and American. Among its holdings, there are works by major artists of the 20th century, among them Piet Mondrian, Franz Kline, American Abstract Expressionists, major representatives of Pop art and second wave feminism. Unlike the Los Angeles County Museum of Art, MOCA receives minimal government funding, does not have a steady income and thus relies mostly on donations. In effect, in recent years, due to the global economic crisis, the museum has constantly struggled with financial difficulties. One of the ways to raise money for MOCA is the annual Gala, which was started in 2007 as a "single-evening, experimental artwork conceived by some of the most outstanding visual artists working today" ("MOCA Announces"). For example, the 2007 Gala was directed by the celebrated Japanese artist Takashi Murakami, then in 2009 by the Italian artist and filmmaker Francesco Vezzoli, who invited dancers from the Bolshoi Ballet and Lady Gaga to perform for MOCA. At the event, Lady Gaga's "piano customized in pink and blue butterfly motifs by … Damien Hirst" was auctioned for $450,000 in support of MOCA ("MOCA Announces"). In 2011,and this is the focal point of this essay, the Gala was directed by the ultimate star of performance art Marina Abramović, who invited an icon of music and popular culture, Deborah Harry (aka Blondie) to perform for MOCA.

Marina Abramović, who now lives in New York, was born in 1946 in Belgrade, then Yugoslavia, and in the early 1970s emigrated to the United States. Calling herself "the grandmother of performance art" (Scott 102), she authored and performed some of the most significant pieces in the history of performance art, among them: *Rhythm 10* (1973) in which she rhythmically cut her fingers with knives, *Rhythm 0* (1974) during which she made herself vulnerable to the audience, *Rhythm 5* (1974) during which she lay inside a burning star until she lost consciousness, *Imponderabilia* (1977) with her then partner Ulay, during which they stood naked facing each other and the visitors had to squeeze between them, *Rest energy* (1980) in which they held an arch-bow pointed at her heart so that Ulay could kill her if he let the arrow go, and – importantly for this

essay – *Cleaning the Mirror* (1995), in which she lay nude under a skeleton.[1] She has by now achieved the status of a cult figure, a true matron of contemporary art, and that of a celebrity also, especially after her performance at MoMA entitled *The Artist is Present* (closed just before the Gala at MOCA), where almost a million people came to sit face to face with her and silently look into each other's eyes,[2] and the earlier *Seven Easy Pieces* at the Guggenheim Museum (2007).She has also made herself talked about because of her co-operation with Lady Gaga, who based her latest video-clip on the so-called Abramović method.

As usual, the 2011 MOCA Gala, which took place on November 12 at MOCA, Grand Avenue, Los Angeles, was attended only by America's ultra-wealthy elite – celebrities, artists, moguls and politicians, among them Gwen Stefani, Tilda Swinton, Pamela Anderson, Dita Von Teese, Kirsten Dunst, David LaChapelle, California governor Jerry Brown and Los Angeles mayor Antonio Villaraigosa. The tickets ranged from $2,500 to $10,000, and table prices ranged from $25,000 to $100,000. Altogether over 750 people attended and in the end, the Gala raised $2.5 million ("MOCA Gala"). However, even before it started, the Gala became extremely controversial and started a heated discussion, with questions concerning the ethics of making art, the status of the artist, the interdependency of money, art, and show business, and the production and consumption of cultural images. In this essay, I want to point to some aspects which I believe reveal the tensions surrounding the ways in which visual art functions in the contemporary United States and the ambiguities surrounding what I call, after Garrie Lim, the "branding" of major artists and celebrities, that is their public personas functioning as marketable products (23-27). Interestingly for this essay, those tensions made themselves manifest during the 2011 MOCA Gala through the way food was used in the course of the performance.

In order to clarify my points, I need to describe the chronology and highlights of the 2011 Gala. Upon arrival, all the guests were asked to proceed to a huge dinner tent, where one of the tenets of Abramović's artistic manifesto was projected over the entrance: "An artist should avoid falling in love with another artist." There, the guests were asked to put on white lab coats, completely covering their designer outfits, which was supposed to make them symbolically

1 For a detailed account of Abramović's early work see *Marina Abramović* by Mary Richards.

2 A documentary of this performance, entitled *The Artist is Present*, was released shortly after the event.

anonymous and classless.[3] Then everyone proceeded to the tables and the Gala started. Abramović's manifesto was read in full, Blondie sang her hit songs, and the guests were offered sophisticated food. The point which triggered most of the controversy was Abramović's idea of decorating the tables with young artists who, for over three hours straight, played the role of centerpieces, constantly revolving and watching the ultra-wealthy eat their refined dishes. As art critic Linda Yablonsky, who was present at the Gala, describes: "Their job was to either lie naked under plastic skeletons revolving on the $100,000 dinner tables, or poke their heads through the $50,000 and $25,000 table tops while turning themselves on lazy Susans and locking eyes with guests throughout the evening." The controversy was over the fact that the names of the performers were not mentioned in the gala program and that they were paid a mere $150 together with a year-long MOCA membership (Wagley).

The performers were young artists who went through an audition for which "800 online submissions [were sent and] 200 people [met] to find 85 performers for the job" (Finkel). Those anonymous, low-paid artists who could not afford to attend the Gala themselves were those who made it possible for it to happen. As I have already pointed out, this triggered a lot of controversy even before the Gala took place. The discussion was started by the famous choreographer Yvonne Rainer, who wrote a letter to MOCA's director calling Abramović's work "exploitative" to the young performers, and arguing that the "desperate voluntarism" of the performers "says something about the generally exploitative conditions of the art world" in which "people are willing to become victims of a celebrity artist in the hopes of somehow breaking into the show biz themselves." According to Rainer, with the "sub-minimal wages for the performers, the event verge[d] on economic exploitation and criminality." Rainer also criticized the very idea of "wealthy diners as a means of raising money" and expressed her "dismay" that MOCA could "stoop to such degrading methods of fund raising," suggesting that the museum rename itself "MODFR, or the Museum of Degenerate Fund Raising" for, in the words of Linda Yablonsky, making "young people [into] abject table ornaments and clichéd living symbols of mortality in order to assume a novitiate role in the temple of art." Art critic Mark Cohen pointedly commented on the context of Rainer's letter claiming that: "What Rainer does not spell out explicitly . . .is the extraordinary poignancy of making use of young performers in this way against the backdrop of protests by the "99%."" Cohen's comment strikes a sensitive chord, provoking questions concerning the

3 This idea did not work 100%, as some people refused to wear the coats, which already
 made it impossible to completely break away from the outside-of-performance class-
 marked context.

fuzzy relation between the young artists' possible exploitation and their sense of agency. It has to be made clear that the performers were not forced to participate in the MOCA Gala; they knew exactly what the pay would be and had the time to withdraw (and in fact some of them did). Therefore it seems problematic to assume that all of them were naïve dupes of Abramović's fame. Still, as most of them were at the early stages of their artistic career, their uncredited participation in the MOCA Gala calls for a question concerning their being privileged or abused. This dilemma is pointedly voiced in a blog entry written by Ej Hill, one of the artists who played the part of a centerpiece during the Abramović Gala. Even though Hill realized that his participation in the Gala would involve travelling "through [a] moral gray area," he still wanted to perform:

> [When I found out about the audition] [i]mmediately, I was excited, nervous, and flushed. I mean, here's a woman whose name over the last year and a half (for better or worse) has become almost synonymous with "performance art" but whose career has spanned the past four decades. She is one of the artists whose work was introduced to me at the very beginning of my artistic explorations and continues to inform much of my own practice; I couldn't not pursue this.

Abramović herself commented on the controversy in a way very similar to Hill, refusing to acknowledge the ambivalence of the young artists' participation in her performance. She noted that: "We've heard from a lot of people saying how happy they are to be part of it because they respect my work. They are not being used" (qtd. in Finkel). She also stated that she herself did not get any fee for the project and that the $150 that went to each of the young artists was all the Museum could afford to pay. She added that she had hired "young people not to take advantage [of them] but because it took stamina to get through one of her durational pieces," somehow narcissistically concluding: "I'm the idiot. I'm sixty-five and still doing this!" (qtd. in Yablonsky). Thus Abramović refused to see the ambivalence of the situation and disregarded the fact that the whole event went solely to her credit, solidifying the Marina Abramovic brand. She did not address the question of the impact of the MOCA Gala on her status as an artist, explaining that the reason for which she wanted to direct it was her desire to help the museum, which was struggling under the donor system: "If museums don't have any money, there's no culture. It's a miserable state of mind for everybody" (qtd. in Finkel). So on the one hand Abramović tried to play down the economic dimension of the event, focusing solely on the artistic quality of her work which young artists admire, while on the other she acknowledged art's de-

pendency on money, but only in relation to art institutions, not the people whom she had hired to put on her performance.

Interestingly, this repressed economy-triggered tension came up in the form of food in the very narrative of the performance Abramović directed for MOCA. In the finale, when the dessert was served, it was conceived in the form of two edible cakes, shaped as look-likes of Abramović and Harry. The two women themselves cut into the cakes to hand them round to the ultra-rich donors. So literally what happened was that the two artists – Abramović and Harry – invited the wealthy consumers to eat their sweet sexualized representations until only battered scraps remained. Linda Yablonsky noted: "When it was all over, the cut-up cakes resembled mutilated bodies that made for a ghoulish sight." Significantly, in their cake versions, the two women were ageless, their faces wearing full make-up, their hair in refined disarray, and their bodies absolutely flawless apart from the perfectly replicated star Abramović had cut on her belly in one of her performances in the 1970s and which had become part of her image. The cake bodies lay on stretchers looking both submissive and somehow aggressive in the almost pornographic precision with which they were replicated. They seemed to say: "Eat me, eat me until you're sick." This can be read as a powerful artistic statement on the part of Abramović, not only in relation to her own status as an artist in the United States who gets "consumed" by show business, but also on the status of other artists/celebrities in the USA who may feel that they have to be symbolically or physically consumed to make a career or stay on top.

Yet, there seems to be another dimension of the Abramović-Harry cakes: the way in which the cakes addressed the still omnipresent sexualization and commercialization of the female body. As I have already pointed out, the cakes did not represent the 65-year-old Abramović and the 66-year-old Harry, but their ageless, perfected versions. In fact, after the initial cutting was performed by Harry and Abramović, it was continued by young semi-nude men who dismembered the cakes, cut off the breasts and cut out the precisely executed vaginas to the screams of the guests: "I want the breast! Give me the vagina!" (qtd. in Yablonsky). Thus the consumption of the dessert quickly turned into the consumption of naked, sexualized female bodies, ending in symbolic bodily abuse. However, I believe that there is more to it: what I find particularly significant in Abramović's cake idea is the correspondence, intended or not, between the cake-females and the status of the women (for these were only women) who recreated Abramović's famous *Nude With Skeleton* performance on the $100,000 tables. Even though, as Linda Yablonsky reports, it was not Abramović's idea but the museum's to use only women as nudes, in effect only women were put in

the mute and nude, to-be-looked-at position. *Los Angeles Weekly* journalist Catharine Wagley recalls the words of MOCA's Director Jeffrey Deitch:

> "That was my request to Marina Abramović," said [Jeffrey] Deitch, citing the discomfort the conventional businessman feels when confronted with male nudity. "We subjected people to a lot of things," he continued, but said when you push something out to the edge you have to be careful not to go over.

Wagley quotes artist Marjan Vayghan, who rhetorically asked at a public forum following the 2011 MOCA Gala: "But why was it the female body that was still always subject to display?" It seems that with her dessert idea, Abramović, while abiding by Deitch's request, nonetheless perverted the very idea of the female body put on display, as the consumption so quickly and obviously turned into an act of symbolic violence and sexual abuse. What is more, it turned out that some guests did feel uncomfortable even with the women placed nude under the skeletons. For example, as Yablonsky notes, "Governor Brown was smiling but seemed uncomfortable at the nude before him. 'That's a fake vagina, isn't it?' asked collector Michael Ostin, refusing to believe that the woman on display did not have 'some kind of enhancement.'" So it seems that at least in the case of some guests, the fact that nude female bodies were put in a defamiliarized context, jerked out of pornographic or romaniticized convention, and "thrown" right in their faces with a silent gaze that seemed controlling, that very fact stripped bare the apparent neutrality of the female nude put on display. The ensuing violent consumption of Abramović's and Harry's look-likes may have only strengthened the awareness of the violence done to female representation.

What is more, as the guests went on with the cakes, it turned out that the heads were not edible. In this way the representations of Abramović and Harry all of a sudden became reminiscent not only of the female artists lying under skeletons, but also of the young performers' heads rotating on the tables: they were all artists dependent on the powerful and rich who were welcome to "consume" them. It also sent another albeit naïve message that the rich were welcome to consume the bodies, but not the heads (minds). In fact, Abramović's focus on the head and the separation of the head and body opened a train of associations. For example, artist Adam Vuiitton brought with him a sign showing a guillotine. He explained that since performing artists appeared "beheaded on the tables of the ultra-rich," the guillotine seemed a relevant metaphor (Wagley). Also, the media likened Abramović to Marie Antoinette with whom the artist has several things in common: they both came from Europe, they share initials, they both had to do with cakes and ended up decapitated. Playing on the words

assigned to Marie Antoinette, newspapers ran titles "Let them eat cake!" or "This year's dish is performance art." Additionally, the cut off heads triggered visual associations with the Biblical story of John the Baptist beheaded by Salome.[4] This biblical association clearly introduces a sense of gender confusion, yet does not cease to pose questions concerning sexuality and power relations.

All the above readings of the Abramović-directed Gala reflect, I believe, the confusion surrounding not only the economic aspect of such events, but also the very status of art and artists in the contemporary USA. Contrary to Marie Antoinette's possible intentions, at the MOCA Gala it was the wealthy who ate the cakes and the under-privileged who got symbolically beheaded on the tables, with Abramović and Harry taking up an ambivalent position of being both part of the spectacle played out for the rich and at the same time meta-level commentators on the circulation of images, politics of gender, power relations, art's dependency on money and show business, and the problematic ethics behind all this. Their position, however, was radically different from that of the young anonymous artists because Abramović and Harry (Blondie) had already been functioning as brands and the MOCA event was instrumental in strengthening their status.[5]

In conclusion I want to go back to the young performers with a quick comment on the power relations between them and the Gala's guests. Catherine Wagley notes that "The way they described it, the performers had more power than guests did in their roles at the gala." This is confirmed by the aforementioned Ej Hill, who gives a detailed account of his experience:

> For a total of about four hours last Saturday, I was the most powerful person at my table. I watched as the wealthiest people I've never met, reluctantly took seats around me. First, their faces showed signs of stunned disbelief as they entered the space. Second, the awkward laughs and iPhone photos came, then it was confused and forced smiles as they sat down. Finally, came the extreme discomfort from the reality of the situation—they would actually have to eat in front of us. . . .The performance lasted only a few hours, but during those few hours, from a seemingly degraded position, I silently dictated an entire conversation. . . . They fumbled with their forks, stuttered on words and took out their phones to read invisible text messages. They employed all sorts of techniques to distract themselves in order to ease the tension. . . . I may have gone home to a tiny studio apartment in Koreatown in-

4 I thank Professor Elisabeth Frost for pointing this out to me.
5 There is an illuminating essay by Amelia Jones "'The Artist is Present': Re-enactments and the Impossibility of Presence," where she discusses the problematic nature of performance art, the artist's presence and the impact of the outside context and the artist's status on the very experience of performance art.

stead of a 6-bedroom house in Brentwood, but for those few hours, I was in complete and total control of that table and the people sitting around me knew it as well.

Hill concludes his account by claiming that "For four hours, we, the hired help, sat at the head and watched as the wealthy, many of them self-aware for the first time, performed for us." Abramović herself also seemed strategically overoptimistic, noting that: "Kings, aristocrats, and popes used to be the supporters of art. Today, in Europe, governments do it. In this country, we have businessmen and they want to be entertained. I want to take a different approach" (qtd. in Yablonsky), stressing the transformative potential of her work. In my view both statements offer simplified, one-sided accounts of the event. Catchy as it may sound, Hill's impression seems to verge on wishful thinking: How could major American celebrities be made self-aware for the first time if most of what they do is to be put on display? The question as to whether Abramović managed to take a different approach remains problematic as well. After all, the MOCA Gala guests paid, came and were entertained. They may have felt uncomfortable for a while, but it did not save MOCA from financial problems,6 did not produce a shift in the donor system, nor did it better the situation of young artists in America. To me, the 2011 MOCA Gala seems like a bitter comment both on the way art is dependent on business in the USA and on the way Marina Abramović herself has adjusted to the system, for she, as a very wealthy person, is clearly a beneficiary of the way art functions. This is why her Gala seems reminiscent of one of David La Chapelle's photos of Paris Hilton wearing a bikini that says "Eat the rich." Or maybe the tenet placed at the entrance of the tent should be read as a warning to the young artists: Don't fall in love with another artist or else they'll get all the credit and you'll end up rotating under the table, an anonymous, depersonified silent gaze that maybe for a while disrupts the comfort of the rich, but after all is only a table decoration.

Works cited

Boehm, Mike. "No Fall Gala for MOCA This Year." Los Angeles Time. 7 September 2012. Web. 8 Jan. 2014.

Cohen, Mark. "Who Will Rein Her In? Marina Abramović versus Yvonne Rainer." *Art Critical.* November 9, 2011. Web. 7 Jan. 2014.

Finkel, Jori. "MOCA Gala's Main Dish is Performance Art." *Los Angeles Times.*12 Nov. 2011. Web. 7 Jan. 2014.

6 The 2012 MOCA Gala was cancelled mostly due to financial problems (Boehm).

Hill, Ej. "Better than Flowers." *Tumblr*. 20 Nov. 2011. Web. 7 Jan. 2014.

Jones, Amelia. "'The Artist is Present': Artistic Re-enactments and the Impossibility of Presence." *The Drama Review*. 55.1 (2011): 16-45. Print.

Lim, Gerrie. *Idol to Icon: The Creation of Celebrity Brands*. London: Marshall Cavedish Business, 2005. Print.

Marina Abramović: The Artist is Present. Dir. Matthew Akers, Jeff Dupre. Show of Force, AVRO Close Up, Dakota Group. 2012. DVD.

"MOCA Announces Music &Popular Culture Icon Deborah Harry to Perform at MOCA Gala 2011." *Art Daily*. Royalville Communications. 22 Jan. 2012. Web. 7 Jan. 2014.

"MOCA Gala Raises $2.5 Million with Marina Abramovic's 'An Artist's Life Manifesto.'" *Art Daily*. 17 Nov. 2011. Web. 7 Jan. 2014.

Rainer, Yvonne. "The Letter to Jeffrey Deitch." *BlouinArtinfo*. Louise Blouin Media. 9 Nov. 2011. Web. 7 Jan. 2014.

Richards, Mary. *Marina Abramović*. London and New York: Routledge, 2010. Print.

Scott, Sue. "Marina Abramović: Between Life and Death." *After the Revolution: Women who Transformed Contemporary Art*. Ed. Eleanor Heartney and others. Munich: Prestel Publishing, 2007. 100-117. Print.

Wagley, Catherine. "Marina Abramović's MOCA Gala Controversy: Jeffrey Deitch Confronted and the Performers Speak Out." *Los Angeles Weekly Blogs*. 19 Dec. 2011. Web. 7 Jan. 2014.

Yablonsky, Linda. "Let Them Eat Cake." *Artforum*. 16 Nov. 2011. Web. 7 Jan. 2014.

An Abject Guide to America:
CSI Lab Autopsy and Stomach Contents as an (Ironic) Index of Interiorizing the Global and the Local

Zofia Kolbuszewska

> In our current eagerness to establish political readings of early modern texts—an eagerness whetted by the dearth of such readings in New Criticism—we have allowed political concerns to consume a range of other discourses through which individuals in the period attempted to comprehend their experience of the world and to wring meaning from it.
>
> —Michael Schoenfeldt (1997)

Crime Scene Investigation (CSI) TV shows, especially the series set in Las Vegas, Miami, and New York, as well as such forensic TV series as *Bones* have become an important landmark in the mediascape of America, and are often considered to be narratives expressing a new sense of American identity after 9/11, especially when regarded in the perspective of the global intruding onto the local and the local mapping onto the global. These shows feature criminal investigations in which autopsies play a very important if not a central role. The stomach contents of dead crime victims or dead perpetrators is often analyzed because they might provide an important clue, perhaps a lead, or even the conclusive evidence of a crime.

The recent surge in forensic imagination, understood as "a desire to speak with the dead," as Stephen Greenblatt has put it (1)—fulfilled by reading and interpreting traces in order to produce a hypothetical re-construction of the past—has affinities with baroque (and neobaroque) pansemioticism, that is "the idea that every object, whether natural or artificial signifies one or several other objects (which can in turn be abstract qualities, virtues or vices, or particular states of affairs or events)" (Westerhoff 633-34). Such extremely complex, and baroque in nature, interpretation of forensic evidence, in particular the examination of remains, is clearly a focus of several episodes of the season seven of the series *Bones*, which began on FOX in 2005. The series is devoted to the investigative work and adventures of the forensic anthropologist Dr Temperance "Bones" Brennan. She is employed by the Jeffersonian to identify skeletal remains from archeological sites and occasionally mass graves that appear in the

wake of genocidal wars around the globe. Yet, in order to create good press for the Jeffersonian she is asked to assist the FBI.

In episode six, "The Crack in the Code," a young woman's blood-stained skull and a spine with rearranged vertebrae are found at the foot of Abraham Lincoln's monument in the American Heritage Museum. The skull and the spine are accompanied by a piece of graffiti: the question "Where is the rest of me?" smeared on Lincoln's statue in blood—which on closer scrutiny turns out to contain the blood markers of five FBI agents. The staged remains convey a hieroglyphic message, or, perhaps, an emblematic riddle, addressed to the investigators by the serial killer Christopher Pelant, who is a mad computer genius, hacker and a polymath.

I am, however, more interested in exploring the ways in which not entirely digested food found in the stomachs of human corpses represented in the forensics-informed American TV programs can be regarded as an abject guide to American foodways and an indirect introduction to a particular perspective on social, political and environmental concerns in the first decade of the twenty first century. Even as the examination of stomach contents is represented in these programs as producing potential leads, it can also be interpreted as a manifestation of the ways of producing knowledge which is reminiscent of the early modern epistemology. Knowledge thus constructed is characteristic, as Gregg Lambert puts it in *On the (New) Baroque*, of the return of the baroque in modern culture, or a rise of the new baroque—often referred to as neobaroque— paradigm (ix-xv). It should be noted that the early modern epistemology shaped and was being shaped by, among other things, spectacular autopsies performed in anatomical theaters, where the dissected body and its parts were examined in their own right as anatomical specimen, but also as local micro-models of a macrocosm, a universe.

Michel de Certeau considers the cadaver of modern medicine to be a book, "a cipher that awaits deciphering" and traces this attitude to the transformation of the seen body into the known body between the seventeenth and eighteenth centuries, which was facilitated by "the transformation of the body into extension, into open interiority, like a book, or like a silent corpse placed under our eyes" (De Certeau 3 qtd in Angel 16). Reflecting on the relationship between the dead body and text which is revealed by the etymological connection linking the word "corpse" to the word "corpus," Maria Angel points out that these terms derive from the Latin "corpus" meaning body. Both these bodies are "the sites for investigative and critical procedures that rely upon certain kinds of visibility" (16). The critic observes that not unlike a book, a dead body "takes shape as both a visibility and a repository of knowledge" (16). She proposes a model of dead body and book as "a series of laminated surfaces that are unfolded, refold-

ed, and discovered in acts of research" (17). The dead body is thus interchange-able with the anatomical atlas. I propose further that the dead dissected body, or more precisely, the stomach and its not-entirely-digested contents, can be con-sidered interchangeable with the geographical atlas.

A vast body of critical discourse and fandom writing has arisen around and about the American *CSI* shows and other forensic TV series. The *CSI* shows are discussed and interpreted in the framework of media studies, from the point of view of the history of ideas, in the epistemological perspective of anthropology and the production of knowledge as well as in terms of political science. It has been pointed out that forensic TV dramas envision political and micro-social processes such as governance through crime (Byers and Johnson xvii-xix, Wil-son 7-10). Byers and Johnson observe that "The terrain of the *CSI* universe in-volves three key elements: risk as omnipresent, responsibility for risk (and agen-cy more generally) as largely individualized, and the provision of security as one of the few collective enterprises (at times it seems the only) remaining to us" (xix).

The editors of the collection of essays on *CSI* franchises *The CSI Effect: Television, Crime, and Governance* also point out that human actions and rela-tions are constructed in these programs "first as occurring among autonomous, largely ahistorical individuals who make rational choices (whether they are fo-rensic heroes or criminal villains), and second as involving the workings of chance. In other words, through neoliberal rationality—here in a fictional uni-verse of criminal offenders and victims—human subjects, actions, and relations operate just as 'free' markets do"; in the forensic shows "human subjects and relations are imagined to require and be shaped by minimal social intervention" (xix). As Sue Tait observes "*CSI* allows us to look at novel imagery of violence but elides the social and cultural contexts which may produce it. Instead vio-lence is instrumentalized as a vehicle for the spectacularization of science, reflecting the graphic imperative emblematic of the contemporary mediascape" (60).

She also points to the so far unprecedented fascination with and belief in the apparent capability of scientific procedures and laboratory technology to estab-lish and reconstruct unquestionably and unambiguously the circumstances of a crime, which, it needs to be noted, defies the vision of complexity introduced by the operation of chance.

> While forensic dramas are not new, *CSI* visualizes the forensic in new ways and fo-cuses on the team of forensic scientists. *CSI* also differs from earlier forensic dramas in the range of scientific specialisations engaged to analyse evidence and the extent to which the capabilities of *CSIs*, their vision in particular, are augmented by tech-

nology. A variety of machines and optical devices are used—microscopes, cameras, computers, alternative light sources, gas chromatographs and spectrographic equipment—not to produce a type of knowledge, but The Truth. Within this fictioned [sic] universe evidence is rarely open to interpretation; rather, according to the head *CSI*, Gil Grissom, it cannot lie: "there is no room for subjectivity in this department" (S1: e1). What distinguishes *CSI* from other crime dramas is the focus on scientific procedures. (47-48)

It thus comes as no surprise that the emphasis on the strictly scientific character of the investigation that is represented as producing largely unequivocal results has given rise to the so called *CSI* effect; a phenomenon that Corinna Kruse examines in the article "Producing Absolute Truth: *CSI* Science as Wishful Thinking," while Katherine Ramsland devotes the book The *C.S.I. Effect* to it in order to familiarize the broad reading public with crime scene investigation and encourage young adepts of criminology. The *CSI* TV series turn out to have contributed—it remains, however, to be seen to what degree (Kruse 87, Harvey and Derksen 21)—to generating the desire and public demand for epistemological closure in investigations, pressure in the external world on law enforcement institutions and laboratories to be as efficacious and efficient as the investigative teams in the forensic shows —which incidentally contributed to the allocation of additional funds to forensic laboratories (Byers and Johnson xviii)—as well as a tendency among jurors to rely on the decisive verdict of the scientific interpretation of evidence rather than on deliberation (Kruse 87).

On the other hand, Elizabeth Klaver points out that the concept of autopsy "can navigate various disciplines with ease, traversing a number of seemingly disparate fields from medical science to the arts and humanities, for at its most fundamental denotation it simply points to the privileging of vision in Western culture" (*Sites 3*)—as it derives from two Greek roots: "auto" and "opsis" and means "to see with one's own eyes." According to Klaver "a concept like autopsy suggests that there has been a working intersection since the Renaissance between the fields of science and the arts and humanities, despite the widespread belief in an elemental and formidable gap separating fields essentially seen as freestanding structures" (*Sites 4*). In spite of the efforts of numerous thinkers, the gap persists. Klaver observes the culturally sanctioned distribution of attitudes: "[o]n the one side, the objectivity of science; on the other side, the subjectivity of the arts and humanities" (*Sites 4*). Yet, the gap proves a cultural construction "when an idea like autopsy is deployed" (Sites 4); a construction "designed to produce (or be the product of) disciplinary boundaries that may or may not be necessary or even accurate" (*Sites 4*) and which are "always under pressure from their own constructedness" (*Sites 4*).

In discussing the representations of autopsy in forensic TV series, Sue Tait argues that the autoptic vision projected by the *CSI* drama has affinities with the Gothic eroticization of the corpse, and thus brings out the internal tension that has also haunted and simultaneously fuelled the tradition of the detective story as a genre since its very inception—that which is between rationality and irrationality, between scientific investigation and imaginative curiosity, the latter being typical of early modern epistemology.

> *CSI* renders the corpse as the ideal docile body, a vehicle for the constitution and performance of scientific expertise. This instrumentalized view of the corpse enables the performance of a Gothic eroticism and the conceit that a rational imperative frames our looking authorizes a necrophilic gaze. (46)

Tait further observes that "Examination and anatomization is performed with pedagogic pretension, which enables the reproduction of the morbid eroticism which pervaded Renaissance culture prior to the 'the ideal of a disinterested field of investigation' (Sawday 5). Science offers a refuge for the pornography of Death" (50). As David Castillo shows in *Baroque Horrors: Roots of the Fantastic in the Age of Curiosities*, Gothic sensibility and imagination are indebted to the "shadows that lurk in our closed spaces [and] are symptoms of the baroque horror (vacui) that continues to haunt the architecture of modernity" (xiii). Castillo emphasizes that it is the study of the baroque that provides new contexts "within which to rethink broad questions of intellectual and political history, especially with respect to the origins and meaning of the modern episteme" (xiii).

Thus, the Gothic fascination with the corpse can be seen as a dark double of both the early modern approach to autopsy as a theatrical spectacle and the uncanny, self-presenting images of bodies open to gaze in early modern anatomical atlases. Moreover, the presence of what Gere, drawing on Jacques Derrida, refers to as "spectral technologies," contaminates the *CSI* genre with characteristics of a ghost story. In an interview with Mark Lewis and Andrew Payne, Derrida proposed that contemporary technologies such as film, TV and the telephone "live on or off [...] a ghostly structure" (Derrida qtd. in Gere 132). Gere points out that it is modern technologies that enable the haunting of the living by dead crime victims. The meta-level question implicitly asked in each forensic show is "whether it is possible to understand what the traces of the dead mean" (Gere 133).

However, revealing the normally hidden, concealed or encased recesses of the body in *CSI* representations of autopsies can be classified as "carnogra-

phy"—an intersection of pornographic and the horrific exposing of the flesh that becomes familiar through the knowledge of carnality in porn and carnage in slasher horror (Tait 50). Tait observes that "[t]he autoptic gaze of *CSI's* morgue scenes, which is often supplemented by digitally produced shots which simulate bodily interiors and the effects of violence upon them, are examples of this 'carnographic' revelation" (50).

Yet, the examination of stomach contents defies the carnographic revelation through the clearly abject character of both the procedure and its object—a not entirely digested, half-fluid matter. The very procedure of examination is often carried out by pre-technological means. The forensic examiner often assesses the stomach contents' viscosity and the degree of digestedness by means of his senses: olfactory, haptic and optical. The examination of the contents of the stomach by means of laboratory technologies not only reveals the probable time of demise, but also provides a guide to the whereabouts of the decedent before death and thus provides investigators with valuable leads.

I interpret representations of the examination of stomach content in forensic shows in the perspective proposed by Michael Schoenfeldt in "Fables of the Belly in Early Modern England." Schoenfeldt emphasizes that "Whereas our post-cartesian ontology imagines inwardness and materialism, soul and stomach as necessarily separate realms of existence, the Galenic regime of the humoral self demanded the invasion of social and psychological realms by biological and environmental processes"; it imagined "the inevitable permeability of bodies and of selves" (244) as well as recommending a balance between the assimilation of food and purification, between ingestion and the production of feces.

The process of digestion was believed to occur in three stages: the first, termed concoction, took place in the stomach proper and liquefied food to chyle, a fluid that was to be absorbed by the body. The second stage occurred in the liver and converted the chyle into blood. The third stage took place in various parts of the body that drew what nourishment they needed from the blood (244-245). Schoenfeld concludes that inasmuch as digestion does not happen exclusively in the stomach but rather throughout the organism, "[t]he human body is from that perspective just a giant stomach" (245). Given the porousness of the boundary between the body and the universe and imagining the body as a giant stomach, the stomach can be regarded as a site of epistemological interest yielding information about the world. Also, the relationship between the macrocosm and the microcosm mirroring each other is reflected in the vision of the body as a stomach.

Inasmuch as the human body is considered the stomach, the world can be regarded as the body. In this perspective, the forensic examination of the contents of the stomach reveals the nature of the interactions between the micro-

cosm and macrocosm, the microcosm providing information about the macrocosm, while the macrocosm contributes to the fashioning of the microcosm's identity. The analysis of partially digested matter that makes up the contents of the deceased person's stomach brings out a vision of reality as a Chinese–box series of universes receding into infinity; *a mise en abyme* of organisms so characteristic of baroque epistemology. It is vital, however, that the stomach contents be only partially digested; by being partially assimilated, they testify to the contribution of the macrocosm to the fashioning of the subject. Moreover, their being partially recognizable allows forensic experts to determine the subject's itinerary by tracing the remains of food to their original condition and place of origin. The examination yields indexical clues concerning the time and other circumstances of the decedent's death, thus making possible attempts to reconstruct the decedent's most recent past while simultaneously providing an insight into the complexity of current social, cultural and political issues.

In what follows I will discuss the examination of stomach contents in the autopsy scenes in the fourth episode of season one of *CSI Las Vegas* (S1 e4), the seventh episode of the fourth season of *CSI New York* (S4 e7) and the tenth episode of season seven of *Bones* (S7 e10). In the episode of CSI LV "Pledging Mr Johnson" the middle-aged woman's leg which had been chopped off by a boat propeller is found in Cave Lake, leading to the recovery of the rest of her body. The examination of her stomach contents during the autopsy reveals that her last meal consisted of calamari, which provides a clue directing the investigators to the local restaurant that prides itself on an outstanding calamari menu. The head of the crime laboratory in Las Vegas, Gil Grissom, deduces from the fact that the woman was wearing high heels and a fancy dress that she probably did not go to the restaurant alone, and obtains a memory portrait of the man she had dinner with from a waitress. This leads to the interrogation of the man, who admits to having been her lover, which leads to the final exculpation of the husband of her murder, and subsequent arrest of the husband for the murder of his wife's lover. Not only do viewers follow the investigation, but they also get an insight into the complicated issues connected with the lives of passion of middle-aged couples and they learn of the exquisite local food culture of Nevada. In the episode, the abject matter retrieved from the dead woman's stomach in a paradoxically baroque fashion leads to the investigation of the feasting habits of the inhabitants of Las Vegas and its environs. The internal, physiological and the repulsive map onto the external topography, the cultural and the desirable.

The examination under microscope of the stomach contents of a young dead real estate agent, a victim of a serial killer, washed ashore on a beach in the *CSI NY* episode "Like Water for Murder," directs the investigators to a grand dark chocolate styling show in New York; a fashion show that links New York to the

capitalist global world of opulence and places the metropolis in the cosmopolitan network of the global capitals of fashion and luxurious life styles: Miami, Los Angeles, Paris, and Milan.

The dead woman's stomach matter contains coco butter seeds, identified by a crime lab investigator as crystals of Criollo, the world's most expensive dark chocolate. They appear side by side with yellow plant material, which the electronic morphological search in botanical databases identifies as "Turnera Aphrodisiaca," aka "Damiana," from Central America. The substance can be smoked and ingested as a drug or an aphrodisiac. The remains of the Damiana chocolate in the murder victim's stomach link the woman to a fraudulent fashionable chocolate designer who forces female real estate agents into intimacy as a price for being their client. Following the designer to his meetings with real estate agents, the detectives learn where elegant apartments to let are localized in Lower Manhattan, and realize that this is the territory of the serial killer's operations, which leads to his arrest in a later episode of the show's first season. Thus the murder victim's stomach contents maps onto both the global world of luxury and sophistication and on the detailed topography of Lower Manhattan in the aftermath of the 9/11 catastrophe. Yet again, the individual and the abject points to the global and the glamorous world of global financial privilege, only to invoke the incursion of global politics into the topography of the local, mundane life of the city's neighbourhood.

The episode of the series *Bones* "The Warrior in the Wuss" begins with Cam, the head of the crime laboratory at the Jeffersonian in Washington discussing with Dr Hodgins the budget cuts that affect his newest equipment order. He hesitates whether to send the equipment back. Later on it is this equipment that enables him to perform an autopsy of an undigested mescal worm found in the stomach of a dead man upon whose remains two young men stumble in the woods. The examination of the belly contents of the mescal worm leads to the identification of the kind of soil the worm assimilated and thus makes it possible to determine the region from which this alcohol had been imported. Then, relying on Dr Hodgins's knowledge of the local pubs, the pub in which the deceased drank mescal is identified. Admittedly, the double autopsy performed in the crime lab at the Jeffersonian has got a parodic ring to it, yet it is reminiscent of the baroque motif of a universe within a universe. Not only does this instance of *mise en abyme* map the abject individual physiology onto the economical geography of the global world but also the world of the abject species (the worm) onto the human world. The partially interiorized other (the not-entirely-digested worm) is crucial for determining the dead human's identity.

(Neo)baroque pansemioticism is reflected in Dr. Hodgins's comparison of the mescal worm to the Rosetta Stone. The deciphering of hieroglyphics by the

French scholar Jean-François Champollion in 1822 was made possible by comparing three inscriptions on the Rosetta Stone, an ancient Egyptian stele, layered, so to speak, one above another: hieratic style hieroglyphics, a demotic hieroglyphic inscription and finally the same text in Greek. The multi-layered complexity of the process of deciphering the identity of the victim from the contents of the contents of the victim's stomach is compared here to the deciphering of hieroglyphics.

Furthermore, the ambivalence of the political, economical and social relationships between US and Latin American countries and how these relationships reflect on the situation at home can be reconstructed from this complex layering of abjection. These relationships are shown as reconstructed from the information provided by the analysis of the stomach contents of the Central American mescal worm that is part of the stomach contents of the victim of a murder committed in Washington, DC. What is also worth noting is a parodic juxtaposition in the beginning of the *Bones* episode of the operation of cutting as the necessary stage of an autopsy performed in the forensic lab and the budget cuts discussed by the members of the forensic crew.

It should be emphasized that in all cases of the examination of the deceased's stomach contents discussed above it is the incomplete digestion, the incomplete assimilation—thus the observable, and to some extent measurable, sense of otherness that makes the detection possible. Establishing the identity of a murder victim and attempts to reconstruct the circumstances of his or her death are thus possible when there is an interplay, a tension between the same and the other. Absolute strangeness or complete sameness are beyond detection.

The abject that underlies the representations of the examination of stomach contents in American forensic TV shows reveals the abjected aspect of the representations of American society as a set of autonomous, ahistorical individuals whose behaviors exemplify neoliberal rationality that perceives the world solely in terms of a free market; a vision apparently championed by the forensic TV shows, yet defied by the very presence of abjection in the core of media representation. The awareness of such abjection makes it possible to restore the historical and political character of the interrelations of the local and the global, and provides an insight into the limitations of the apparently absolute autonomy of individuals, thus offering an alternative guide to the attractions of American local (food) culture(s).

Works Cited

Allen, Michael, ed. *Reading CSI: Crime TV under the Microscope*. London: I. B. Tauris, 2007. Print.

Angel, Maria. "Physiology and Fabrication: The Art of Making Visible." *Images of the Corpse: From the Renaissance to Cyberspace*. Ed. Elizabeth Klaver. Madison: U of Wisconsin P, 2004. 16-38. Print.

Byers, Michele and Val Marie Johnson. "*CSI* as Neoliberalism: An Introduction." *The CSI Effect: Television, Crime, and Governance*. Ed. Michele Byers and Val Marie Johnson. Lanham: Lexington Books, 2009. xiii-xxxvi. Print.

Byers, Michele and Val Marie Johnson, eds. *The CSI Effect: Television, Crime, and Governance*. Lanham: Lexington Books, 2009. Print.

Castillo, David R. *Baroque Horrors: Roots of the Fantastic in the Age of Curiosities*. Ann Arbor: The U of Michigan P, 2010. Print.

Certeau, Michel de. *The Writing of History*. Trans. Tom Conley. New York: Columbia University Press, 1988. Print.

"The Crack in the Code." *Bones*. S7 e6. Created by Hart Hanson. Fox, 2012.

Gere, Charlie. "Reading the Traces." *Reading CSI: Crime TV under the Microscope*. Ed. Michael Allen. London: I. B. Tauris, 2007. 129-139. Print.

Harvey, Elizabeth, and Linda Derksen. "Science Fiction or Social Fact?: An Exploratory Content Analysis of Popular Press Reports on the *CSI* Effect." *The CSI Effect: Television, Crime, and Governance*. Ed. Michele Byers and Val Marie Johnson. Lanham: Lexington Books, 2009. 3-28. Print.

Hillman, David, and Carla Mazzio, eds. *The Body in Parts: Fantasies of Corporeality in Early Modern Europe*. New York: Routledge, 1997. Print.

Klaver, Elizabeth. *Sites of Autopsy in Contemporary Culture*. Albany: SUNY Press, 2005. Print.

Klaver, Elizabeth, ed. *Images of the Corpse: From the Renaissance to Cyberspace*. Madison: U of Wisconsin P, 2004. Print.

Greenblatt, Stephen. *Shakespearean Negotiations: The Circulation of Social Energy in Renaissance England*. Berkeley: University of California Press, 1988. Print.

Kruse, Corinna. "Producing Absolute Truth: *CSI* Science as Wishful Thinking." *American Anthropologist* 112.1 (2010): 79-91. Print.

Lambert, Gregg. *On the (New) Baroque*. Aurora: The Davies Group Publishers, 2008. Print.

"Like Water for Murder." *CSI: NY*. S4 e7. Created by Anthony E. Zuiker, Ann Donahue, Carol Mendelsohn. CBS, 2008.

"Pledging Mr Johnson." *CSI: LV*. S1 e4. Dir. R. J. Lewis. Prod. Anthony E. Zuiker. CBS, 2000.

Sawday, Jonathan. *The Body Emblazoned: Dissection and the Human Body in Renaissance Culture*. London: Routledge, 1995. Print.

Schoenfeldt, Michael. "Fables of the Belly in Early Modern England." *The Body in Parts: Fantasies of Corporeality in Early Modern Europe*. Eds. David Hillman and Carla Mazzio. New York: Routledge, 1997. 242-261. Print.

Tait, Sue. "Autoptic Vision and the Necrophilic Imaginary in *CSI*." *International Journal of Cultural Studies* 9.1 (2006) : 45-62. Print.

"The Warrior in the Wuss." *Bones*. S7 e10. Created by Hart Hanson. Fox, 2012.

Westerhoff, Jan C. "A World of Signs: Baroque Pansemioticism, the *Polyhistor* and the Early Modern *Wunderkammer*." *Journal of the History of Ideas* 62.4 (2001): 633-650. Print.

Wilson, Christopher, P. *Learning to Live with Crime: American Crime Narrative in the Neo-conservative Turn*. Columbus: The Ohio State UP, 2010. Print.

Unhappy Meals: Fast Food and the Crisis of the Underground in American Goth-themed Fiction and Graphic Novels

Agata Zarzycka

Introduction

This paper tracks down connections between fast food and Goth subculture in selected post-2000 novels and graphic novels dealing with American Goths. That such a juxtaposition of themes may seem neither aesthetically promising, nor culturally relevant paradoxically provides this discussion with a broader context, namely, the issue of changes in the subculture-mainstream polarity. Specifically, I intend to show that at the time of the Gothic subcultural potential becoming paradigmatic and uncontrollably dispersed over popular culture, its significance as a countercultural commentary is sustained especially effectively thanks to the convention's trademark self-reflectiveness and auto-irony, which in this analysis underlies the symbolic Goth migration from underground clubs to fast food restaurants. As confirmed by the examples discussed, Gothic self-reflective irony proves useful in addressing the identity formation issues preoccupying youth culture, which in turn confirms the cultural productivity of the Gothic policy of ambivalence in the mainstream/subculture polarity.

The consideration of the countercultural potential of the examples discussed is based on a combination of research devoted to the Goth movement as an actual social phenomenon and an analysis of Goth characters and artifacts as appropriated by popular culture and turned into an aesthetic and fictional trope. In order to avoid any possible inadequacy connected with interpreting the latter in the light of the sociologically informed debates over the Goth uniqueness with regard to the commercialization of subcultures, I start the essay with a brief discussion of the way the convention's development, including differences between the European and the American Goth movement, may have influenced theorizations of its subcultural potential and the productivity of its bond with popular culture. In a later part of the essay, I analyze two fictional examples of restaurants serving as a middle ground between the mainstream and the subcultural reality. I move on to showing fast food as a prop in a humorous and politically aware negotiation of Goth identity in relation to the mainstream. The essay ends with a consideration of a fast food reference in a novel depicting the Goth as one of many culturally mediated factors which are remixed in the process of the formation of a contemporary teenage identity.

Goths and the Crisis of Commercialization

The dependence of the Goth culture on broadly understood consumption, from the involvement in the music industry through the circulation of aesthetic accessories to cultural appropriation and cannibalization, has made the movement controversial in terms of the rebellion against consumerism which is conventionally ascribed to subcultures of the late 20th century, such as the punk movement from which Goth culture has evolved (Goodlad and Bibby 1, 13-14). An explicit political agenda has been a characteristic not always correctly ascribed to punk as opposed to Goth movement, a distinction introduced by Dick Hebdige's 1979 work Subculture: The Meaning of Style, which has proved inspirational for, though also criticized by subsequent Goth-interested researchers such as Carol Siegel (21-23) or Lauren M. E. Goodlad and Michael Bibby (2-4, 13). As the latter observe, defined in such terms, the subculture's subversive potential should have been completely erased by the growing popularity of the Gothic in various pop cultural spheres (11). The alternative character of the Goth convention has further been questioned in the face of its intense popularization observed in the American media throughout the 1990s, when according to Goodlad and Bibby, the practice of "commodifying the very notion of subculture" (16) developed.

That the Goth movement has remained successfully countercultural despite those processes seems easier to explain in an American than a European context, as – according to Siegel – the growth of the phenomenon in the 1990s' USA was fuelled not so much by class, but rather by sexuality politics. Specifically, Siegel sees the American Goth evolution as a reaction to the "abstinence education" (32) addressed to young people throughout the 1990s and into the 2000s, and aimed at limiting or even eliminating affirmative attitudes towards sexuality (39-46). Thus, a major source of Goth subversion is taken outside the immediate confrontation with capitalistic consumerism, which enables the convention to realize at least a part of its rebellious potential also from inside commercialized popular culture. Moreover, the Goth movement, predominantly depicted as transnational (Goodlad and Bibby 6), has also generated a mode of consumerism that has been regarded as resistant towards the dominant capitalism and theorized among others by Goodlad and Bibby, Paul Hodkinson or Carol Siegel as alternative due to its ability to tame mechanisms of production and consumption for the convention and community's specific use, and thus to resist the uprooting and identity-destroying impact of commercialization (Goodlad and Bibby 14-15, Hodkinson in Siegel 19). Goodlad and Bibby even coin the term "mainstream alternative" to capture the Goth subcultural ambivalence (27) and argue that

"goth's constitutive tension between resistance and consumerism has permeated the structure of postmodern culture and society" (33).

Such ambivalence, hitherto discussed with reference to the subcultural community, is even more clearly observable on the level of Gothic aesthetics infiltrating popular culture. Many scholars, including Catherine Spooner, talk about 21-st-century Western culture as growingly submerging in a Gothic paradigm (ix). The latter is also affected by that fusion, as illustrated by what Spooner calls the "hybridiz[ation]" of the Gothic: "twin Gothics – Gothic as the profoundly serious business of trauma and haunting, and Gothic as sensation, pleasure and romance – go hand in hand" (xi). The convention "has become witty, sexy, cool. It has transcended its cult interest niche to become what would have once been unthinkable: fashionable" (xi). Such a rejuvenated dimension of the Gothic, especially when condensed in the Goth trope inspired by the movement's youth-focused subcultural dimension but incorporated into the realm of pop cultural aesthetics, constitutes a prolific ground for cultural explorations of teenage angst, as confirmed by the five examples presented below.

Pete Hautman's *Sweetblood* (2003)

Hautman's novel, distinguished with the Minnesota Book Award and included by the Young Adult Library Services Association in the "Best Books for Young Adults: Annotated List 2004" (n.p.), provides an example of the Goth trope employed to discuss a more broadly understood set of issues connected with the formation of a teenage identity. Sweetblood tells the story of a teenage diabetic, Lucy Szabo, who due to her illness develops a fascination with vampirism and steps on a path to self-destruction by getting involved with the local Goth community which is informally dominated by Wayne, a middle-age man known for his taste for underage lovers. Lucy's angst-ridden Goth adventure that leads her to a near-death experience becomes her quest for coming to terms with her diabetes, identity, family, and peer environment. In a "Teacher's Guide" to the book, available on the author's personal website, the subcultural motif, somewhat euphemistically referred to as "lifestyling," is mentioned as the last of five topics suggested for classroom discussion, the other four being: "alienation," "self-identity," "chronic illness," and "love and friendship" (n.p.).

The Goth community in Sweetblood is reduced to the role of a background against which the protagonist eventually defines her independent self; a process in which the charm and seductiveness of the subculture are gradually compromised as shallow and its leader – as pathetic. Accordingly, the place of Lucy's initiation into the cultural underground is a rather mainstream café, Sacred Bean, which becomes a liminal space between the reality of the day – filled with social

pressure, teenage frustration, and confusion – and that of the night, where more than one level of danger waits for Lucy in her trip into the subcultural community. Initially, "The Bean" provides a setting for the girl to reflect upon her teenage angst: "I order a triple cappuccino and sit at the back corner table and brood – something I do well. . . . I don't expect the caffeine to stop the brooding, but it might make me brood faster. I stare across the room . . . and try to figure out what is going on with me. . . . Life didn't used to suck" (70). The café also serves as an instrument of temptation and rule breaking when a mysterious and attractive boy, acting in fact on Wayne's orders, lures Lucy: "Hey, you want to go over to the Bean? They're open till two. They have live music at night" (75).

Soon, in a chapter aptly titled "Espresso Yourself," the café reveals its liminal nature, and makes the protagonist muse some more upon self-fashioning and dealing with frustration:

> The frowning barista has a bone in her nose. . . . I think it must be hard for her to talk. . . . The Bean is different at night. Different crowd; not so Joe College. I see a lot of leather but very few books. I am looking for Guy [Wayne's messenger], but there are too many black-leather-jacketed, black-haired guys. Cigarette smoke hangs in a layer about four feet off the floor. The room is lit by a dozen tiny halogen track lights scattered across the dark ceiling: an upside-down field of miniature search-lights cutting through the nicotine fog. It's hard to see across the room. . . . I wonder why she [the barista] is so unhappy, and why she has chosen to stick an ugly old tur-key bone in her nose. Maybe it is an act. Maybe she doesn't know how to act, so she sticks a bone in her nostril and acts pissed-off. I've been there. Only without the bone. (77-78)

Lucy's reflection, however, gives way to her own "self-expression" of the kind which by the end of the novel will be revealed as fake and potentially destructive: "[I] go looking for a table where I can sit and act blasé. . . . I feel ultrahip and worldly sitting with my triple latte late at night surrounded by black leather and cigarette smoke and women speaking a strange tongue I am my own cool self. I can sit here and be a part of this scene even though I'm only in high school" (78). Soon after that, the girl makes actual contact with Goths and leaves the middle ground of the café to attend a full-blown underground party (80-81) and thus step onto a spiral down that will eventually threaten her life.

Still, it is the café, usually associated with mainstream clientele, that functions as a Gothicized uncanny setting and a liminal space, which for the protagonist becomes a Campbellian threshold in the eventually successful quest for self-definition. The treacherous combination of familiarity and strangeness of the place, made literal by the sounds of a foreign language used by two musi-

cians performing in Sacred Bean the night Lucy goes there, reflects the indirectness of the danger she will expose herself to by getting involved with the subculture. The disquieting metamorphosis of the café can be inscribed in the discourse of the uncanny, whose original, estrangement-based explication (Masschelein 1) evolved throughout the 20th century to the rank of a multidisciplinary notion that offers a framework for "abstract and theoretical concerns, the postromantic and neo-Gothic aesthetics, and the sociopolitical climate of the mediatized postindustrial Western society" (5). Thus, the familiar-turned-strange effect, potentially reflective of generalized contemporary anxieties, seems to offer the right scenery for the teenage heroine to start a both decisive and risky stage of forming her identity through confrontation with countercultural experience. The estranged café becomes what Hein Viljoen and Chris N. Van der Merwe understand as the "threshold" – a space marking the protagonist's entrance into a new dimension of existence (10). Reflective of Lucy's subjectivity, Sacred Bean's in-betweenness bears the combined attributes of a "liminal space" (Joseph 139) and "postmodern liminality [which] becomes a metonym of adolescent agency" (138), both of which concepts are broadly applied, as Michael Joseph points out, in the studies of children's and young adult literature at the turn of the 20th and 21st centuries. Thus, the Gothicization of a mainstream setting in Sweetblood reinforces the conventionalized scrutiny of the teenage identity formation process.

Ross Campbell's *Wet Moon* (2004, ongoing)

While Sweetblood can hardly be classified as a subcultural insider, Ross Campbell's graphic novel Wet Moon is definitely rooted in Goth-inspired subcultures, which results, among others, in the depiction of the perspective of the alternative community as the normative one while marginalizing the external mainstream reality. Still, the series' trademark café Burial Grounds seems to play a role analogical to that of Sacred Bean. It is in the café that Cleo, the protagonist, has to confront disturbing factors which do not usually belong to the safe bubble of the Goth reality: not only the down-to-earth demands of a barista's job, but also prejudice and a fear of the abject.

The transgressive aspect of the café seems all the more noticeable when juxtaposed with the paradoxical sense of mundane domesticity which can be traced in the depiction of an explicitly subcultural club called the House of Usher. On the one hand, attributes such as the portal-shaped main entrance (*Feeble Wanderings* 64), overstuffed, antiquated furniture, framed pictures on the walls (65), decorative details including a Giger-like toilet-paper-holder (80), and finally the deafening music (66) make the place atmospheric and welcoming for Goth-

fashioned club goers (64-65). On the other hand, all of the above constitute more or less fixed elements of the main characters' daily lives, which makes the action set in the House of Usher banal rather than subversive. Cleo first tells her friend, Mara, about stepping on some chewing gum the day before (66), and next becomes an object of romantic interest on the part of Connor – a student of graphics, who sketches a monster for her (69-71). His gesture is, however, compromised when Trilby, another friend of Cleo's, reveals the drawing to be a part of the man's trademark pick-up strategy tested on a number of other girls, and mocks the picture itself (73-74). At the same time, Mara commits an act of plain, down-to-earth violence by starting a fight with another girl over her boyfriend (72). Thus, even though the alternative aura of the House of Usher is momentarily redeemed when Cleo and Trilby become fascinated by the passing Fern – a silent, uncanny character in an extreme BDSM outfit (74-75) – the club seems less relevant for the protagonist's overall experience than the Burial Grounds. While that difference may partly be caused by the fact that Cleo visits the former only as a customer looking forward to some quality time with her friends, and gets to know the latter from the far more demanding and mundane perspective of a worker, it is the exposure to the mainstream social reality that proves to be most challenging for the heroine.

Despite its more open character as compared with the niche House of Usher, the café is also laced with subcultural aesthetics manifested in its name and signboard design, the stylized menu with items such as "Massacre Macchiato" or "Evil Espresso," and finally the appearance of its pierced and tattooed staff members (*Unseen Feet* 36, *Drowned in Evil* 96). Still, when Cleo reflects upon her first work experience, she writes in her diary "Burial Grounds kind of sucks. It's so hectic and crazy and the most fucked up people come in there and I only get three smoke breaks for like seven hours of work, I was freaking out" (*Drowned in Evil* 118).

A major source of Cleo's frustration is the café's liminality which involves not only a violation of her social comfort zone, but also a more totalizing transgression connected with uncontrolled manifestations of the organic in the social space. On her first day of her work, the girl becomes a witness to a display of homophobia when one of the customers starts protesting against her favorite table being occupied by a pair of Cleo's gay friends (99) who have come to reassure her during her debut as a barista (97). While, luckily for the protagonist, a much more experienced café worker calmly handles the situation, the word choice of the prejudiced customer – "He's sick and he's gay! . . . [T]hat's my spot, that's where I always sit. Now it's contaminated!" (99) – can be read as foreshadowing Cleo's subsequent abjection experience. The notion of the abject, most frequently exemplified by various kinds of organic waste (Kristeva 2-4),

constitutes one of the fundamental Gothic concepts, whose liminality is underlined by Julia Kristeva when she defines the term as "something rejected from which one does not part. . . . what disturbs identity, system, order. What does not respect borders, positions, rules. The in-between, the ambiguous, the composite" (4). While the rebellious Goth aesthetics often seems to embrace various aspects of tamed abjection in order to establish its own countercultural position, it does not prepare Cleo for the moment when another customer complains about the broken toilet and hands her a bag of excrement (100), or the moment when one of her friends unexpectedly throws up all over the floor (101). Even though the protagonist's reaction to these extreme situations does not go beyond comments such as "terrible" and "seriously the worst!" (101), their overall effect can be specified as a disturbing estrangement produced by the condensation of the abject preceded by the overlapping discourses of disease and exclusion in the café – a public space of socialization and consumption. Thus, in terms of its borderline character, the Burial Grounds seems to play a similar part in Cleo's development as the Sacred Bean plays in Lucy's, yet the fact that its liminality comes, on one level, from fundamental abjection, and on another –from the mainstream violating the subcultural, and not the other way around, makes the uncanny aura of the place more profound.

Aurelio Voltaire's *Oh My Goth!* (2002) and *What Is Goth?* (2004)

While in the young adult novel Sweetblood and the Goth graphic novel Wet Moon coffee-serving restaurants function first of all as thresholds or liminal spaces for the protagonists, Aurelio Voltaire, a proponent of meta-conscious humor within the contemporary Goth movement, employs references to fast food and more generally pleasure food in acts of more explicitly sociopolitical criticism. His works are laced with a characteristically Gothic humorous metaconsciousness and irony – attributes ascribed to the convention from its 18th-century beginnings (Horner and Zlosnik 4, 9-10; Spooner, *Contemporary Gothic* 23) to contemporary manifestations (Horner and Zlosnik 12-13, 15, 17; Spooner, *Contemporary Gothic* 23). Simultaneously, however, they carry a significant critical potential aimed at normative factors in American society.

Voltaire's 2002 graphic novel *Oh My Goth!* is based on a collection of comics which the artist – whose creative output also involves music and visual arts – used to advertise his shows among the Goth audience in New York throughout the 1990s (*Oh My Goth!* n.p.). The plot, overtly intertextual and parodic first and foremost towards the Goth subculture itself, involves an episode in which the protagonist, Hieronymous Posche – an alien modeled on the author, who tries to communicate with human beings – decides to use drastic measures in his effort

to pacify the teenage angst of a Goth girl met at a club, and treats her to a Happy Meal at McDonald's (n.p.). The very concept of counteracting Goth Weltschmerz with fast food definitely ironizes the subculture and underlines its commercialization – especially because the cure proves effective. Still, the exposure of the popular mainstream restaurant to Gothicization constitutes an even more spectacular act of criticism towards normative social practices, and especially the hypocrisy connected with the ideology of happiness, pointed out by Halberstam as a target object of Gothic "technologies" (22), and by Siegel as an important aspect of Goth subcultural rebellion (2, 24-25). Joe L. Kincheloe perceives McDonald's as a provider of what he calls "good life" discourse (45), which involves, among others, the promotion of the economic American dream (51-52), implicit classism, racism (52-60) and unrealistic social optimism (72), as well as populism (55) aimed at neutralizing health-connected controversy over fast food (62). The atmosphere of falsity surrounding the popular fast food place is suggested in *Oh My Goth!* by an array of visual details, from the catchphrase "2 billion dead cows" on the restaurant's sign through the advertised "this week's toy" in the form of a mooing cow skull on a spring; or the ominous 6.66 $ fee on the cash register's screen; to a friendly inscription on a waste bin, asking the customers to "help us pretend that we recycle" (n.p.). Thus implied hypocrisy also indirectly undermines the Happy Meal therapy and brings its effectiveness back into the sphere of the Gothic delight in the macabre as well as Goth enjoyment of morbidity aimed at undermining conventional aesthetics (Siegel 19).

Social criticism parallel to Goth self-mockery is expanded in Voltaire's other work, *What Is Goth?* Published in 2004, the humorous and meta-conscious guide to Goth culture can be seen as especially relevant in terms of relations between the subculture and the mainstream because of the anti-Goth media-fuelled campaign depicted by Siegel as Goth victimization (9-10, 30, 158) which was triggered in America by the Columbine High School shootings in 1999 (Spooner 109-110). As a result, public demand for information about the subculture grew in the early years of the 21st century, and Voltaire's book became a much needed awareness-raising material that presented a self-reflective, but also subculture-supportive perspective of a movement insider. The impact of *What Is Goth?* and its author on the mainstream was confirmed when the former was mentioned, and the latter interviewed, in a Fox News commentary after a 2005 murder case in which Goth characteristics were ascribed to the convict[1]. As Voltaire's official website puts it, "*What is Goth?* cemented Voltaire's place as an authority on

1 The interview is available for watching on Voltaire's official homepage, at: http://www.voltaire.net/on_camera/

the Gothic subculture" (n.p.), granting him a politically relevant position that adds significance to the way he employs one of America's culinary symbols:

> Americans love pie. Some more than others. Some people eat pie every day, regardless of whether it's good or bad for them. Goths are people who like Halloween – a lot. They like Halloween as much as you like pie. If you don't like Goths, don't get your knickers all in a twist. Going out of your way to ridicule them just takes up valuable time. Time you could be spending… eating pie.
>
> Goths are harmless.
>
> Just give them some candy corn; they'll go away. (81)

The author is obviously defensive as far as Goth style is concerned, but at the same time auto-ironic about it when he reduces the subculture to a fondness of Halloween comparable to the consumerist's natural fondness of food. The ultimate ridicule, however, seems aimed at mainstream prejudice and mundane tastes.

Adam Rex's Fat Vampire: A Never Coming of Age Story (2010)

While Voltaire's double parody is clearly involved in the political dynamics of the majority-minority aspect of the Goth, *Fat Vampire* by Adam Rex, published in 2010, represents a time when the subculture has ceased to be an object of especially intense controversy and is growingly often perceived as just one among many pop cultural conventions that constitute the intermedial environment in which contemporary teenagers function. No part of the novel's plot revolves around fast food; however, its cover design, carried out by Dan Saelinger, constitutes a direct visualization of the Goth-and-fast-food fusion: it presents a close-up of a shake-like drink in a plastic cup which carries a fang-shaped bite mark oozing with red, blood-like fluid. That image is not only an apt reference to both the book's title and its young adult target readership, but also a reflection of recent developments within the Gothic-mainstream exchange.

Amy C. Wilkins' argument for the Goth being employed by young people as a means of handling the "geek" stigma (27-28) seems especially relevant for the novel, as it is focused on the failed attempt of a fifteen-year-old nerd and social outcast, Doug, at building up an empowering identity for himself. Doug's self-formation technique is based on remixing various elements of popular culture, for instance by copying reactions or utterances observed in films in order to enhance his social skills (Rex 253, 256) or forming a repository of witty remarks based on comic-book quotes (6). He also tends to think of himself in terms of

a pop cultural character rather than a "real-life" individual (202-203, 314). The protagonist's approach to socialization remains unsuccessful until he is accidentally turned into a vampire, which gives him the hope of profiting from the dark charm of the vampiric trope and thus gaining the desired popularity (6-7). He is temporarily successful, realizing his dream of becoming a mysterious crime-fighter (239-240) and seducing a girl (242). However, instead of driving Doug's self-formation process to a narrative closure, the novel's resolution makes his story fall apart into a number of endings, none of which is suggested as the real one (322-333). Thus, the reader eventually finds out that – as pointed out by one of the novel's characters (219) – the protagonist's quest for popularity has not been a sufficient identity axis, and that no cultural models or clichés can replace the effort everyone must put in to their individual development.

The above realization is especially spectacularly confirmed by the vampire motif, which is simultaneously literal – in the world of the novel vampires are real and so are the stereotypical supernatural powers that Doug gains on being changed – and culturally constructed, as explained by Doug's vampire teacher:

> You [Doug] wanted to know the rules. I believe, sometimes, that the rules can change. That the rules are not rules at all. Why did "my" vampire look like that? [The vampire who transformed the speaker looked like a rotting corpse] . . . I have no idea. Maybe because he thought he should? Maybe because that was what the world believed of vampires in his day? . . . Then the years passed, and a notion of a different kind of vampire captured the popular imagination . . . So, shortly after our Mr. Stoker published his stuffy little book, I finally emerged, a . . . butterfly. . . . I changed. The conception of what a vampire is, what he looks like and how he behaves, changed. It can change again. . . . How often do we remake ourselves to suit the expectations of society? . . . There are so many more of them [humans] than us [vampires], Doug . . . And the vampire was only ever what they needed it to be. (192-193)

The suggested incorporation of the vampire trope into the broader dynamics of a pop cultural remix, already reflected by the novel's cover design, demonstrates that while, as Spooner puts it, "twenty-first-century Gothic retains the capacity to surprise us – to horrify, and to delight" (*Twenty-First-Century Gothic* xii), it does not always require the convention's uniqueness in order to offer a productive cultural commentary. While Doug's lesson about the importance of an active search for one's identity may seem similar to the one learned by Lucy from *Sweetblood*, a significant difference is that in Rex's work the Goth and the Gothic tropes provide an insight into not so much the presumed social threat of subcultural identification, but rather the mechanisms of the postmodern, intertextual

and omnipresent popular culture that increasingly often becomes a background for young people's self-definition.

Conclusion

As shown by the examples discussed, the current mainstreaming of Goth as a cultural trope seems to be something that the subculture itself has been ready for, analogically to the way in which it has survived the commercialization dated back to the 1990s. Moreover, the said process proves to work in both directions and in some cases effectively Gothicizes mainstream icons. As in the case of the Gothic convention in general, the subversive potential of those mutually dependent commercialization/Gothicization phenomena rely on many factors, the attitude of the readers definitely belonging to the most prominent of these. Still, what the development of Goth tropes suggests is that a healthy dose of self-reflective irony has so far been able to prevent a crisis for the convention and, moreover, has granted it power to counterpoint mainstream culture, even if the effectiveness of Gothic commentary sometimes demands the swapping of underground lairs for fast food restaurants.

Works cited

"Best Books for Young Adults: Annotated List 2004". Young Adult Library Services Association. Web. 15 Jan 2014.
<http://www.ala.org/yalsa/booklistsawards/booklists/bestbooksya/annotations/2004bestbooks>.
Campbell, Ross. *Wet Moon 4: Drowned in Evil*. Portland: Oni Press, Inc., 2008. Print.
---. *Wet Moon 2: Unseen Feet*. Portland: Oni Press, Inc., 2006. Print.
---. *Wet Moon 1: Feeble Wanderings*. Portland: Oni Press, Inc., 2004. Print.
Goodlad, Lauren M. E. and Michael Bibby. "Introduction." *Goth: Undead Subculture*. Eds. Lauren M. E. Goodlad and Michael Bibby. Durham and London: Duke UP, 2007. Print.
Halberstam, Judith. *Skin Shows: Gothic Horror and the Technology of Monsters*. Durham and London: Duke UP, 1995. Print.
Hautman, Pete. *Sweetblood*. New York: Simon and Schuster, 2003. Print.
Horner, Avril and Sue Zlosnik. *Gothic and the Comic Turn*. Basingstoke and New York: Palgrave-Macmillan, 2005. Print.
Joseph, Michael. "Liminality." *Keywords for Children's Literature*. Eds. Philip Nel and Lissa Paul. New York and London: New York UP, 2011. 138-145. Print.
Kincheloe, Joe L. *The Sign of the Burger: McDonald's and the Culture of Power*. Philadelphia: Temple UP, 2002. Print.
Kristeva, Julia. *Powers of Horror: An Essay on Abjection*. Trans. Leon S. Roudiez. New York: Columbia UP, 1982. Print.

Masschelein, Anneleen. *The Unconcept: The Freudian Uncanny in the Late-Twentieth-Century Theory*. Albany: State New York University Press, 2011. Print.

Rex, Adam. *Fat Vampire: A Never Coming of Age Story*. New York: Balzer + Bray, 2010. Print.

Saelinger, Dan. Cover: *Fat Vampire: A Never Coming of Age Story*. New York: Balzer + Bray, 2010. Print.

Siegel, Carol. *Goth's Dark Empire*. Bloomington and Indianapolis: Indiana UP, 2005. Print.

Spooner, Catherine. "Preface." *Twenty-First-Century Gothic*. Eds. Brigid Cherry, Peter Howell and Caroline Ruddell. Newcastle upon Tyne: Cambridge Scholars Publishing, 2010. IX – XII. Print.

---. *Contemporary Gothic*. London: Reaktion Books, 2006. Print.

"Teacher's Guide: *Sweetblood*". Pete Hautman's official homepage. Web. 15 Jan 2014. <http://www.petehautman.com/sweetblood.html>.

Viljoen, Hein and Chris. N. Van der Merwe. "A Poetics of Liminality and Hybridity." *Beyond the Threshold: Explorations of Liminality in Literature*. Eds. Hein Viljoen and Chris. N. Van der Merwe. New York: Peter Lang, 2007. 1-26. Print.

Voltaire. *What Is Goth? Music, Makeup, Attitude, Apparel, Dance, and General Skullduggery*. Boston: Red Wheel/Weiser, 2004. Print.

---. *Oh My Goth! Version 2.0*. Dover, New Jersey: Sirius Entertainment, 2002. Print.

What Is Goth? Aurelio Voltaire's official homepage. Web. 15 Jan 2014. <http://www.voltaire.net/what_is_goth/>.

Wilkins, Amy C. *Wannabes, Goths, and Christians: The Boundaries of Sex, Style, and Status*. Chicago: Chicago UP, 2008. Print.

Devouring Heroism: An Archetype Crisis in American Pop Culture

Oskar Zasada

Action heroes have been a staple of the American film industry for many years now. The archetype of a heavily armed muscular male who could overcome seemingly impossible odds became both a pop cultural phenomenon and one of Hollywood's most recognized products. Citizens of westernized countries had plenty of time to familiarize themselves with such characters; it is undeniable that their destructive escapades have provided entertainment for countless viewers. Nevertheless, for over ten years now the demand for action heroes has been dropping steadily. Currently, the usage of this archetype centers around nostalgia and the collective efforts of the people who helped to popularize it in the first place. The goal of this paper is to determine what factors are responsible for the action hero's pop cultural decline.

Because the popularity of a given pop cultural phenomenon is directly linked to its consumption by the masses, this work makes use of food analogies to depict events in a more engaging manner. Furthermore, to understand the present it is often necessary to provide some information about the past. These paragraphs are not meant to be a detailed historical summary of the action genre, as such a work would likely take up enough space to fill several books. However, the action hero archetype did not suddenly manifest itself out of nowhere, and neither did the various factors that caused it to lose its relevance. That is why this work has been divided into seven sections, four of which reference numerous events and phenomena in a chronological fashion. The next two are devoted to heroic archetypes with greater degrees of sustainability than the one undergoing a crisis. The final section concludes the work by providing and examining the common traits that influence the pop cultural standing of these character types. All of the elements listed above are necessary to illustrate the action hero's steady pop cultural degradation and the shortcomings responsible for it.

Pirates, gunslingers, and spies, oh my

The roots of action pictures can be traced back to the adventure and western genres. Reaching back to the silent era of cinema, adventure movies aim to "provide an action-filled, energetic experience for the film viewer" ("Adventure Films").Swashbucklers, which are also part of the above genre, present quick-witted and conflict-prone individuals as their protagonists. Indeed, the main

character's hot-blooded attitude often mirrors the picture's other elements, be-
cause "a Swashbuckler is about speed. These are fast films, in all ways. The plot
whips along, the swordfights streak across the screen, and the dialog is rapid
fire" (Foster). As for the lead characters in westerns, they "are normally mascu-
line persons of integrity and principle – courageous, moral, tough, solid and self-
sufficient, maverick characters, . . . possessing an independent and honorable
attitude . . ."("Western Films"). By presenting scenarios where exceptional men
tackled untamed nature and adverse conditions, these genres laid the ground-
work for the action hero archetype. However, it was the creation of a British
writer that elevated this concept to truly absurd levels.

The first James Bond novel was introduced by Ian Fleming in 1953. The
character made his appearance on the silver screen a little less than a decade lat-
er, although a CBS television adaptation of Casino Royale came out as early as
1954 (Kamp 2). Initially, the author envisioned Bond as little more than a vehi-
cle meant to drive the plot forward. In his 1962 New Yorker interview the spy's
creator stated "I wanted Bond to be an extremely dull, uninteresting man to
whom things happened; I wanted him to be a blunt instrument..." (Fleming).
While the author did develop his creation's persona in the following years, Bond
can still be perceived as a blank screen onto which the audience project their
hidden desires and power fantasies. In the same fashion, all of the movies in the
franchise serve as representations of their respective decades. Each installment
adjusts to the flow of time and keeps up with technological nuances (Anderson).
Such an approach increased both accessibility and sustainability. It created a se-
ries that still remains fresh and relevant despite being more than fifty years old.
It is easy to see why pictures featuring Fleming's brainchild had such a strong
impact on the action genre of the sixties and provided a beacon of inspiration for
other filmmakers in the years to come.

Cops and robbers in the seventies

Inspiration quickly turned into competition, as a new style of action movies
started to form in the early seventies. Set mostly in urban areas and character-
ized by their grim and gritty atmosphere, these pictures were a unique mixture of
tried and tested formulas. By combining detective fiction, crime dramas and
a hefty amount of action elements, the film industry gave birth to something
new. With films such as *Assault on Precinct 13, Dirty Harry, The French Con-
nection*, and *Taxi Driver*, Hollywood decided to focus its hopes and assets on
the adult demographic (Dirks, Film 70s). As a result, the world presented in
these pictures was less than ideal. Poverty, disregard for human life, abuse of
illegal substances – the intensity of the societal problems listed was intentionally

blown out of proportion. Such an approach helped to highlight the fact that the protagonist was a competent individual, able to survive in an inherently hostile environment. Of course the abilities of such a character were not really on a par with the ones possessed by the previously described super spy. This made the former more grounded in reality and easier to relate to for the average viewer. It also led to an emotional investment in the picture at the same time, as no progress could be made without real effort on the character's part. Additionally, moral ambiguity and cynicism were often the most noteworthy aspects of such individuals. Using bloody interrogation methods and holding racist opinions, these fictional lawmen were inherently flawed, just like normal human beings. In typical thriller fashion, the atmosphere of danger and uncertainty also factored into the equation. Fernando Ray's character in *The French Connection* got stabbed with a knife in his first scene. During the movie's climax, his partner accidentally shot another policeman while trying to apprehend the elusive main villain (Friedkin). Because of the strong emphasis on moral, psychological, and societal factors, the archetype underwent notable modifications. Played by Clint Eastwood, the character of Harry Callahan was one of the best depictions of the ongoing evolution. Even though the actor was mostly known for portraying lone gunslingers, his transition into an urban setting was exceptional. While Eastwood's role in *Coogan's Bluff* might be considered a half-way point between the two genres, it was his performance in *Dirty Harry* that left a permanent mark on American pop culture. Film historian Eric Lichtenfeld believes that Callahan's character played a key role in the formation of the action hero archetype (23). In accordance with the constantly shifting standards of popular culture, further developments were still ahead.

The explosive eighties

The eighties were a time period that really put the word *action* in *action hero*. Some of the most prominent movies of the genre premiered at that time, but few of the future stars actually made their debuts. Most of them, like Schwarzenegger and Stallone, were simply elevated to new heights in their acting careers thanks to more impressive roles. In 1982 Sylvester Stallone starred in *First Blood*. The movie focused on a shell-shocked veteran's tragic inability to cope with his new surroundings. Because of this, it shared a connection with the action films popularized in the previous decade. Nonetheless, the series it launched was transitional in nature. It quickly changed its focus and established John Rambo as the next icon of the action genre (Earnshaw).This led to the creation of a very successful and enduring action franchise, which fueled Hollywood's hunger for cinematic violence even further. Nonetheless, the movie that became

the genre's prime trendsetter came out in the second half of the decade. *Die Hard*, starring Bruce Willis, took the theatres by storm in 1988. The picture's approach to the established formula was somewhat unconventional, pitting an ordinary police officer against a highly organized crime group in a closed environment. The casting process for the main character was peculiar too, as various celebrities refused to accept the role. Reluctantly, the studio offered it to Willis who was known as a comedy actor at that time (Doty). The naysayers were quickly proven wrong, as Willis demonstrated that one didn't need excessive muscle mass to be an action star. He opted to portray a funny and endearing everyman instead – one who found himself in the wrong place at the wrong time. The unexpected success essentially gave John McClane iconic status. It also paved the way for many imitations that often transplanted the original's plot elements into truly bizarre settings. Feeding off the ideas of others was, and still remains, one of the classic traits of pop culture, and therefore some of those pictures were even able to achieve very impressive box-office ratings. The movie *Under Siege*, starring Steven Seagal, is one such heavily inspired production, but there are many more (Harris).

Dubbed as the action era, the eighties were a golden age for the entertainment industry, shaping viewer consciousness on a level that was both national and global. The action-oriented protagonists who emerged at that time were a whole new breed and the people who portrayed them had a lot to do with that. Most were glorified bodybuilders and martial artists who blurred the line between the actor and his character, having a detrimental effect on both. While it is true that their impressive physical attributes gave them a certain degree of screen presence, their acting abilities left much to be desired. Some of these performers never even received professional training. These new action stars lacked the proper skills of self-expression possessed by their predecessors. On screen they were nonentities, devoid of personality. Sometimes even ordinary communication proved to be a serious issue for them. To give an example, at the beginning of his acting career Schwarzenegger was not able to properly deliver his lines. His accent was very strong and he only had a rudimentary understanding of English. In his first movie, *Hercules in New York,* his lines were actually dubbed over (Ashlin). In *The Long Goodbye* he played a deaf-mute assassin (Williams, 61). Steven Seagal is another action star who deserves a special mention at this point, as it is almost impossible to tell the characters he has portrayed apart. They are nearly identical to one another, with the only noticeable differences being their names and background information. Of course, with four victories the record for the highest number of Golden Raspberry Awards for Worst Actor belongs to Sylvester Stallone (Idato).

Considering all of the information presented above, one might ask about the reason behind this genre's enormous success in the 1980s. Most of the lead actors' performances certainly were not deep or emotional enough to be the cause. However, these individuals seemed like the perfect role models for the young generation of that decade. The belief that one could attain an action star's physique with a bit of hard work and dedication might seem naive from today's perspective, but it mixed really well with the plastic optimism of Reagan's presidency. It was a blatantly unrealistic premise, but people still supported it. Action stars were also the only actual human beings who could provide living opposition to the ever growing realm of literary and animated fiction, where almost every character was attractive and in peak physical condition. In its defense, the blank slate of a muscle-bound protagonist did make for an effective vehicle to drive the plot forward. There was no need to focus on the lead and his personal problems, which made it easier to immerse oneself in the action-packed experience. Viewers were able to project themselves onto the hollowed out protagonist, effectively turning the movie into a personal fantasy visualized on-screen. More interactively-oriented media like video games simply were not sufficiently developed back then. This caused the action genre to become the number one choice for people who sought a brief reprieve from their boring lives. While it was not the first example of escapism by any means, its range and scale were remarkable. American cinema flooded the minds of viewers all over the world with images of muscular heroes who effortlessly avoided gunfire. The American Dream received a fresh image. The original had its beginnings in frontier life and advocated the idea of achieving prosperity through hard work and diligence (Mankel). However, the version presented by action stars boasted a more simple premise. It signified the ability to defy all odds and defeat one's enemies, as long as one had the ideological high ground and possessed the stature and firepower necessary to maintain it.

CGI's rise to power: the nineties and beyond

The golden age of action heroes spilled over to the next decade, but it did not last for long afterwards. Changes were still in the making, yet the end of the 1980s was marked by two events that held importance for the genre as a whole. The first one was the emergence of Tim Burton's Batman, which helped to strengthen the pop cultural appeal of a nascent subtype of action films based entirely on comic book characters (Knight). The second event was gradual in nature. Growing more impressive with every year, advancements in computer generated imagery made it easier for motion pictures to make use of blatantly unreal elements. Movie companies went into a technological arms race, aiming to pro-

vide the best cinematic experience possible to win over one another's audiences. As one might expect, this lead to previously unimaginable movie budgets in an attempt to establish a greater amount of successful franchises. If the eighties were sequel-oriented, then the nineties have secured their place in the history of cinema as "the decade of remakes, re-releases, and more sequels" (Dirks, Film 90s). It is not hard to see why – James Cameron's Terminator 2: Judgment Day arrived at the cinemas in 1991. With an estimated budget of more than one hundred million dollars and extensive use of CGI technology, the picture's financial and critical success was a testament to Cameron's directorial vision (Hinson). Three years later, another movie by the same director had a strong impact on the industry. A spy-themed action comedy, True Lies proposed a unique mixture of ideas. It combined the allure of Bond movies with the action persona of Arnold Schwarzenegger, creating a picture that was filled to the brim with breathtaking scenes and special effects. At the same time, it clearly did not let realism and the cohesiveness of its own plot weigh it down (Ebert). Even with the emphasis on stunts and CGI, gratuitous violence was still in high demand. The masses eagerly ingested every bit of gore served to them by directors. And the word ingest seems very fitting. Anthony Lane, a movie critic for The New Yorker, has gone so far as to compare the 1994 movie Pulp Fiction to fast food, claiming that "the film attacks your senses and gives you almost nothing to remember it by, let alone to nourish you" (Lane). In 1995 the Bond franchise managed to make a more than impressive vault into the nineties with Golden Eye. As was customary, both the film and the protagonist had to meet the peculiarities of that time from a fresh perspective, and so a new incarnation of the famous agent was cast. Adapting also meant utilizing the technological advancements made by the industry. That is why the movie starring Pierce Brosnan was the first one in the series to use computer generated imagery (McBride). As the decade went on, the public was steadily gorging on gunfights, vehicle chases and explosions, fuelling Hollywood's movie-making machine for years to come. Virtually nothing seemed to suggest that serious trouble was in store for the muscle-bound archetype. Then something unusual occurred. After the turn of the millennium, action heroes started suffering from disuse. The crisis occurred on two fronts: famous icons went into retirement and successful newcomers were few and far between. To name but a few, actors such as Dwayne Johnson, Vin Diesel and Wesley Snipes certainly had the bodies and attitudes required to become the next generation of action heroes. It is undeniable that, during the first decade of the new century, they were able to create memorable performances. Nonetheless, most of those performances were already tainted by a strong presence of the unreal, or pandered to very specific subcultures. Indeed, fantasy and science-fiction were taking bigger and bigger bites out of the industry. With the start of a new dec-

ade, action stars did make various attempts to reclaim the silver screen, but they were not very successful. The film audiences hungered for new experiences, and so a zombie romance won the box office confrontation with Stallone's Bullet to the Head (Subers). After a ten year break in his acting career, excluding a few minor cameos, Schwarzenegger made a comeback in The Last Stand. The movie performed well below expectations, earning only a marginal gross of 6.3 million in the month of its premiere (McClintock). Action films that did live up to their legacy were few and far between. Directed by Stallone, the 2010 ensemble action film called Expendables managed to rekindle some interest in the archetype and its 2012 sequel used that interest to further expand the concept (Browne). However, both pictures also proved that the main force responsible for maintaining the viewers' fascination with action heroes was nostalgia. People wanted to see their aging childhood idols interact with each other on a scale that was previously unheard of. It was not unlike going back to one's favorite fast food restaurant after a very long break and ordering a supersized meal. A victim of its own success, the action hero archetype appears to have been chained to the actors and characters who helped to popularize it in the first place. It is true that a new installment of a famous franchise would almost certainly result in an impressive profit, but with very modest prospects for innovation and the lack of opportunities for newcomers the archetype's future looks rather bleak.

Daring deeds and high scores

Presently, different types of heroes hold a greater sway over the minds of the masses. For example, the American soldier archetype – an enormous, multilayered construct spanning film, literature, and other media. While the archetype possesses a vast number of different incarnations, this section will only focus on the one that the author considers to presently have the greatest pull on contemporary American pop culture; the soldier's representation in the shooter video game genre certainly is entitled to such a claim. Different titles have covered every major conflict that the USA has engaged in, starting from the archetype's Independence War roots and ending with the more recent exploits in the Middle East. Indeed, most of these games can be categorized according to the specific conflict that they portray. In its breadth, the archetype known from first-person shooters is quite similar to its film counterpart. Then again, war films have the option to focus specifically on societal and moral aspects of a given confrontation. Such an approach makes it possible to closely examine the interactions between soldiers, as well as their beliefs and motivations. Contrary to this, an FPS game usually requires its plot to match the dynamic game play. It can be argued that the shooter incarnation dehumanized the archetype to a certain degree, turn-

ing human struggles and suffering into cheap entertainment. War heroes became player avatars, allowing the users to carelessly kill thousands of nameless Nazis, communists, and terrorists in recreations of various real world conflicts. Game developers did not have to deal with serious societal dissonance like film studios did during the USA's involvement in Vietnam (Paris). The ability to become a hero in the safety of one's own home took escapism even further than the action films had done. The key word being hero, as most of such games mimic the approach of wartime propaganda movies; they present their protagonists as courageous freedom fighters who are always ready to defend the helpless and unfortunate. Moral ambiguity and ideological differences are generally ignored. Nevertheless, titles promoting perspectives different to the one presented above do exist; they provide a shrewd critique of the genre and offer greater insight into the archetype (Hamilton). That being noted, the similarity between the plot elements of regular military shooters and the cinematic blockbusters of the '80s is also noticeable. If we accept that games can be considered art, then shooters would be the gaming equivalent of Lane's "fast food cinema." With their impressive visuals and copious amounts of violence, they take the player through a series of frantic gunfights, leaving him hungry for more sensations without providing any sort of intellectual nutrition. Millions of people all over the world buy new installments of war-themed shooters every year, supporting the efforts of game developers, who are not unlike a combination of junk food chains and movie studios. However, even if the American soldier archetype appears to have been hollowed out, its pop cultural relevance is undeniable. It is highly possible that by sacrificing some of its depth for adaptability, it was able to avoid sharing the fate of the action hero archetype. Pop culture, after all, is fueled by ever changing trends and patterns, and simplifying a concept makes it easier for the target audience to digest.

Truth, justice, and special effects

Currently, young and old cinema goers also have different protagonists to look up to. Known as superheroes, these fantastic paragons have established an impressive grip on the film industry. This was not always the case, however. Adaptations created during the early years of the superhero phenomenon took the form of Saturday movie serials and were aimed almost exclusively at younger audiences. Released in 1941, *Adventures of Captain Marvel* was the first to make its debut and many others soon followed (Stedman, 125). The first full-length superhero film to achieve both financial success and critical acclaim was *Superman*, directed by Richard Donner. Thanks to revolutionary special effects, its promise to make audiences believe that a man could fly turned out to be more

than just an empty slogan (Culhane).In the ten years that followed the movie spawned three sequels, but it did a lot more for the industry as a whole. Along with *Star Wars* and *Close Encounters of the Third Kind* it "helped usher in a new era of film-making that respected and exalted science fiction, fantasy, and adventure stories" (Freiman). The recognition that it received also made it possible for other directors to try their hand at transferring superhero comics to the big screen. The first wave of such movies arrived in the 1980s, with the previously mentioned *Batman* film closing the decade and reinforcing the nascent subgenre's foothold. The first half of the 1990s was a time of rapid expansion for superheroes; it gave even independent writers and artists a chance to see their characters come to life on the silver screen. Lichtenfeld claims that *The Crow*, written and illustrated by James O'Barr, was the first American underground comic to make use of this opportunity (287). Directed by Alex Proyas and starring the late Christopher Lee, the movie instantly gained a cult following in the goth subculture and beyond. It also confirmed that the last decade of the 20th century was a time of creative freedom and experimentation for superhero films. Because of the sheer breadth of the archetype, screenwriters and directors were free to utilize a wide array of themes and conventions. This resulted in the creation of movies that were fundamentally different from one another, while still technically belonging to the same subgenre. Embracing diversity proved to be the correct course of action. With the increasing influence of CGI, the 2000s gave birth to even greater examples of cinematic unreality, transferring many of the flagship titles from publishers like Marvel and DC onto the big screen. Their immense potential ushered in a wave of sequels and spin-offs, establishing many renowned series. Although the genre's focus was at first limited only to big American names, other intellectual properties soon followed. While Hollywood was feeding the viewers with adaptations of famous origin stories, others wanted to introduce their own ideas and carve out a fair slice of its success. International projects, eastern releases, unusual mixtures of different movie genres – everything signified that the USA not only lost its pop cultural monopoly on superhero icons, but also helped to start a new chapter in the archetype's history. While some may argue that presenting previously used story arcs with the help of a new medium is not very innovative, most of these movies were only obliged to maintain the main plot elements, leaving room for a certain dose of originality. It was also about scope. Comic books were a niche medium at first, reaching only a limited number of people, most of them underage. But after the transition had been made, movie studios focused on serving the largest amount of customers possible with a pre-packed meal of heroism and supernatural abilities. Presently, superhero movies are still in bloom, which is not surprising, considering that the number of variables offered by comic book protagonists is limited only

by human imagination and the movie's budget. In the words of clinical psychologist Robin S. Rosenberg, "[superheroes] provide escape, their familiar storylines are comforting, . . . they allow us to see issues, existential crises, and our own problems in displacement. Moreover, the variety of superheroes—of powers, of personality, of personal dilemmas—lets our fascination fall on the superheroes who are the best *match* for us"(33).

A heroic conclusion

All of the archetypes discussed above share common traits that influence their pop cultural standing. The action hero's issue with sustainability revolves around breadth, depth, and adaptability. Appropriately enough, the other archetypes effectively utilize the potential behind one or more of those traits. The video game incarnation of the American soldier usually does not offer much depth or food for thought, but its breadth and the level of interactivity that it provides for its player base more than make up for this deficiency. On the other hand, superheroes can be a source of original and innovative ideas, many of which still remain untapped. It is not uncommon for them to present a wide spectrum of moral and existential dilemmas, while still providing a hefty amount of action for the viewers. Their enormous presence outside the silver screen is noteworthy as well, covering a great deal of media and products. The muscle-bound protagonist cannot really hope to match any of the above qualities. However, the thing that makes it nigh-impossible for him to leave a lasting impression on today's pop culture is his inability to adapt. The archetype cannot make full use of the industry's technological advancements without crossing over to the realm of fantasy and science fiction. Because action heroes constantly engaged in feats that were nearly herculean in nature, their fans rapidly got accustomed to a certain level of unreality. Then, before anyone realized it, technology became sufficiently advanced to provide viewers with footage of actual superhuman powers and abilities. Cinemas showcased characters who could telekinetically deflect bullets instead of shooting them out of guns. The people who portrayed those characters were actors first and foremost. They were able to deliver convincing performances instead of relying solely on their physiques. It is true that the action hero's explosive attitude set the whole genre ablaze. However, just like an explosion, the archetype's reign was spectacular but short-lived, leaving only a barren landscape with bleak prospects for the future. Now the actors who helped to promote the concept are using nostalgia and group effort to regain its pop cultural relevance. Unfortunately, in its current state the archetype seems like one of the action genre's evolutionary dead ends.

Works Cited

"Adventure Films."*Filmsite.org*. American Movie Classics Company LLC., 2013. Web. 22 June 2013.

Anderson, Kyle. "Bond, James Bond: The 60s." *Battleship Presentation*. Battleship Presentation, 2013.Web. 23 June 2013.

Ashlin, Scott. Rev. of *Hercules in New York*, dir. Arthur Allan Seidelman. *1000 Misspent Hours and Counting*. Scott Ashlin, 2013. Web. 12 July 2013.

Browne, Niall. "Weekend Box Office Wrap Up: August 19, 2012." *Screen Rant*. Screen Rant LLC, 2013. Web. 7 July 2013.

Culhane, John. "Special Effects Are Revolutionizing Film." *The New York Times*. New York Times Company, 2013. Web. 12 July 2013.

Dirks, Tim. "Film History of the 1970s." *Filmsite.org*. American Movie Classics Company LLC., 2013. Web. July 8 2013.

---. "Film History of the 1990s." *Filmsite.org*. American Movie Classics Company LLC., 2013. Web. July 11 2013.

Doty, Meriah. "Actors who turned down 'Die Hard'." *Yahoo! Movies*. Movietalk,13 Feb. 2013. Web. 5 July 2013.

Earnshaw, Helen. "Rambo: Greatest Action Heroes." *Female First*. First Active Media Ltd., 13 Feb. 2013. Web. 22 July 2013.

Ebert, Roger. Rev. of *True Lies*, dir. James Cameron. RogerEbert.com. Ebert Digital LLC, 2013. Web. 9 July 2013.

Fleming, Ian. "Bond's Creator." Interview by Geoffrey T. Hellman. *The New Yorker,* 21 Apr. 1962: 32. Print.

Foster, Matthew M. "The Important Swashbucklers." *Foster on Film*. Matthew M. Foster, 2013. Web. 22 June 2013.

Freiman, Barry M. "One-on-One Interview with Producer Ilya Salkind." *Superman Homepage*. Nick Jones, 2013. Web. 5 July 2013.

Friedkin, William, dir. *The French Connection*. Perf. Gene Hackman, Roy Scheider, and Fernando Rey. 20th Century Fox, 1971. DVD.

Hamilton, Kirk. "What Does A Marine Think Of *Spec Ops: The Line*'s Criticism of War?" *Kotaku*. Gawker Media, 12 Mar. 2013. Web. 14 June 2013.

Harris, Scott. "9 Movies That Ripped Off the 'Die Hard' Formula." *NextMovie.com*. MTV Networks, 18 Mar. 2013. Web. 2 July 2013.

Hinson, Hal. Rev. of *Terminator 2: Judgment Day*, dir. James Cameron. *The Washington Post*. The Washington Post, 2013. Web. 11 Aug. 2013.

Idato, Michael. "Rambo TV series in works, without Sylvester Stallone." *The Sydney Morning Herald*. Fairfax Media, 22 Aug. 2013. Web. 24 Aug. 2013.

Kamp, David. "The Birth of Bond." *Vanity Fair*. Condé Nast Digital, Oct. 2012: 2. Web. 23 June 2013.

Knight, Alex. Rev. of *Batman*, dir. Tim Burton. *Zero Distraction*. Alex Knight, 9 June 2013. Web. 15 June 2013.

Lane, Anthony. Rev. of *Pulp Fiction*, dir. Quentin Tarantino. *The New Yorker*. Condé Nast, 2013. Web. July 8 2013.

Lichtenfeld, Eric. *Action Speaks Louder: Violence, Spectacle, and the American Action.* Middletown: Wesleyan University Press, 2007: 23, 287. Print.

Mankel, Mirco. "The American Dream - A historical overview." *American Dream Reference Page.* Mirco Mankel, 22 Dec. 2009. Web. 18 July 2013.

McBride, Clare. Rev. of *Goldeneye*, dir. Martin Campbell. *The Literary Omnivore.* Wordpress.com., 1 Nov. 2013. Web. 3 Nov. 2013.

McClintock, Pamela. "'Expendables' Stars Face Cold Winter at Box Office." *The Hollywood Reporter.* THR, 2 June 2013. Web. 7 July 2013.

Paris, Michael. "The American Film Industry & Vietnam." *History Today.* History Today Ltd., 2012. Web. 18 June 2013.

Rosenberg, Robin S. "Our Fascination with Superheroes." *Our Superheroes, Ourselves.* Ed. Robin S. Rosenberg. New York: Oxford University Press, 2013: 33. Print.

Stedman, Raymond William. *Serials: Suspense and Drama By Installment.* Norman: University of Oklahoma Press, 1971:125. Print.

Subers, Ray. "Friday Report: 'Warm Bodies' Heats Up, 'Bullet' Cools Off." *Box Office Mojo.* IMDB, 2 Feb. 2013. Web. 7 July 2013.

"Western Films."*Filmsite.org.* American Movie Classics Company LLC., 2013. Web. 22 June2013.

Williams, Joe. *Hollywood Myths: The Shocking Truths Behind Film's Most Incredible Secrets and Scandals.* Minneapolis: Voyageur Press, 2012: 61. Print.

Part Three: Crisis

Performing Witness: The New Documentary Poetics
Elisabeth A. Frost

In his 1957 Nobel Prize speech, Albert Camus famously asserted that the writer "cannot put himself today in the service of those who make history; he is at the service of those who suffer it." But how to go about such "service" in the twenty-first century, a time that is marked not only by local and global crises—not unlike Camus's own time—but also by a radically altered understanding of identity, political systems, and history itself? I argue that increasingly, contemporary U.S. poets are engaging with, and reinventing, the notion of witness. Ironically, to do so many are finding models among under-recognized writers of the early twentieth century, rather than in the overt political agendas of descendants of the historical avant-gardes or through the activist, "engaged" writing of the 1960s and after. Diverging from both of these modes, today's documentary poets offer us a third way, reviving largely neglected modernist traditions of multi-voiced writing that make liberal use of archival sources and often employ mixed media. These models provide both poetic templates for social/political engagement and a way to move beyond the often essentialist assumptions that informed identity politics a generation ago. Thus, the crises of the twenty-first century are leading many poets back to modernism to find ways to theorize identity and to reinvent the poetics of witness.

Throughout the twentieth century, overtly "engaged" poetry has embraced one of two approaches. In the first, cultural activists assume that consciousness is transformed when people consume, and are moved by, the "message" of a work of art, including both its content and its emotional valences. To reach a reader or listener, the poem must be accessible and direct. From the Viet Nam era forward, this transparency of expression went hand in hand with identity politics—the idea that to be effective, activism must emerge from one's own personal identity, which also enables group affiliation along the lines of categories such as race, gender, sexuality, and ability/disability. For movements from Black Arts to second-wave feminism, poetry was a powerful tool in the cause.[1] In the manifesto-poem "Black Art," Amiri Baraka called for "poems like fists," "assassin poems." But perhaps the most frequent rhetorical tool was a powerful first-person speaker. In "Poem about my Rights," for example, June Jordan asserts, "I am the history of rape / I am the history of the rejection of who I am,"

1 See Bibby on Viet Nam era poetry and Whitehead on second-wave feminist poetry for especially strong and cogent explorations of poetry and identity politics.

and she concludes, "from now on my resistance . . . may very well cost you your life."

In contrast to the activist poetics of identity politics, the historical avant-gardes and their off-shoots seek to "free" the complacent reader of conventional engagements with language and, by extension, the ideologies of official culture. Starting in the 1970s, Language writers on both the west and east coasts of the U.S. turned to Frankfurt School thinkers and post-structuralist theorists who linked conventional means of expression to power, domination, and capital. Given an ideologically corrupted language, the goal was to restore agency to the reader by disrupting conventions that promote the "consumption" of words in the familiar, expressive modes of either lyric or narrative poetry. In rebellion against the speech-based mainstream poem of the day, Robert Grenier famously declared, "I hate speech." Bruce Andrews, Ron Silliman, Lyn Hejinian, Carla Harryman, and Charles Bernstein, among many others, created procedural modes of composition that rejected linear narrative, the personal lyric voice, and indeed personal experience itself as a basis for aesthetics or activism.

Both of these approaches have been heavily critiqued. The "message"-based, identity politics poetry of personal voice is often labeled naïve or essentialist, while the avant-garde deformation of language as instrument of ideology is criticized for being obscure and elitist. I would argue that the new documentary poetics confounds this binary. It does so by acknowledging—while also problematizing—questions of identity and the influence of official culture. As Michael Davidson puts it, many of today's writers "imagin[e] poetics through a hemispheric frame or through new forms of citizenship." Davidson poses questions fundamental to the poetics I will describe today: "How might it be possible," he asks, "to think outside the Subject, capital S, and its foundational role in projects of capitalist expansion? What forms of agency exist beyond the lyric 'I' but do not, in the process, jettison the collective?" (On the Outskirts 4). The examples of documentary poetics I will discuss form their own answers to these questions. They offer both a collective approach and a poetics of affect and expression. On the one hand, they embrace identity politics, in order to represent multiple standpoints, especially marginalized subject positions, and voice what has been silenced or suppressed. On the other hand, they develop methodologies of polyvocality, championed primarily by writers associated with modernism and the avant-garde. Avoiding easy bifurcation between the lyric "I" on the one hand, and avant-garde disruption on the other, this poetics pluralizes subjectivities and performs witness. The reader is invited to become what Sandra Harding has called a self-generated subject of knowledge, assisted by the poet, who plays the role of shaper and editor, rather than autobiographical voice. In sum, the new

documentary poetics performs social positions in acts of witness that extend outward in an invitation to the reader.

In her 1993 anthology, Against Forgetting, Carolyn Forché coined the phrase "poetry of witness" for writing that emerges from situations of extremity, in particular political repression or mass violence—contexts in which the compact between the individual and the state has been shattered. The resulting writing functions as trace, evidence, a defiant voicing of trauma and resistance against oppression, whether the subject matter addressed relates directly to such circumstances or not. The organization of Against Forgetting promotes this contextualized and historical reading through its sections, each of which demarcates a specific, often catastrophic, historical event (from the Armenian genocide, through both world wars, ending with the 1989 protests in Tiananmen Square). Within that structure, historical background is provided, and works are arranged simply by poet, each following the last chronologically, according to their years of birth.[2] The point of this use of a thoroughly historical framework is to avoid imposing any system of values on the work—any aesthetic or content-based categorization. By design, Forché chooses to invoke no particular aesthetic agenda, and she makes the point that the content of a given poem does not necessarily reflect political or other violence. Rather, Forché argues that "if a poet is a survivor of the camps during the shoah, for example, and the poet chooses to write about snow falling, one can discern the camps in the snow falling" (cited by Cooley). Forché's sole criterion for inclusion is the biographical fact of the poet's survival of oppression, violence, or political trauma. Using this logic, Against Forgetting relies on the most irrefutable meaning of "witness": the dual assertions this happened and I was there.

In this respect, Forché follows the same path as trauma studies and memory studies, which take first-person accounts as a given. Shoshona Felman, for example, citing Elie Wiesel and Paul Celan, singles out the involuntary nature of most acts of textual witness: it is the singularity of the eye-witness's experience

2 See the web site of Academy of American Poets for a thorough description of Against Forgetting (http://www.poets.org/viewmedia.php/prmMID/5688) and of Forché's ongoing theorization of the poetry of witness, including her essay "Reading the Living Archives: The Witness of Literary Art" (http://www.poetryfoundation.org/poetrymagazine/article/241858). Forché credits the phrase "poetry of witness" to Czesław Miłosz's The Witness of Poetry (Harvard University Press, 1984), drawn from the poet's prior lectures at Harvard. But Forché's definition and theory of witness draws most strongly on Emmanuel Levinas's Ethics and Infinity. See also a video of her lecture "Not Persuasion, But Transport: The Poetry of Witness," delivered on October 25, 2013, at Poets Forum in New York City (http://www.poets.org/viewmedia.php/prmMID/23785#sthash.xEFSZb3f.dpuf).

that compels testimony against injustice and in memory of trauma. For this rea-
son, Felman privileges direct, personal experience, exemplified in her powerful
epigraphs to the co-authored book Testimony. One is from Terrence Des Pres's
"The Survivor": "Where men and women are forced to endure terrible things at
the hand of others... [s]urvival and bearing witness become reciprocal acts" (n.
p.). For memory studies, then, lived experience remains, in ethical and historical
terms, an irrefutable source of authority. But what about what Felman calls
"voluntary" witness? What about the writer who has not personally survived a
trauma but nonetheless wants to bear witness? In keeping with this ethically
complex position, documentary poets develop methods that do not privilege
lived experience but that do widen the idiom and points of reference for poetry
and offer an ethical means of representing what Susan Sontag has called "the
pain of others."

Mark Nowak, one of its most important recent practitioners, argues that
documentary poetics is "a modality," whose examples exist "along a continuum
from the first person autoethnographic mode of inscription to a more objective
third person documentarian tendency (with practitioners located at points all
across that continuum)" ("Documentary Poetics"). Among contemporary poets,
the influence of WPA-era writing, art, and photography is all keen—especially
in the work of Muriel Rukeyser, Charles Reznikoff, Walker Evans, James Agee,
Dorothea Lange, and Richard Wright, among others. At the same time, formally
there is also frequent use of the long poem (narrative or lyric in mode), with
models including William Carlos Williams' Paterson and Charles Olson's Max-
imus poems, both of which also exemplify early uses of archival materials.[3]

Rukeyser's under-studied 1938 masterpiece The Book of the Dead is per-
haps the universal touchstone, for it not only employs the formal methods of col-
lage and polyvocality favored by other modernist era writers but explicitly as-
sumes the task of witness against exploitation and the silencing of injustice by
corporate powers. In the late 1920s, during construction of the Hawk's Nest
Tunnel in West Virginia, the valuable mineral silica was discovered. Miners
were then required to dry mine the silica, without proper ventilation or recourse
to protective masks that would have minimized exposure to lethal silica dust.
The result was the death of hundreds of miners from silicosis, followed by a
cover-up by Union Carbide. To document this atrocity, Rukeyser traveled to
Gauley Bridge, West Virginia, along with a photographer. She conducted inter-
views with the miners and their families, and from this material she assembled
"The Book of the Dead" (published as a long section of her book U.S. 1 in

3 Other recent practitioners include C. S. Giscombe, Brenda Coultas, Juliana Spahr, C.D.
 Wright, Jena Osman, Joseph Harrington, Claudia Rankine, and Kristin Prevallet.

1938). Together with the interviews, Rukeyser drew extensively from sources as various as stock market quotes and Congressional testimony. The result is a polyvocal work that constitutes both a revolutionary formal intervention into poetic practice and a profound act of personal and political witness.[4]

Naming Rukeyser as point of departure, as do many recent documentary poets, the writer Claudia Rankine considers specifically the ways in which the documents of a given time and place, including contemporary ones, might "allow the field of the poem to be open to all the ways we are domestically and globally intertwined." Significantly, Rankine's "we" is inclusive and indeterminate—its speakers are not limited to those who have lived through a given circumstance or lay claim to a particular identity category. Rather, through this "we" Rankine attempts to explore new realities of global traffic. Poet and critic Nicole Cooley has argued that what she calls the "poetry of disaster" "invokes the collective alongside the individual, often in tension with each other." Such writing raises crucial ethical questions about voice and experience often taken for granted in lyric poetry: that is, not just whose voice is heard, but also for whom is it ethical to speak, especially about events one did not experience directly.

Contrary to Rukeyser's symbolically-infused Book of the Dead, the question of the "right" to bear witness allows me to turn to the Objectivist poet Charles Reznikoff, whose several versions of the project Testimony serve as another precursor to the new documentary poetics. Testimony is a series of unadorned, assiduously anti-poetic narratives drawn from court testimony by Reznikoff, who was himself a lawyer (and, like Rukeyser, a journalist). The first volume of Testimony explores the period 1885 through 1915 in the U.S., and it divides that history not by chronology but by geographical region. Reznikoff chose this structure not only in keeping with the organizing principle of his source (the Reporter, a series of legal records), but also because he sought a record of experience that was linked to place as well as time—a period of industrialization and economic upheaval in the U.S. Both more formally straight-forward and more enigmatic than Rukeyser's text, Testimony describes the effects of greed, negligence, and ethical disregard for others in its innumerable legal accounts, replete with murder, theft, and injury (intended and otherwise). But rather than assessing blame or motive, Reznikoff presents unadorned, often mysterious, accounts of violence. The first volume of Testimony, in prose, was later revised as free verse, to be published as Testimony: The United States 1885-1890: Recitative (1965). A later volume documents a very different kind of historical vio-

4 Davidson's chapter on Rukeyser in *Ghostlier Demarcations* provides an excellent reading of the documentary impulse and methodology in "The Book of the Dead."

lence: that of survivors of the shoah. In all his work, Reznikoff employs a spare style and a fidelity to the historical record that are of considerable interest to recent poets (although his work continues to be under-recognized in the academy).

Building on the legacy of both Rukeyser and Reznikoff, poets like Nowak and Rankine have embarked, for at least the past fifteen years, on a revival of documentary poetics. Certainly 9/11 and the wars that have followed have precipitated a new poetry of engagement. In addition, digital production allows imagery, film, and poetry to mix with ease. Finally, recent theorization of "the archive" among scholars and creative artists alike also contributes to this multimedia genre. Some recent examples of documentary poetics are personally and historically elegiac—Susan Howe, Anne Carson, Joseph Harrington, and Kristin Prevallet all use documents and photos to explore silence, death, and loss. Many others overtly engage social/political matters, including: contemporary street life in Harlem (Thomas Sayers Ellis); the corporate control of beach access in Hawaii (Juliana Spahr); the events surrounding the 1911 Triangle Shirt Waist Fire in New York City (Chris Llewellyn); the Amistad slave rebellion (Kevin Young); the lives of the incarcerated in a notorious Louisiana prison (C.D. Wright); and the survivors and displaced persons emerging from the disaster of Hurricane Katrina (Cynthia Hogue, Nicole Cooley, and others).[5]

These many projects vary in form, tone, and historical reference. But underlying each is a notion of the poet not as romantic ego but as archivist. And by offering multiple, self-consciously constructed standpoints, by engaging with but also complicating identity, these works renew the public role of poetry and redefine witness itself.

The most recent volume by Mark Nowak, Coal Mountain Elementary, exemplifies this trend. Nowak is a poet, a social critic, and a labor activist. He has served as an advocate for workers, in part by reaching out to unions, including the United Autoworkers of America (UAW) and the National Union of Metalworkers (NUMSA). Through collaboration with both of these organizations, Nowak has taught creative writing to Ford workers everywhere from Minnesota to Pretoria, with special attention to workplaces that are experiencing downsizings, closings, and/or strikes. He has also worked through PEN World Voices on several outreach projects involving workers; in 2013, for example, he taught a

5 See Ellis's *Skin, Inc.: Identity Repair Poems* (Graywolf, 2013); Spahr's *Well Then There Now* (Black Sparrow Press, 2011); Llewellyn's *Fragments from the Fire: the Triangle Shirtwaist Company fire of March 25, 1911* (Viking, 1987); Young's *Ardency: A Chronicle of the Amistad Rebel* (Knopf, 2011); Wright's *One Big Self: An Investigation* (Copper Canyon, 2006); Hogue's *When the Water Came: Evacuees of Hurricane Katrina* (with photos by Rebecca Ross, University of New Orleans Press, 2010); and Cooley's *Breach* (Louisiana State University Press, 2010).

poetry workshop for taxi drivers in New York City, sponsoring a reading of these writers in conjunction with established poets. Nowak's own poetry is inseparable from his activism. One of his several verse plays, "Capitalization" (2004), concerns Ronald Reagan's summary firing of striking air traffic controllers; it has been staged not only in U.S. theaters but also at rallies for striking Northwest Airlines mechanics. Another, Redundancy (2005), explores the impact of American plant closures following the passage of the North American Free Trade Agreement (NAFTA). His three books of poetry all engage issues of work and community, and all use documentary and archival sources to do so. Coal Mountain Elementary directly addresses the effects of globalization and worker exploitation in specific communities in the U.S. and abroad, combining documentary evidence through photographs with various forms of spoken and written testimony.[6]

Coal Mountain Elementary owes a debt to Rukeyser's Book of the Dead, in that Nowak documents mining disasters, still very much in evidence half a century after Rukeyser's project. The book combines photography and found texts. In this regard, Nowak's methods are actually closer to those of Reznikoff's Testimony than to Rukeyser, in that he eschews the dramatic monologue, never fictionalizing speech and resisting aestheticization of the incidents or the words he culls from existing sources. In this respect, even more than Nowak's earlier volume of documentary poetry and photography of dying factory towns in the U.S. (called Shut Up Shut Down), this book follows Adorno's injunction to resist the beautiful and the lyric. In similar terms, Celan is relevant: Felman cites the poet on his late writing in terms that sound like the Objectivist poets and indeed could serve as a description of Nowak's practice: "the concern of this language is . . . precision. It doesn't transfigure, doesn't 'poeticize,' it names and places" (35). In Nowak's volume, the content is culled only from existing texts, positioning the role of the poet not as "maker" but as researcher. The photos are, likewise, stark and documentary in style.

Formally, the book makes use of frequent and often ironic juxtaposition. The title—its reference to "elementary" learning—comes from Nowak's appropriation of lesson plans supplied on the Web site of the American Coal Foundation. Divided into three "lessons," the volume begins each section with a portion of the Coal Foundation's instructions to potential teachers of these activities:

6 Biographical and other details are drawn from the John Simon Guggenheim Memorial
 Foundation web site's "Fellows" page: http://www.gf.org/fellows/16838-mark-nowak,
 and from the National Poetry Foundation's "Harriet" blog:
 http://www.poetryfoundation.org/harriet/2012/04/domestic-workers-united-writers-
 workshop/. Nowak's other poetry books are Shut Up Shut Down (2004), and Revenants
 (2000), both from Coffee House Press.

Section 1 is called "Coal Flowers: A Historic Craft," section 2 "Cookie Mining," and Section 3 "Coal Camps and Mining Towns." Within each of the book's "lessons," prose and photos (the latter taken by Nowak and Ian Teh) derive from specific events: a series of mining disasters between 2005 and 2006 in China, and a single such disaster, an explosion in the Sago Mine of West Virginia, in January 2006. Sources are listed in an exhaustive Works Cited; those relating to the China incidents are taken from journalistic sources, while those concerning the West Virginia disaster are "verbatim excerpts from over 6,300 pages of testimony" recorded in the weeks and months following the Sago Mine explosion (179). Juxtaposing photos, the Coal Foundation's suggested lesson plans, and excerpted personal accounts of each catastrophe, the book continually shifts voices and discourses. As the Works Cited explains, italics denote the events in China, while boldface is used for the West Virginia disaster. With the various typefaces and fonts, as well as the alternation between verbal and visual information, Coal Mountain Elementary makes its strategies explicit, providing multiple voices even as it firmly situates the reader in its methods.

The central irony lies in the verbatim pedagogy of the Coal Foundation. Nowak excerpts, for example, a lesson on the mining process: "Students will: / 1. participate in / a simulated 'mining' / of chocolate chips / from cookies, / using play money / to purchase / the necessary property, / tools, and labor" (69). This procedure puts students in the position of management (calculating profits), while rendering harmlessly "sweet" the deadly realities of mining. The juxtapositions throughout this section are particularly disturbing. One features a list of states (Montana, Pennsylvania, and so on) to be purchased for set dollar amounts by the students. This page faces a West Virginia miner's account of an "Excel spreadsheet" whose columns, created after the Sago Mine explosion, contain a list of "items."[7] The word "item" is apparently internal code for a dead body— a code that allows those in the company communicating by radio or print to hide the realities transpiring. The miner explains the system used in the spreadsheet: there was "An item number, they just had more or less a code" (103). Names and numbers—like those of U.S. states and sale prices in the students' lesson— are itemized to hide the truth in a perverse accounting.

Equally grotesque juxtapositions from this section begin with the following page:

A mine explosion left at least five miners dead in Xinjiang yesterday, one day after 34 workers were killed in a pit in Henan province. The accident came in the wake of a call from Premier Wen Jiabao for local governments to pay special attention to

7 In keeping with Nowak's format, I preserve in my quotations the use of boldface and italics.

prevent industrial accidents. . . . Twenty-five workers were underground at the time of the blast. Only 11 escaped." (70)

Ironically, this particular lesson plan is about not only profit but also reclamation—returning the land to its original state. Students calculate this fictionalized "expense" in their cookie management; as the instructions cheerfully point out, "Consumed chips / will eat into profits!" (112). Nearby in the text, a photo documents the experience on the ground. An aging "no trespassing" sign posted in a snowy patch of bare trees announces, "DUE TO ACTIVE COAL MINING, THIS AREA IS CLOSED TO ALL RECREATIONAL ACTIVITIES" (100). Reclamation is nowhere in sight.

The events documented from both parts of the globe proceed chronologically, with parallel scenes before, during, and after the explosions and the attendant tallies of the dead. The structure of each section relies on the page as unit of composition, likewise structuring a reader's experience: with the exception of the Coda, no segment of Coal Mountain Elementary exceeds a page, and most consist of a paragraph or (in the case of the instructions for the lessons) short lists or lines. The brevity of the texts, and the immediacy of the images, lend them urgency, drawing attention to the alternation between China and the U.S. The events are not simultaneous—but the similarities serve to condemn the mining industry globally. Still, Nowak respects the particularity of each context, refusing to alter or merge the sources in a way that would aestheticize or obscure the details of the survivors' accounts.

In addition, and contrary to avant-gardist disruption, Nowak's text particularizes subject positions, and his speakers all embody the power of personal narrative. Nowak makes far more use of voice than Reznikoff in the Objectivist, mainly third-person narratives of Testimony. Rather, Nowak uses first-person accounts whenever possible (the excerpts from the China disaster clearly present more difficulties than those drawn from the U.S.). As the passages I cited suggest, Nowak reaffirms the importance of speech and voice in poetry (not to mention in a human rights context). The very struggle to speak, transcribed verbatim, adds to the emotional impact:

I tried to check everybody's—I checked everybody's pulse. I felt for a pulse. And I think most of them had hemorrhaged, hemorrhaged out, and there was some physical evidence there that you could see. I mean, that I thought, you know, with the hemorrhaging, most of them had hemorrhaged and some of them, there was foam, a lot of foam, and a pulse. They were ice cold. And they appeared to be deceased. (127)

This speaker's halting repetitions capture the difficulty and the necessity of articulating trauma. It is critical to Nowak's project that such witness not be aestheticized, even though it must be included selectively. Nowak cites the words of those who survived, but he does not appropriate their language, at least not with the violation that this term usually implies. His poetics honors those whose survival provides an inviolate experience, and a critical standpoint, from which to recount the devastating effects of mining on individuals and communities.

I would argue that Coal Mountain Elementary borrows elements from both the avant-garde and "movement" poetry. His work reveals the middle ground, and the paradox, that documentary poetics offers. While he refuses conventional lyricism, his work affirms the importance of voice, experience and emotional response in a singular poetics of witness.

I would like to close by mentioning briefly another mixed-media documentary work, this one by Claudia Rankine, one of many of her innovations in this re-emerging genre. In addition to book publication, Rankine has worked in theater and in video. The first of her video essays, made in collaboration with the artist John Lucas, led to several more over the past ten years. Rankine and Lucas identify these short works (on Rankine's web site) as "Situations."8 "Provenance," their first, collages together imagery of sleeping passengers aboard an airplane, with a voice-over text about exhaustion, unconsciousness, and the body's release into sleep and vulnerability. In addition is another sound-text, indecipherable at first. This background murmuring soon becomes audible, and the listener/viewer realizes it consists of tapes of emergency ("911") calls. Then one realizes that the 911 calls are those made from the World Trade Center on September 11, 2001. The "main" text, the voice-over (Rankine's voice), continues soothingly, while the "other" voices become louder, more insistent. All the while, the passengers focused on remain asleep, oblivious.

What is this work "witness" to? A collective experience of dissociation, violence, loss, confusion, vulnerability. It is at once fictional and "true," reflective and distanced. It does not exactly say, "This happened," nor "I survived." But it does say "we." We have struggled, continue to struggle with the documents of the violence of our times.

Works Cited

8 See Rankine's web site to access "Provenance" and the other "Situations." Also of considerable importance is Rankine's 2004 text *Don't Let Me Be Lonely* (Graywolf), which employs documentary materials and methods, but does so in a fictionalized series of narratives, collaged together with photographs, drawing, and other graphic elements.

Baraka, Amiri. "Black Art." The Leroi Jones/Amiri Baraka Reader. Second Edition. Ed. William J. Harris. New York: Basic Books. 1999. 219. Print.

Bibby, Michael. Hearts and Minds: Bodies, Poetry, and Resistance in the Vietnam Era. New Brunswick, NJ: Rutgers University Press, 1996. Print.

Camus, Albert. "Albert Camus - Banquet Speech." Nobelprize.org. Nobel Media AB 2013. Web. 2 Jan 2014. <http://www.nobelprize.org/nobel_prizes/literature/laureates/1957/camus-speech.html>.

Cooley, Nicole. "Poetry of Disaster." Poets.org. Academy of American Poets. Web. 2 Jan 2014. <http://www.poets.org/viewmedia.php/prmMID/22467>.

Davidson, Michael. Ghostlier Demarcations: Modern Poetry and the Material Word. Berkeley: University of California Press, 1997. Print.

---. On the Outskirts of Form: Practicing Cultural Poetics. Middletown, CT: Wesleyan University Press, 2011. Print.

Felman, Shoshona. Testimony: Crises of Witnessing in Literature, Psychoanalysis and History. New York: Routledge. 1992. Print.

Forché, Carolyn, ed. Against Forgetting: Twentieth-Century Poetry of Witness. New York: W.W. Norton, 1993. Print.

Grenier, Robert. "On Speech." This 1 (1971). 86. Print.

Harding, Sandra. Sciences from Below: Feminisms, Postcolonialisms, and Modernities. Durham, NC: Duke University Press, 2008. Print.

Jordan, June. "Poem About My Rights." Directed By Desire: The Collected Poems of June Jordan. Port Townsend, WA: Copper Canyon Press. 309-312. 2005. Print.

Nowak, Mark. Coal Mountain Elementary. Minneapolis, MN: Coffee House Press. 2009. Print.

---. "Documentary Poetics." www.poetryfoundation.org. The Poetry Foundation (Harriet Blog). Web. 2 Jan 2014. <http://www.poetryfoundation.org/harriet/2010/04/documentary-poetics/>.

Rankine, Claudia. "An Interview with Claudia Rankine." By Jennifer Flescher and Robert N. Casper. Jubilat 12 (2006). Web. 2 Jan 2014. <http://poems.com/special_features/prose/essay_rankine.php>.

Rankine, Claudia and John Lucas. "Provenance." www.claudiarankine.com. Video. Web. 2 Jan 2014. <http://claudiarankine.com>.

Reznikoff, Charles. Testimony: The United States, 1885-1890: Recitative. New York: New Directions, 1965. Print.

Rukeyser, Muriel. The Collected Poems of Muriel Rukeyser. Pittsburgh, PA: University of Pittsburgh Press, 2005. Print.

Sontag, Susan. Regarding the Pain of Others. New York: Macmillan. 2003. Print.

Whitehead, Kim. The Feminist Poetry Movement. Jackson, MS: University Press of Mississippi, 1996. Print.

Writing of Crisis and Crisis of Writing: Charles Reznikoff's *Testimony* (1934)

Jacek Partyka

I

This paper reconsiders a rather forgotten text which was one of the first releases of the publishing enterprise called The Objectivist Press – Charles Reznikoff's *Testimony* (1934). Originally intended to be entitled *My Country 'Tis of Thee* (the beginning of the song "America" by the Rev. Samuel Francis Smith), this sequence of prose vignettes is an anti-Whitmanesque picture of America – unsurpassed for its brutality, and delivered in a controlled and passionless language. *Testimony* engages with American reality on two levels: firstly, because of the sources it springs from, the book relates to the period before the Civil War; secondly, and more importantly, it delivers a verdict on the Depression era of the 1930s. In the former function it is a "chunk" record of American history; in the latter – part of American documentary *engagé* literature.

The word "crisis" is doubled in the title of my paper, but in all probability its significance in the context of Charles Reznikoff's volume is still not accentuated in a sufficient and satisfactory way. Nor does it bring to the foreground an ambiguity that hides in the term. Manifesting itself as an unstable situation or a negative change or a testing time, "crisis," once proclaimed, always signals a key problem and requires preventive measures. Its contextual meaning and valuation, however, are far from being so obvious as to be stated in unequivocal terms. As the eyes of different beholders will see it, "crisis" either marks the final phase of an already long lasting decline, or, conversely, it initiates a time (a necessary one) of welcome recovery. This apparent mutual contradiction (a "doom" presenting itself as a "boom") disappears only when we resort to the strategy of double focus – i.e. when we accept the inconsistency in our definition of "crisis" as a prerequisite for our being able to define it at all. My paper assumes a perspective of this kind, focusing and fusing various crises – societal, economic, political and, perhaps most importantly, cultural – and different understandings of them so as to create a meaningful context for a critical analysis (and rehabilitation) of one of the major but undeservedly neglected literary publications of the 1930s in the USA.

In the 1930s, in a socio-economic climate that must have appeared mercilessly hostile to American literature and the American publishing market, an unprecedented rise in the popularity of different types of written documentary could be observed. Paradoxically, the Great Depression coincided both with the

emergence of "the American way of life" as a relevant and commonly accepted phrase, and with an almost obsessive desire to record America's cultural uniqueness, not only in written form, but also in aural and visual media (Vescia *xvii*). Books based on documentary evidence proved to be an all-too-enthusiastically accepted challenge for well-established authors of fiction as well as for literary critics and those taking their first steps in the field. Even a short list of major titles should not pass over Theodore Dreiser's reportage 'Tragic America' (1931); Sherwood Anderson's volume of essays *Puzzled America* (1935); Edmund Wilson's *The American Jitters: A Year of the Slump* (1932), a collection of lengthy articles envisioning the beginning of the decade as one of the most troubling periods of American history; Nathan Asch's travel book *The Road: In Search of America* (1937); and Ruth McKenny's then-scandalous and today still-intriguing *Industrial Valley* (1939), which sketched the economic and social conditions in Akron, Ohio. In all these texts a critical perspective on capitalist America finds its expression in a form that may be called a verbal snapshot, the mention of which brings to the foreground yet another important issue of the time: the recognition of photography as a medium that does not – as it was commonly held – distort the reality being represented. Documentary texts were often accompanied by photos so as to "strengthen" if not – give credence to their impartiality. Dorothea Lange's and Paul S. Taylor's *An American Exodus* (1932), Erskine Caldwell's and Margaret Bourke-White's *You Have Seen Their Faces* (1937), Richard Wright's and Edwin Rosskam's *12 Million Black Voices* (1941), or James Agee's and Walker Evans's *Let Us Now Praise Famous Men* (1941) treat the verbal and the visual as equally significant and mutually complementary elements of extended reportage. The very idea of such a combination was, in fact, not new at all – suffice it to mention the pioneering work *How the Other Half Lives: Studies Among the Tenements of New York* (1890) by Jacob Riis, who memorably exposed the squalor of late nineteenth-century New York slums and the exploitation of children in factories and in other jobs at the time. The period from the beginning of the 1930s to the 1950s is often considered the "Golden Age of Photojournalism," *Life* magazine being one of the driving forces and proponents of publications of this kind (from 1936 on). Although not accompanied by visual material, Reznikoff's book should be considered against this contextual backdrop of the era.

II

Charles Reznikoff's poetry is sometimes perceived as "artless," i.e. devoid of elements that to a great extent inform high modernist verse: "instead of modernist discontinuity there is continuity; in place of reliance on symbol and metaphor

there is realistic, almost photographic precision of language" (Heller 59). Rezni-koff stands out, or better still: stands aside, assuming the role of a by-stander/witness, who – whether sketching urban life, the experience of Jewish immigrants in America, reading legal documents in nineteenth-century America and twentieth-century Europe, or pondering upon distant Jewish history – remains emotionally detached from the event or the problem that has been selected as the subject matter of his writing. The certain artistic code of rules that he implies he adopted combines "legal training and the moral imperative of the Jew as historical witness" and "the Objectivist and Imagist principles" (Heller 59). The search for a lucid, precise and objective mode of writing dates back to the poet's early years. "Early History of a Writer" from the sequence "By the Well of Living and Seeing" brings the following confession:

The law that we studied

was not always the actual law

of judges or statutes

but an ideal –

from which new branches were ever springing

as society became complicated

and the new rights of its individuals clear.

I found it delightful

to climb those green heights,

to bathe in the clear waters of reason,

to use words for their daylight meaning

and not as prisms

playing with the rainbows of connotation:

…

the plain sunlight of the cases,

the sharp prose,

the forthright speech of the judges;

it was good, too, to stick my mind against the sentences of a judge,

and drag the meaning out of the shell of words.

(Poems 1918-1975 168-169)

The terseness and compression in Reznikoff's short early poems is achieved through the frequent use of parataxis, fashioned after haiku and old Chinese poetry. Two of his pre-war volumes are characteristically titled *Uriel Accosta: A Play & A Fourth Group of Verse* (1921) and *Five Groups of Verse* (1927), comprising numbered clusters of laconic poems. As only some of them have titles, they appear to be mutually related, building up and expanding the same motifs. Taken separately, they are sometimes labeled "*near*-poems, narrow misses"[1]. An analogical strategy, or principle, to write groups is evident in *Testimony* (1934). The juxtaposition of fragments, scenes or vignettes, sometimes apparently unrelated, forces the reader to consider the whole as a paratactic construction. The connection between the fragments is implied by the titles of the three thematically isolated groups (albeit there is no particular order or hierarchy within each one). In this sense *Testimony* (1934) is a literary collage, or a group of short (semi-poetic) documentary prose.

As the epigraph to *Testimony* (1934) is taken from St. Paul: "Let all bitterness, and wrath, and anger, and clamor, and railing, be put away from you, with all malice" (Ephesians 4: 31), the book allegedly aims to combine evidence with instruction, or better still – it instructs through the use of authentic materials. The very term "testimony" means, first and foremost, a declaration or statement made under oath or affirmation by a witness in a court – often in response to questioning – to establish a fact, but also the tablet bearing the Mosaic law, the Decalogue: "And the Lord spake unto Moses, saying: ... And thou shalt put into the ark the testimony which I shall give thee" (The Book of Exodus 25:16). On the threshold of the text of *Testimony* lies a paratextual note that reads: "I glanced through several hundred volumes of old cases – not a great many as law reports go – and found almost all that follows. C. R." Not only does the "Note" secure for the text a reading that is consistent with authorial intention, but, more importantly, it foregrounds the problem of links between the source document and literature, the boundaries dividing the real from the fictional, the invented and the relayed – or, perhaps, it simply annihilates such "impossible" (because always rough and liquid) distinctions. Although the original court transcript had been subject to Reznikoff's cuts and substantial re-wording, the final version of *Testimony* contains remnants of the witnesses' voices – they are printed in inverted commas which signal "the material residue of an oral record whose idiosyncratic diction and phraseology announce the presence of a historical witness" (Davidson 161).

1 See: Burton Hatlen's comment on Peter Quartermain's criticism concerning the Imagistic phase in Reznikoff's career, 152.

Creating such "found" literature that refurbishes and rearranges existing texts is the literary equivalent of a collage. In its pure form, it draws entirely on outside texts. Combining snippets that have been found together with original poetry can be seen in the works of Ezra Pound, T. S. Eliot, William Carlos Williams, Louis Zukofsky, Charles Olson, David Antin, Susan Howe and, of course, Charles Reznikoff. Among notable examples of twentieth-century found poetry is Charles Olson's "There was a Youth Whose Name was Thomas Granger" (1947) which makes use of a trial account of Thomas Granger, a teenager accused of numerous acts of copulation with animals who was executed in 1642, originally included in William Bradford's *History of Plymouth Plantation.* To a certain extent, the genre bears an inherent likeness to "ready mades" in sculpture or "pop art" images in painting or "sampling" in music – the idea behind such "creations" is to find (uncover) the poetic in the ordinary and the common. In its own way, *Testimony* resembles Muriel Rukeyser's "The Book of the Dead," a typical instance of literature directly addressing social and political issues of the time, and the centerpiece of her major volume *U.S. 1* (1938). The composition of this long collage poem was occasioned by the tragedy of workers employed in the operation of drilling a tunnel (directing water to a nearby hydroelectric plant) from Gauley's Junction to Hawk's Nest in Fayette County, West Virginia. As a huge deposit of exceptionally pure silica was discovered in the process, the tunneling construction was soon turned into a large–scale mining operation. In order to lower the costs, the contracting company had the workers drill the rock dry and did not provide any protective masks. As a result, up to 2,000 people died of silicosis. Drawing on her personal investigation of the survivors, her inspection of the site, and documentary material available, Rukeyser managed to create a poem that appropriated testimonies so as to become a borderline case study – a poetic discourse incorporating unaltered documents, a hybrid literary form ceaselessly oscillating between the lyrical and the mundane. It is hard to tell whether "The Book of the Dead" is mostly poetry that extends the document, or, perhaps, a document that unnecessarily "slides" into poetry.

III

Reznikoff's *Testimony* does not constitute a homogenous, stylistically consistent whole but oftentimes assumes forms that seem tinged with manifest literariness: poetic prose, micro stories, short narratives in the spirit of Hemingway's *In Our Time*, vignettes, or epistolary excerpts. The question whether in this particular case "literariness" is an inherent quality of the sources Reznikoff drew upon, or whether it is an outcome of the author's deliberate, desired editorial gestures is,

of course, an open one. As Reznikoff demonstrates, even one skillfully isolated sentence from a forensic report can lose its technical "dryness" and turn into the shortest, but at the same time one of the most powerful excerpts in the whole volume: "In gunshot wounds the edges are sunken; in wounds made with a knife the edges are smooth and the lips of the wounds stick out" (59). Some of the utterances made by witnesses begin to function as memorable adages: "Yes, all the world is folly and vanity" (17), "Are there no devils left in hell?" (9), and – taken separately – sound like a harsh judgment passed on America. The author's (if the term "author" applies here at all) strategy of serial writing forces the reader to make sense of a particular elemental story in a contextual relation to the preceding and/or the following one. The interpretation that consists in filling in the gaps of the text effects the formation of the reader's yarns that are spun simultaneously with Reznikoff's narratives, thus providing a much needed semantic complement. The often-quoted vignette featuring a mutilated and partly-devoured body on the side of a road is a case in point:

> The body was in a clump of post-oak bushes, ten or twelve feet from the road, the left foot over the right one. It was on its back. From the eyes down all the face was gone, the face bones were gone, and the brains had been eaten out of the skull by the hogs. The hogs were eating the body when it was found. There was plenty of blood under the head, in the clothes, and on the ground, but no other wounds on the body, except where the hogs had broken the skin of the fingers. (7)

The shocking description of the corpse is preceded by a short tale of two villains who, having brutally murdered the owner of a local shop, are detained, tried and sentenced to imprisonment. While in a cell, one of them experiences a disturbing vision in his dream: his hands are tied and aflame, and suddenly, as if out of nowhere, a leather-covered Bible appears, the pages of which also catch fire. For Michael Davidson (164), the mutual dependence between the two fragments can be explained in the following way:

> The "burning book" in Jim's dream refers both to biblical and legal forms of justice – the refining fire of God's vengeance against sinners and the purifying fire of blind justice. In the pages of both books, Jim is found guilty. The anonymous, half-eaten body found near the road must be contrasted to the religious and legal definitions of humanity as they come together in Jim's dream. By juxtaposing these two stories, Reznikoff seems to be showing victim and murderer in their primal moments of flesh and spirit – the body turned back into earth and the body dreaming of its transcendence. (164)

Arbitrary as Davidson's inscription of a "missing link" between Reznikoff's two fragments of laconic prose may seem to be, the creation of such an "extra yarn" is unavoidable in any act of interpretation of *Testimony*. The composition of the volume is founded on a principle (never overtly expressed by Reznikoff) of significant omissions. And an association with Hemingway's claim "that you could omit anything if you knew that you omitted and the omitted part would strengthen the story and make people feel something more than they understood" (6) is by no means far-fetched here. Both writers (who, at certain moments in their lives, worked as journalists) were favorably inclined towards understatement, and both avoided needless expenditure of language. The exclusion of superfluous and extraneous material in their writings possesses a meaning of its own.

In the context of the date of publication (1934), the fact that a series of meticulously selected testimonial fragments is topped with a group entitled "Depression" acquires a fundamental significance and transports the whole compilation to the plane of the contemporary times, the Depression era of the 1930s: business failures that pushed people to suicides, streets filled with the unemployed, humiliation and hopelessness. The group of "depression" fragments is concluded with the following static scene:

> As the case was turned over upon the wharf, a rattling was heard inside. The look-ing-glass was broken. The pieces were wedge-shaped; the cracks radiated from a center, as if the glass had been struck by a pointed instrument. (71)

As a result of a radical de-contextualization, the isolated vignette has no definite link to the legal documents the whole book draws upon and derives from. The reader is left in the dark as to who the case belongs to and who is responsible for the damage caused to the object. The implied "criminal" character of the seemingly banal discovery on the wharf remains unexplained. At the same time, however, Reznikoff seems to pack the case with symbolism (the "case" in its double sense as a container, or a chest, and as a matter undergoing official investigation) – the smooth wholeness of a mirror surface is smashed after a presumed act of violence. The panoramic view of law cases shows America shattered to pieces by the "pointed instrument" of violence, "the violence which punctuates every part of this book, the violence that undercuts American society as told in case after case after case after case" (Sweney 223).

IV

Apart from being a collage survey of the history of the United States prior to the Civil War, *Testimony* takes a most critical view of an economy and culture which is based on slavery (in different forms). The ramifications of such a system are seen in passages that sketch a plethora of evils that men can do (and in fact: did). Taken separately, the elements of *Testimony* sometimes make rather difficult reading as Reznikoff deleted historical and social background from the scenes being presented – juxtaposed and read as a series, they bring a powerful effect of condensed violence that explodes and rages on as if for no apparent reason. This strategy, however, is not to be understood as the author's perverse proclivity to derive pleasure from offering his readers a vision of a world that has gone mad; such a panorama of American life is by no means senseless, cheap pulp fiction, but an invitation to ethical reflection.

The formal bizarreness of *Testimony*, a work crossbreeding poetry and prose, literature and document, the objective account and (because of its careful editing) the subjective compilation thereof, was Reznikoff's tentative response to the rapidly changing world around him, a world he perceived as somehow fundamentally flawed: this slim volume expressed a distrust of the forces of unconstrained capitalism, surely, but at the same time it functioned (to a very limited degree) as a *Zeitgeist* barometer of modern(ist) literature, pointing to the insufficiency of the writer's creative language (which Reznikoff decided to supersede with quotations and reported speech). The formal decision to do so can been seen as almost inevitable: as Monique Claire Vescia claims, "the text [of *Testimony*] addresses a number of needs in American culture at that particular point in time, among them the necessity of creating an American history, and the related desire to establish a shared sense of community in the face of a disintegrating social order" (33). Thus the book demonstrated a set of overlapping issues: how to write of history, how to write of history so as to write of the present crisis, and how to find an appropriate (critical) language both for the former and the latter.

The analogy between Reznikoff's mode of composition and Cubism has been drawn by many critics (Vescia 36, Davidson 139, Bernstein 218), and as a proposed critical perspective it does hit the nail on the head. After all, the author himself, quoted by Kenneth Burke in the introduction to *Testimony*, stressed his intention to look at history "not from the standpoint of an individual, as in diaries, not merely from the angle of the unusual, as in newspapers, but from every standpoint – as many standpoints as were provided by the witnesses themselves" (xiii). As the Cubist painting challenges the flatness of the canvass and views the object being represented from myriad angles simultaneously, the combined

fragments of testimonial evidence seem to undermine the idea of one privileged framework of historical perspective. And this raises the issue of its objectivity.

Testimony is fundamentally informed by the paradox of its claimed veracity, which, in turn, constitutes a springboard for the question of the work's generic classification. Making use of firsthand and therefore purely subjective pieces of eyewitness accounts, the "almost" absent author builds up a "meta-account" that is expected to convey a certain truth of the time past. This effect of "objectifying the subjective" (Vescia 42) seems unavoidable. Any convincing documentary literature, Reznikoff implies, needs to be rooted in the authenticity of individual experience (i.e. "contaminated" by partiality). It is essential to note that the plurality of perspectives in *Testimony* is as debatable now as it was upon the volume's first publication (and, regrettably, the only one so far). In 1934, Kenneth Burke provocatively observed that, in fact, there is only *one* perspective in Reznikoff's work – the one of the law court (xv); the contemporary critic, Monique Claire Vescia, favors an even more radical assertion that the only standpoint is the one of the person who chose, edited and then arranged passages in a meaningful series – the author himself (43). Unwilling to side with either of the contentions, as they are too radical, I would venture the opinion that the uniqueness of *Testimony* as a project lies in its approximating "borderline" speech, which can be attributed fully neither to Reznikoff nor to the persons whose words were recorded in the form of legal documents.

In *Testimony*, Reznikoff's writing of the crisis testified to (or was correlated with) the crisis of writing: the book further weakened the already flimsy distinctions between the original and the derivative, the writer and the editor, the act of creation and the act of appropriation. His poetics of reported speech was by no means unprecedented; however, it was exceptional in its sheer radicalism. While, for instance, Pound, in *The Cantos*, incorporated historical documents ("the single greatest poetic innovation wrought by *The Cantos*," according to Michael Thurston, 137), thus blurring generic boundaries in his verse, Reznikoff's step went much further, to the extremity of turning the ancillary texts into the exclusive discourse of the work. A selection of testimonies to the pain suffered by black slaves, the humiliation experienced by mates on steamboats, tales of domestic violence and examples of deadly depression synechdochically embraced antebellum (and contemporary) America's social life.

V

According to Michael Davidson, as a writer drawing upon legal sources, Reznikoff was a "witness of witnesses" and one of his major accomplishments during the Depression era lay in the fact that by means of editorial work he managed to

create a "social narrative for acts of private observation" (151). Thus every record of individual suffering that was chosen acquired an additional meaning. The compilation and edition of documents became tantamount to frameworks of enabling empathy – or, in other words, the "witness of witnesses" simply made it possible to transfer private experience into the public domain. In a sense (and to a very limited extent), Reznikoff demonstrated how *identification* with local miseries could be instrumental in developing a national *identity*.

The decision to build a book on the foundation of authentic court depositions did not necessarily stem from Reznikoff's alleged conviction of history's "legal structure" (see Davidson's controversial claim, 151). But there is no doubt whatsoever that the choice of the source material must have appeared obvious as it was immediately available to a young lawyer and writer employed by the editorial board of *Corpus Juris*, an "encyclopedia of law for lawyers" (Hindus 250). While preparing entries, Reznikoff had to browse through huge volumes of testimonies published and distributed in the late nineteenth century within the National Reporter System. The amount of vice recorded there was overwhelming, and it was vice that became the diagnostic index of America's moral condition (both past and present). It is must be noted, however, that Reznikoff did not limit himself to seeking inspiration only in the context of jurisprudence – the poems from his 1936 volume *Separate Way*, for example, make use of such various inter-texts as *Mishnah*, Ilia Ehrenbourgh's *Civil War in Austria*, or Albert Bushnell Hart's anthology *American History Told by Contemporaries*.

In the editing process, the text acquires a different status and, from now on, displays a semantic richness that goes far beyond its significance as a legal document. In other words, the writer-editor's role comes down to recombining the original discourse so as to enable it to unveil its other potential. Thus, Reznikoff's testimony displays the so-far-hardly-visible in the original documents. Not only are American archives re-activated and pushed into circulation again, but the refined and shortened cases become more digestible to ordinary readers.

The fact that the name Charles Reznikoff features on the covers of *Testimony* as the author and *not* as the editor should by all means come under closer scrutiny. Genealogical investigation concerning the term "author" is, in the case of *Testimony*, quite revealing – as a professional lawyer, Reznikoff must have been familiar with its myriad meanings. Significantly, he re-gained for literature an ancient – and fundamental – bond between the terms "author" and "testimony." In ancient Roman law, the usage of the former applied to a codified way of making a transaction valid in a situation when it was to be concluded by a minor or a ward. The Latin word *auctor* denoted a guardian who, "acting on behalf," endowed his ward with legal capability. Thus, the formula *auctor fio* ("I ap-

prove") would officially transfer the "authority" to somebody who was not yet entitled to it. A legally incapable minor was allowed to enter into business undertakings only while acting *tutore auctore*. Apart from that, *auctor* was also the term used for describing an "advisor," a "vendor" as well as a person found guilty of instigating criminal deeds (i.e. one capable of ultimate persuasion); *auctoritas*, in turn, referred to moral authority or prestige (in this sense Roman legal and literary texts spoke of the "authority" of the people, the emperor, or of the law in general). Last but not least, in its earliest and most rudimentary ancient usage, *auctor* was simply a "witness" (Berger 368, Agamben 148-149). It is possible to identify a common root that aptly reconciles all these apparently diverse meanings. Each particular sense of the term *auctor* conveys the idea of a close relationship that occurs between two subjects, whereupon a certain action (be it a legal procedure, a transfer of property, or a decision to be made) of one is enabled, authenticated and legitimized by the other:

> If *testis* designates the witness insofar as he intervenes as a third in a suit between two subjects, and if *superstes* indicates one who has fully lived through an experience and can therefore relate it to others, *auctor* signifies the witness insofar as his testimony always presupposes something – a fact, a thing or a word – that preexists him and whose reality and force must be validated or certified. (...) Testimony is thus always an act of an "author": it always implies an essential duality in which an insufficiency or incapacity is completed or made valid. (Agamben 149-150)

The above-quoted recognition of the link between "author" and "testimony" ought, I think, to be employed in the context of testimonial literature. It must be remembered that the classical world did not know creation *ex nihilo* – the prerequisite for every act of creation was then the existence of some secondary material that needed restructuring and improvement. In its primal role, authorship was invariably referential and complementary: "every author [was] co-author" (Agamben 150). Resurrecting this ancient tradition, the author Reznikoff, the witness of witnesses, managed to complement the muteness of often anonymous and long forgotten victims whose fate he discovered in old – and theoretically useless – documents.

VI

From the very beginning of his long but not very spectacular literary career Reznikoff gave the impression of being a man who felt in exile to a foreign language. He never managed to learn Hebrew well, which gave him – a Jew – a "sense of spiritual disconnectedness" (Bernstein 228). As a writer, he was

forced to operate within the "foreign" linguistic context, i.e. English, and per-
haps that is why in major poetical works, or projects, *his* is the language of oth-
ers, *his* is merely reported speech. Thus, having reduced himself to the role of an
editor, he resorted to the words of others so as to convey his own devotion to
their fates – a somewhat peculiar yet fruitful mixture of estrangement and pas-
sion, and this more in human than artistic terms. His *Testimony* (1934) testifies
to the crisis in economic/social/political terms as well as – if only by implication
– to the crisis of writing as such. Granted, it is questionable whether the book
can be considered as "written," yet one thing is certain: in 1934, amidst the rap-
idly spreading paralysis of the Depression, Reznikoff turned the word "crisis"
against itself – the language of old, long forgotten legal documents became alive
and relevant *again* to witness the vices of the past and the present.

Works Cited

Agamben, Giorgio. *Remnants of Auschwitz. The Witness and the Archive*. Trans. Daniel
 Helier-Roazen. New York: Zone Books, 1999. Print.
Berger, Adolf. *Encyclopedic Dictionary of Roman Law*. Vol. 43, Part 2. 1953. Philadelphia:
 The American Philosophical Society, 1991. Print.
Bernstein, Charles. "Reznikoff's Nearness." *The Objectivist Nexus. Essays in Cultural Poet-
 ics*. Ed. Rachel Blau DuPlessis and Peter Quartermain. Tuscaloosa and London: The
 University of Alabama Press, 1999. 210-239. Print.
Burke. Kenneth. "A Matter of the Document." Charles Reznikoff. *Testimony*. New York: The
 Objectivist Press, 1934. Print.
Davidson, Michael. *Ghostlier Demarcations. Modern Poetry and the Material World*. Berke-
 ley and Los Angeles: University of California Press, 1997. Print.
Hatlen, Burton. "Objectivism in Context: Charles Reznikoff and Jewish-American
 Modernism." *Sagetrieb* Vol. 13, Spring and Fall 1&2 (1994): 147-168. Print.
Heller, Michael. *Conviction's Net of Branches. Essays on the Objectivist Poets and Poetry*.
 Carbondale and Edwardsville: Southern Illinois University, 1985. Print.
Hemingway, Ernest. *A Moveable Feast*. London: Arrow Books, 1996. Print.
Hindus, Milton. "Charles Reznikoff." *The "Other" New York Intellectuals*. Ed. Carole S.
 Kessner. New York and London: New York University Press, 1994. 247-267. Print.
Reznikoff, Charles. *Poems 1918-1975: The Complete Poems of Charles Reznikoff*. Ed. Sea-
 mus Cooney. Santa Rosa: Black Sparrow Press, 1996. Print.
Reznikoff, Charles. *Testimony*. New York: The Objectivist Press, 1934. Print.
Sweney, Matthew. "Deposition: The First *Testimony* (1934)." *Sagetrieb* 13.1&2 (Spring and
 Fall 1994): 217-223.
Thurston, Michael. *Making Something Happen. American Political Poetry Between the World
 Wars*. Chapel Hill & London: The University of Carolina Press, 2001. Print.
Vescia, Monique Claire. *Depression Glass. Documentary Photography and the Medium of the
 Camera Eye in Charles Reznikoff, George Oppen, and William Carlos Williams*. New
 York & London: Routledge, 2006. Print.

The Pale Horseman: Crisis in the Fiction of Katherine Anne Porter

Joseph Kuhn

"I can't live in their world any longer": Miranda Gay's protest at the end of *Old Mortality* (1937) against "the legend of the past" in post-Confederate Texas seems to circumscribe Katherine Anne Porter's imagination within the regional and the minor (*Collected* 230-231). It is indeed possible to see Miranda as an epigone of Quentin Compson, a female Quentin Compson who did the genteel thing and did not commit suicide. But to emphasize the regional in Porter's stories is to overlook what Robert Penn Warren called their projection against "the *chiaroscuro* of modern civilization," especially modern European civilization (14). From "The Fig Tree" (written in the 1920s) to *Pale Horse, Pale Rider* (1938), the Miranda stories can be arranged as a chronological series in the life of a young Texan in which the perspective of a global South, a South that was an extension of the crisis in interwar Europe, becomes more and more evident. Indeed the final work featuring Miranda, *Pale Horse, Pale Rider*, shifts into a virtually cosmological setting in the opening section when Miranda dreams that it is the pale horseman of the *Book of Revelation* (chapter 6) who brings the influenza epidemic of 1918 to the United States.

It is evident that Porter's fiction, with its neo-Agrarian affiliations, moves outward to incorporate what T.S. Eliot, the mentor of many in the Nashville group, called "the mind of Europe" (16). For Porter, this "mind" manifests itself as a stylistic principle as much as anything else. In stories such as "Noon Wine" (1937) the neo-classical rigour and discrimination of Porter's language displays a need to objectify southern experience and submit it to European standards of universality and external judgment.[1] Porter's final major work, *Ship of Fools* (1962), acts out this return to the European center in that members of the German diaspora in Mexico travel by the ship *Vera* to late Weimar Germany. But the narrowing *völkisch* sentiment among the passengers on the vessel shows that any reference by Porter to the "mind of Europe" as a restorative order had also to be, in the actual conditions of the early 1930s, an acknowledgment of the contemporary disintegration of that order. The novel intimates that with the post-Versailles breakdown of the nineteenth-century *jus publicum Europaeum* the possibility of the biopolitical state opens out (some of the German passengers,

1 In "'Noon Wine': The Sources" Porter says that "my South" fell back "into right perspective" with her stay in Europe between 1931 and 1936 (Porter *Collected* 721-722).

for example Herr Rieber and Frau Rittersdorf, raise the possibility of the culling of so-called unneeded lives).[2] Porter takes the ship into the very heart of the disintegration, the Weimar republic in the last year and a half of its existence, and thereby heightens the ironic gap between the pilgrim-like implications of the name *Vera* (Truth) and the ship's final harbour in what will shortly become the Third Reich.

This arc of a return to a Europe in crisis is central to "The Leaning Tower" (1941), the predecessor of *Ship of Fools*. Charles Upton, an American painter, arrives in the Berlin of late 1931 and witnesses on the bitterly cold streets a procession of the emaciated, the war-wounded, the unemployed and prostitutes, each profile giving expressionistic witness to a "darkness" that was "pre-human" (Porter *Collected* 472). By the conclusion of the story the memory of the *jus publicum Europaeum* remains only in the broken souvenir of the tower of Pisa that Charles's landlady keeps in her glass cabinet, an index of her querulous bourgeois longings for pre-war prosperity. This miniature tower shows that in this new Berlin even symbols are no longer symbols. They have suffered a loss of aesthetic dignity and turned into mere private tokens: the frail plaster ribs of Frau Reichl's holiday trinket can hardly carry the symbolic weight of old Europe.

Porter herself made the voyage from Mexico to Berlin in the summer of 1931 and it was there that she recommenced work on *Pale Horse, Pale Rider*, a work that she completed in New Orleans in 1937.[3] Her visit to Berlin helped to turn this work from an autobiographical fragment concerning her own survival of the 1918 influenza epidemic into a narrative that concentrated on symbolic aspects of the interwar crisis, both in Europe and in the United States. The chiliastic iconography that was often used to express this crisis is evident in the opening dream sequence in which Miranda—who already has the flu virus although she is not aware of it—imagines she is being pursued by the fourth horseman of the Book of Revelation. The most significant source for this section and its graphic power is Albrecht Dürer's etching of "The Four Horsemen of the Apocalypse" (1498). It was Dürer of whom Porter said that "I have his view of

2 Porter's work therefore can be said to witness that post-Versailles moment when "land, order and birth" no longer have a determining role in the *nomos* of the modern nation state and this state "decides to assume directly the care of the nation's biological life as one of its proper tasks" (Agamben *Homo Sacer* 175).

3 In a letter of December 3 1937 Porter says that she began the novel in Mexico and went on with it in Berlin and Basel (*Letters* 154).

the Apocalypse, and it is mine" (*Collected* 692).[4] It was also Dürer who was revived among the philosophers, theologians and feuilletonists during the crisis in the years following 1918 (in Germany just after the First World War a sense of crisis pervaded many disciplines, including those of history, theology and science).

In the *Book of Revelation* there is a battle between the forces of the *Imperator* Christ, including his servants, the four horsemen, and the earthly imperium of Rome, the early persecutor of Christianity. In using the symbol of the horseman, Porter, a radical libertarian, is suggesting that the Rome-like structures of power in the contemporary world have become too strong and that they need to be undone. She summons what Jacob Taubes was to call an apocalypticism "from below" to delegitimate these structures (Taubes *Political* 142). This apocalypticism is appropriate to *Pale Horse, Pale Rider* because Porter saw the strength of executive power growing in the United States in the last years of the First World War. The passing of the Espionage Act (1917) and the Sedition Act (1918) made any criticism of the government a criminal offence. Miranda lives in "fear and suspicion" of the impersonal, accusatory eyes that gaze over her (*Collected* 307). She cannot even begin to voice her pacifist principles ("Suppose I were not a coward, but said what I really thought? Suppose I said to hell with this filthy war?") because this could lead to her prosecution under emergency wartime legislation and her possible imprisonment (*Collected* 285).

In her dream the horseman rides past Miranda and later she pulls through her near-fatal infection. In the final paragraph of the novel, when she leaves the hospital, she inherits the "dazed silence" of post-Armistice America, its "noiseless houses," "empty streets," and the "dead cold light of tomorrow" (*Collected* 330). She apparently returns to the security of an eventless linear time, but now her dulled belief that there is no crisis is itself the crisis. The pale horseman has not so much gone away as been forgotten.

The implication for the post-Armistice Miranda is that the crisis that Porter traces back to the last months of the First World War will be a continuing, if sometimes muffled, presence in the ensuing two decades. In 1940 Porter wrote to Robert Penn Warren: "Do you remember, Red, I told you in New Orleans in 1937 that [*Pale Horse, Pale Rider*] really was a parable of Fascism? Now it is grisly, re-reading a prophecy begun nine years ago in the very middle of its fulfilment" (*Guide*). Porter could with some justification point to a certain prescience in her short novel. At the beginning of the narrative the two Lusk Commit-

4 Some details of Porter's account, such as the "shabby" garments that flap upon the rider's "bones," are taken from the Dürer picture rather than the stark account of the horseman in the Bible (*Collected* 282).

teemen who try to coerce Miranda into buying a Liberty Bond testify to a shift from a liberal, civic America to a nation having more in common with the totalitarian societies that were to come into prominence in interwar Europe (Porter prompts the reader by giving the younger man "a square little mustache") (*Collected* 283).[5] Miranda's feeling that she is one of countless "speechless animals" letting themselves "be destroyed" comes close to Hannah Arendt's insight that the aim of such societies was to create the "superfluous" person, and the nondescript government agents themselves demonstrate what Arendt called "radical" evil because they simply carry out a function in a total system and therefore seem outside of evil as it has been traditionally conceived as an act of will (Porter, *Collected* 304) (Arendt, *Origins* 457, 459).

It is appropriate that in *Pale Horse, Pale Rider* Porter should signal the coming of the biopolitical state by presenting crisis through the biological trope of illness. Her use of this trope shows an awareness of etymon. Miranda's illness reaches back to the ancient Greek etymological roots of the word crisis as a separation or division. There were two different Greek developments out of this initial sense of a dividing of parts or the application of judgement. In one development, that of Galenic medicine, the word crisis was applied to the turning point of an illness: this sense points to Miranda's suspension in her sickness between the two worlds of life and death. In another development of the word crisis, that of the Septuagint or the Greek translation of the Bible, it came to be applied to the expectation of the Last Judgment (Kosselleck 357-360). The infected Miranda's confrontation with the apocalypticpale horseman, who in some translations of *Revelation* 6: 8 brings pestilence or plague, joins the biological and the eschatological fields of association together.

It is the religious meaning of crisis that has a decisive creative force. Although many of the writings on crisis in immediate post-war Europe were epistemological in nature—Paul Valéry in "The Crisis of the Mind" and Ernst Troeltsch in "The Crisis of Historicism" argued that the mind could no longer rely on progressive models of philosophy or history but was thrown back on its own finitude and relativism—Porter suggests an even more radical crisis or separation than that apparent in current ways of knowing. Hers is a separation between the mundane and spiritual orders, and its name is Apocalypse. The phantasmagoric imagery of the "lank greenish stranger" from the Book of Revelation who pursues Miranda on horseback serves to quicken and contract the time of "indifferent happening" and to place it in relation to an eternal truth (Taubes *Occidental* 5).

5 Incidents of workers being forced to buy Liberty Bonds by fellow employees were common in 1918 (*Capozolla* 10).

That a religious language of crisis should be used to ground a political crisis is to make use of the Weimar idiom of political theology. In this sense *Pale Horse, Pale Rider* can be seen as a prelude to *Ship of Fools.* The Weimar focus of the summer of 1931 in that novel, which Porter regarded as the summation of her writing, throws a retrospective perspective on her preceding work and suggests that Porter's idea of crisis needs to be given a stricter legal definition through the Weimar discourse of the state of exception. When Porter uses the phrase "a state of emergency" to describe the duties of Captain Thiele on the *Vera* in 1931 she is referring quite specifically to Article 48 of the Weimar constitution, which allowed for the President and the Chancellor to suspend the law in unusual circumstances and to rule without legislative support (Porter, *Ship* 104). As the Weimar jurist Carl Schmitt put it: "Sovereign is he who decides on the exception" (5). It might be thought that Porter could not have had this degree of familiarity with this Weimar constititutional law, but closer inspection reveals the pertinence of Article 48 to the whole allegorical conception of the *Vera* as the Weimar ship of state (an allegorical topos that goes back to Plato's *Republic*).When, in the central episode of the book, Captain Thiele banishes Wilhelm Freytag from the captain's table because the Captain finds out that this blond German is married to a Jew, he effectively excercizes a sovereign decision which suspends the law. Freytag must join the Jew Herr Löwenthal at a distant table, contained within the space of the state but under a ban and under the aspect of an inclusive exclusion. The episode is pointedly called "the Freytag crisis" (Porter, *Ship* 244). In this state of exception on the Weimar ship of state in late 1931, the law steps outside the law while still being law and therefore provides an inadvertent legal bridge to Nazi dictatorship, which might be described as a continuous state of exception. This is why *Ship of Fools* is, as critics widely recognize, a prophecy of the Third Reich. But it is worth emphasizing that the action of the novel takes place at the end of the Weimar republic, a time when there was a balance of possibilities in the resolution of crisis.

The Weimar jurists, according to Giorgio Agamben, did not invent the juridical state of exception, whose origins lie rather in the first French Republic and in the United States (Agamben sees precedents in Lincoln's extra-legal decrees during the Civil War). In *Pale Horse, Pale Rider* Porter depicts a society, the America of 1918, that was experiencing the predominance of the state of exception in all but name. In the case of President Wilson's government, the encroachment of sovereignty was supported by a willing legislature and by a culture of coercive voluntarism. But even so, according to Agamben, the United States during World War I became "a laboratory for testing and honing the functional mechanisms and apparatuses of the state of exception as a paradigm of government" (*State* 7). There is no Captain Thiele figure in *Pale Horse, Pale*

Rider: instead of a direct portrayal of modern sovereignty Porter displays its effects in the gathering cumulus of "fear and suspicion" that Miranda experiences (*Collected* 307). What is claustrophobic about the scene of *Pale Horse, Pale Rider* is that Miranda no longer has entry into the public or political realm, but she has been forced into a closed domain of private reflection. To use the Greek distinctions of Hannah Arendt in *The Human Condition*, Miranda belongs only to the natural, apolitical realm of the household or of repetitive labor and this realm is to be distinguished from the public space of the *polis* in which one participates by speech and action (119).When the Liberty Bond salesman in the theatre gives his speech, Miranda can only protest silently: "Coal, oil, iron, gold, international finance, why don't you tell us about them, you little liar?" (*Collected* 306). This inward turn explains why Adam and Miranda's romance has such an air of temporal unreality: both are suspended in the "dream of time" suggested by their prelapsarian names and in this bubble they lack the "tough filaments of memory and hope" needed as coordinates for a properly historical way of existing in the present (*Collected* 317).

In her work, Porter is attuned not only to the modern state of exception but also to an abandoned form of biological being that is indissociable from it and created by it. She has a creative instinct for honing in upon characters who can stand for nothing more than their natural life. These figures range from the Mexican Indians bent to the ground in "The Fiesta of Guadalupe" (1920) and "Hacienda" (1934) to the mute subnormal protagonists of "He" (1927) and "Holiday" (1960). One senses the working of this instinct in *Pale Horse, Pale Rider* when Miranda survives her ordeal to hear "ragged tuneless old women" in another ward greeting the Armistice by singing "My country, 'tis of thee" (*Collected* 326). Such hapless and sometimes appallingly stricken figures are brought into focus with the creation of the modern *polis*. In *Ship of Fools* the Captain's exercise of the exception in the "Freytag crisis" is correlated with the emergence under ban of such characters as Herr Glocken the hunchback and Herr Löwenthal the Jew, who can own nothing but their naked biological selves. Giorgio Agamben has argued in a series of studies that what modern sovereignty produces as the object of its rule is the exposed self that he calls *homo sacer*. Such a person simply embodies bare or natural life, the animal life that the Greeks called *zoē* and which they distinguished from the structured human form of life called *bios*.[6] Agamben names this self *homo sacer* after an ancient Roman legal term that

6 The ancient distinction between life as a structured story (*bios*) and life as unbounded material (*zoē*) appears in Hannah Arendt's *The Human Condition*, a major influence on Agamben. The early Greeks excluded *zoē* from politics but, for Agamben, the "decisive event of modernity" is that *zoē* should be politicized and included by non-inclusion in the totality of the political (*Homo Sacer* 4).

designates a person who is exiled from the public community and who may be killed without any legal consequences. This person is therefore *sacer* (sacred) because he is polluted and has nothing in common with the profane world of men, but the Roman definition adds that this *homo sacer* may not be killed as part of a sacrifice (in this he is unlike a sacred animal, which is made sacred by being separated from the common world and consigned to the gods by its death). Such a person therefore falls outside both human and divine law and, for Agamben, it is exactly this ancient form of *homo sacer* that continues in modern sovereignty, whose aim is to produce bare life as its object.

Throughout *Pale Horse, Pale Rider* Miranda feels that she and others are being pushed into a shadowy, voiceless realm of bare life and therefore qualify as examples of *homo sacer*. Observing a theatre audience, for example, she says: "we are speechless animals letting ourselves be destroyed, and why?" (*Collected* 304).[7] In her feverish visions during her illness at the hospital Miranda's sense of being a merely supplementary life allows for an identification with more public victims of future totalitarian states. She imagines a fog that conceals "all terror and all weariness," including the contorted bodies of "abused, outraged living things." The fog then divides to reveal "two executioners, white clad" who are pushing a "misshapen" old man toward her. The man protests that he is "not guilty" but he is swept onward to his fate (*Collected* 321).[8] Obviously this incident is a "prophecy of Fascism" in showing the sovereign right to kill *homo sacer* outside of law.

There is, however, an exception to the prevalence of the figure of *homo sacer* in the novel. Adam Barclay, the soldier with whom Miranda is in love, is perhaps to be considered not as this kind of figure but as a sacrificial victim of the order of the lamb or a Dionysius; that is to say, he belongs not to historical time but to that of myth and repetition. In one of Miranda's influenza dreams he

7 Agamben deliberately separates the legal sense from the religious meaning of the word sacred, although both carry the implication of separateness from the ordinary case. In Agamben's legal definition "sacredness" is the "originary form of the inclusion of bare life in the juridical order" (*Homo Sacer* 85).

8 The old man's plea that "the crime of which he was accused did not merit the punishment he was about to receive" shows that he is an example of what Hannah Arendt, in her study of totalitarianism, called the "superfluous" man, a figure on which Agamben partly modelled *homo sacer* (*Porter Collected* 321). The juridical connection between legal offence and punishment has been severed in the case of the superfluous man, as is shown most paradigmatically in the concentration camps. It is significant that the two executioners are doctors. In the "integration of medicine and politics," Agamben says, "the sovereign decision on bare life comes to be displaced from strictly political motivations and areas to a more ambiguous terrain in which the physician and the sovereign seem to exchange roles" (*Homo Sacer* 143).

appears as a Saint Sebastian figure who survives every arrow and stands before her "untouched in a perpetual death and resurrection" (*Collected* 317). Miranda thinks of him as "Pure . . . all the way through, flawless, complete, as the sacrificial lamb must be" (*Collected* 307). But her relationship with Adam belongs not so much to historical time as it does to a bubble of being that is outside of the temporal. When Miranda shifts her thought about the relationship into historical time she has to face the "awful knowledge that there was nothing at all ahead for Adam and for her" (*Collected* 303). Adam is "beyond experience already, committed without any knowledge or act of his own to death"(*Collected* 296).

Miranda's emotions are caught up in historical time and its transformations. What Porter's symbol of the plague so astutely recognizes is that modern sovereignty creates the biopolitical subject: the person who willy-nilly belongs to an organism and who communicates with other parts of that organism through infectability rather than properly authored speech (Miranda ultimately brings Adam not love but the mortal infection of the virus). At various places in the novel Miranda realizes that she is held hostage by her very corporeality, as when she reflects just after her ordeal: "The body is a curious monster, no place to live in" (*Collected* 326). Most telling is that turning point of her illness in which she dreams of contracting into a "fiercely burning particle of being" (*Collected* 323). But what Porter calls this elementary particle's "stubborn will to live," its desire to expand in "its own madness of being," is not auspicious, and this is exactly because of the particle's restriction to *zoē*, to immanent and bare life. Miranda just survives her illness as this "particle," but the dawn that greets her as she leaves hospital is "the dead cold light of tomorrow" in which "there would be time for everything" (*Collected* 330). It is a return to the homogenous time of the indifferent happening.

Can the naturalistic outlook and the promise of a demythologized southern future found at the end of such Miranda stories as *Old Mortality* and "The Grave" (1935) be seen differently in the light of the ambiguous inheritance of life at the end of *Pale Horse, Pale Rider*? In "The Grave," for example, the nine-year-old Miranda sees the opened womb of a mother rabbit shot by her brother and is obscurely stirred by the sight of the unborn rabbits. This image combines birth and death as a single naturalistic continuum and, in the dialectic of Miranda's education, it replaces the Neo-Confederate memorials of the ring and the coffin nail which Miranda and her brother had earlier retrieved from the open graves at the cemetery and which now become mere archeological emblems of marriage and mortality. But the image of the rabbit fetuses makes Miranda "terribly agitated," perhaps because the image of bare existence contained in them is not a promising analogue for the human (*Collected* 380). This is why in the coda of "The Grave," which takes place twenty years later, Porter brings up another

of her figures of *homo sacer*, a Mexican vendor of sugar rabbits, who is display-
ing his wares in a fetid market. He causes Miranda to recall the "bloody" image
of the rabbit fetuses from her childhood and to be "reasonlessly horrified" as
a result (*Collected* 380).

In *Pale Horse, Pale Rider* Miranda's relationship to the bare life within her
partakes of the post-war crisis of language. In the Aristotelian paradigm of the
classical *polis* the citizen enters this public space by passing from animal voice
to *logos*. But in the modern *polis* that Miranda inhabits, this is not so much
a passage as an experience of the threshold, an incomplete emergence. In one of
the early dreams of her fever Miranda imagines herself sailing through a jungle
in a ship and she can barely hold herself distinct from the clinging animal nois-
es. Only "two words" pass over the threshold that separates this animal "bellow
of voices" from articulations of the *logos*: "danger" and "war" (these words
alone now make political man) (*Collected* 312). Later, in the hospital, Miranda's
unconscious speech during her fever emerges as "babbling nonsense," including
the Billy Sunday-like babble that turns her kind German doctor Hildesheim into
a "Hun" and infant murderer (*Collected* 319, 322). Her speech takes to an ex-
treme the fate of the word in the new *polis*, which becomes cut off from subjec-
tive intention and can be released as empty ideological ciphers. Indeed this pro-
cess of the hollowing out of the word under conditions of bare life gives rise in
the novel to a thanatopolitics of language. Through the whiteness of the signs in
Miranda's consciousness—the white walls and white lamps of the hospital cor-
ridor, the "blank, still stare of mindless malice" of the "pale" horseman, and the
"empty streets" of the post-Armistice world—death as the final signified or nul-
lity shines through the sign, threatening to breach the act of representation ("soft
carefully shaped words like oblivion and eternity are curtains hung before noth-
ing at all," thinks Miranda) (*Collected* 282, 330, 323).

In conclusion, Porter's fiction, especially *Pale Horse, Pale Rider*, dramatiz-
es the crisis of the late 1910s and the 1920s in its two associated forms of the
state of exception and bare life, the forms represented respectively by the intru-
sive Lusk Committeemen and by Miranda or the man in the wheelchair. The
presence of the pale horseman from the *Book of Revelation* in the prologue gives
a tone of religious horror to the rest of the novel which it is difficult to account
for. This is where Agamben's model of *homo sacer* becomes relevant because
this approach uses the sacred to analyze what it is in the modern *polis* that goes
beyond the threshold of the normal. Porter was well aware of how the two posi-
tions of sovereign and *homo sacer*, by being suspended outside of usual law,
give the character of the political sacred to the modern *polis*. Indeed in "On
a Criticism of Thomas Hardy" (1940) she comes surprisingly close to the princi-
pal theorist of the exception, the conservative Carl Schmitt, who had argued that

the authority of the modern sovereign was founded on a deeper theological analogy with that of God. Porter writes similarly that the "idea of God" "has been harnessed rudely to machinery of the most mundane sort [of government]" (*Collected* 600). But for her, as distinct from Schmitt, this meant that a church of "dissent" had to counter this line of command from beneath (*Collected* 598). The appearance of the horseman in *Pale Horse, Pale Rider* is an attempt to overpower the modern *polis*, and its underpinnings in the political sacred, through apocalyptic intervention.

By the end of the novel, the apparent threat of the horseman recedes. Miranda's final escape from the plague had already been predicted in the prologue of the novel when the pale rider rides indifferently past Miranda. But the horseman has only temporarily been forgotten and his "malice" can "bide its time" (*Collected* 282). Porter's work such as *Ship of Fools* and "Noon Wine" sets out to question the complicity in this post-Armistice forgetting and to probe the new moralities that are consequent upon the introduction of the "state of exception" as a form of government. This hard, ethical orientation of Porter's work—which is at the core of her last major work, *Ship of Fools*, and of such classic stories as "Noon Wine"—keeps returning to the question that came to the fore when Porter was in Berlin in 1931: how is it possible for good citizens to so readily adapt themselves to political evil?

Works Cited

Agamben, Giorgio. *Homo Sacer: Sovereign Power and Bare Life*. Trans. Daniel Heller-Roazen. Stanford: Stanford University Press, 1998. Print.

---. *State of Exception*. Trans. Kevin Attell. Chicago: University of Chicago Press, 2005. Print.

Arendt, Hannah. *The Human Condition*. Chicago: University of Chicago Press, 1998. Print.

---. *The Origins of Totalitarianism*. Second Edition. Cleveland: World Publishing Company, 1958. Print.

Capozolla, Christopher. *Uncle Sam Wants You: World War I and the Making of the Modern American Citizen*. Oxford: Oxford University Press, 2008. Print.

Eliot, T.S. *Selected Essays*. London: Faber and Faber, 1951. Print.

Guide to the Robert Penn Warren Papers. Yale University Library. n.d. Web. 4 October 2013.

Kosselleck, Reinhart. "Crisis." *Journal of the History of Ideas* (2006): 357-400. Print.

Porter, Katherine Anne. *Collected Stories and Other Writings*. New York: Library of America, 2008. Print.

---. *Letters of Katherine Anne Porter*. Ed. Isabel Bayley. New York: Atlantic Monthly Press, 1990. Print.

---. *Ship of Fools*. Boston: Little, Brown, 1962. Print.

Schmitt, Carl. *Political Theology: Four Chapters on the Concept of Sovereignty.* Trans. George Schwab. Cambridge, Mass.: MIT Press, 1985. Print.

Taubes, Jacob. *Occidental Eschatology.* Trans. David Ratmoko. Stanford: Stanford University Press, 2009. Print.

---. *The Political Theology of Paul.* Ed. Jan Assmann Aleida Assmann. Trans. Dana Hollander. Stanford: Stanford University Press, 2004. Print.

Warren, Robert Penn. *Selected Essays.* New York: Vintage Books, n.d. Print.

Warren, Robert Penn, ed. *Katherine Anne Porter. A Collection of Critical Essays.* Englewood Cliffs, N.J.: Prentice-Hall, 1979. Print.

Indigestible America and the Crisis of Multiculturalism in Aleksandar Hemon's Fiction

Marta Koval

Although multiculturalism has been one of America's successful ideological banners, ethnicity remains an issue of political and cultural debate. Every decade opens a new facet of the problem and reveals new cultural "traps," as in the American context the problem of ethnicity implies the problem of American identity. Werner Sollors suggests that the latter, as the central drama in American culture, should be viewed in terms of ethnicity-oriented consent and descent. He believes that these notions can be used to describe in the most neutral way cultural conflicts that "can tell us much about the creation of an American culture out of diverse pre-American pasts" (*Beyond Ethnicity* 6). Works of ethnic or immigrant literatures, Sollors continues, explain much about how Americanness is perceived by strangers and newcomers. They can be read not only as an expression of intercultural communication, but "also as handbooks of socialization into the codes of Americanness" (7), even though the latter concept is open to diverse interpretations.

Ethnic and immigrant experience remains a very broad topic, which this paper does not aim to discuss. Instead, it will focus on mental and emotional constructions that new immigrant writers create in a situation when the New World is no longer that new and the language of consent is challenged less by cultural distinctions based on "ethnic insiderism" (Sollors's term) and more by a sense of nostalgia and displacement that is not necessarily determined by descent and ethnic otherness, but seems to be universal and for diverse reasons incurable.

Aleksandar Hemon, an American writer of Bosnian-Ukrainian descent who lives in the States and writes both in Serbian and English, introduced the Yugoslav theme into recent American fiction. His short stories and particularly his novels are characterized by a dual Bosnian-American perspective, which may be described as typical for immigrant fiction. They are also marked by despair and an increasing sense of irreversible loss that the so-called American dream fails to reimburse. If we look at Hemon's writing retrospectively, we will see that its American component has become more expressive and narratively more significant whereas the Bosnian (or even broader – European) component/ has acquired distinct nostalgic features. For the characters of Hemon's novels, the American world generates a specific "grammar of home" with a clear opposition of "here" and "there" which have almost no chance to blur. The image of Sarajevo invoked in dreams and memories expands the semantics of "home" and its

boundaries by means of political and cultural elements. Mnemonic images shape a mental landscape where nostalgia, despair and a non-acceptance of Americanness intertwine and constitute a reality of its own.

Nowhere Man (2002) and *The Lazarus Project* (2008) feature new immigrants from Bosnia who escaped from their home country because of the Yugoslav war (or before it) and found themselves stranded in the United States. Their direct or indirect experience of the war serves as a distinctive feature of their otherness and accounts both for their nostalgic mood mixed with a sense of guilt and a subsequent inability to adjust to American life. In this experiential frame, ethnicity loses much of its significance. For Hemon's characters, the idea of home has an ambiguous meaning – while their actual (physical) home is in Chicago, Sarajevo is the place where they *feel* at home or at least they *want to believe* so. That image of their emotional home, now remote in terms of distance and time and based on the contrast with actual life, is structured by their tender memories, whereas the image of their American home is determined by a sense of alienation and temporariness.

The title *Nowhere Man*, which in the context of the novel speaks for itself derives from the Beatles' song which the protagonist Jozef Pronek and his friends admired and sang when they were younger: "He's a real Nowhere Man,/Sitting in his Nowhere Land,/Making all his nowhere plans for nobody." The inability to make sense of his American life and its permanent emotional and mental comparison with his former life in Sarajevo turned Jozef himself into a Nowhere Man. When Sarajevo and the past come up as a memory or a night dream, the sense of inner comfort is regained. This novel, as well as *The Lazarus Project* published a few years later, represents what Svetlana Boym in her analysis of different modes of nostalgia identifies as reflective nostalgia (as opposed to restructive nostalgia). It is concerned with the "irrevocability of the past and human finitude. *Re-flection* suggests new flexibility, not the reestablishment of stasis. The focus here is not on recovery of what is perceived to be an absolute truth but on the meditation on history and passage of time" (49). According to Boym, longing (*algia*) is the essence of this mode of nostalgia, and for the protagonist of *Nowhere Man* it determines his mental and emotional attitudes.

Jozef Pronek lives in the States but his home is still in the Sarajevo of the past. The past is a tentative grid of happenings and minor details that emerge from time to time in his mind in the most unexpected circumstances: the narrator remembers his childhood family trip to Goražde and a summer teenage romance with a girl from Goražde because a woman on the metro is reading a newspaper article about the collapse of defenses in Goražde and a newspaper with the same title lies on a pile of newspapers in the ESL school. Narratives of the kaleido-

scopic Bosnian past are structured by the character's memories, which infiltrate and modify his perception of the American reality. The latter is dull and emotionless and focused only on the material side of life, whereas stories of the past are rendered through colors, sounds, and movements which are graphic, distinct, and idealistic:

> Sarajevo in the eighties was a beautiful place to be young – I know because I was young then. I remember linden trees blooming as if they were never to bloom again, producing a smell I can feel in my nostrils now. The boys were handsome, the girls beautiful, the sports teams successful, the bands good, the streets felt as soft as a Persian carpet, and the Winter Olympics made everyone feel that we were at the center of the world. I remember the smell of apartment-building basements where I was making out with my date, the eye of the light switch glaring at us from the darkness. (*Nowhere Man* 49)

Full-fledged and emotional descriptions of Sarajevo feel even more so because the American cityscapes and human relationships that Hemon makes his protagonist experience invoke an aesthetic aversion because of their internal and external ugliness, meaninglessness and dullness. As Hemon's essays collected in the 2013 volume show, it is a deliberate authorial policy aimed, as we may presume, to show extreme cases of "America's indigestion" that paradoxically is both tragic and funny.

For Pronek, happy moments of the past converge with the place where the past "took place." Thus for him nostalgia means not only longing for the abandoned country. Rather it is a "yearning for a different time – the time of our childhood, the slower rhythms of our dreams. . . . The nostalgic desires to obliterate history and turn it into private or collective mythology, to revisit time like space, refusing to surrender to the irreversibility of time that plagues the human condition" (Boym xv). Pronek's memories are full of apparently insignificant details that emphasize the significance of the local and personal as opposed to the global and universal that America stereotypically tends to embody. These details are not only the expression of local longing, but also a "result of a new understanding of time and space that made the division into 'local' and 'universal' possible" (Boym 11). Notably, Pronek is hardly aware of this. Rather he is made to experience time and space in a new way and "has internalized this division, but instead of aspiring for the universal and the progressive he looks backward and yearns for the particular" (11). The inability or unwillingness to embrace his new American life with its seemingly more global concerns and responsibilities, even if expressed on a provincial scale, will be articulated even more clearly in *The Lazarus Project*.

The "indigestion" of Americanness has explicit cultural reasons (as is typical for ethnic immigrant fiction), but in Hemon's novel cultural background is defined less by ethnic otherness and more by a sense of nostalgic displacement. When Boym speaks about the significance of cultural experience which shapes a sense of nostalgia and adds a cultural tone to it, she emphasizes that

> [c]ulture is not foreign to human nature but integral to it; after all, culture provides a context where relationships do not always develop by continuity but by contiguity. Perhaps what is most missed during historical cataclysms and exile is not the past and the homeland exactly, but rather this potential space of cultural experience that one has shared with one's friends and compatriots that is based neither on nation nor religion but on elective affinities. (Boym 53)

For Hemon's characters, such a lack of shared "space of cultural experience" creates the atmosphere of inner alienation which makes them plunge into memories and dreams about their native country. It would have been a typical flight from the painful reality but for the fact that the abandoned land was war-torn Yugoslavia. Immigration let Hemon's characters escape the tragic lot of many of their relatives and friends but that did not in any way prevent a sense of loss or make the past less attractive.

The image of Sarajevo produced in American memories of Hemon's characters not only expands the semantics of "home," but also reveals the crisis of American multiculturalism as an ideology and practice. Consent is made problematic not only because of ethnic otherness which often becomes the subject of irony, but because of the differences in pre-American experience. In both *Nowhere Man* and *The Lazarus Project* this experience is explicitly shaped by the recent Yugoslav war. There is a strong sense of guilt that infiltrates Pronek's memories of Sarajevo, his family, and the recent past: the guilt for abandoning his elderly parents, fleeing the country at a time of ethnic unrest and simply not being in the city during the siege. On the one hand, the sense of guilt balances the emotional burden of nostalgia and deprives it of an idyllic flavor. On the other, it deepens the sense of loss and exclusion from the space of shared experience: "I look up and I see the plane disappearing into the clouds. Pronek takes the last look at the city sprawling in the valley, as if kissing a dead person, the fog creeping along between buildings" (*Nowhere Man* 72). Many episodes fromthe past that he remembers are narrated in the Present Simple. In this way grammar serves to create a deceptive closeness of the past, bringing it into the present. However, not all memories of the past are welcome as a shaping force of the present. Many beautiful moments from the previous life would clash

against the reality of the war: Sabina, Josef's tender and greatest love, lost both her legs in a breadline shelling. She was on the TV news, "lying in the middle of the mayhem, her husband pressing his torn shirt against her blood-spurting stumps" (*Nowhere Man* 55). Pronek, who still remembers the lemon-and-milk scent of her skin, her eyes, their awkward dates at the *Nostalgija* café-bar and their night walks, cannot accommodate the horror of her mutilation in his mind. It simply does not fit in the homely image of the Sarajevo of his memories.

For Pronek (and the characters of *The Lazarus Project*) nostalgia and the memories it invokes create a sense of displacement. As Jozef puts it, "there was nowhere he wanted to be" (*Nowhere Man* 219). The writer offers no remedy for such painful feelings, but at a certain point in the story the reader realizes that the nameless narrator who was telling part of Pronek's earlier story was Pronek himself – not the one who was seized by despair, home-sickness and mental displacement, but the American Jozef Pronek, now well-settled, cured of nostalgia, but still surrounded by the mysteries of the past. Although the protagonist of Hemon's novel managed to escape what Boym defines as the danger of confusing the actual home and the imaginary one (xvi), his split self and his double fictional identity are indicative of the power of the past which always stays with us.

Earlier in 2013 Hemon published a volume of nonfiction under the promising and ambitious title *The Book of My Lives*. It includes essays that earlier appeared in different American magazines. In fact, Hemon's essays are not really nonfiction. Many of them are so artistically exquisite and emotionally expressive that they can be read as fictional memoirs or stories. All these essays are highly autobiographical accounts of the writer's pre-American and American life. All of them tell stories that at some point became plots of Hemon's fiction, thus they can be read as auto-comments and pre- or post-reflections on diverse episodes of the writer's life. The technique of auto-commenting has been widely used by contemporary writers who are clearly interested in explaining themselves to their readers. And there would have been nothing unusual about Hemon's using it but for a striking difference in the approach to American life that the writer and his characters demonstrate when the same (or a very similar) situation is presented from opposite emotional and evaluative perspectives. Hemon-the essayist is a sober-minded and pragmatic American of mixed Slavic descent who is able to look at cultural otherness, a sense of emotional and mental homelessness and a need for belonging colored by unavoidable nostalgia from a mental and emotional distance and convincingly speak about a necessity (and possibility) of working through them:

> Displacement results in a tenuous relationship with the past, with the self that used
> to exist and operate in a different place, where the qualities that constituted us were
> in no need of negotiation. Immigration is an ontological crisis because you are
> forced to negotiate the conditions of your selfhood under perpetually changing exis-
> tential circumstances. The displaced person strives for narrative stability – here is
> my story! – by way of systematic nostalgia. (*The Book of My Lives* 17)

Hemon's essays theorize situations of his fictional characters with a special em-
phasis on the inevitable opposition between "us" and "them" experienced by
immigrants in a new home country and the pain of being away from their old
home, which in their case was war-torn Yugoslavia. His essays are full of warm
memories and insights into his new Canadian and later American life. There is
a strong awareness of the inevitable change of mental and emotional attitudes
that are to a considerable extent determined by nostalgia. However, the latter
does not achieve the level of neurotic incurable longing. The experience of
Hemon-the writer, although similar to the experience of his characters, is much
less emotionally charged. In the essay "The Lives of a Flaneur," first published
in 2011 under the title "Mapping Home," Hemon brings up one of his favorite
themes – a return to Sarajevo after a couple of years spent in the States. There is
a similar episode in *The Lazarus Project*, when Vladimir Brik unexpectedly de-
cides to return to his home city. This is an experience that may radically change
his life again: his admiration of Sarajevo is overwhelming and his previous
American life looks even more miserable and artificial compared with it. Walk-
ing along the Sarajevo streets, Brik is fascinated anew by every detail of its ur-
ban views and at a certain moment remarks with a moving excitement, "Every-
thing was as I remembered it, yet entirely different; I felt like a ghost. People
passed by without glancing at me; I was fully unexceptional and insignificant, if
not perfectly invisible. . . . Nobody seemed to remember me. Home is where
somebody notices your absence" (*The Lazarus Project* 278). The essay men-
tioned earlier refers to the same experience, but the tone of the account is much
less emotional:

> I was trying to reconcile the new Sarajevo with the 1992 version I'd left for Ameri-
> ca. It wasn't easy for me to comprehend how the siege had transformed the city, be-
> cause the transformation wasn't as simple as one thing becoming another. Every-
> thing was fantastically different from what I'd known and everything was fantasti-
> cally the same as before. (*The Book of My Lives* 104-105)

Hemon's comments recognize the unavoidable complexity and ambiguity of his immigrant situation: "As a Bosnian in Chicago, I'd experienced one form of displacement, but this was another: I was displaced in a place that had been mine. In Sarajevo, everything around me was familiar to the point of pain and entirely uncanny and distant" (*The Book of My Lives* 105-106). Thus the private real-life situations described in Hemon's essays echo fictional situations in his novels although the latter are emotionally tense (sometimes even hysterical) as if to emphasize the fact that marginal reactions may be more revealing and may problematize even more the achievement of consent on a personal rather than collective level.

Both in his fiction and essays, the writer invokes the idea of home. For his characters it is determined by the opposition of "us" and "them" (with respective ethnic and cultural components related to it) and nostalgia. Hemon's characters in *Nowhere Man*, *The Lazarus Project* and such stories as "Blind Jozef Pronek & Dead Souls" and "Imitation of Life" clearly enact the pattern of reflective nostalgia, which is not only oriented on an individual narrative that "savors details and memorial signs," but also defers homecoming (Boym 49) since it might ruin the sweetness of longing with the realities of life. Moreover, as Boym claims, "Homecoming does not signify a recovery of identity; it does not end the journey in the virtual space of imagination. A modern nostalgic can be homesick and sick of home, at once" (50). Vladimir Brik's return to Sarajevo makes him realize his displacement even more and challenges the remedial action of homecoming to a place which is no longer one's home.

In "The Life of a Flaneur" Hemon meticulously relates his experience of the interiorization of Chicago as the process of creating a new home which is directly linked to a quest for a new identity:

> Your sense of who you were, your deepest identity, was determined by your position in a human network, whose physical corollary was the architecture of the city. . . . Vast as it is, Chicago ignored the distinctions between freedom and isolation, between independence and selfishness, between privacy and loneliness. In this city, I had no human network within which I could place myself; my Sarajevo, the city that had existed inside me and was still there, was subject to siege and destruction. My displacement was metaphysical to the precisely same extent to which it was physical. But I couldn't live nowhere; I wanted from Chicago what I'd got from Sarajevo: a geography of the soul. (*The Book of My Lives* 117-118)

Although the writer does not sound didactic, memories of his first years in the States are so full of specific details that they can function as a guide for a stranded immigrant on how to convert an alien place into a personal space and thus

create a double home that would not be totally free from nostalgia but would comfortably accommodate it in a new reality: "When I came back from my first visit to Sarajevo, in the spring of 1997, the Chicago I came back to belonged to me. Returning from home, I returned home" (*The Book of My Lives* 127). As Hemon admits, this feeling completed the process of merging his immigrant interior with his American exterior. America became "digestible" and Chicago turned out to be a living creature with its own stories that were also worth telling. Hemon does not allow his characters to achieve this degree of harmony in their new life-setting. For them a sense of distance from their old home and the past that is irreversibly lost "opens up a multitude of potentialities," awakens "multiple planes of consciousness" and stimulates human creativity (Boym 50). In some cases their split fictional selves keep the past alive and present in the present, as in *Nowhere Man*. Or, as for Vladimir Brik, America remains a place where one can live but never feel at home because home stay sforever in the past.

Nostalgia is an essential element of either scenario. As a sense of aimless longing and incurable dissatisfaction, it can make America "indigestible." Although Hemon's essays show that the opposite is also possible, his fiction is explicitly nostalgia-dominated. The writer's paradoxical position and seeming inconsistency can be seen as the "exaggeration of differences" that according to Sollors may be essential for welding Americans into one people and the "symbolic construction of American kinship" (15). However, in order to remain functional, this time the language of consent must adapt to the still new experiences of new American citizens which include nostalgia as their overtone and the past of another ethnic war whose trauma multicultural America makes even more painful.

Works Cited

Boym, Svetlana. *The Future of Nostalgia*. New York: Basic Books, 2001. Print.
Hemon, Aleksandar. *The Book of My Lives.* New York: Farrar, Straus and Giroux, 2013. Print.
---. *The Lazarus Project*. New York: Riverhead Books, 2008. Print.
---. *Nowhere Man*. New York: Vintage International, 2002. Print.
Sollors, Werner. *Beyond Ethnicity: Consent and Descent in American Culture*. New York: Oxford University Press, 1986. Print.

Humanity in Crisis: Man-made Apocalypse in Margaret Atwood's *Oryx and Crake* and *The Year of the Flood*

Anna Gilarek

Margaret Atwood's recently completed *MaddAddam* trilogy marks the author's return to dystopian writing, which she initiated with her 1985 classic – *The Handmaid's Tale*. Similarly to its acclaimed predecessor, the trilogy employs futuristic settings in order to address current problematic issues, by defamiliarizing extratextual reality on a diegetic level. Another feature shared with *The Handmaid's Tale* is the setting of the novels – although the author is Canadian, the texts are set in the United States. This authorial decision can be explained by Atwood's conviction that "the States are more extreme in everything" (qtd. in Howells 163), as well as by her recognition of the leading role of the U.S. both in setting trends and in the ongoing process of globalization. Consequently, such a choice of setting might be seen as indicative of the author's conviction that the crisis she describes is of a global, rather than a national character. The aim of this essay is to address Atwood's diagnosis of contemporary crisis, as well as the potential solutions that she explores, based on the first two installments of the trilogy: *Oryx and Crake* (2003) and *The Year of the Flood* (2009). The author's handling of the utopian, the dystopian and the apocalyptic willbe analyzed, particularly with regard to environmental issues, the loss of sustainability and potential sources of sustenance.

Generic considerations

The novels display a certain degree of generic variety: they are most obviously associated with dystopian and apocalyptic writing, but elements of other genres can also be traced. These include features of utopia, critical utopia, last man narrative, and satire. In fact, satire is inherent in utopias and dystopias, as their aims overlap – the most crucial one is to critically evaluate the current sociopolitical or economic situation. Both dystopian and utopian settings are employed not merely as a means of projecting possible futures, but primarily for social criticism regarding the present.

Oryx and Crake and *The Year of the Flood* feature a not-so-distant future in which a particularly deadly virus has killed off most of mankind. The remaining humans struggle in a world afflicted by climate change and a scarcity of food. The post-apocalyptic world of the novels, as is typical of the dystopian genre, serves as a warning against the possible pernicious effects of current trends.

However, it is not so much the post-disaster reality that is to trigger the recognition and consideration of present-day issues on a non-diegetic level. The most scathing criticism of our reality is to be found in the descriptions of the pre-catastrophe world, which are accessible through flashbacks. The novels' post-apocalyptic present and pre-catastrophe past are both in the reader's future; however, they are clearly an extrapolation and logical projection of the challenges that the extratextual world is facing at present. The author's aim of undertaking social critique becomes clear when the first of the epigraphs she chose for *Oryx and Crake* is analyzed: it is a quotation from *Gulliver's Travels*, in which Jonathan Swift specifies that his "principal design was to inform . . . , and not to amuse" (qtd. in Atwood, *Oryx* vii). This intertextual reference emphasizes the strong didactic element, which is also characteristic of utopian and dystopian texts.

What is more, Atwood emphasizes the realist character of her writing by disavowing any connections to the science fiction genre, which she seems to perceive as one dealing with unrealistic settings and problems, whether rightly so is another matter. Regarding *Oryx and Crake,* she maintains that the novel cannot be categorized as science fiction since it features "fact within fiction" (qtd. in Erickson 193). Consequently, the author insists that her novel is representative of speculative fiction due to its indisputable relation to extratextual reality, which constitutes the starting point for the creation of the extrapolated diegetic world. Atwood further develops this point by stating that "we've taken a path that is already visible to us" (qtd. in Erickson 193), so her novels are therefore far from pure conjecture. Atwood is interested not only in showing what might be, but, even more so, in what already is and how the two are connected:

> As with *The Handmaid's Tale,* it [*Oryx and Crake*] invents nothing we haven't already invented or started to invent. Every novel begins with a what if, and then sets forth its axioms. The what if of *Oryx and Crake* is simply, What if we continue down the road we're already on? How slippery is the slope? What are our saving graces? Who's got the will to stop us? (Atwood, "Perfect Storms")

Hence, Atwood's dystopian novels serve as a mirror reflecting back present ills and projecting possible consequences. In a darkly comic manner, the author experiments with hypotheses and, simultaneously, issues a warning regarding our current mode of conduct. Thus, in keeping with the dystopian tradition, the novels turn into cautionary tales.

Finally, the two novels, especially *The Year of the Flood*, are cited among those, until recently relatively rare, which tackle the issue of anthropogenic climate change. In their 2011 study of climate change in literature and literary criticism, Adam Trexler and Adeline Johns-Putra note "a particular explosion in the numbers of such novels in the past ten years" (186). A new genre seems to have emerged, referred to as climate fiction, or cli-fi in short (Glass). Time will tell whether the popularity of the label, and the genre itself, will turn out to be short-lived, yet the current literary response to the problem of climate change proves the point that need to address this issue has clearly been recognized.

Crisis

It seems undeniable that apocalyptic writing can be seen as a "genre born out of crisis" (Thompson qtd. in Garrard 86) and it is the various faces of this crisis that Atwood presents in her novel: social, economic and ecological. She depicts a world of progressing environmental degradation, growing consumerism, exploitation of the weak and, above all, of corporate dominance. National governments appear to have lost any impact or significance, while various corporations exercise seemingly unlimited power. Despite claims about the liberating potential of the free market and the equalizing effects of globalization, it is a strongly stratified society: affluent employees of corporations inhabit walled and closely guarded corporate compounds, while the less fortunate occupy a vast sprawl known as the "pleeblands," considered "ultra-hazardous" (*Oryx* 302) by compound-dwellers. Gang-ridden, crime-infested and poverty-stricken, the pleeblands are separated from the compounds by walls, the physical barrier only increasing the perception of pleeblanders as the Other, feared and despised at the same time. Nonetheless, while the compounds offer a life of relative comfort, high-tech solutions and security, the apparent well-being comes at a price – corporate employees are not only walled off, but perhaps primarily, walled in. In the compounds relative safety is traded for ubiquitous control and surveillance, akin to Foucauldian panopticon. All activities are closely monitored, often without the knowledge of those concerned. Consequently, all forms of resistance or insubordination are swiftly detected and punished. Among the many neologisms that Atwood coins to convey the problematic nature of corporate life is "corpicide," which may be understood as suicide by disobedience: "if you're Corp and you do something they don't like, you're dead. It's like you shot yourself" (*Flood* 244). Corporate power is ensured by the corporation security force – CorpSeCorps – whose authority is far-reaching and unquestionable.

The first two novels in Atwood's trilogy reveal two sides of this divided society owing to their central characters – the first is told from the point of view of

male representatives of the compound culture, while the second from the per-
spective of female pleeblanders who suffer not only from being underprivileged,
but, most of all, for being underprivileged women. However, the two novels dis-
play not only a different focalization, but also a different thematic focus. While
Oryx and Crake tackles the problem of uncontrolled bioengineering and its po-
tential consequences, *The Year of the Flood* concentrates on environmental is-
sues. Regarding the latter issue, Atwood focuses primarily on the effects of
global warming: the disappearance of the succession of seasons in moderate
zones and scorching heat in previously temperate climates. The world struggles
with the effects of the rising sea-level on the one hand, and faces seemingly end-
less droughts on the other. All of the above result in a complete transformation
of the earth's surface:

> The coastal aquifers turned salty and the northern permafrost melted and the vast
> tundra bubbled with methane, and the drought in the midcontinental plains regions
> went on and on, and the Asian steppes turned to sand dunes and meat became harder
> to come by. (*Oryx* 28)

The ultimate consequences depicted by Atwood include species extinction, out-
breaks of epidemics, and famine. Droughts result in displacing farmers and fruit
producers, which leads to poverty and social instability.

Corporate hegemony and climatic disasters constitute the background for
other vices of the moderns that Atwood satirizes. She is especially critical of the
encroachment of the Internet, the ultimate simulacrum which fosters perversion
and voyeuristic tendencies. The latter is clearly perceptible in the popularity of
such web sites as those presenting assisted suicide, live execution, pornography
in its different varieties, or crimes "with grisly pictures of the victims" (*Oryx*
103). These are easily available, even for underage users, who frequently be-
come addicted to cyberspace and what is has to offer to those greedy for un-
healthy excitement.

Atwood also addresses the situation of women, a theme which was promi-
nent in *The Handmaid's Tale*. She points to rampant sexual violence and the in-
dustrialization of sex, as well as to the dangers connected with the availability of
pornography and child pornography in particular. All of these contribute to the
objectification of women, the most extreme form of which is human trafficking
– both for the sex industry and for private use as the sex slaves of affluent indi-
viduals. The ultimate instance of the commodification of women is SeksMart,
a company which provides sexual services for CorpsSeCorp members, as well as
for influential Corporation employees. The company's fairly explicit name

evokes inescapable associations with a supermarket, conceptualizing women as products to be bought, used and discarded when no longer needed.

Considering this aspect, the novels can also be read from an ecofeminist perspective. The abuses of the environment depicted by Atwood match the injustices encountered by women in this society. In this context, anthropocentrism, the justification for human dominion over the natural world, overlaps with androcentrism, the justification for male supremacy in society. Thus, it might be argued that the novels expose the patriarchal character of western culture, wherein unequal social standards parallel the lack of environmental justice and respect for the environment.

In *Oryx and Crake*, which can be read as a "ferocious satire on late modern American capitalist society" (Howells 164), Atwood shows, to use Frederick Jameson's terms, a late capitalist society (Hall 15) – the multinational capitalism of postmodernism, characterized by its global reach, the merging of government and business, and an unparalleled rise of consumerist culture, complete with vicious intercorporational competition, omnipresent and dishonest advertising, uninhibited consumption, mass production and wastefulness. Such a multinational capitalist system preys on people's wants – appetites which are identified by the eponymous Crake as humanity's major problem: "the tide of human desire, the desire for more and better" (*Oryx* 377). Corporations take advantage of human weakness, providing what people seem to want most – good looks and eternal youth. Since these seem to be in greatest demand in this society, most corporations are "body-oriented" and their research is directed at ways of improving appearance and stalling the effects of aging. Again, according to Crake, human mentality is what enables corporations to draw profits from people's fears and insecurities: "Grief in the face of inevitable death. . . the wish to stop time. The human condition" (*Oryx* 371). Thus, Atwood portrays the society as obsessed with financial success, good looks and sex. Considering such a characterization of human nature in the twenty-first century, it is hard to resist the conclusion that Atwood's diagnosis of the world's ills is not as far-fetched and fictional as we would like it to be. Consequently, introducing a high degree of dystopian distortion seems redundant, as the reader easily recognizes the trends illustrated by the author as highly characteristic of present-day reality.

While compound-dwellers spend their money on appearance enhancement procedures and products, pleeblanders mostly cannot afford to do so. Yet they will not hesitate to buy medicines when ill, hence the other area of corporate interest – health-oriented corporations. Such corporations will resort to anything to generate profits: from selling pills which can only work as placebos, while advertising their marvelous effects, to marketing untested drugs to unaware pleeblanders, who thus become unconsenting test subjects. The latter practice is car-

ried to the extreme as corporations purposefully create synthetic viruses and spread diseases only to be able to offer expensive remedies.

In fact, all corporate activities can be seen as morally questionable. To name another example, bioengineering companies enable their clients to order children, programmed according to parents' specifications. The novels dramatize the bioethical issues that arise at the intersection of technology and profit-oriented enterprises. The relation between corporate power and the development of technology is explored, and in particular the ethical dimension of this relation. In *Oryx and Crake* Atwood focuses especially on the issue of genetic manipulation: gene splicing and transgenic technologies. In corporate laboratories new species are created, most for their marketable value, others for the fun of it. These include pigoons – pigs with embedded human neocortex tissue, which enables them to be used to grow transplant organs for people. Other new species include such hybridizations as wolvodogs (dog/wolf), liobams (lion/sheep), and rakunks (raccoon/skunk). Scientists also engage in the production of genetically modified food – both of animal and plant origin. An example of the latter is modified coffee, which can be machine-picked, hence making numerous small producers of coffee redundant, which, in turn, causes a worldwide wave of riots and protests against corporate monopoly. The most unsettling example of genetically engineered animals are ChickiNobs – laboratory-grown chickens without heads and other parts deemed as useless, such as feathers or beaks, yet with multiple oversized breasts.

Oryx and Crake raises the issue of the ethics behind such manipulation of nature, as well as the matter of the humane treatment of animals and the limits of scientific endeavors. In her typically ironic manner, Atwood exposes the disquieting nonchalance and lack of reflection with which such experiments are undertaken: "There'd been a lot of fooling around these days: create-an-animal was so much fun, said the guys doing it; it made you feel like God" (*Oryx* 59). Not only does the author instill in the readers a strong sense of unease with such procedures, but she also shows how easily such experiments can get out of scientists' control, to the detriment of people and entire ecosystems. For instance, fluorescent rabbits "slipped their cages and bred with the wild population [and became] a nuisance" (*Oryx* 119). Wolvodogs and pigoons, which managed to escape once the pandemic wiped out most of humanity, have become a danger with which the remaining humans have to reckon. Wolvodogs are characterized by uncommon cunning and violence. Moreover, they quickly ravage the dog population, destroying the ecological balance: "it hasn't taken much to reverse fifty thousand years of man-canid interaction" (*Oryx* 135). As for pigoons, they are unusually smart, capable of learning and with a good memory, probably due to

the inclusion of human tissue. Moreover, once in the wild, they take a liking to flesh, including that of humans.

Atwood voices doubts about bioengineered species through the central figure of the story, Jimmy, who is "worrying about the ChickiNobs and wolvodogs. Why is it he feels some line has been crossed, some boundary transgressed? How much is too much, how far is too far?" (*Oryx* 262). Atwood presents a society that valorizes crossing boundaries, and ethical boundaries in particular. The lack of an integral system of ethics to guide such undertakings may be seen as the root cause of the crisis, which leads to the loss of sustainability in every sense: ecological, social and economic (Amaladass 31). These three pillars of sustainability are visibly shaken in Atwood's fictional universe, a universe afflicted by ecological degradation, social inequality, moral collapse and poverty. It is increasingly argued that a fourth pillar should be added to the debate concerning sustainability: the cultural dimension (Hawkes 25). Especially in *Oryx and Crake,* Atwood bemoans the loss of cultural identity – primarily due to the homogenizing effects of globalization, but also as a consequence of the consistent undervaluing of art and culture. Since corporate products are the result of bioengineering, scientific knowledge is in demand in this technocratic society. Consequently, a new kind of social division arises: the privileged class of bioengineers and IT specialists versus all the others, who are "filed among the rejects" (*Oryx* 248). Though the latter may be gifted in other areas, such as the arts or humanities, these skills cannot be capitalized upon and are therefore of no value from the corporate point of view, which prioritizes profit-making. This might be seen as Atwood's commentary on an already existing trend: the underfunding of humanistic studies, dismissing them as mere pastimes of no utilitarian value (Bergthaller 728).

All things considered, the world depicted by Atwood appears to be devoid of any possibility of continuance, as the disintegration of the fundamental pillars of sustainability might very well make it impossible to maintain ecologically sustainable development. However, it must be noted that the future depicted by Atwood is far from being inescapable and can be prevented. As the author observes, "nothing can be predicted, because there are too many variables. So I'm looking at possible futures, not inevitable ones" ("Question and Answer"). Consequently, she mentions certain attempts at changing the potentially catastrophic status quo and analyzes the sources of sustenance to be found in alternate lifestyles.

Utopian solutions: ecotopianism vs. posthumanism

Though undeniably dystopian, the novels may in fact be analyzed in terms of
a flawed utopia. Atwood herself has commented that "utopia and dystopia are
two sides of the same coin" (qtd. in Howells 162). Dystopia may in fact be
a progression from utopia gone wrong, in which case we are dealing with anti-
utopia, or, to use Tom Moylan's terms, critical utopia, a utopian project with
undeniable imperfections (10). Both *Oryx and Crake* and *The Year of the Flood*
can be categorized as representative of this trend.

The most obvious case of a utopian venture within which dystopian ele-
ments are clearly discernible is the compound culture itself – gated communities
in which life is supposed be perfect, well-organized and planned according to
predetermined strict rules. Needless to say, it is a utopia only for a chosen few,
as well as one in which freedom is severely limited and whose foundations are
morally questionable.

Within the narrative space offered by speculative fiction, Atwood also ex-
plores two examples of what might be referred to as counterculture with regard
to the destructive ways of society and to corporate hegemony. In *Oryx and
Crake* she envisions the creation of a new, less destructive hominid species to
replace humans, and in *The Year of the Flood* an ecology-oriented community is
depicted. Though apparently different, the two approaches – posthumanism and
ecotopianism – rely on the same premise: the conviction that anthropocentrism,
the foundation of the western system of thought, is a misguided notion. Both
stances are based on the conviction that the belief in human exceptionalism has
to be abandoned if true respect for the natural world is to be achieved. Also,
both the posthuman and ecotopian communities in the novels achieve a degree
of sustainability which is incomparably higher than that of the modern society as
it is depicted in the novels. Lastly, both are ambiguous to a considerable extent,
which renders them critical utopias.

In the first novel, Crake, a young scientific genius, is of the opinion that the
human kind in its current state is beyond reform. Moreover, he seems to adhere
to the ideas of Thomas Malthus, whose *Essay on the Principle of Population*
may be seen as "the most influential forerunner to the modern environmental
apocalypse" (Garrard 93). According to Malthus' theory of population, if popu-
lation growth is not limited, the depletion of resources will continue until the
point of exhaustion, at which time sustainability and our survival as a species
would no longer be possible. Crake is of the opinion that the continued un-
checked growth in human population can be blamed on our irresponsible and
self-centered attitude: "Homo sapiens doesn't seem to be able to cut himself off
at the supply end. He's one of the few species that doesn't limit reproduction in

the face of dwindling resources. In other words – and up to a point, of course – the less we eat, the more we fuck" (*Oryx* 15). Thus, even though we are dependent on resources, we are not able to limit our appetites and consumerist habits, which, in Crake's eyes, is irrational and short-sighted. Crake displays an awareness of what the consequences of persisting in this attitude might be: "we're running out of space-time. Demand for marginal resources has exceeded supply for decades in marginal geopolitical areas, hence the famines and droughts; but very soon, demand is going to exceed supply for everyone" (*Oryx* 375).

Hence, he designs a plan for saving the planet, which includes destroying the human species by means of a virus of his own creation. It is spread, ironically, by a pill he develops for the corporation, advertised as a supplement providing unlimited and unfailing sexual prowess, protection from sexually transmitted diseases and the prolongation of youth. Knowing human nature as he does, Crake knows that the popularity of the pill will be immense, thus ensuring the circulation of the virus. In the meantime Crake develops his eugenic enterprise – – the creation of a hominid species through transgenic eugenics.

The Crakers, as they are called, are bioengineered so as to shed some human features that Crake perceives as potentially destructive, but equipped with those animal characteristics that he deems useful. Allison Dunlap comments on this interspecies amalgam:

> They are, quite literally, creatures whose bodies challenge human constructions of "the animal" and "the human." Like cats, the Crakers purr; like the rabbits of this world, they glow with the green from a jellyfish gene; like "the canids and the mustelids," they mark their territory; and like various hares and rabbits, the Crakers eat leaves and grass. (9)

Regardless of the sense of unease that may be felt at such a departure from humanity as we know it, physically the Crakers are the embodiment of perfection: "They look like retouched fashion photos. Or ads for a high-priced workout program" (*Oryx* 123). They are of various skin colors, yet there is no racism as Crake programmed them "not to register skin color" (*Oryx* 387). Moreover, Crake programmed into Crakers an innate immunity to microbes as well as a repellent against predators in the males' urine. He also equipped them with built-in insect repellent in their skin, as well UV-resistance, which is especially significant in a world of global warming and ozone layer depletion. They are also provided with the ability to digest various plants, so consequently they are herbivores who pose no danger to the animal world. Finally, in contrast to the

human species, they reach adolescence at the age of four, as Crake was convinced that "far too much time was wasted in child-rearing" (*Oryx* 201).

Mentally, Crakers are friendly, calm, rather naïve, with limited vocabularies, and incapable of symbolic thinking, which, according to Crake, is to preclude the rise of hierarchical arrangements, forms of worship, or money. As a consequence, they do not display violent behavior, greed or aggressive sexuality. Those traits, in Crake's view, are closely related to human reproductive patterns and the resulting territoriality and need for dominance. He sees war as "misplaced sexual energy" (*Oryx* 373), thus preventing it lies in changing human procreative habits. Consequently, there is no pair-bonding among the Crakers and no sexual competition, only frolicsome mating every three years: "their sexuality [is] not a constant torment to them, not a cloud of turbulent hormones: they [come] into heat at regular intervals, as [do] most mammals other than man" (*Oryx* 387). Thus, their mating patterns, like their numerous other characteristics, are modeled on animals. The female mates with four males of her choosing, and the issue of paternity remains completely irrelevant. Thus, gone are the sense of ownership towards women and children: "no more prostitution, no sexual abuse of children, no haggling over the price, no pimps, no sex slaves. No more rape" (*Oryx* 210). It might thus be argued that Crake establishes a feminist utopia of sorts. The Crakers' community fulfills all the requirements for a such a utopian scheme: it is a world of gender equality, hence there is no patriarchal oppression of women and no sexual violence. In addition, their community is pacifist, communal, ecology-friendly and non-industrial in character, all of which coincide with the features typically identified as those distinguishing a feminist utopia (Lefanu 54).

Being convinced that by creating Crakers, he has eradicated "human predation" (*Oryx* 124), Crake destroys the human race. It is his conviction that they will continue in this artificially created status quo. However, it turns out that just as bioengineered animals start to live their own life once in the wild, the Crakers too begin to develop in unforeseen directions. Firstly, Crake was a staunch opponent of all hierarchies and of religion and he was sure that he had eliminated the neural complexes responsible for both. Still, a leader emerges among the Crakers. Moreover, despite Crake's conviction that "God is a cluster of neurons" (*Oryx* 199), the Crakers begin to deify Crake, their god-like Creator. In time, it becomes clear that "they're conversing with the invisible, they've developed reverence" (*Oryx* 199). They also learn to use violence when forced defend themselves. It may be argued that, given time, the Crakers might evolve in such a way so as to repeat the mistakes of *homo sapiens*. Crake may thus be perceived as a Dr Frankenstein character, since his scientific manipulation gets out of control.

As in any critical utopia, Crake's vision is fraught with contradictions: can a life close to nature originate in its manipulation? Can a world without violence be born from genocide? Can a utopia be the result of eugenic programming instead of a conscious choice and effort? It cannot be denied that Crake's vision of a posthumanist utopia is driven primarily by the welfare of the planet. Atwood comments that he is "the most altruistic person around" (qtd. in Brooks Bouson 103). Still, whatever his intentions, when the attempted utopia entails the loss of humanity, its attainment becomes a questionable goal. It might of course be argued that this society is already largely dehumanized; however, regardless of this fact, Crake's actions seem too radical to be lauded.

Despite its origin in biotechnology and transgenic science, Crake's vision of utopia can be seen as an attempt to look for sustenance in ecotopian ventures. The Crakers remain in perfect harmony with their ecosystem and the animal world – their ecological footprint is practically non-existent – in this sense, it is a successful ecotopia. This scenario is fully explored in *The Year of the Flood*, in which the action centers around members of God's Gardeners – a religious cult of environmentalists who distance themselves from the mainstream society, whom they blame for their careless attitude to the natural world and for its destruction. They establish a community which strives to achieve ecological sustainability by producing their own organic food and medicines, and by saving water and energy. They refuse to buy and use any corporate products, as well as those that they consider unnatural – such as genetically modified food. They consider sustainability to be conditional on redefining the relationship between the human and non-human world, based on respect for every living being, a tenet which can be seen as the cornerstone of their theology. This idea, along with the rejection of anthropocentrism, happens to be one of the primary assumptions of Deep Ecology (Bergthaller 739), to which they seem to adhere in their radicalism and Earth-centered approach. An ecology-conscious lifestyle becomes their religion, which is evident in their practices: the saints they celebrate, the hymns they sing and the doctrine they preach: "Insofar as you do it unto the least of God's creatures. You do it unto Him" (*Flood* 53).

Their theology is also apocalyptic in character – they are a cult convinced of an impending disaster matching the biblical flood, of which they expect to be sole survivors:

Let us today remember Noah, the chosen caregiver of the species. We God's Gardeners are a plural Noah: we too have been called, we too forewarned. We can feel the symptoms of coming disaster as a doctor feels a sick man's pulse. We must be ready for the time when those who have broken trust with the Animals - yes, wiped

them from the face of the Earth where God placed them - will be swept by the Wa-
terless Flood . . . (*Flood* 91)

God's Gardeners believe that punishment will come for breaking the covenant
with the animal world. The Waterless Flood, as they call it, does indeed come,
taking the form of a laboratory-grown virus, courtesy of Crake. However, God's
Gardeners consider themselves forewarned: they practice survival skills, learn to
eat meat when necessary and stock supplies in secret places. Thus, despite their
deep spiritualism and apparent religious fanaticism, they are in fact quite prag-
matic in their approach. Due to their strict rules about not using any corporate
medicines, avoiding people who display symptoms of sickness and hiding in
their well-supplied storehouses, a relatively large number of Gardeners do in-
deed survive.

Still, though they display ecological awareness and most of their criticism
leveled at the contemporary world is valid, this ecotopian scheme is laden with
imperfections as well. First of all, they rely on hierarchy in their organization,
though, admittedly, it depends on the members' loyalty and the skills they ac-
quire. Their leader, Adam One, assumes a guru-like status and he is the indis-
putable decision-maker. He is not always completely honest with the Gardeners,
manipulating facts and hiding the truth whenever he deems it necessary for the
general welfare of the group. More importantly, he misinterprets the Bible in
order to make it sound consistent with the Gardeners' creed, inventing such ri-
diculous theories as the contention that "[the Apostles] were told to be fishers of
men instead of being Fishers of Fish, thus neutralizing two destroyers of Fish!"
(*Flood* 196). Moreover, despite a strict order against computers, Adam One
owns one and accesses the Internet. The leader is not the only member to bend
the rules: some of the cult members are not ardent believers, but refugees from
corporations and from the anarchy in the pleebland streets. Hence, they secretly
disregard some of the regulations. Moreover, to a degree, the Gardeners adhere
to socially-constructed gender roles, for instance the women's personal freedom
is compromised by instructing them to have long hair and expecting them to
comply with this rule. Finally, the Gardeners have some very unappealing hab-
its: they wear dirty rags and shower only once a week, all for the sake of con-
serving resources.

Though apparently contradictory, the two standpoints that Atwood explores
– posthumanism and ecotopianism, overlap to a degree. Just like Crake, the
Gardeners await the cleansing of the earth. Crake's diagnosis concerning the
roots of the current crisis is very similar to theirs – it is human nature that consti-
tutes the problem (Bergthaller 180). Thus, the solution lies, generally speaking,

in "housebreaking the human animal" (Bergthaller 180), taming desires and the resulting destructive impulses. Paradoxically, in both schemes this involves blurring the human/animal boundary, as this dichotomy becomes less valid in each case: in Crake's vision by genetic manipulation, and in the Gardeners' ecotopia by embracing human affinity with the animal world. Both realize that economic growth is bound to have a negative impact on nature, as long as we believe that human exceptionalism grants us the right to dominate the non-human world and destroy it in the name of progress.

Despite the fact that Atwood is wary of both the abuses of technoscience and the pitfalls inherent in ecotopianism, it has to be contended that it is not outright criticism. Firstly, Atwood emphasizes that *Oryx and Crake* is not an anti-science book – it is the handling of capitalist science that provokes her apprehension (Interview). The same applies to her evaluation of God's Gardeners. While it is true that Atwood definitely satirizes such cults' fanaticism, she does express sympathy with their motives and their endorsement of ecosophy and ecoethcial behavior.

A matter of ethics

It is ethics, Atwood seems to be suggesting, that is the answer to current ailments. The author would probably subscribe to Donald Worster's oft-quoted evaluation of the ecological crisis: "We are facing a global crisis today, not because of how ecosystems function but rather because of how our ethical systems function" (qtd. in Glotfelty and Fromm xxi). Atwood gives no answer as to how to attain an ecoethical stance, but indicates the need to pursue it by visualizing the potential effects of indifference, as the ecological crisis is closely interwoven with its manifestation in all other spheres of life. Ultimately, assuming an ethically sound attitude both in our relation to the environment and in our handling of technology and technoscience, as well as in our economic enterprises, might prevent the precariously unbalanced pillars of sustainability from total collapse.

The trilogy, just as any utopia or dystopia, is aimed at inciting the reader to undertake action – socially, politically, or ecologically-conscious action. Considering what Hannes Bergthaller regards as one of the main ecocritical assumptions, namely that "the roots of the ecological crisis are to be found in a failure of the imagination" (730), Atwood's novels, just as all cli-fi novels, may be perceived as instruments stimulating the readers' imagination and inspiring environmental activism, as well as social reform. This might prevent the man-made apocalypse that she describes – man-made not only in the sense that the deadly virus was unleashed deliberately, but primarily because of what human society represents in the novels. This apocalypse is not a spectacular catastrophic mo-

ment, but a gradual process, already happening both on a diegetic and a non-diegetic level.

Works cited

Amaladass, Anand. "Sustainable Development and Religion: Towards An Economic-Eco-Socio Spirituality." *Essays in Ecocriticism*. Ed. Nirmal Selvamony et al. New Delhi: OSLE-India, Chennai, Sarup & Sons, 2007. 29-39. Print.

Atwood, Margaret. Interview. *Margaret Atwood Oryx and Crake*. Web. 1 Jul. 2013.

---. *Oryx and Crake*. Leicester: Charnwood, 2003. Print.

---. "Perfect Storms: writing *Oryx and Crake* by Margaret Atwood." *Margaret Atwood Oryx and Crake*. Web. 1 Jul. 2013.

---. "Question and Answer." *Margaret Atwood Oryx and Crake*. Web. 1 Jul. 2013.

---. *The Year of the Flood*. London: Bloomsbury, 2009. Print.

Bergthaller, Hannes. "Housebreaking the Human Animal: Humanism and the Problem of Sustainability in Margaret Atwood's *Oryx and Crake* and *The Year of the Flood*." *English Studies* 91.7 (2010): 728-743. Print.

Brooks Bouson, J. "It's Game Over Forever. Atwood's Satiric Vision of a Bioengineered Posthuman Future in *Oryx and Crake*." *Margaret Atwood. New Editon*. Ed. Harold Bloom. New York: Bloom's Literary Criticism, 2009. 93-110. Print.

Dunlap, Allison. "Eco-Dystopia: Reproduction and Destruction in Margaret Atwood's *Oryx and Crake*." *Journal of Ecocriticism* 5.1 (January 2013): 1-15. Print.

Erickson, Mark. *Science, Culture and Society: Understanding Science in the 21st Century*. Cambridge: Polity Press, 2005. Print.

Garrard, Greg. *Ecocriticism. The New Critical Idiom*. Abindgdon: Routledge, 2004. Print.

Glass, Rodge. "Global warning: the rise of 'cli-fi'." *The Guardian*. Friday 31 May 2013. Web. 19 Jul. 2013.

Glotfelty, Cheryll and Harold Fromm. *The Ecocriticism Reader: Landmarks in Literary Ecology*. Athens, GA: University of Georgia Press, 1996. Print.

Hall, Terry Ryan. "Exploring the New Front of the Culture War: *1984, Oryx and Crake,* and Cultural Hegemony." MA thesis of Western Kentucky University, 2008. *Masters Theses & Specialist Projects*. Web. 1 Sept. 2013.

Hawkes, John. *The Fourth Pillar of Sustainability*. Melbourne: Common Ground Publishing Pty, 2001. Print.

Howells, Coral Ann. *The Cambridge Companion to Margaret Atwood*. Cambridge: Cambridge University Press, 2006. Print.

Lefanu, Sarah. *In the Chinks of the World Machine. Feminism and Science Fiction*. London: The Women's Press Limited, 1998. Print.

Moylan, Tom. *Demand the Impossible. Science Fiction and the Utopian Imagination*. New York: Methuen, 1986. Print.

Trexler, Adam and Adeline Johns-Putra. "Climate change in literature and literary criticism." *Wiley Interdiscplinary Reviews: Climate Change* 2.2 (March/April 2011): 185-200. *Wiley Online Library*. Web. 25 Jul. 2013.

Food (and) War in *Gravity's Rainbow*

Dominika Bugno-Narecka

The purpose of this paper is to explore the complex relations between the concepts of food and war in Thomas Pynchon's *Gravity's Rainbow*. Long after the era in which consumption, digestion or indigestion, and the excretion of food products were regarded as embarrassing bodily functions neither talked about in public, nor written about in literature, Pynchon provides a plethora of peculiar examples of food's use and misuse that not only distort the stereotypical, solemn approach to war, but also imply the horror of any sort of military conflict. As will be shown in this paper, representations of food are Pynchon's means of manifesting the atrocities of war, and to be precise, of World War II.

It must be mentioned at the very beginning that food is understood here in its widest sense: as any product which is and can be potentially consumed, that is, inserted into the digestive system, by the characters of the novel. Such a wide definition allows for the distortion and creation of unusual combinations in conflict with conventional nutrition. As far as the second key term for this study is concerned, war comprises conflict in its broadest meaning, that is, the clash of any two opposing and contrasting ideas as well as unresolvable tension between them. When it comes to military conflict, war will denote here a particular historical event, namely World War II.[1] Such a general approach to both food and war opens new interpretative perspectives for critical readers of *Gravity's Rainbow*, for it is possible to analyze the novel in terms of food during a military conflict on the one hand, and a conflict within the representation of food on the other. The former problem is mainly related to the lack of life-sustaining food and to starvation. The latter may be caused by traumatic experience of war manifested in curious "food" combinations and scenes of "food" consumption. Thus, the argument concerning the representation of food in Pynchon's *Gravity's Rainbow* can go in two directions: food and war, and food war. Though seemingly

1 Frederick Ashe in his article "Anachronism Intended: *Gravity's Rainbow* in the Sociopolitical Sixties" claims that although Pynchon sets his novel at the end of World War II, he is in fact engaged with the history of America in the sixties (64). Ashe's paper provides sound arguments for this thesis. Other military conflicts alluded to in *Gravity's Rainbow* include World War I, the Vietnam War and the Cold War. They are, however, of secondary importance for this paper. For more information see: Roger Berger. "Death Was No Enemy: A Note on Thomas Pynchon, Wilfred Owen, and the First World War." *Pynchon Notes* 20-21 (1987): 105-108. Eric Meyer. "Oppositional Discourses, Unnatural Practices: Gravity's History and 'The '60s.'" *Pynchon Notes* 24-25 (1989): 81-104.

different, the two approaches will emerge as belonging to one and the same continuum and will become folds in a neobaroque superfold.

The first of the two proposed approaches assumes that food in *Gravity's Rainbow* can be analyzed in terms of nutrition during war, and as has already been said, in the case of Pynchon's novel that is the final phase of the military conflict known in history as World War II. That particular moment is a turning point for nations that are to be formed[2] and an impending end to the horrors of genocide and holocaust.[3] Military activity may come to a close, but the nutrition problem remains. The spectrum of the food issue is extended and suspended between two extremes. On the one hand, there is a lack of basic food products resulting in hunger among different individuals and groups of protagonists in the novel, while on the other, there is an excess of consumable products, for example, of some specific stimulants, like coffee, cigarettes, alcohol or drugs.

The two extremes cannot be anything other than two directions in which a food fold can extend. According to Gilles Deleuze, the fold has no beginning or end, and it stretches in an undisturbed continuum into infinity, making "two really distinct parts of matter inseparable" (Deleuze, *The Fold* 5). Because these "distinct parts," or extremes, belong to an undisturbed continuum, there is no "absolute distinction" between them. Another consequence of such morphology is that the mentioning of one extreme immediately evokes the presence of the other extreme. In other words, it is only possible to know one by means of the other, which in the case of food representation in Pynchon's novel means that we only get to know the excess of food by means of its shortage, and the other way round: the lack of food and hunger imply the existence of food excess.

Both these extremes are visible in *Gravity's Rainbow* already at the beginning of the novel. The lack of a certain food product, it might be said a luxury good and an exotic fruit at the same time, caused by war triggers survival instinct in Pirate Prentice and leads him to finding a remedy to the crisis situation. "Pirate, driven to despair by the wartime banana shortage, decided to build a glass hothouse on the roof" (6) of his London lodging and grow his own fruit. As a result, an excess of food appears in the subsequent scene, acquiring the form of a Banana Breakfast which consists of:

2 The Zone is presented in the novel as the place where displaced groups of people – the refuse of war – strive to prosper and organize themselves into social structures (Rosenberg 98). Yoshihiro Nagano emphasizes that this process of national formation is "inseparable from the development of rocketry" (82).

3 As will be indicated in the second part of this paper, there is a lot about World War II that Pynchon neglects to depict, but leaves to the reader's knowledge (Dalsgaard 35). Yet, tiny details in food representation make that absent issue present.

banana omelets, banana sandwiches, banana casseroles, mashed bananas molded in the shape of a British lion rampant, blended with eggs into batter for French toast, . . . tall cruets of pale banana syrup to pour oozing over banana waffles, a giant glazed crock where diced bananas have been fermenting since the summer with wild honey and muscat raisins, up out of which, this winter morning, one now dips foam mugs full of banana mead . . . banana croissants and banana kreplach, and banana oatmeal and banana jam and banana bread, and bananas flamed in ancient brandy...(12)

This banana feast, a celebration of life and its warm and colored affirmation (Lèonet 40), manifests artistry, extreme mastery of skill and the desire for perfection. In other words, it manifests virtuosity, also when the process of preparing the meal preceding the above description is taken into account. According to Omar Calabrese, virtuosity is the "qualitative excess" not restricted to the arts and artistic performances, but also present in daily life (64). Hence, the Banana Breakfast, a meal which is part of the daily routine, is an artistic distraction in the everyday life of London, constantly threatened by V2 rockets falling around.

To balance this idle picture, the situation in the Zone is more dramatic. People, including the main characters, often starve and suffer from hunger. Statements like "So Franz and Leni were hungry for a time" (189); "Ilse is awake, and crying. No food all day" (193); "Sausages and fondue: Slothrop's starving" (314) or "Slothrop hasn't seen a potato for months" (515) are frequent in the novel. An empty stomach and harsh reality cause various reactions in similar types of situations. These reactions can be grouped into three categories. Some protagonists will share whatever they have. The need to help others is stronger than rules of capitalism under the circumstances of war:

When Slothrop has cigarettes he's an easy mark, when somebody has food they share it—sometimes a batch of vodka if there's an army concentration nearby, the GI cans can be looted for all kinds of useful produce, potato peels, melon rinds, pieces of candy bars for sugar, no telling what's going to go into these DP stills, what you end up drinking is the throwaway fraction of some occupying power. (652)

Apart from difficulties in finding food, the above fragment also indicates the cruel fate of ordinary people who suffer because of the ideas and actions of "some occupying power" and have to make do with waste, "the throwaway fraction."

The second group will trade what they currently possess for something to eat. For them, exchange of goods is still the norm. Slothrop, for instance, ex-

changes the lapis lazuli eyes of a doll for "a ride and half a boiled potato" (336).
Another good example can be a market scene in a German town near Wismar:

> little vortices appearing in a crowd out here usually mean black market. . . . News-
> papers already lie spread out on the cobbles for buyers to dump out cans of coffee
> on, make sure it's all Bohnenkaffee, and not just a thin layer on top of ersatz. Gold
> watches and rings appear abruptly sunlit out of dusty pockets. Cigarettes go flashing
> hand to hand among the limp and filthy and soundless Reichsmarks. Kids play un-
> derfoot while the grownups deal, in Polish, Russian, north-Baltic, Plattdeutsch.
> (674-675)

Driven to despair, the third group of people will steal from those who have
something useful, mainly something edible, for which they will get punished:

> One night Slothrop is out raiding a vegetable garden in the park. Thousands of peo-
> ple living in the open. He skirts their fires, stealthy— All he wants is a handful of
> greens here, a carrot or mangel-wurzel there, just to keep him going. When they see
> him they throw rocks, lumber, once not long ago an old hand-grenade that didn't go
> off . . . (434)

Stealing food is dangerous, especially during the war. It is still considered
a crime that requires punishment, although it ensures the survival of the fittest
during a military conflict. Pynchon provides another example: "In Mecklenburg
Thanatz steals a cigarette butt from a sleeping one-armed veteran, and is beaten
and kicked for half an hour by people whose language he has never heard be-
fore, whose faces he never gets a look at. . . . His daily bread is taken away by
another DP " (793). As he is outnumbered by the assailants, Thanatz does not
even protest against his food being taken by the foreigners.

Obtaining food during the war or immediately after it ends, and not getting
sick having consumed it, is like a wheel of fortune. If you are lucky, you feed or
are fed thanks to the hospitality and selflessness of others. Otherwise you starve
and either live to see better times or not. If you drink water without boiling it
first, you either poison yourself and suffer terribly like Slothrop after drinking
water from a pond in Tiergarten in Berlin, or you die like the refugees after
crossing the Kalahari desert who drank water until they died. It is tragic and
ironic at the same time that water which sustains life poses a deadly threat.

Paradoxically, the lack or scarcity of standard daily food products is bal-
anced, in a sort of chiastic exchange, with the excess of cigarettes, alcohol and
coffee available. There always seems to be just enough cigarettes to distribute

and share with others, to smoke after sexual intercourse or to begin one's day. "Those who happen to be smoking might last an instant longer" (59) says the narrator. The excess of this stimulant is also manifested in the variety of brand names used by Pynchon. Among the cigarettes being smoked one can find Lucky Strikes, Kyprinos Orients, Woodbines, Cravens or Armies. The same goes for the diversity of alcohol available. Pynchon names different kinds and specific brands of beer, vodka, gin, wine, brandy, whiskey or champagne, to provide just a few examples. The scene in which Slothrop suggests a drinking game and gets all his comrades drunk perfectly illustrates the excessive abuse of alcohol in the novel. In terms of coffee, there is the distinction between Bohnenkaffee, "bean coffee, the real article" (Weisenburger 222) and a luxury good during the war, and ersatz-kaffee, the wartime counterpart, which causes indigestion. Despite the hardships and danger, coffee is an extremely popular drink in the novel, usually accompanied by a cigarette or a croissant. As far as drugs are concerned, apart from being frequently smoked, they can be found in food like Hollandaise sauce accompanying broccoli (290). But the drug industry is not immune to external threat or circumstances beyond its control. As will be shown in the second part of the paper, even such a prominent business as drug market might suffer from the brutality of war to the extent that "people take the cocaine out of Coca-Cola" (537) and pray for daily bread and also for daily illusion (537).

The problem of drugs allows us to move smoothly to another set of food related issues. It can be said that drugs constitute that inflection of the food-during-the-war fold which extends or unfolds onto the conflict within the representations of food in *Gravity's Rainbow*. As stated by Gilles Deleuze, the unfolding "follows the fold up to the following fold" because "[a] fold is always folded within a fold" (Deleuze, *The Fold* 6) by means of inflections that make inclusion and extension possible. The smooth movement from fold to fold, that is the constant production of folds, is enveloped by the contemporary notion of superfold (Munster 34). The fold consisting of food during the war can be extended or unfolded to become a part of the larger fold covering the whole spectrum of food issues in *Gravity's Rainbow*. On the one end of this superfold there is food during the war and on the other end there is unusual food which is at war with reason and common sense and which will now be discussed.

The second approach to the representation of food in *Gravity's Rainbow* states that the way food is presented in the novel can be described in terms of tension and conflict, in other words, a food war. War here may mean a tension between what is normally eaten, that is, the traditional use of food products, and their distorted, misappropriated and sometimes very original use during the war. But, as it is typical of the fold, on the other extreme there is a conflict that in-

volves products, objects or concepts normally impossible to be consumed which are made edible or made to resemble edible products.

To illustrate the former part of problem – the unusual use of food – let us consider the passage in which groups of Russians complain about the lack of potatoes in the fields they cross. Potatoes are an important, if not essential, ingredient of their everyday diet. In the novel, however, they have been picked by the SS for the sake of providing fuel for the rockets: "they've been chasing these nonexistent potato fields now for a month—"Plundered . . . stripped by the SS, Bruder, ja, every fucking potato field, and what for? Alcohol. Not to drink, no, alcohol for the rockets. Potatoes we could have been eating, alcohol we could have been drinking. It's unbelievable"" (651). Indeed, it seems incredible that somebody can appropriate somebody else's food to fuel the rocket industry. The outrage seems even greater when it comes to cocaine production, as all permanganate resources are taken over and used in rocket construction. The rocket industry has brought disaster onto the cocaine market, for part of the rocket, namely the turbopump, needs potassium permanganate which is the touchstone of cocaine manufacture that determines the drug's purity. If it is possible to use potatoes to produce weapons, it is also possible to use food as a weapon. The most vivid example is the grotesque scene in which Slothrop and Schnorp use custard pies to shoot down a reconnaissance plane from the balloon they are traveling in to Berlin.

The three examples above show the unusual, even grotesque use of products normally eaten by man or used in the drug industry but also set for consumption. To a large extent, the extraordinary application of these products is determined by the external circumstances of wartime: the threat to one's life, the need to arm oneself and the unimaginable measures to obtain necessary means to do so.

The second aspect of the food war, that is, of the conflict within the realm of food, is closely related to the traumatic experience of World War II. David Cowart claims that Pynchon has been criticized for obscuring the actual horror of the death camps, and that he prefers to represent Nazi genocide and the horrors of war obliquely, more indirectly (74). Cowart's statement is supported by Eric Meyer, who states that Pynchon's text is unable to "make The War 'present,' to represent it palpably as a historical reality" (92). One of the ways the terrifying experience of war is expressed in *Gravity's Rainbow* is by means of grotesque and disgusting food sequences, comprising of "most surprisingly disagreeable flavours and unsettling combinations of ingredients" (Bevan 21). These "unsettling combinations" can be observed in several scenes involving the consumption of so-called "food," of which three deserve particular attention.

One of the most prominent instances contains propositions of dishes suggested by the participants at the Utgarthalokis' dinner, during which a surprise

roast is to be served. In order to avoid this attempt at cannibalism, the characters invent a preposterous game in which all the participants struggle with their experience of food, war and physicality, wounds and body physiology exposed in an extreme way during the war. The suggestions for dishes like snot soup, smegna stew, scum soufflé, clot casserole, scab sandwiches, booger biscuits, slime sausages or mold muffins, to name just a few milder alliterative examples of the proposed courses, seem only possible on the grounds of language, backed, however, with the experience of atrocity of World War II and the death camps. Here, as well as in the subsequent examples, the conflict appears on the level of language. War, following Eric Meyer, is the struggle for the sign (93), a struggle which could also be named as a war of words at the table, for language "brings to life unthinkable" (Bevan 21) fusions of ingredients and flavors. In addition, it is a struggle to make the absent war present in the text.

A similarly inconceivable blend of flavors takes place during the disgusting English candy drill scene in which Slothrop is made by Darlene and Mrs Quoad to taste different kinds of sweets with most unusual flavors, including: wine jelly called Marmalade Surprise with a "dribbling liquid center, which tastes like mayonnaise and orange peels" (138), cherry-quinine petit fours or eucalyptus-flavored fondant. War associations also appear in the context of the candy feast. The raspberry candy is so sour that it tastes to Slothrop like nitric acid, which is used for fertilizers, but also for liquid-fueled rockets. Some of the candies are shaped like weapons exploited during the war: "an exact quarter-scale replica of a Mills-type hand grenade, lever, pin and everything, one of a series of patriotic candies put out before sugar was quite so scarce, . . . a 455 Webley cartridge of green and pink striped taffy, a six-ton earthquake bomb of some silver-flecked blue gelatin, and a licorice bazooka" (139). One of the above candies "turns out to be luscious pepsin-flavored nougat, chock-full of tangy candied cubeb berries, and a chewy camphor-gum center" (139). The consumption of such candy is an explosion of implausible flavors that devastate the taste buds and the palate, not to mention upsetting the stomach or affecting one's head and brain. The grenade or the bomb simply goes off in your mouth. The result is that "Slothrop's head begins to reel with camphor fumes, his eyes are running, his tongue's a hopeless holocaust" (139). Slothrop's reaction to the disgusting candies is similar to the debilitating gas poisoning. The candies paralyze the senses and affect the body's organs like the gas weapons used by the Germans against Jews in concentration camps (the holocaust). The struggle with the candies is like a battle for survival during the war, of which Darlene's statement encouraging Slothrop to show a little backbone is a reminder: "Don't you know there's a war on?" (139)

The unthinkable articulated in language may also be read as an allegory. Brigadier Pudding consuming excrements and urine in another scene involving

"food" may stand for consumption in a consumerist and capitalist society, but the whole event may as well represent the totalitarian relationship between those who have power and rule, and the ordinary people who have to subordinate themselvesto the very few in power. The party in power takes in or absorbs, metaphorically speaking feeds their minds with all kinds of ideas, i.e. food for thought. That is the part of the scene in which Katje Borgesius consumes a meal, judging by the remains, consisting of some meat with Hollandaise sauce. The next steps entail reshaping the acquired ideas (the process of chewing and swallowing food), adjusting them and taking the best part for oneself (the process of digesting) and conveying the ideas in a devoured form to the people (Katje excreting into Pudding's mouth), making them consume and live off them. The subordinates, in turn, consume what those in power provide or endow them with. In order to fight the destructive effects of the imposed system (the E. coli infection) one has to take some serious protective measures to remain alive (Pudding takes penicillin prescribed by Pointsman). Unfortunately, a totalitarian system can be deadly when absorbed without measure and caution. After an illness, "Brigadier Pudding died back in the middle of June of a massive E. coli infection" (631). Not without meaning is the fact that Pudding was a military man reactivated in 1940 during World War II. He might stand for the blind obedience of soldiers to the regime and for fighting for the cause as ordered by the superiors.

Having considered all the above, it seems that although Pynchon does not refer to or describe war directly as a hateful and merciless military conflict leading to the suffering of innocent people and death in numerous ways, he expresses the cruelty of war by means of food and the brutal way it is presented and processed in the novel. What can be observed in *Gravity's Rainbow* is a transition from a representation of food during the war to a food war, a conflict between the traditional use of food for nutrition and life sustention, and its application alluding to the horrible experience of World War II. The transition acquires the form of a superfold that incorporates smaller folds, each having two extremes. The food-during-the-war fold is extended between a lack of food and its excess, while the food war fold enfolds the unusual use of food products on the one end and unthinkable combinations of ingredients that resemble food on the other. The superfold is composed of all the possible variations of food and war presented in this paper, variations that constitute one infinite continuum.

Works Cited

Ashe, Frederick. "Anachronism Intended: *Gravity's Rainbow* in the Sociopolitical Sixties." *Pynchon Notes* 28-29 (1991): 59-76. Print.

Berger, Roger. "Death Was No Enemy: A Note on Thomas Pynchon, Wilfred Owen, and the First World War." *Pynchon Notes* 20-21 (1987): 105-108. Print.

Bevan, David. *Literary Gastronomy*. Amsterdam: Rodopi, 1988. Print.

Calabrese, Omar. *Neo-Baroque: A Sign of the Times*. Trans. Charles Lambert. Princeton: Princeton UP, 1992. Print.

Cowart, David. *Thomas Pynchon and the Dark Passages of History*. Athens & London: The University of Georgia Press, 2011. Print.

Dalsgaard, Inger H. "*Gravity's Rainbow:* 'A Historical Novel of a Whole New Sort.'" *Pynchon Notes* 50-51 (2002): 35-50. Print.

Deleuze, Gilles. *The Fold: Leibniz and the Baroque*. Trans. Tom Conley. London: The Athlone Press, 1993. Print.

Lèonet, Yves-Marie. "Waking from the Apollonian Dream: Correspondences between *The Birth of Tragedy* and *Gravity's Rainbow*." *Pynchon Notes* 22-23 (1988): 35-46. Print.

Meyer, Eric. "Oppositional Discourses, Unnatural Practices: *Gravity's* History and 'The '60s.'" *Pynchon Notes* 24-25 (1989): 81-104. Print.

Munster, Anna. *Materializing New Media: Embodiment in Information Aesthetics*. Hanover & London: University Press of New England, 2006. Print.

Nagano, Yoshihiro. "The Formation of the Rocket-Nation: Abstract Systems in *Gravity's Rainbow*." *Pynchon Notes* 52-53 (2003): 81-99. Print.

Pynchon, Thomas. *Gravity's Rainbow*. London: Vintage Books, 2000. Print.

Rosenberg, Martin E. "Invisibility, the War Machine and Prigogine: Physics, Philosophy and the Threshold of Historical Consciousness in Pynchon's Zone." *Pynchon Notes* 30-31 (1992): 91-138. Print.

Weisenburger, Steven. *A Gravity's Rainbow Companion: Sources and Contexts foe Pynchon's Novel*. Athens & London: The University of Georgia Press, 1988. Print.

Eating Itself to Death: The USA as Seen by McCarthy and Twain

Agnieszka Kaczmarek

In an 1868 short story "Cannibalism in the Cars" by Mark Twain, train passengers become captives in a snowdrift. With plenty of wood to keep warm, but no food, they form a committee to nominate candidates who will be nutritious to eat. In Cormac McCarthy's Pulitzer Prize-winning novel entitled *The Road* (2006), a father and his son struggle desperately to remain alive in a post-apocalyptic world where the main source of sustenance is human flesh. By juxtaposing selected episodes from these two texts, I would like to present Twain's and McCarthy's disturbingly similar visions of eating Americans, and to discuss the uses of the theme of cannibalism.[1]

One may ask whether it is worth juxtaposing these two seemingly different writers, if Twain, who employed humor as his main literary tool, was influenced, among others, by Artemus Ward, one of the most popular 19th-century American humorists, while McCarthy is considered to be the spiritual heir of William Faulkner (Frye 3). However, the publication of *The Road* has definitely enlarged the circle of its author's literary models, and prompts the analyses of McCarthy's prose in view of Twain's writing (Sheehan 96).[2] Furthermore, "Cannibalism in the Cars" and *The Road* share strikingly close similarities. Both works were created during key moments in US history. The former came out after the Civil War, in the November 1868 issue of *Broadway* printed by George Routledge and Sons (Bird 123), and the latter was published after the outbreak of the military conflict in Iraq in 2003. Despite some obvious differences that arise from the length of the works under comparison, it is possible to draw inter-textual parallels between McCarthy and Twain. Their protagonists are men on the road, a motif traditionally read as the process of regaining or raising consciousness on particular issues. They also have to go through ordeals resulting from the fearsome forces of nature, and are forced to adapt to hostile environments. As Maggie Kilgour claims, anthropophagy – traditionally employed to lampoon freeloaders in society – in the era of capitalism carries a new shade of meaning and criticizes those "seen as consuming without producing" (241). Whereas Twain's text does exemplify political satire, *The Road*, written by

1 For the sake of clarity, "Cannibalism in the Cars" is cited in brackets as CC, and *The Road* as TR.

2 Sheehan also mentions Hemingway, Steinbeck, and Flannery O'Connor.

McCarthy who was brought up in capitalism, does not seem to touch upon the problem voiced by Kilgour. With the motif of cannibalism, Twain and McCarthy evidently blur the clear-cut distinction between the savage and the civilized, presenting the crisis of universal values in their homeland. Therefore, in the brutal scenes they describe we may find the Freudian interpretation of anthropophagy as an expression of the fear of losing independence and autonomy, as well as a yearning for safety and a sense of belonging to a given place (Davis and Hurm 57).

Before we take a closer look at the motif of cannibalism, it is interesting to consider Twain's short story and McCarthy's novel against a wider historical background. Both writers composed their narratives when the US faced the crises of identity which distorted the image of the country as a democratic nation. Greatly interested in history and biography (Branch 584), Twain penned "Cannibalism in the Cars" a few years after the Civil War, which had divided not only the country but many families between the Union and the Confederacy, with Lincoln and his wife, Mary Todd Lincoln, serving as a classic example in this regard.[3] After the military conflict, which had involved brotherly fights in a literal sense, Americans had to reorganize their state during the so-called Reconstruction, which was, in fact, "the carnival of corruption" (Nye and Morpurgo 556). Moreover, scholars are agreed on the impact of the experience Twain gained in Washington, D.C. as secretary to Senator William M. Stewart (Branch 585). While working for Stewart at the turn of 1867 and 1868, a period that overlaps with the writing of "Cannibalism in the Cars," Twain observed the growing tension between Congress and President Andrew Johnson, and followed the proceedings of the first presidential impeachment in American history. Thus, apart from the writer's disillusionment with the then government, "Cannibalism in the Cars" reflects "a dark and disturbing vision of the America Twain saw developing at the time" (Davis and Hurm 47; 54).

According to Frye, history and the transformations it brings are deliberately echoed in McCarthy's characters' thoughts, statements, and queries, although historical events do not form the basic foundation of his narrative (Frye 4). With reference to Vince Brewton, Pierre Lagayette also claims that "some clear and discernible correlation exists between McCarthy's work and the cultural periods that inspired them and led to their publication" (80). McCarthy's *The Road* came out in 2006, after the Bush administration's main justifications for the Iraq War were proved to be wrong, that is, after the 2004 Duelfer Report, which stated that no evidence was found for the purported weapons of massive destruction

3 Stephen W. Berry, *House of Abraham: Lincoln and the Todds, a Family Divided by War*. Boston: Houghton Mifflin, 2007.

programs. In his conclusive remarks on the novel, Paul Sheehan points to "the most sinister 'ghost' in *The Road*," which is "the Western response to the 'worstness' of Islam," voiced by Bush when he declared war on terrorism in 2001 (104). For Lagayette in turn, the events described in *The Road* cast doubt upon the aftereffects of the Cold War, and, consequently, question "the very way Americans regard themselves as the only true defenders of right and virtue" (84). Furthermore, the story of the man and the boy appears to be a sequel to *Cities of the Plain* in McCarthy's saga. In the latter novel, published in 1998, in addition to referring to the USA as a "pale empire" and a "leprous paradise," McCarthy's protagonists discuss the post-World War II period in their homeland:

> Anyway this country aint the same. Nor anything in it. The war changed everything. I dont think people even know it yet...
>
> How did the war change it?
>
> It just did. It aint the same no more. It never will be. (*Cities* Kindle ch. 1)

Both Twain and McCarthy consciously prepare us for the scenes of anthropophagy. The short story of cannibalism takes place in December of 1853, when a heavy snowstorm starts late in the evening, and the night turns into "the pitchy darkness" (CC 111). With sinister gusts of wind, the snow deepens very quickly, and the train gradually reduces speed, finally coming to a stop. The railroad track is blocked with enormous drifts compared to "colossal graves" heralding death to the reader (CC 111). The earlier animated conversation ceases and the passengers become overwhelmed by "that tremendous prairie solitude that stretches its leagues on leagues of houseless dreariness" (CC 111-112). In addition to the inclemency of the weather and the inhospitableness of the place, the broken part of the driving wheel foreshadows impending disaster. Finally, after a few days of great hunger, the "cadaverous and pale" Richard Gaston articulates the pragmatic thought on everyone's mind: if there are no provisions whatsoever, one of the passengers has to make the supreme sacrifice to save the rest.

After a heated discussion full of reasoned argument and polite expressions, the passengers decide upon their first, long-awaited dinner, Mr. Lucius Harris of St. Louis, whom the narrator is particularly fond of: "I liked Harris. He might have been better done, perhaps, but I am free to say that no man ever agreed with me better than Harris, or afforded me so large a degree of satisfaction" (CC 115). Upon the breakfast menu, the same narrator comments:

Messick was very well, though rather high-flavored, but for genuine nutritiousness and delicacy of fiber, give me Harris. Messick had his good points – I will not attempt to deny it, nor do I wish to do it – but he was no more fitted for breakfast than a mummy would be, sir – not a bit. Lean? – why, bless me! – and tough? Ah, he was very tough! You could not imagine it – you could never imagine anything like it. (CC 115-116)

Still, the reader does imagine it, as the scene of cannibalism is prolonged with additional descriptions of the meals whose main course consists of human flesh.

As clearly seen above, "Cannibalism in the Cars" abounds with comic elements like the majority of Twain's literary pieces. Despite its murky subject matter, the story makes the reader smile due to the style of writing typical for Twain, who exposes morally important but thorny issues in a very playful manner. The chief source of humor in the tale being analyzed is clearly the ceremonial language of politics employed by the passengers to select the victims they are going to eat (Bird 123). In effect, the reader needs to read a few lines of the cannibals' dialogue to realize that Twain's story is a highly critical commentary on the American legislative body, and instead of the title "Cannibalism in the Cars" the tale could be renamed "Cannibalism in the US Congress." As revealed in the first paragraph of the story, the narrator Twain is "from Washington," which, as mentioned before, reflects the writer's own experience, and his interlocutor is "perfectly familiar with the ins and outs of political life at the capital" (CC 110). One after another, the passengers "nominate" a candidate for their first meal; Mr. Bascom of Ohio suggests that "the House proceed to an election by ballot;" Mr. Sawyer of Tennessee opposes it and advocates that first they should "elect a chairman of the meeting and proper officers to assist him;" Mr. Bell of Iowa would like "to offer a resolution," and finally "the motion to elect officers . . . [is] passed" (CC 112-113). Clearly, the whole procedure quickly turns into a farce. The absurdity of the Congressional proceedings is reinforced by the fact that the cannibals address the audience as "Gentlemen." In addition to the superficial vocabulary of politeness, Twain criticizes the workings of the US Congress, including the trivial discussions and lack of seriousness in dealing with important issues, the lack of decency, the heartless moral code, and the inhumane pragmatism, all readable in the statement by Mr. Halliday of Virginia:

I move to further amend the report by substituting Mr. Harvey Davis of Oregon for Mr. Messick. It may be urged by gentlemen that the hardships and privations of a frontier life have rendered Mr. Davis tough; but, gentlemen, is this a time to cavil at toughness? Is this a time to be fastidious concerning trifles? Is this a time to dispute about matters of paltry significance? No, gentlemen, bulk is what we desire –

substance, weight, bulk – these are the supreme requisites now – not talent, not ge-
nius, not education. (CC 114)

To put it another way, the characters' behavior, even if exaggerated, reflects
Twain's critical comment on the American state machinery, yet we should not
overlook the fact that his cannibals are regular train passengers. By attributing
bloodthirsty traits to ordinary citizens, the author obviously finds fault with
American society, which has elected its representatives to Congress since the
origins of the country.

The longer the travelers cannibalize, the more grotesque the story becomes,
but we obviously laugh less and less. However, our laughter never turns into the
disgust arising from McCarthy's descriptions in *The Road*. What also decreases
the intensity of distaste while reading Twain is the fact that "Cannibalism in the
Cars" exemplifies a frame tale, a story within a story, which helps to increase
our distance from the sophisticatedly discussed brutality (Bird 123). In addition,
the reader realizes quite early that not everyone was eaten, if a participant of that
grisly event is still alive. The end of the story is reassuringly optimistic, as well,
when the train conductor, questioned about the cannibal narrator, refers to him
as "a monomaniac," and Twain, the narrator of the first story, acknowledges him
to be "a madman" recounting "harmless vagaries," not "a bloodthirsty cannibal"
(CC 117). Be that as it may, we cannot be absolutely certain that the nightmare
scenario is just the fabrication of the insane monomaniac, if it is finally revealed
that the alleged anthropophagus became snowbound, which resulted in his being
"sick and out of his head two or three months afterward" (CC 117). Twain thus
makes the story inconclusive by putting a question mark at the end over the
country's destiny.

A science fiction novel with naturalistic descriptions, *The Road* presents
McCarthy's vision of a post-apocalyptic world where human beings are in dan-
ger of becoming extinct. When we start to read the first paragraph of *The Road*,
we immediately enter a theater of horror and fear. Cold, in stinking clothes, cov-
ered with dirty blankets and a piece of tarpaulin, the main character of the novel
has just awakened from a nightmare that we know will continue. In his dream,
he and his son illuminate the way in a cave, and the boy leads the father to "a
black and ancient lake" (TR 1-2). There, on its shore, they find a blind, semi-
transparent creature, whose "eyes dead white" are compared to "the eggs of spi-
ders" (TR 2). Its pulsating heart, brain, and bones are not only visible to the na-
ked eye, but they also cast a shadow on the walls of the cave (TR 2). Corre-
sponding to the blind beast from the dream, the world in which McCarthy's
characters have to wake appears to be suffering from "glaucoma," an eye dis-

ease that may lead to complete loss of vision (TR 1; Danta 10). In other words, from the very first pages, the USA the novelist depicts is far away from the image of a political and economic superpower, and instead represents a land that has lost its bearings in the world.

According to Alex Hunt and Martin Jacobsen, in the introductory fragments of *The Road* the reader finds a clear reference to Plato's *Republic*, which uncovers his "Allegory of the Cave" and "Simile of the Sun" (155-156). Obviously, the novel presents a distorted version of the philosophy. The sun, which in *Republic* symbolizes the constant absolute that illuminates forms and objects, in *The Road* disappears irretrievably, covered with clouds of ashes, which indicates a world devoid of truth and replete with shadows. Moreover, in *Republic* the eye stands for changeable, sometimes erroneous, human perception, whereas the author of *The Road* puts forward the suggestion that the eye of the world is not only wrong, it is sick, with no signs of recovery. Hunt and Jacobsen also note that Socrates' disciple in *Republic* is Plato's brother, Glaucon, and his name and the word "glaucoma" come from the Greek term *glaukos*, equivalent to the English "glaucous," denoting a pale tint of gray, the dominant color of the landscape painted in *The Road* (156-157). It is worth stressing that not only the material world is gray in the novel. As Danta remarks, the heart of the father is also this color: "Raw cold daylight fell through from the roof. Gray as his heart" (TR 27), which means that it "must take account of the shattering of the world" (Danta 19).

Apart from the grayish overtones, McCarthy, similarly to Twain, composes a world of gradually deepening blackness, as the nights are not only dark – they are "dark beyond darkness and the days more gray each one than what had gone before" (TR 1). To escape the steadily dropping temperature, the father and the son are constantly on the road, heading south. "Barren, silent, godless" (TR 2), the USA they cross is burnt to the ground by firestorms, and "everything dead to the root" (TR 20) is covered with ashes as far as the eye can see: "the shoals of ash and billows of ash rising up and blowing downcountry through the waste" (TR 13). What the good guys, as the characters call themselves, pass on the way are dilapidated buildings and abandoned roadside gas stations plundered of their last drop of fuel a long time ago. The cities they walk through are literal graveyards with valueless money scattered in supermarkets and worthless but dead human life here and there. Long-faded billboards advertize goods it is no longer possible to find or buy (TR 135), whereas high-priced electronic equipment "[sit] unmolested on the shelves" (TR 195). Pharmacies remain empty, and water with sugar is the only obtainable remedy for any kind of disease (TR 267). In barns, there are no horses or cows, just the lingering odor of extinct farm an-

imals (TR 127), and old newspapers present "quaint concerns" like the time when flowers close their petals (TR 28).

Severe, terrible famine constantly permeates McCarthy's world of darkness, and it is simply impossible to skim through the numerous passages on food, an easily available product to the *homo capitalisticus* of the present-day West, but a luxury to the characters of *The Road*. When it is not perilous to build a fire, and there is something to eat, they have canned food: sausages and corn, beans or potatoes, frequently splitting one portion into two (TR 76). One of their meals consists of fermented, cold beans with rice, prepared days before when they had a chance to cook them safely (TR 29). Grateful for whatever is available, after the meals they rinse the cans with water, drinking everything to the last drop. Most of the time, however, the father and the boy live below starvation level. Compared to "sappers" (TR 83), they usually scavenge through debris and trash, inside and outside ruins which have been checked thoroughly many times before. In the hope of finding edible leftovers, they once ferret out a bit of corn-meal which rats have already helped themselves to, but which the sappers make cakes with (TR 88). Another time, their main and only course is a handful of dried raisins eaten "in the dead grass by the side of the road" (TR 92). Usually hostile, nature occasionally offers some sparse fare: a few shrunken, dried mushrooms (TR 40), or a few dried, tasteless apples (TR 127-128). With nothing in their knapsacks, they are forced to eat dirty snow (TR 107), or drink marshy water (TR 214), which becomes the main course more and more frequently on their journey to the south.

Although very occasionally, McCarthy does allow miracles to occur in the land of dead vegetation. From time to time, there is a rare treat for the novel's characters, such as a can of Coca Cola, seen as "a poignant reminder of a lost civilization" (Sheehan 106). As the boy drinks it for the first time in his life, its smell and bubbles constitute an extraordinary experience which the father wishes to prolong, acutely aware it is unlikely to happen again (TR 22-23). Another miracle that occurs is the bunker full of "the richness of a vanished world," namely spaghetti sauce, stew and different soups (TR 147). There they can stay a bit longer than just one day, so they have time to take a bath, cut their hair, and wash their jeans. The menu of another feast they enjoy under a roof and by a fire consists of hot potatoes and beans. Eating out of bone china dishes, they unhurriedly swallow the simple fare, with "the pistol lying to hand like another dining implement" (TR 224). For safety reasons, they even decide to hide their trash in case those following them think they have plenty of food (TR 205).

With hardly anything to eat, people consume whatever is left, and if the only beings alive are humans, the main source of sustenance is human flesh. Not a rat race any longer, life on the road turns into a continuing hunt, whose possible

ending is plainly described by the man's wife before she commits suicide. To all arguments against self-destruction, she answers: "Sooner or later they will catch us and they will kill us. They will rape me. They'll rape him. They are going to rape us and kill us and eat us and you wont face it" (TR 58). The reality of the road is even more horrid when the characters enter a southern mansion with white Doric columns in front, where, as it is mentioned, slaves used to serve dishes on silver trays (TR 111-112). With the heaps of clothes, shoes, belts, and sleeping bags, the house turns out to be a concentration camp in which there is a cellar full of people kept alive as food supplies: "Huddled against the back wall were naked people, male and female, all trying to hide, shielding their faces with their hands. On the mattress lay a man with his legs gone to the hip and the stumps of them blackened and burnt. The smell was hideous" (TR 116). Terrifying as it is, the scene leaves little to imagination, showing very vividly that the ages-old civilization is burning at the stake. In the dehumanized vision of the US created by McCarthy, slaves do not bring food anymore – they serve as food themselves.

To protect himself and the boy, the father, after teaching his son how to carry the fire inside him, that is, how to be good despite the circumstances, turns into a murderer. In self-defense, he has to kill in order not to be eaten or let anybody eat the boy. When he returns to the scene of the crime to gather their belongings left behind in their hurry, the parent finds just the skin, bones, and guts of his victim which have been boiled and devoured by the man's comrades (TR 73). Needless to say, the shooting affects the boy, yet the father also struggles to rationalize the event to himself. Unlike the speaker in Thomas Hardy's poem "The Man He Killed," the protagonist of *The Road* does not treat the man he annihilated as his would-be friend, but as a carnivorous animal in search of prey: "My brother at last. The reptilian calculations in those cold and shifting eyes. The gray and rotting teeth. Claggy with human flesh" (TR 79). In an attempt to ease his conscience, the father explains to himself that his responsibility is the child, and his job is to "wash a dead man's brains out of his [boy's] hair" (TR 77). If he shirks this duty, he may see what he and his son have seen before: "a charred human infant headless and gutted," left roasting on the grill (TR 212), but next time it could be different, it could be his boy.

The question remains what else Twain and McCarthy would like to reveal to us apart from the degree of cruelty leaking out of the scenes of cannibalism. In their thought-provoking analysis of "Cannibalism in the Cars," Adam B. Davis and Germ Hurm note that in literary texts "the metaphor of cannibalism is tied to fear of major cultural realignments, fear that culture itself will ultimately fail in its essential function (as an idea, at any rate, if not in fact) of distinguishing the human from the 'lower' creatures" (49). Clearly, in both the literary texts under

scrutiny, the failure of culture is painfully evident, as the human is replaced with the predatory. In Twain's story, the art of argumentation, traditionally attributed to learned persons, has been employed effectively by the well-mannered cannibals to kill their fellow passengers. As Davis and Hurm also note, "language, mankind's claim to distinction, is made to deny and yet imply the possibility of a predatory and barbaric core after all" (53). In other words, sophistication and refinement, linked with culture in a broad sense, help the anthropophagi to act pragmatically and exterminate the Other. This visualized fiasco of civilization in post-Civil War America is verbalized emphatically by Twain's character, Mr. Halliday of Virginia, who claims that "substance, weight, bulk – these are the supreme requisites now – not talent, not genius, not education" (CC 114). Thus, to claim that "Cannibalism in the Cars" is solely a political lampoon would be an undue simplification. Instead, it represents "a fable of man's general condition" (Brach 591), and additionally reveals the "essentially cannibalistic nature" of humankind (Davis and Hurm 55), no matter how civilized or educated.

Davis and Hurm's juxtaposition of anthropophagy with the cultural degradation of humanity from the civilized to the primitive is highly visible in *The Road* as well. The majority of the remaining population is comprised of hordes in rags, holding pipes, chains, clubs, and any other things useable as a weapon. The chief characters of the novel are depicted as "two hunted animals" (TR 138), chased by the hunting, animal-like humans with "reptilian calculations" in their cold eyes (TR 79). According to Paul Sheehan, McCarthy's cannibals resemble zombies rather than vampires, since they embody horror and terror with no aristocratic inclinations (94). Interestingly enough, Sheehan regards the anthropophagus as "the anti-capitalist par excellence," because instead of accumulation there happens to be the consumption of his own kind (95). He concludes: "the loss of civilization, therefore, is signified by a disconcerting compact: the absence of capitalist exploitation, in favor of the horrors and abominations of cannibal consumption" (95).

Synonymous, for example in Kerouac, with fruit-bearing personal experience, the road has traditionally been equivalent to progress and the advancing civilization. As represented in McCarthy's novel, the road seems to provide both positive and negative imagery. Thanks to the remaining system of interstate routes, it is easier for the protagonists to proceed further and further, to the warmer parts of the country. However, the hazard of losing their lives regularly outweighs this positive aspect. As Sheehan claims, "the man and the boy's journey is permanently fraught with danger because the road entails *visibility*, and this, in turn, convokes *vulnerability*, that is, exposure to others . . . [who], as a general rule, mean death" (95). As a result, the picture of the American road symbolizing all the blessings of capitalism, prosperity, improvement and mo-

dernity has been cracked as has the asphalt itself. No longer safe to walk on, not bumpy but broken, the road in McCarthy turns into "a strangely ominous and suspenseful space, suggestive of a threatening, uncanny 'post-America'" (Sheehan 95), the waste land where *homo homini lupus est.*

It should be stressed that cannibalism is just another version of the brutality omnipresent in McCarthy's fiction since *The Orchard Keeper*, his literary debut in 1965. The recurrent waves of violence do not come as a surprise, if the author openly treats cruelty as a fact of everyday life. In his first interview with Richard B. Woodward, meaningfully entitled "Cormac McCarthy's Venomous Fiction," he shares with the interviewer part of his personal philosophy: "There's no such thing as life without bloodshed . . . I think the notion that the species can be improved in some way, that everyone could live in harmony, is a really dangerous idea. Those who are afflicted with this notion are the first ones to give up their souls, their freedom. Your desire that it be that way will enslave you and make your life vacuous" (Woodward). It is worth mentioning that the constant eruption of violence in McCarthy's works may reflect, among other things, his readings in Gnosticism, which plainly advocates the dominance of evil in the world (Frye 5).

In the case of McCarthy, the manifestation of barbarous behavior is not exclusively indicative of cultural failure. In fact, the author of *The Road* explicitly pictures the fall of Western civilization exemplified by the US in the fragments invoking book collections. While penetrating the post-apocalyptic world, the father once "stood in the charred ruins of a library where blackened books lay in pools of water. Shelves tipped over. Some rage at the *lies* arranged in their thousands row on row" (TR 199; emphasis mine). Another time, in another run-down place, the man found "soggy volumes in a bookcase. He took one down and opened it and then put it back. Everything damp. Rotting" (TR 138). When he walked out of the building, he eyed the gray reality, the desolate ground, the ubiquitous ashes, and there he saw "the absolute truth of the world" (TR 138). The picture is plain: the world of ideas is smashed to pieces, and the accumulated wisdom of generations amounts to a pack of lies. Thus considered, Jorge Luis Borges's total Library of Babel still remains "useless," yet it stops being "perfectly motionless," "incorruptible," and "infinite" (85). In contrast to Borges's fiction, the symbol of knowledge and culture does not endure in McCarthy's work, passing away together with those who created it.

The transition from the pre-catastrophic world to the post-apocalyptic one brings about the impoverishment of language, the means of communication as well as the basic carrier of culture. In the long run, it obviously results in "the death of names" (Pryor 33), the unstoppable process that the main character is acutely aware of:

The world shrinking down about a raw core of parsible entities. The names of things slowly following those things into oblivion. Colors. The names of birds. Things to eat. Finally the names of things one believed to be true. More fragile than he would have thought. How much was gone already? The sacred idiom shorn of its referents and so of its reality. Drawing down like something trying to preserve heat. In time to wink out forever. (TR 93)

As shown above, McCarthy does not limit his narration to informing the reader that the gradual extinction of the language is the subject of his main character's deliberations. A stylistic virtuoso, the author of *The Road* minimizes syntax by reducing sentences to short phrases, or even single words. This intended linguistic limitation significantly helps him to create the atmosphere of loss omnipresent in the novel. It also stresses the emptiness of meaning and lack of creative thinking in the post-apocalyptic world, which, by focusing exclusively on food and safety, becomes "a world on the literal verge of the posthuman" (Snyder and Snyder 36). However, it does not mean that McCarthy reduces the means of expression to a minimum. Quite the reverse—he is well-known for his deep affection for language. While composing a narrative with poetic overtones, he is able to write prose characteristic of a skillfully variable syntax and a noticeably rich diction (P. Snyder and D. Snyder 31-33). Not only does McCarthy coin new words, but he also employs archaisms from multiple sources, e.g., nineteenth-century military guidebooks (35). By a curious paradox, the archaisms used obviously highlight his impressive lexicon, yet in *The Road* they additionally become "a sign of civilization's fall" (Pryor 33), stressing the bygone era before the apocalypse. Thus, similarly to Twain's text, cannibalism is not the only phenomenon described in *The Road* to express the failure of broadly defined culture. Through his conscious choice of words and through his character's deliberations over "the death of names" (Pryor 33), McCarthy also shows how language as the basic carrier of culture registers its fall, additionally voicing in this way his concerns about the country he lives in.

The acts of cannibalism depicted by McCarthy and Twain are obviously the fatal consequences that have ensued from the scarcity of food. In Twain's story, it is clearly explained to the reader why the passengers feel forced to devour other travelers. By contrast, McCarthy reveals no adequate reasons for the global catastrophe, about which we have sparse information. Consequently, there has been speculation over its most likely causes: either a nuclear disaster or an ecological cataclysm (Danta 11). When asked by *The Wall Street Journal* about the calamity described in the novel, McCarthy admits it is insignificant to specify what kind of disaster befell the earth: "I don't have an opinion. At the Santa Fe Institute I'm with scientists of all disciplines, and some of them in geology said

it looked like a meteor to them. But it could be anything - volcanic activity or it could be nuclear war. It is not really important" (Jurgensen). Nevertheless, McCarthy's well-known ecological concerns reverberate through the very same statement, when he continues his reply and touches upon the possible eruption of the Yellowstone caldera, adding that its last explosion covered the whole surface of North America with a one-foot layer of ash (Jurgensen), the desolate gray landscape familiar to the reader of *The Road*. Neither Twain nor McCarthy suggests a man-made catastrophe that leads to the practice of cannibalism. The author of the short story analyzed here points straight at the invincible forces of nature, whereas the twentieth-century writer prefers to refrain from a clear-cut explanation, although he gives an indirect indication of a natural disaster as well.

Interestingly enough, the failure of culture depicted through the metaphor of cannibalism appears to be interlaced with the collapse of technology overpowered by nature. In both stories, there is the motif of the train (in Twain, on the prairie, and in McCarthy, in the woods), which reminds us of "the machine in the garden" defined by Leo Marx in his 1964 book, among other things, as the tension resulting from the intrusion of technology into the pastoral ideal. Obviously, in both the analyzed texts the garden is lost, and there is not "the machine's increasing domination" that Marx touches upon (364). Quite the contrary, as in "Cannibalism in the Cars" one of the parts of the train breaks down in the struggle with massive snowdrifts, and in *The Road*, the shortage of fuel makes the engine come to a dead halt. Thus both Twain and McCarthy are very explicit about the domination of nature over people, its crushing power and their futile attempts to deal with adverse circumstances. What we observe in the scrutinized texts is the reverse picture of "the machine in the garden," that is, the next phase Western civilization entered, or, in the case of McCarthy, is entering, after technological revolutions. In reference to Twain, we should remember that he composed the story while the first transcontinental railroad was nearing completion (the Union Pacific built a railroad west from the Mississippi, and the Central Pacific east from California). As Dana Sliva observes, in "Cannibalism in the Cars," Twain "uses the advent of the train to represent the societal fear of technological failure," and "the stopping of the train by nature represents not only the end of progress, but the end of civilization"(2), known before the arrival of the train, we could add. In effect, we may express a similar opinion with regard to *The Road* by McCarthy, as the technological failure is depicted through the fuelless train, cars caked with ash, and "unmolested" computers. Of course, with such imagery, McCarthy does not announce an end to technological innovations. Rather, he would like us to reconsider our human relations by putting aside electronic devices, which definitely upgrade standards of living, yet do not seem to improve the quality of life in communities.

In conclusion, Twain's vision of the US in the late 1860s and McCarthy's representation of his country on the threshold of the third millennium overlap. Through the metaphor of anthropophagy, both writers express their deep cultural, social, and political concerns about the direction the US decided to take after history-making events. By interpolating the brutal scenes into the stories, the authors describe their America as a spiritual desert where the moral values the USA has always officially identified with do not prevail. In Twain's short story and *The Road*, cannibalism indicates the fall of broadly defined culture, which, in both texts, is additionally exemplified by the authors' attitude to language, and interwoven with the failure of technology. Obviously, it does not mean that both McCarthy and Twain announce the final and inevitable fall of civilization. In "Cannibalism in the Cars," there is a hint that some anthropophagi survived, and the last pages of *The Road* raise hopes that the boy will endure, roaming further with the nuclear, two-parent family that found him. In other words, the motif of cannibalism helps the artists express an acute anxiety that on the path of inner and national development, on the journey to a better tomorrow, we lose cultural universals which are far more important than what we consume. Yet, no matter how much we fear "cultural realignments" signaled by the metaphor of cannibalism (Davis and Hurm 49), Twain and McCarthy suggest that we have to move on. At the end of the short story, the monomaniac wishes the narrator "a pleasant journey" (CC 117), and in *The Road*, the father, before he dies, instructs the boy to keep going south and have the gun close to him all the time: "You need to go on, he said" (TR 297), so we also need to keep going.

Works Cited

Bird, John. "Cannibalism in the Cars." *The Routledge Encyclopedia of Mark Twain*. Eds. J.R. LeMaster and James D. Wilson. New York: Routledge, 2011. 123-124. Web. 17 Sept. 2013.

Borges, Jorge Luis. "The Library of Babel." Trans. James E. Irby. *Labyrinths: Selected Stories and Other Writings*. Eds. Donald A. Yates and James E. Irby. Harmondsworth: Penguin Books, 1983. 78-86. Print.

Branch, Edgar M. "Mark Twain: Newspaper Reading and the Writer's Creativity." *Nineteenth-Century Fiction* 37.4 (1983): 576-603. Jstor. Web. 21 Aug. 2013.

Danta, Chris. "'The Cold Illucid World': The Poetics of Gray in Cormac McCarthy's *The Road*." *Styles of Extinction: Cormac McCarthy's The Road*. Eds. Julian Murphet and Mark Steven. London: Continuum International Publishing Group, 2012. 9-26. Print.

Davis, Adam Brooke, and Gerd Hurm. "At the Margins of Taste and the Center of Modernity: Mark Twain's 'Cannibalism in the Cars'." *New Literary History* 29.1 (1998): 47-65. *Jstor*. Web. 21 Aug. 2013.

Frye, Steven. "Histories, Novels, Ideas: Cormac McCarthy and the Art of Philosophy." *The Cambridge Companion to Cormac McCarthy*. Ed. Steven Frye. New York: Cambridge UP, 2013. 3-11. Print.

Hardy, Thomas. "The Man He Killed." *The Poetry Foundation*. Web. 7 Oct. 2013.

Hunt, Alex, and Martin M. Jacobsen. "Cormac McCarthy's *The Road* and Plato's 'Simile of the Sun.'" *Explicator* 66.3 (2008): 155-158. Web. 14 Oct. 2013.

Jurgensen, John. "Hollywood's Favorite Cowboy." *The Wall Street Journal*. 20 Nov. 2009. Web. 5 Jan. 2014.

Kilgour, Maggie. "The Function of Cannibalism at the Present Time." *Cannibalism and the Colonial World*. Eds. Francis Barker, Peter Hulme, and Margaret Iversen. Cambridge UP, 1998. 238-259. Web. 11 Jan. 2014.

Lagayette, Pierre. "The Border Trilogy, *The Road*, and the Cold War." *The Cambridge Companion to Cormac McCarthy*. Ed. Steven Frye. New York: Cambridge UP, 2013. 79-91. Print.

Marx, Leo. *The Machine in the Garden*. London: Oxford UP, 1979. Print.

McCarthy, Cormac. *Cities of the Plain*. Picador, 2010. Kindle.

--- . *The Road*. London: Pan Macmillan, 2009. Print.

Nye, Russel Blaine, and J. E. Morpurgo. *A History of the United States. The Growth of the United States*. Vol. 2. Harmondsworth: Penguin Books, 1955. Web. 15 Nov. 2013.

Pryor, Sean. "McCarthy's Rhythm." *Styles of Extinction: Cormac McCarthy's The Road*. Eds. Julian Murphet and Mark Steven. London: Continuum International Publishing Group, 2012. 27-44. Print.

Sheehan, Paul. "Road, Fire, Trees: Cormac McCarthy's post-America." *Styles of Extinction: Cormac McCarthy's The Road*. Eds. Julian Murphet and Mark Steven. London: Continuum International Publishing Group, 2012. 89-108. Print.

Sliva, Dana. "The Little Engine That Couldn't: Societal Fears, Upward Mobility, and the Failure of Technology in Mark Twain's Works." *Agora* 16 (2007): 1-7. Web. 21 Aug. 2013.

Snyder, Phillip A., and Delys W. Snyder. "Modernism, Postmodernism, and Language: McCarthy's Style." *The Cambridge Companion to Cormac McCarthy*. Ed. Steven Frye. New York: Cambridge UP, 2013. 27-38. Print.

Twain, Mark. "Cannibalism in the Cars." *The Oxford Book of American Short Stories*. Ed. Joyce Carol Oates. Oxford: Oxford UP, 1994. 110-117. Print.

Woodward, Richard B. "Cormac McCarthy's Venomous Fiction." *The New York Times Magazine*. 19 Apr. 1992. Web. 14 Nov. 2013.

Part Four: Sustenance

"Resistance Is the Opposite of Escape": Still Life as Sustenance in the Poems of Wallace Stevens and Gertrude Stein

Paulina Ambroży

In his lecture "The Irrational Element in Poetry," delivered at Harvard in 1936, Wallace Stevens expresses a concern central to the understanding of still life's place in the imagination of modernist poets and artists:

> We are preoccupied with events, even when we do not observe them closely. We have a sense of upheaval. We feel threatened. We look from an uncertain present towards a more uncertain future. One feels the desire to collect oneself against all this in poetry as well as in politics. If politics is nearer to each of us because of the pressure of the contemporaneous, poetry, in its way, is no less so and for the same reason. [...] Resistance is the opposite of escape. The poet who wishes to contemplate the good in the midst of confusion is like the mystic who wishes to contemplate God in the midst of evil. There can be no thought of escape. Both the poet and the mystic may establish themselves on herrings and apples. The painter may establish himself on a guitar, a copy of *Figaro* and a dish of melons. These are fortifyings although irrational ones. The only possible resistance to the pressure of the contemporaneous is a matter of herrings and apples. (Stevens, *Opus* 225)

The painter Stevens is referring to is Picasso, whose papier-collé still lifes from 1912 show avant-garde art's tenuous positioning against the pressures of the real. For example, his *Glass and Bottle of Suze* of late 1912 features a silhouetted and somewhat elusive table with a glass and a bottle in a surrounding of pasted press cuttings about socialist anti-militarist demonstrations and the war in the Balkans. The painting, in which the private and intimate world of still life is assaulted and contaminated by the public discourse of politics and the war, problematizes the tensions between the aesthetic individualistic practice of the avant-garde and the historical condition in which it emerged. Through the wallpaper scraps and the table, which are markers of the private interior, Picasso references the still life's decorative function and its "ideology of aestheticism" (Cottington 132), while the disorderly cheap newspaper cuttings also pull us outside this space into the contingent and discursive "pressures of the contemporaneous."

Bearing in mind Picasso's dislocations of the boundaries between the private and public concerns of art, and drawing on Stevens' premise which in the modern still life sees forces of resistance and sustenance against the contemporary

confusion and upheaval, I shall examine the "matter of herrings and apples" in the works of two masters of this ekphrastic genre: Wallace Stevens and Gertrude Stein. Their idiosyncratic practices and distinctive imaginative orders serve to enrich our understanding of the complexity and potential of poetic still life. And thus, the goal of the study is to investigate how the fragility of human experience and the continuously "turning worlds" of modernity are reflected in Stevens' leanings towards the expressive potential of chiaroscuro, with its dark disquiet in the manner of seventeenth century art, and Stein's obsession with the "thingness" of the word and her use of still life as a form of sustenance against private turbulence and change. In my analyses of selected poems from Stevens *Parts of a World* and Stein's *Tender Buttons*, I will try to show that still life reveals the urgency of time for Wallace Stevens, and for Stein – "intersections between objects and consciousness" (Dubnick 72-73) that can cut into the flesh of life and reaffirm the conditions of intimacy through the sensuality and incantatory whisperings of things, objects, and foods.

Still life, which is one of the most self-reflexive forms, for it emphasizes focus, composition and design, foregrounding aesthetic qualities of objects and spaces, was particularly attractive to the artists and poets of the modernist period who tried to frame and impose order on the shifting reality and the increasingly fragmented world. As stated by Norman Bryson, "[s]till life's potential for isolating a purely aesthetic space is undoubtedly one of the factors which made the genre so central in the development of modernism" (80). And yet, there are other important factors involved in modernist art's continuous engagements with this form. As "an art symbiotic with civilization" (Davenport 11), it can provide fresh ways of seeing and confronting reality. Analysing Cèzanne's still lifes, the phenomenologist Meyer Shapiro states boldly that "our knowledge of proximate objects, and especially of the instrumental, is the model or ground of all knowledge" (44). Modernist ekphrastic still life can be seen in similar terms – as both the source and model of knowledge, an objective correlative of the modernist epistemology. But it can also be treated as a form of sustenance in a time of crisis, being a continuation of the ancient tradition of food and object representations, where "the real root of still life," as Davenport contends, was "an utterly primitive and archaic feeling that a picture of food has some sustenance" (7).

What attracts modernist poets to the genre are a peculiar mixture of craftsmanship, self-reflexivity and a subtle "residue of didacticism" (Davenport 9) and contemplativeness inscribed in the form. The gaze which the still life evinces, as Peter Skira aptly argues, is far from static and fixated on the aesthetic function of the objects being represented; rather, it reveals "the intertwining of interrogation and spectacle, the pendulum movement between life and questioning" (7). This peculiar combination of the intense spectacle of life and question-

ing in the form makes still-life capable of expressing the whole range of human conditions, conflicts and relations in the complex structure of modern reality.

Exploring both aesthetic and more broadly universal dimensions of the genre, Costello argues that

> [t]he space of still life, with its absorbing textures, colors, and shapes, its play of light and reflection on surfaces transparent and solid, its dialectic of order and disorder, stasis and mutability, contains nothing that would seem to matter much in the affairs of the world. Some fruits or flowers, a broken dish, a light-drenched glass of water, the containers, utensils, consumables, and ornaments of the everyday, these subjects show off the skill and imagination of the artist, not his political or social insight. (xii)

Naturally, we can think of still life as part of the search for a pure form or "pure poetry," as Wallace Stevens himself would have it, and many ekphrastic poems can be investigated in those terms. However, the genre, especially as seen and practiced by modernist poets, is a far cry from being a static, utopian exile into the realm of eternal beauty, or an abstract or nostalgic illusion of timeless perfection. Rather, as Costello convincingly asserts further on in her study, it reveals a close affinity with the lyric, since both "explore the given and potential language of objects, their associative power, and their uncanny otherness, the way they evoke and refuse our subjectivity" (13). As such, it becomes a "threshold form" which oscillates between the private and the public, the timeless and the historical, becoming thus "a lively threshold between imaginative order and the irreducible, turning world" (Costello 12).

This Object is Merely a State: Wallace Stevens

Glen McLeod, who analyses Stevens' relationship to modern art (1993), draws a direct link between the poet's practice and still-life, contending that it may be suggestive of his "entire approach to life" (83). In Stevens' own words, "[t]he poem of life" consists of "the pans above the stove, the pots on the table, the tulips among them" (Stevens, *Collected Poems* 423). Indeed, his own aesthetic program, whose premise is that a poem must be abstract but adhere to the real; it must change, give pleasure and be human, captures many concerns preoccupying still life artists. As observed by McLeod, the direct impulse behind Stevens' interest in the genre comes from painting, and more specifically, the 1938 exhibition "The Painters of Still Life" at the Wadsworth Atheneum, which had a profound influence on Stevens' 1942 volume *Parts of a World* (McLeod 82-83). Here we can find such works as "The Poems of Our Climate," "Prelude to Ob-

jects," "Study of Two Pears," "The Glass of Water," and "Dry Loaf," in which still life motifs are foregrounded and explored, "setting the tone for the entire book" (McLeod 82). The poem "Dry Loaf," from this particular book, ekphrastically refers to Joan Miró's painting *Still Life with an Old Shoe* (1937). Stevens, like Miró, who painted his work in response to the turmoil of the Spanish Civil War (1936-1939), uses still life as a springboard to talk about the bareness of reality destroyed by the war:

> That was what I painted behind the loaf,
>
> The rocks not even touched by snow,
>
> The pines along the river and the dry men blown
>
> Brown as the bread, thinking of birds
>
> Flying from burning countries and brown sand shores
>
> (Stevens, *Collected Poems* 200)

The loaf, a frequent motif in still life painting, in this poem is not singled out for purely aesthetic reasons: Stevens foregrounds its "dryness" which spreads over and contaminates both the foreground and the background of his design, as the still life is set in a landscape, in the manner of seventeenth and nineteenth century rogographic forms. The monochromatic brownness becomes the objective correlative of the reality as wasteland caused by the war and economic depression – a land of hollow, arid forms, of "the dry men blown/Brown," devoid of life, depth and color. Contrary to the traditional poetics of still life, where the goal is "brilliance of focus" and illumination through an interplay of shadow and light which results in "the surplus of appearance" (Bryson 64), Stevens' poem asks us to step into Miró's deep shadow, the "burning browness" of the background, for the horrors of the war, hunger, bare rocks, birds fleeing from fire, and the waves of marching soldiers. The existential deprivations hidden behind Stevens' version of the dry loaf, present us with the "surplus of *dis*appearance," where the excess of brownness and bareness carries moral value and conveys the annihilation of both contour, beauty and substance under the pressures of the economic crisis and the war-ridden reality.

"Dry Loaf" shares the destructive impulse with another interesting still life from this period, namely "The Glass of Water":

> That the glass would melt in heat,
> That the water would freeze in cold,
> Shows that this object is merely a state,

One of many, between two poles. So,
In the metaphysical, there are these poles.

Here in the centre stands the glass. Light
Is the lion that comes down to drink. There
And in that state, the glass is a pool.
Ruddy are his eyes and ruddy are his claws
When light comes down to wet his frothy jaws.
(Stevens, *Collected Poems* 197)

McLeod traces this poem's origin to the glass goblets often shown in the Dutch still lifes which were reprinted in the 1937 issue of *Apollo* art magazine, where the poet might have seen them (McLeod 88). Here Stevens seems to be deconstructing the very idea of the stillness of the objects in the representation, along with the utopian desire to freeze reality in a perfect and unified form with a clear center. For the poet, as noted by Costello, the physical center where "the glass stands," is linked with the metaphysical one, but again, just as in "Dry Loaf," where the initial solidity and centrality of bread dissipates into "burning countries and brown sand shores," the poem carries a threat of change, violence and disintegration ("this object is merely a state, / one of many"), and presents material reality as process and "a flux of states without equilibrium" or a definable center (Costello 36).

What is also crucial to an understanding of Stevens' use of imagery here is the fact that the figure of the lion is a recurrent motif in his private mythology, functioning as the symbol of both the pressures of reality and the counter-force of the poetic imagination. Explaining his poetic mission in a letter to Renato Poggioli, the poet confesses:

I want to face nature the way two lions face one another – the lion locked in the lute facing the lion locked in stone. I want, as a man of imagination, to write poetry with all the power of a monster equal to that of the monster about whom I write. I want man's imagination to be completely adequate in the face of reality." (Stevens, *Letters* 790)

In the original goblet evoked by the poem, the lion is etched in the transparent glass surface and frozen in a powerfully violent posture. Stevens activates and destabilizes this image. Confronted with the force of Stevens' imagination, the glass lion loses its polished stillness, its original transparency and perfection; the figure, "with its frothy jaws," stepping down to drink light from an imaginary

pool, just like the dried loaf of bread in the previous poem, signals the proximity of external violence, darkness and chaos that threaten the aesthetic order. "The glass pool," evocative of the rich Romantic tradition of "aquatic sources of tranquil contemplation" (Costello 36), under the pressure of entropic forces and impatient vision dissolves into impatient "refractions," causing "The *metaphysica* / "plastic parts of poems" to "crash in the mind" (Stevens, *Collected Poems* 182) With these dynamic gestures, Stevens topples the majestic immobile beauty of the Dutch goblet, the aesthetic escapist refuge, directing our perception down towards the ground, to "the center of our lives, this time, this day," to the "spring of the politicians / Playing cards," and the quotidian brutality of life "among the dogs and dung" (Stevens, *Collected Poems* 182). The figure of "politicians/Playing cards," Costello observes further, suggests the fragility and provisionality of ideological orders and centers which can be easily shuffled, pushed to the periphery and displaced, at the same time forcing us to acknowledge the contingency of the forces that shape and destabilize our lives (182). Against this contingency, Stevens has the mobility and adequacy of his imagination in the act of finding which "has still to discover," and learn how to resist the dimmed light of this fluent mundo.

Not Unordered in Not Resembling: Gertrude Stein

Offering an interesting insight into the diverse uses of still life forms in modernism, Costello writes of the assault on the private and the domestic in the aggressively public "glass-and-steel" ideology of modernism: "[T]he many anxieties of location arising within and after modernism – among them the collapse of distance, the violation and evacuation of the personal, the inhuman scale and power of the public realm – caused these artists to reconfigure intimate space" (Costello 18). Still life, so deeply linked to the intimacy of domestic order, appears thus as a form especially fit for such reconfigurations. One of the modernist poets whose work counteracts the aggression of the increasingly panoptic space and withstands the "anxieties of location" is Gertrude Stein.

Unlike Stevens, whose still life poems confront and intersect with the public realm of the "tragic time" ("Dry Loaf," *Collected Poems* 199), Stein uses still life to protect private experience from the encroachments of the aggressive and the inquisitive public. The poem which can serve as a counterpoint to Stevens' "The Glass of Water" is "A New Cup and Saucer" from Stein's early volume of prose-poems *Tender Buttons* (1914). The poem is not an ekphrasis, as was the case with Stevens', but, for clarity of argument, I shall juxtapose it with a work by a nineteenth-century master of still life, Henri Fantin-Latour (1836-1904).

Examining the formal and expressive capacity of still life, Jeanne Przybylski points to its "physiognomic" character. Still life can be described as

> Weighted with ambition and yet resolutely minor, still life was said to be nothing but color and form; yet color and form were to be endowed with a mysterious eloquence that conveyed the nature of the individual through the painting of everyday things, as if such objects had yielded their secrets to the inquiring eye of a detective. Such eloquence was not merely anecdotal or "literary," a function of iconography and inventorying. It might be more accurately described, to use Duranty's word, as "physiognomic," a product of physical impressions and traces – a cumulative effect of the deep, domestic familiarity born of the habits of daily use worn into the surfaces of commonplace objects and imprinted from their surfaces to the surface of the painting. Still-life painting was thus conceptualized as simultaneously optical and tactile, objectively neutral and yet subjectively charged, purely formalist and yet almost evidential in its ability to "produce" the inhabitant of its domestic setting. (29)

Stein's objects from her prose-poem volume *Tender Buttons* share this quality, being composed out of "physical impressions and traces" that reveal the imprints of the poet's habits, feelings and needs, and, as the poet herself argues, "expressing the rhythm of [her] visible world" (Stein, *Lectures* 56). However, there is yet another level of meaning behind the volume: *Tender Buttons* was created in a period of personal crisis and radical change for Stein, who separated from her brother Leo, with whom she had shared the flat at Rue de Fleurus 27, but who moved out in 1913 as Stein was cementing her relationship with Alice B. Toklas. It can be thus said that the poems, on a more personal level, are her way of coming to terms with this change and, in Patricia Hadas' words, they can be read as "a labyrinth of privately colored and coded musings on the subjects of separation and replacement, the objects of anger and love" (70).

When juxtaposed with the painterly still life of Henry Fantin-Latour's "White Cup and Saucer" (1864), Stein's "NEW CUP AND SAUCER" strikes us as a somewhat similar exercise in style and form:

A NEW CUP AND SAUCER

Enthusiastically hurting a clouded yellow bud and saucer, enthusiastically so is the bite in the ribbon. (Stein, *Tender Buttons* 321)

Both the painting and the poem foreground the aesthetic value of the objects being represented, but at the same time they also reveal traces of human presence which pull us into the more private, intimate space of their works. To foreground his set, Fantin-Latour chooses a dark brown background, suggestive per-

haps of a wooden table, whose function is to present the whiteness, austerity, singularity and minimalist beauty of the cup and the saucer. However, the paint-er subtly undermines the starkly dramatic sublimity and perfection of his com-position by adding a slightly deconstructive element – a spoon – that is not only too big and oddly placed on the saucer, but that also points to a bizarre asym-metry in the shape of the plate, which is visibly elongated and flattened to the right, becoming a somewhat too welcoming nestle for the spoon. Such an ar-rangement combines optic and tactile elements through its dynamic gesturing towards the very activity of painting, as well as the functionality of the object being represented which is also made for use. Fantin-Latour fuses the optical and tactile qualities of his cup and saucer, triggering a subtle interplay between surface and depth to reinforce the effect of human presence and activity behind the empty cup and to uncover the agency of the painter, his touch in the re-presentation of the object. Stein's version is equally minimalist – Stein baits us with the simplicity of the title, enhanced further by the use of capital letters in the first edition, but the content and form of her new cup are much more surpris-ing for the reader – it consists of one truncated sentence barely mentioning the object described and hovering inconsequentially between meaning and its lack – but it is more dynamic from the start and more overtly charged with the poet's subjectivity, as it flaunts not so much the novelty of her china, which clearly calls for adequate strategies of defamiliarization, but more so the novelty of her perception and thinking about objects and foods.

Unlike Fantin-Latour, whose work emphasized the singular tranquility, uni-formity and stillness of the cup, the poet, in the manner of Picasso, animates both the color and contour of her set, imparting a greater sense of privacy and humanity to the objects being represented. Her still life is "a space that is filled with moving, a space of time that is filled always filled with moving" (Stein, *Lectures* 161), as the poet herself admits. Similarly to Fantin-Latour, whose spoon hints at the proximity of the cup's user and the painter's own touch, Stein also conflates optical perception and physical touch, pouring into her cup hints of her conception of the interior space as a realm with a somewhat turbulent and clouded atmosphere rather than a totalizing aesthetic order. Here Stein puts into practice her conviction that "a writer should always have that intensity of emo-tion about whatever is the object about which he writes" (Stein, *Lectures* 210). The twice-repeated word "enthusiastically" indicates the speaker's overflowing delight, which is instantly checked, however, by the unexpected interference of the word "hurting," equally intense in its emotive power, which, however, intro-duces dents and cracks in her representation. Unlike Latour's polished and pure set emerging from darkness through its perfect integrity, luminosity and clarity, Stein's cup and saucer are thrown at us in the poetic act of "hurting," "biting"

and "clouding." Fantin-Latour's impeccably cool whiteness that seems to hide nothing but the innocence of its delicate shadowing is here dimmed into an imperfect yellow or, perhaps, as Stein's language is relentlessly "clouding" any certainty, it is already filled with tea and milk and thus "hurt" by its "clouded yellow" hue. The equally mysterious "bite" in the ribbon might be a result of the poet's indelicate handling of the new cup which chips its ribboned brim or her enthusiastic "biting" into the tea-filled cup, which might have resulted in the bitten and hurt lip or tip of her tongue, legitimizing the word "hurting." Or, given Stein's efforts in the whole volume to shake rigid patterns of naming and defining, it might just as well be a presentation and renewal of the old cup though the poet's fresh ways of looking and unnaming. Stein's clouded and chipped idiom is fuelled by its dynamic and enthusiastic handling, whose goal is to bring forward the thingness of objects as well as her mental and physical engagement with them. The integrity of Latour's cup is dissolved in Stein's poem through her faintly figurative lexicon, with the central word bud, suggestive perhaps of the flower pattern on the china, but evoking also the notions of tenderness, renewal, growth and life which informs the whole collection of *Tender Buttons*, and which can be seen as a tribute to her new life with Alice.

The dynamic sensuality of Stein's poem becomes indicative of her approach to language, where "the gaps between familiar bearings produce a constant slippage between inside and outside"(Alford 321), leaking a clouded and brittle meaning. In his reductionist form, released from the cozy clutter and dense decor of the bourgeois interior, Fantin-Latour's work offers us not only a presentation of an object, but also a space for unobstructed meditation. In contrast, Stein's still life's function is to disrupt and obstruct our reverie, following the self-reflexive style of Cèzanne and of Picasso (Alford 321). Stein invites us both to her atmospheric household, with details of her life, private rituals and her sensuous relations to objects, rooms and people, (the most important here is her relationship with Alice B. Toklas), as much as to the artist's "studio" – the space of the interior's imaginative expansion in the restless activity of her mind which tries to resist and subvert the purity of narrow definitions[1] as well as to withhold the pressure of her break-up with Leo and the anger and hurt it caused.

William Carlos Williams thus defines the role of still-life – "It is the life- but transmuted to another tighter form" (Williams 198). For modernist poets, this form was both a challenge and a chance to explore its expressive potential. Stevens' still lifes from the late '30s and early '40s show how "[t]he crack in the

1 In her study of Stein's Tender Buttons, Linda Mizejewski argues that Stein's descriptions break the Victorian pattern of True Womanhood which defines the woman's role too narrowly, as a domestic goddess presiding over the household but also confined to it (33).

tea-cup," to quote W.H. Auden, can "ope[n] /A lane to the land of the dead" (66). Though seemingly self-contained and carefully crafted as aesthetic forms, "The Glass of Water" and "Dry Loaf," prove a fruitful focus for the explorations of the anxieties of the world in "depression," both economic and psychological. Stein's still lifes, in turn, register her efforts at rearranging her life after her separation from her brother, and pull us into the intimate and seductive space of her "new" household, inscribed with her "psychological essence" and the strongly private "pulse" of her life (DeKoven 82).

Works Cited

Alsdorf, Bridget. "Interior Landscapes. Metaphor and Meaning in Cézanne's Late Still Lifes." *Word & Image: A Journal of Verbal/Visual Enquiry*, 26.4 (2010): 314-323. 2010. Web. 3 Oct. 2013.

Auden, W.H. *The Penguin Poets: W.H. Auden.* Ed. W. H. Auden. London: Penguin Books, 1958. Print.

Bryson, Norman. *Looking at the Overlooked: Four Essays on Still Life Painting.* Cambridge, Mass: Harvard University Press, 1992. Print

Costello, Bonnie. *Planets on Tables: Poetry Still Life, and the Turning World..* Ithaca and London: Cornell University Press,. 2013. Print.

Cottington, David. *Cubism in the Shadow of War.* New Haven: Yale University Press, 1998. Print.

Davenport, Guy. *Objects on a Table: Harmonious Disarray in Art and Literature.* Washington, D.C.: Counterpoint, 1998. Print.

DeKoven, Marianne. "Gertrude Stein and Modern Painting: Beyond Literary Cubism." *Contemporary Literature* 22.1 (1981): 81-95. Print.

Dubnick. Randa, K. 1976. "Two Types of Obscurity in Writings of Gertrude Stein." *Gertrude Stein Advanced.* Ed. Richard Kostelanetz. McFarland: Jefferson and London, 1990. 63-84. Print.

Hadas, Pamela. "Spreading the Difference: One Way to Read Gertrude Stein's Tender Buttons." Special Issue of *Twentieth Century Literature* 24.1 (1978): 57-75, Web. 18 Sept. 2013.

Knight, Christopher. J. "Gertrude Stein, *Tender Buttons,* and the Premises of Classicalism." *Modern Language Studies* 21.3 (1991): 35-47. Web. 13 Sept. 2013.

Kostenaletz, Richard. *Gertrude Stein Advanced.* Jefferson, NC: McFarland, 1990. Print.

McLeod Glen. *Wallace Stevens and Modern Art: From Armory Show to Abstract Expressionism.* New Haven: Yale University Press. 1993. Print.

Mizejewski, Linda. "The Pattern Moves, the Woman Behind Shakes It." *Women Studies* 13 (1986): 33-47. Web. 5 Aug. 2013.

Przybylski, Jeanne. "The Making of Modern Still Life in the 1890s." *Impressionist Still Life.* Eds. Eliza E. Rathbone and George T. M. Shackelford. New York: The Philips Collection in Association with Harry N. Abrams, Inc., Publishers, 2001. 28-33. Print.

Skira, Peter. *Still Life: A History.* New York: Skira Rizzoli, 1989. Print.

Stein, Gertrude. *Lectures in America.* 1935. New York: Vintage, 1975. Print.

---. "New Cup and a Saucer." *Tender Buttons.* 1914. *Selected Writings of Gertrude Stein.* Ed. Catharine R. Stimpson. New York: Library of America, 1998. 313-55. Print.

Stevens, Wallace. "Dry Loaf." *The Collected Poems.* New York: Vintage Books, 1982. 199-200.

---. "The Glass of Water." *The Collected Poems.* New York: Vintage Books, 1982. 197-8. Print.

---. "The Irrational Element in Poetry." *Opus Posthumus: Poems, Plays and Prose.* Ed. Samuel French Morse. New York: Vintage Books, 1982. 216-228. Print.

Stevens, Holly. Ed. *Letters of Wallace Stevens.* Berkeley: University of California Press, 1996. Print.

Williams, William Carlos. *Selected Essays.* New York: Random House, 1954. Print.

"Twas very hard to get down their filthy trash": Investigating Food and Crisis in Mary Rowlandson's Captivity Narrative (1682)

Veronika Hofstätter

"As drama was the ideal articulation for Elizabethan London, the jeremiad was for the tiny communities in New England" (52). With these words Perry Miller describes the "complex psychological doctrine," a leading type of sermon, which Puritan ministers used to warn the congregation of upcoming crisis situations by giving a "doctrine," "reasons," as well as "applications" as a "scheme of reformation" to avert the impending disaster (Miller 29). And indeed, crisis situations abounded in the early modern world. As Rüdiger Kunow has stated: "[c]risis can ... be understood as a way of coming to terms with change privileging rupture over continuity" (468). The managing of crisis depends on accepting change as based on a historical break rather than stressing continuity. This mechanism can be seen at work in colonial New England where four particular episodes of New England colonial history immediately come to mind in such a context: the Antinomian crisis, the Half-Way Covenant, King Philip's War, and the Salem witchcraft trials. However, crisis situations were also part of life's everyday challenges. Among those were the continuous fight against epidemics, the instability in the supply of healthy food crops, Native American attacks, and the perceived threat of lingering witchcraft. In this context, Mary Rowlandson's narrative *Of the Captivity and Restoration* (1682)[1] exemplifies an outstanding interplay of different moments of crisis in early America: an emotional crisis as Rowlandson became a witness of violence and loss; a spiritual crisis as she had to prove herself a worthy Puritan goodwife in times of challenge; a physical crisis in the fight for survival and sustenance; and an overall crisis of her cultural

1 Robert Diebold's examination of Rowlandson's early editions concludes that the London edition of 1682 is probably the most reliable and closest to the lost first Boston edition (Diebold 3, 246). All used quotes from Mary Rowlandson's narrative are taken from the 1682 London edition; emphasis and capitalization are original unless stated otherwise. As given on the front page, this edition was "[p]rinted first at *New England*: And Re-printed at *London*, and sold by *Joseph Poole*" (Rowlandson, front page). In 1682—the year of its first publication—Mary Rowlandson's captivity narrative was printed in four different editions: the first edition in Boston (which is mostly lost), the "Second Addition" and "Second Edition" in Cambridge, Massachusetts, and the fourth edition in London (Derounian 239).

identity justifying the religious mission in New England for the captivity narrative's Puritan audience.

Mary Rowlandson's account has been read through different lenses by several groups of critics, for example to show her emphasis on Puritan beliefs or to trace the formation of a cultural hybridity due to her experience (Priewe 2). In concurrence with the statement that "various contexts surrounding the experience of Mary Rowlandson shaped its textual production" (Priewe 2), this article puts particular emphasis on specific instances where Mary Rowlandson shares experiences with food and eating.[2] She uses culturally encoded food portrayals—resulting from her social and religious enculturation—to translate her handling of crisis situations for her Puritan audience.

After an overview of the food situation in early New England, the present chapter will then analyze the historical context of Rowlandson's captivity. For the pilgrims, food served as a contact zone with the Native Americans who secured their survival during the first winter of 1620-1621 and helped to guarantee a harvest in the following fall (Boyer et al. 49).[3] The early settlers lived on a food frontier: their cultural expertise of the English model of agriculture and foodways, nutritional value as well as its influence on health and the body, sailed along with them from their home ports to the "New World." Typically, an early modern English diet consisted of grains or bread, legumes, seasonal vegetables, dairy products, meat and fish as well as fruits—cooked or baked; often the ingredients were put together in a one-dish meal, called "pottages" (Wallach 14). The eater's social status determined the amount consumed and the quality of the products available (Wallach 11-15). The settlers' plans to cultivate familiar crops by using their imported seeds for staples like wheat or rye and to raise farm animals partly conflicted with what they encountered in their new environment due to the lack of soil or grass conditions (McWilliams 58-59). Although the settlers accepted new, Native food sources like corn into their diet, their understanding of sustenance clashed with Native American habits. As his-

2 This article follows Roland Barthes, who describes food as a "system of communication, a body of images, a protocol of usages, situations, and behavior," (29) which consequently calls for its close examination.

3 English-speaking Native Americans, like Samoset, an Abenaki, or Tisquantum, called Squanto by the Pilgrims, a Wampanoag, who made their encounters with fishermen or colonizers and learned their language through slavery or trade, helped the pilgrims with diplomatic support with local tribes, particularly to establish an agreement with Massasoit, a Pokanoket sachem (Philbrick 94-100; Wallach 5). Furthermore, Squanto taught them about the condition of the soil, how to fertilize, and successfully start their own cultivation of the land with native and imported seeds around their settlement of Plymouth Plantation (cf. Boyer et al. 49; Philbrick 61-64, 101-02).

torian James McWiliams claims, "they refused to experience the periodic hunger that the Native Americans so readily tolerated" (62).

However, diet was determined not only by the available food but also by the understanding of the body and its functions according to Galen's humoral balance, which was still widely accepted in the early modern era (Eden, *Early* 14, 20; Eden, "Food" 31). With all four bodily humors—black bile, yellow bile, phlegm, and blood—in balance, in the so-called "golden mean," the body was seen to be in its ideal condition and appeared in full health (Eden, *Early* 14; Eden, "Food" 30-31). One's lifestyle and particularly the intake of food could alter the bodily condition in either way (Eden, *Early* 10). Therefore, the wrong foods—with native food sources being particularly problematic as their influence was unknown to the English bodies—could "produce undesirable physical, mental, and moral changes" (Eden, "Food" 30) and a "change in diet" could even mean a "change in person" (Eden, *Early* 10). Accordingly, the intention to establish English foodways can also be seen as a result of re-creating familiar conditions for the settlers to control their hunger and health.

Gradually, English settlers underwent a development from food insecurity based on the problems of growing and raising known food products to the establishment of an English agrarian model with structured kitchen gardens, pastures for livestock and dairy production, and cleared fields fertilized with ashes for crops (McWilliams 63-85). Hence, the "unknown" of the American environment was familiarized through adaptations. The incorporation of corn into the English culinary tradition like the merging of English pudding with corn meal, also known as hasty pudding, is just one example (McWilliams 63). It is important to take into account that—as Carlnita Greene states—"food is much more than mere sustenance as it intersects with a whole host of cultural, social, and political phenomena" (31), such as recipes and preparations among a cultural group or behavioral codes at a shared meal which illustrate power relations and "different degrees of hierarchy, inclusion and exclusion" (Douglas 36) between the eaters. According to McWilliams, in New England "the early years were rough" but in one of "American history's most momentous culinary transitions" … "New England would become self-sufficient in its food supply" and "in a thoroughly English manner" (63). This process of Anglicization can be directly linked to the settlers' negotiation of new and old identities with food as its symbolic expression (Greene 31). When Mary Rowlandson arrived in New England around the mid-seventeenth century, "Indian corn" secured the settlers' survival as a reliable staple food crop and was integrated into the settlers' cuisine.

Mary Rowlandson's captivity of eleven weeks in 1676 was a direct result of the then raging conflict—which is mostly called King Philip's war—between

English settlers and Native American tribes.[4] Reasons for tension were plentiful. Settlers cleared land and let their livestock roam freely, which thereby destroyed the healing plants and food sources for the Natives. Furthermore, Western diseases decimated the tribes; and a continuous loss of land due to English expansion as well as political and social discrimination in the process eventually left the Wampanoags no other possibility than a violent conflict with the English settlers (Boyer et al. 69; Drake 1).[5] Among the war-inflicted towns was Lancaster, where Mary Rowlandson, a prominent Puritan minister's wife, was—along with twenty-four others—taken captive on February 20,[6] 1676 (Baym et al. 236-37; Rowlandson 7-8; Drake 148-49).[7]

Rowlandson and her anonymous editor—who is, although no clear evidence has been presented yet, mostly identified as Increase Mather[8]—use specifically encoded food scenes and references to a food context in which they alternate between passages of othering the Native Americans and situations of "in-

4 Metacom, the leading Wampanoag sachem of the conflict, was named King Philip by the English settlers. However, among many others, Jill Lepore points out the problematic nature of calling the events in 1675-76 in New England King Philip's War. In her monograph *In the Name of War*, she summarizes research perspectives and points out that Philip was not Metacom's true name and that he was also not a king (Lepore xv). Other options for naming the conflict—depending on the perspective—are: "Puritan Conquest," "Metacom's Rebellion," or "Indian Civil War" (Lepore xv).

5 Plymouth Council's decision to try and hang Mattashunannamo, Tobias, and Wampapaquan —all three were counsellors to Philip—for the murder of the Christian Native American Sassamon without clear evidence escalated the conflict into a war in 1675 (Drake 1; Lepore 21-23). They were executed on June 8, 1675.

6 Mary Rowlandson gives the date of February 10, 1675 as the day of the Native attacks but—according to Baym et al.—when translated from the then used Julian into the Gregorian calendar it was February 20, 1676 (236).

7 In the course of the war the allied Native Americans "attacked fifty-two of New England's ninety towns (entirely destroying twelve), burning twelve hundred houses, slaughtered eight thousand head of cattle, and killed twenty-five hundred colonists" (Boyer et al. 69-70). About forty percent of New England's Native population died in the war and it severely deepened the enmity between the settlers and the Native Americans (Boyer et al. 70). About two-thirds of the colonies' Native Americans fought against the settlers as well as Natives with English colonists allied against other Natives (Ulrich 173; Drake 1-2). According to Laurel Thatcher Ulrich, the war "was one of the most destructive wars in proportion to population in American history" (173).

8 All four 1682 editions of the captivity narrative are introduced by an anonymous preface entitled "Per Amicam" in the American editions and "Per Amicum" in the London edition. The preface's author is still debated among Early Americanists but it is mostly agreed that Increase Mather is a very likely option as a major representative of the seventeenth-century Puritan intellectual elite (Derounian 240-41).

betweenness" to eventually create a narrative of Puritan critical affliction and redemption.[9] The text even refers to Rowlandson's God-given spiritual "in-betweenness" as "he [God] wounded me with one hand, so he healed me with the other" (MR[10] 5). Her situation of crisis due to her captivity allows her a certain amount of "mobility" in her actions as a Puritan goodwife. The narrative has a distinctly ambivalent character as Rowlandson negotiates her status and actions on the basis of the pious Puritan "civilized self" and the alien "wilderness" represented by the Natives, whom she, at one point, calls "Barbarous Creatures" (MR 3) or "bloody Heathen" (MR 1). Simultaneously, the narrative also represents passages of transcultural approaches where detailed descriptions of the living conditions during her captivity, for example food options or sleeping arrangements and encounters—friendly and hostile—with members of the community are given (MR 11, 15, 19).

At the beginning of the narrative, which is divided into twenty chapters called "removes," the Natives are described as "ravenous Bears" (MR 3), a metaphor which immediately conjures up a connection to hunger and a longing for food: "ravenous" as being extremely hungry, greedy, and even inhuman as "Bears." They are portrayed as having no kind of self-restraint or modesty as they plunder the English livestock and have "some roasting, some lying and burning, and some boyling to feed our merciless Enemies" (MR 3). Not only do they destroy everything which guarantees sustenance for the Puritans, they even waste precious animals by leaving them "burning," which strongly supports Rowlandson's depiction of her captive space as "a lively resemblance of hell" (MR 3). Being the place of eternal torment in the afterlife, hell as the fundamental non-civilized place is for Puritan settlers an omnipresent and even physical threat—in opposition to the Christian heaven or paradise. The narrator's use of dialectical opposition shows the deep desperation of being a "transplanted Englishwoman thrust into an alien American world" (Ulrich 176). Her fear of being degenerated and consumed by the wilderness, which might result in becoming "wild" and like a Native herself, is a fear well-known to her Puritan audience (Lepore 81; Canup 23-25). Her stay among the Native Americans not only challenges her culturally engrained disgust of alien foods, but in her understanding it might also endanger her health and identity based on the medical model of Ga-

9 Based on everyday experiences and situations, which makes them easily accessible, food images as symbols and metaphors are also dominant in the Bible, which through the sola scriptura doctrine serves as a strong and reliable guideline for the Puritan settlers. Therefore they are omnipresent for Rowlandson as well as for her audience and are utilized in her narrative.

10 For the purpose of simplicity, MR will stand for the reference to Mary Rowlandson's narrative.

len's humoral balance and on what Cotton Mather specifies as the danger of "Criolian degeneracy" (Mather qtd. in Canup 20). According to this understanding, as John Canup states, "the alien environment of America through its influence on the humoral temperament of transplanted Englishmen, [sic] would eventually produce undesirable cultural changes" (21). Cotton Mather defines this "Criolian degeneracy" as a degeneration of the settlers' Englishness through assimilation to the American environment and the "danger of cultural contamination through over-intimate contact with the native human environment" (Canup 23). And eventually this might turn the English settler into a Native American as a corollary (Canup 22-23).

In the beginning of the narrative, the focus is set on Rowlandson as a mother in a crisis which can be analyzed through the lens of food. With her "suffering body of a mother" (Toulouse 659) Rowlandson cannot fulfill her womanly task of providing food for her "poor wounded Babe" (MR 3), her daughter Sarah, who is taken captive with her. Although Sarah is about six years old, this depiction nevertheless follows what Ulrich calls the "'sucking infant' theme" (173), used to emphasize the cruelty of Native Americans by denying food even to the most innocent. It reappears when Rowlandson recounts the murder of a woman with her infant in the fourth remove (MR 19). For the captives there was "not the least crumb of refreshing that came within either of our mouths, from Wednesday night to Saturday Night, except only a little cold water" (MR 4). Another example is stated in the fifth remove, when Rowlandson's mistress refuses to share a meal with her despite her being close to fainting because of hunger and exhaustion (MR 9). By pointing out the intentional denial of food and the restriction on water provision, Rowlandson accentuates her complex crisis situation to her readers by describing her weakened physical condition, which also emphasizes the spiritual challenge of trusting God. Simultaneously, she stresses the representation of the Natives as the Other because they deny them even their most essential needs. This clearly opposes all the principles of the Christian duty of charit,y as the Gospel demands that Chrisitians love their enemies and treat them well (Matt. 5:44).[11] An unmistakable opposition between "wild savage" and nurturing, caring Puritan is created through the description of this physical crisis situation for Sarah and Mary Rowlandson.

Rowlandson even goes beyond using her own suffering to illustrate her crisis and portrays an encounter with the ultimate food taboo in most cultural eat-

11 This duty of charity was for example formulated by the prominent Puritan leader John Winthrop in his famous lay sermon "A Model of Christian Charity" (1630), in which he explicitly quotes Matthew: "Love your Enemies, do good to them that hate you" (Matthew 5:44 qtd. in Winthrop 149).

ing codes: cannibalism.[12] When Mary Rowlandson asks a visiting Native American about her son in the thirteenth remove, he tells her that his "Master roasted him" and he "himself did eat a piece of him as big as his two fingers, and that he was very good meat" (MR 15).[13] Although we learn later that the son is alive, the given statement emphasizes the mere possibility of man-eating. By presenting this powerful metaphor of potential cannibalism among her captors, Rowlandson underlines not only the danger of being murdered and left in the wilderness separated from her society—"no Christian Soul near" (MR 10)—but also the unthinkable danger of being eaten and digested by the "inhuman creatures" (MR 4) themselves. Accordingly, as Jennifer Brown's states, "fear of the Other is often expressed through images of being literally and metaphorically consumed by that Other" (4). This passage exemplifies the binary opposition and follows a Manichean worldview, dividing the world into the good, Puritan society and the evil, savage Natives in the wilderness. The taboo image given here underlines her crisis situation to her audience in her trial of true faith and for physical as well as emotional survival.

12 For Margaret Visser, cannibalism is unthinkable in most societies as it lacks "morality, law, and structure" and "stands for what's brutish, utterly inhuman" (Visser 6). Furthermore, Jennifer Brown states that "[c]annibalism has long been the epitome of the transgression of boundaries" (4).

13 In 1625, George Percy, who became president of Jamestown Colony in 1609 after John Smith left, wrote in his "A Trewe Relacyon" about the so-called starving time: "And now famin beginneinge to Looke gastely and pale in every face, that notheinge was Spared to mainteyne Lyfe and to doe those things w[hi]ch seame incredible, as to digge upp deade corpes out of graves and to eat them. And some have Licked upp the Bloode w[hi]ch hathe fallen from their weake fellowes. And amongst the reste this was moste lamentable. Thatt one of our Colline murdered his whyfe Ripped the Childe out of her woambe and threwe itt into the River and after Chopped the Mother in pieces and salted her for his foode, The same not beinge discovered before he had eaten p[ar]te thereof" (Percy). Although this particular report remained in his private papers and was not published before 1922, one can speculate that settlers like Mary Rowlandson might have heard of such survival cannibalism in the first English permanent settlement in the US. Accordingly, if English, "civilized" settlers were capable of eating their own, the threat of cannibalistic Native Americans as the "uncivilized, savage Other" becomes even more real to the settlers. On May 1, 2013, the Smithsonian Institution, Colonial Williamsburg and Preservation Virginia confirmed the first "scientifically-proven occurrence of survival cannibalism in Colonial America" ("Jane's Story"). Parts of a human skull and tibia were found at archaeological excavations of a seventeenth-century trash deposit at the Jamestown site in Virginia. Forensic evidence "identified chops to the forehead and back of the cranium to open the head; knife cuts on the jaw and cheek indicating removal of the flesh; and markings indicating the head's left side was punctured and pried apart: all physical evidence consistent with survival cannibalism" ("Jane's Story").

However, Rowlandson does not thoroughly adhere to this clear distinction between positive "civilized Puritan" and negative "savage other." While she employs the "passive-victim motif," she "too transcended it" (Ulrich 174). We can see this in several eating and food scenes where Rowlandson approaches a status of "in-betweenness," which, however, needs to be resolved to confirm her Puritan identity to the readers.

To fight starvation and endure her trial, she has to accommodate herself to the available food options. Not only her palate but also her culturally learned understanding of acceptable meals are provoked and the unsatisfying food options pose a steady danger of degeneration. In the fifth remove, Rowlandson states that in the first week "*I* hardly ate anything: the second week I found my stomach grow very faint for want of something; and yet 'twas very hard to get down their filthy trash," and yet the "filthy trash" soon becomes "pleasant and savory to [her] taste" (MR 9). Only her experience of crisis justifies this dangerous eating of "filthy trash," as she needs to survive this time of affliction to prove herself as a true believer who accepts—by eating alien foods—and understands—by staying alive to enjoy eventual redemption—her trial. Simultaneously, she needs direct proof of her yet unchanged person, which follows immediately after this passage, when she tries to convince the Natives to let her rest and pray on the Sabbath day (MR 9).

A highly debated scene among critics, namely when Rowlandson eats raw horse-liver in the seventh remove, illustrates the interplay of the different elements that define her status of cultural "in-betweenness." The instance has been interpreted as Rowlandson's growing adaptability to the situation (Logan 270; Rippl 151) and a sign of her trial of faith through "physical degradation" (Toulouse 661). The noteworthy sensationalist appeal of a Puritan woman with blood smeared around her mouth has been pointed out by Gabriele Rippl (152).[14] While heeding these analyses, I am again following Kunow's definition of crisis when change privileges rupture—here the need to accept bloody food—over continuity, as in regular cooked meals according to culinary tradition and principles of health. I would further argue that this status of half-cooked meat gives particular weight to her "in-betweenness." Claude Levi-Strauss introduced in his *Mythologiques* the categories raw and cooked as vehicles for analyzing cultures,

14 Rippl points out that horse meat has no culinary tradition in England. This sensationalist appeal is supported by Visser's observation that "[w]hen eating and drinking we are particularly sensitive and vigilant, and immediately react to the slightest deviation from what we have learned" (19). Furthermore, Rippl refers to the blood described around Rowlandson's mouth, which might also remind the narrative's audience of cultural traditions involving blood sacrifices, which reformed Christians deny in their religious practice (152).

with raw representing nature being turned into a cultural object by being cooked (Levi-Strauss 11; Ashley et al. 30-31). Accordingly, Rowlandson is neither fully civilized, as she actually eats the liver as a "savory bit" (MR 10), but also not fully converted to the "wilderness," as she attempts to cook it first. She legitimizes her clear deviation from regular food codes and her "in-betweenness" by connecting it to her religious background as she includes Proverb 27:7: "For the hungry Soul every bitter thing is sweet" (MR 10). Her Puritan readership was certainly able to complete the proverb by adding its preceding part: "The full soul loatheth an honeycomb" (Proverbs: 27:7). In this way they would decode this eating scene as an expression of Rowlandson's true faith and her ability to avert a full "conversion" to Native American ways through alien food. The rupture she experiences seems to be only temporary as a necessity for survival. To her audience she proves to have managed this multi-faceted crisis of captivity: she stays the faithful Puritan woman without a change of identity and particularly without turning "savage" or taking on "qualities of that environment" (Finch 47) imposed on her in the wilderness. This assessment of her actions would "convince readers that, in her position, they could have done no better than to act as she had" (Lepore 129).

The second food passage characterizing her cultural "in-betweenness" appears in the fourteenth remove, roughly in the middle of her narrative. The Native Americans kill a gravid deer and give her a piece of the fawn, which she eats, including the bones, as "it was so young and tender" (MR 19). However, my major interest is not her eating of bones but the following passage, where she describes the Native Americans' bleeding of the deer and collecting the blood in the deer's paunch to subsequently boil and consume it. Throughout the narrative Rowlandson is constantly trying to satisfy her hunger; thus not her enjoyment of bones but her denial of eating boiled blood is of particular interest (MR 19).[15] If Mary Rowlandson had eaten the boiled deer blood and stated it in her account, her status as a faithful Puritan goodwife would have been immediately undermined due to her breaking of the dietary restrictions given in the Bible. The Bible gives several passages about eating restrictions, for example in Leviticus 17:12, which forbids eating blood.[16] God tells Moses that eating meat is only acceptable when the animal's blood is sprinkled on the altar by the priest as a sacrifice for the taking of a life (Lev. 17:1-7; Soler 59). Accordingly, the passage again is a reaffirmation of herself as a deeply religious woman, but also

15 The eating of the bones themselves might have attracted a feeling of disgust among her readers according to Gabriele Rippl (152, 156).

16 God tells "the children of Israel" that "[n]o soul of you shall eat blood, neither shall any stranger that sojourneth among you eat blood" (Lev. 17:12).

a way of othering the Native Americans as the opposite of Christian people. That the Native Americans are preparing the deer and enjoy eating its blood opposes God's dietary laws. Therefore, Rowlandson and her readers cannot recognize Native Americans as another version of an equal "race."[17] Again Rowlandson emphasizes her special crisis situation among her captors through an encoded eating scene.

Nevertheless, she also presents scenes of cultural adaptation and attempts of societal integration, like following her captors' example to look for acorns or chestnuts for food (MR 12, 15) and sharing meals. Several passages describe intercultural dinner scenes with Rowlandson being the guest as well as the host. After having successfully traded a product of needlework for victuals, she returns her master Quinnapin's earlier dinner-invitation—a gesture of gratitude for her making a "Cap for his Boy" (MR 12)—who provided her with "a Pancake" of "parched Wheat, beaten, and fried in Bears-grease" (12), which she describes: "I thought I never tasted pleasanter meat in my life" (MR 12). She prepares a meal of "Peas and Bear" (12) for him and her mistress Weetamoo. Clearly this act of mutual hospitality and transcultural negotiation can be read as a key scene of Rowlandson's "in-betweeness" during her captivity in the culturally charged sharing of food. Sarah Sceats writes that eating, foodways, and practices are "encoded in appetite, taste, ritual, and ingestive etiquette through which people communicate" (1) according to their own cultural background as well as based on their current context and prevailing limitations of food sources. When her mistress refuses to eat the meal as Rowlandson "served them both in one Dish" (MR 12)—she only accepts a piece from Quinnapin—she clearly objects to the establishment of a communal unity as to "refuse food is to reject the fellowship" (Visser 97).

With John Hoar's visit to the Sagamores, who was sent to negotiate the redeeming of the captives, we are presented with another intercultural dinner scene. Hoar brings provisions to invite the Sagamores to a meal; however, in the morning most of the food is stolen, which again supports the "uncivilized character" of the Other (MR 26). Nevertheless, Rowlandson expresses surprise that

17 Leviticus further states that when an animal is hunted and killed it needs to be bled dry and then the blood must be covered with dust. Those who eat an already perished animal or an animal killed by predators can counter the impurity by washing their clothes and themselves, but if not they will have to accept their punishment (Lev. 17:12-15). Furthermore, in the thirteenth remove, the narrative states that a young English captive, named John Gilbert of Springfield, is severely "sick of a flux, with eating so much blood" (MR 17), which could be read as a result of his transgression of dietary laws as well as—based on Rowlandson's expressed empathy and care for him—another Native American cruelty in only providing him with inappropriate food.

instead of an expected violent attack to take away all of the food, the reaction of the tribe members is described as: "[T]hey seemed to be ashamed of the Fact, and said, it were some *Marchit Indians* that did it" (26). Accordingly, what appears to be Rowlandson's concession of the Others' own recognition of violating "manners," is immediately refuted by her praising of God's power and protection as well as the comparison of the Natives to the "hungry Lions when *Daniel* was cast into the Den" (MR 26). So even Hoar's "civilized" attempt of establishing Visser's "fellowship" (97) through a shared meal to resolve the crisis of Rowlandson's captivity is subverted by the Natives. The aspect of the Other is once more emphasized when the dinner is ready as the Natives hardly eat, being too involved in their preparation of a dance, which she portrays in great detail with a particular focus on her master and mistress's "exotic" dressing-up (MR 26, 29).

Rowlandson's othering of foods and habits through a distancing, almost ethnographic gaze functions as a kind of conclusion in the twentieth remove. In the context of "a few remarkable Passages of Providence" (MR 29)—emphasizing God's trial through providing for the Natives— she gives an overview of the culinary habits of her captors at the end of her narrative. Her portrayal is characterized by a clear distance to "them" as well as by a strong negative assessment of their foods and foodways. She writes, "[t]hey would pick up old bones, and cut them to pieces at the joynts, and if they were full of worms and maggots, they would scald them over the fire to make the vermine come out; then boyl them" (MR 28) and "many times they would eat that, that a Hog or a Dog would hardly touch" (MR 68). Her description of their consumption of spoiled foods can be read as a direct judgment of Native Americans as lacking a sense of any cultural culinary tradition—and, thus, "civilization"—as they eat what they find like "all sorts of wild birds which they could catch" (MR 28), just like wild animals. I agree with Michael Pollan, who argues that "[o]ur culture codifies the rules of wise eating in an elaborate structure of taboos, rituals, recipes, manners, and culinary traditions" (4), which are, however, often restricted to particular cultural groups (Sceats 1). By putting this passage at the end of the narrative, she summarizes a part of her experiences and reaffirms the dichotomy of "culture" and "savage" and "saint" and "sinner" to her readers. As an early conclusion, she emphasizes God's providence through her affliction, exemplified through Native food and eating which she had to experience during her captivity. Accordingly, all previous passages that might indicate a change in her resulting from eating Native food as a sign of her growing wild are counteracted.

Mary Rowlandson's captivity narrative still posits a challenge to today's readers due to its ambiguity of the retrospective presentation of captivity. Analyzing the text through the lens of food studies from a historical context leads to

several conclusions. On the one hand, Rowlandson presents scenes of her cultural adaptation and attempts at societal integration to her audience. On the other hand, she simultaneously emphasizes the unpredictable and untruthful character of the Native Americans—as well as the so-called Praying Indians who converted to Christianity—throughout the whole account and by that offers a typical civilized/good versus savage/evil portrayal (MR 6, 15, 10). The narrative indeed uses passages of food and eating as tools to translate Rowlandson's crisis experience and cultural "in-betweenness" into a journey of faith to overall affirm her image as a Puritan goodwife for her audience. Her contemporary audience most probably would have interpreted her experiences based on their shared knowledge of food, eating habits, and dietary laws. Through this particular focus, Rowlandson's captivity narrative affirms Puritan orthodoxy that in times of crisis, in trial and affliction, one must keep faith in God's providence to clear away the "filthy trash" (MR 9) and eventually provide honey for the "hungry soul" (MR 10).

Works Cited

Ashley, Bob, et al. *Food and Cultural Studies*. London: Routledge, 2004. Print.

Barthes, Roland. "Vers une Psycho-sociologie d'Alimentation moderne." *Annales: Economies, Sociétés, Civilisations* 5 (1961): 977-86. Trans. and rpt. as "Toward a Psychosociology of Contemporary Food Consumption." *Food and Culture: A Reader*. Ed. Carole Counihan and Penny van Esterik. New York: Routledge, 2008. 28-35. Print.

Baym, Nina, et al., eds. *The Norton Anthology of American Literature*. Vol A. 7th ed. New York: Norton, 2007. Print.

Boyer, Paul S. et al, eds. *The Enduring Vision: A History of the American People*. 7th ed. Boston: Wadsworth, 2001. Print.

Brown, Jennifer. *Cannibalism in Literature and Film*. New York: Palgrave, 2013. Print.

Canup, John. "Cotton Mather and 'Criolian Degeneracy.'" *Early American Literature* 24.1 (1989): 20-34. Print.

Derounian, Kathryn Zabelle. "The Publication, Promotion, and Distribution of Mary Rowlandson's Indian Captivity Narrative in the Seventeenth Century." *Early American Literature* 23 (1988): 239-61. Print.

Diebold, Robert K. "A Critical Edition of Mrs. Mary Rowlandson's Captivity Narrative." Diss. Yale U, 1972. Print.

Douglas, Mary. "Deciphering a Meal." *Food and Culture: A Reader*. Ed. Carole Counihan and Penny Von Esterik. New York: Routledge, 1997. 36-54. Print.

Drake, James D. *King Philip's War: Civil War in New England 1675-1676*. Amherst, MA: U of Massachusetts P, 1999. Print.

Eden, Trudy. *The Early American Table: Food and Society in the New World*. DeKalb: Northern Illinois UP; 2010. Print.

---. "Food, Assimilation, and the Malleability of the Human Body in Early Virginia." *A Centre of Wonders: The Body in Early America*. Ed. Janet Moore Lindman and Michele Lise Tarter. Ithaca: Cornell UP, 2001. 29-42. Print.

Finch, Martha L. "'Civilized' Bodies and the 'Savage' Environment of Early New Plymouth." *A Centre of Wonders: The Body in Early America*. Ed. Janet Moore Lindman and Michele Lise Tarter. Ithaca: Cornell UP, 2001. 43-60. Print.

Greene, Carlnita. "Shopping for What Never Was: The Rhetoric of Food, Social Style and Nostalgia." *Food for Thought: Essays on Eating and Culture*. Ed. Lawrence C. Rubin. Jefferson: McFarland, 2008. 31-47. Print.

The Holy Bible. King James Version. Philadelphia: National Publishing Company, 1978. Print.

"Jane's Story." *Jamestowne Rediscovery*. Historic Jamestowne, n.d. Web. 25 Nov. 2013. <http://www.historicjamestowne.org/jane/jane.php>.

Kunow, Rüdiger. "The Rhetoric of Crisis: Cultural Reformulations and Social Change in the United States in the 1980s." *Amerikastudien / American Studies* 32.4 (1987): 467-80. Print.

Lepore, Jill. *The Name of War: King Philip's War and the Origin of American Identity*. New York: Knopf, 1998. Print.

Levi-Strauss, Claude. *Mythologica I: Das Rohe und das Gekochte*. Frankfurt/M: Suhrkamp, 1971. Print.

Logan, Lisa. "Mary Rowlandson's Captivity and the 'Place' of the Woman Subject." *Early American Literature* 28.3 (1993): 255-77. Print.

McWilliams, James E. *A Revolution in Eating: How the Quest for Food Shaped America*. New York: Columbia UP, 2005. Print.

Miller, Perry. *The New England Mind: From Colony to Province*. Boston: Beacon, 1961. Print.

Oliver, Sandra. "Ruminations on the State of American Food History." *Gastronomica* 6.4 (2006): 91-99. Print.

Philbrick, Nathaniel. *Mayflower: A Story of Courage, Community, and War*. New York: Penguin, 2006. Print.

Percy, George. "A Trewe Relacyon." *Colonial Williamsburg Journal*. The Colonial Williamsburg Foundation, n.d. Web. 25 Nov. 2013. <http://www.history.org/foundation/journal/winter07/jamestowndiary.cfm>.

Pollan, Michael. *The Omnivore's Dilemma: A Natural History of Four Meals*. New York: Penugin, 2006. Print.

Priewe, Marc. "Captivating Borderlands: The Allure of Alterity in Mary Rowlandson's *The Soveraignty and Goodness of God* (1682)." Rennes: PUR. Forthcoming.

Rippl, Gabriele. "'For the Hungry Soul Every Bitter Thing is Sweet': Essen und Transkulturation in Mary Rowlandson's 'A Narrative of the Captivity and Restoration of Mary Rowlandson.'" *Interkulturelle Mahlzeiten: Kulinarische Begegnungen und Kommunikation in der Literatur*. Ed. Claudia Lillge and Anne-Rose Meyer. Bielefeld: transcript, 2008. 143-56. Print.

Rowlandson, Mary. *The Soveraignty and Goodnesss of GOD*. 1682. *Early American Imprints: Series 1, no. 332*. Web. 19. Dec. 2013.

---. *A True History of the Captivity + Restoration of Mrs. Mary Rowlandson.* 1682. *Early English Books Online.* Web. 12 Dec. 2013.

Sceats, Sarah. *Food, Consumption, and the Body in Contemporary Women's Fiction.* Cambridge: Cambridge UP, 2000. Print.

Soler, Jean. "The Semiotics of Food in the Bible." *Food and Culture: A Reader.* Ed. Carole Counihan and Penny Van Esterik. New York: Routledge, 1997. 55-66. Print.

Toulouse, Teresa. E. "'My Own Credit': Strategies of (E)Valuation in Mary Rowlandson's Captivity Narrative." *American Literature* 64.4 (1992): 655-76. Print.

Ulrich, Laurel Thatcher. *Good Wives: Image and Reality in the Lives of Women in Northern New England 1650-1750.* New York: Vintage, 1991. Print.

Visser, Margaret. *The Rituals of Dinner.* New York: Penguin, 1992. Print.

Wallach, Jennifer Jensen. *How America Eats: A Social History of U.S. Food and Culture.* Lanham: Rowman, 2013. Print.

Winthrop, John. "A Model of Christian Charity." *The Norton Anthology of American Literature.* Ed. Nina Baym et al. Vol A. 7th ed. New York: Norton, 2007. 147-58. Print.

Consuming Latinidad: Mexican Foodways in Maria Ripoll's *Tortilla Soup* (2001)

Małgorzata Martynuska

The activity of eating and the associated activities of acquiring, cooking and serving food have fascinated filmmakers for years. Cinema has long explored food in creative ways and presented food and drink as metaphors for personal, familial and social issues. There are so many movies focusing on food in their film narrative that we can talk about an emerging 'food film' genre. Some of those movies feature a professional cook as the main character: *Big Night* (Stanley Tucci and Scott Campbell, 1996), *Babette's Feast* (Gabriel Axel, 1987), *Le Chocolat* (Lasse Halström, 2000). Other movies present food as a complex signifying system, e.g. a way of celebrating ethnicity and communicating emotions or cultural identities. Southern, African-American and Mexican ethnic identities are examined in *Fried Green Tomatoes* (Jon Avnet, 1991), *Once upon a Time When We Were Colored* (Tim Reid, 1995), *Soul Food* (George Tillman, Jr., 1997), and *Tortilla Soup* (Maria Ripoll, 2001). Another interesting movie, *What's Cooking* (Gurinder Chadha, 2000), is a study of food as a cinematic metaphor for multicultural Los Angeles, depicting four middle-class families of diverse ethnic backgrounds celebrating Thanksgiving Day.

In the emerging 'food film' genre, food plays a vital role in the development of film narrative. The camera often focuses on food preparation or consumption, which takes place either in a restaurant kitchen or at home. The film characters discuss issues of identity, class and culture while preparing or consuming food. The movies place family meals in broader contexts, showing how food exists within a culture and exploring ethnic foodways, defined as "the pattern of what is eaten, when, how, and what it means" (Kalcik 38). The cultural and social transformations taking place in American society, such as changes in ethnic composition and the formation of hybrid identities, are reflected by multiethnic foodways. This article depicts Mexican foodways in the film *Tortilla Soup* as metaphors for the hybridization of both Mexican-American cuisine and identity.

"As the Mexicans go from one location to the next, they are able to acquire and prepare the necessary foods that allow them to survive and forge their cultural identity" (Morán 15). The Mexican-Americans who settled in the USA brought their favourite foods with them, including a variety of dishes based on tortillas: *tostados* – tortillas cooked until crisp and served with a salsa dip made from chili peppers; *tacos* – crisp-fried tortillas filled with meat, lettuce and tomatoes; *enchiladas* – rolled tortillas covered with chili pepper sauce (Stroman

8). The idea of eating soup with tortillas is an ancient concept in Mexico, but in the USA this dish evolved into a popular tortilla soup. Traditional Mexican tortillas consist of corn flour, lard, salt, and water, whereas the tortillas of the American Southwest are usually made with wheat flour, lard, salt, and water or milk. Home-cooked tortillas are disappearing in the USA as Mexican-Americans buy packaged, mass-produced tortilla products (Candelaria et al. 843).

US Latinidad

The USA has been experiencing demographic changes with a rapid growth of the Latino population originating in the Spanish speaking countries of Central America, South America and the Caribbean. Those different nationality groups, known as Hispanics, are often represented as sharing a common identity, which gave rise to the concept of 'Latinidad,' defined by Valdivia as "the process of being, becoming, and/or performing belonging within a Latina/o diaspora" (Valdivia 53). The great proportion of Latinidad comprises Mexicans, who are the main subject of this article. Members of the Mexican diaspora have been referred to with five major lexical signifiers: *Mexican* – a person born in Mexico; *Mexican-American* – a U.S. American of Mexican descent, living in the USA; *Chicano/a* – a person of Mexican descent, residing in the USA and positioned socially as a member of an oppressed minority group; *Hispanic* – a person with ancestry from Spanish-speaking countries, living in the USA; *Latino* – a person of Latin American origin, regardless of race, language, or culture, who lives in the USA (Rinderle 296).

In 2001, the U.S. Bureau of Census showed that the number of Hispanics in the United States had reached 35.3 million, which constituted 12.5% of the total population. The statistics for 2013 indicate that Latinos account now for almost 17% of the population. Although three quarters of Latinos remain concentrated in the South and West, with just two states, Texas and California, containing about half of the Hispanic population, new immigrants have begun to settle in other parts of the USA. New York, Florida, and the Carolinas have been attracting Latino newcomers with employment opportunities and, in terms of numbers, Mexican labourers have been particularly visible in this eastwards migration flow (Portes 271-272). The rapid growth of the Hispanic population has become a phenomenon of great importance for the United States and many nativist organizations have reacted to this trend with alarm. However, Latin Americans share the same Western and Christian traditions, together with work ethic and family values, as the American mainstream population and there is no reason why Hispanics should not be able to acculturate to life in the United States.

The way Latin Americans are perceived by the white American mainstream is largely influenced by information coming from the mass media. Although Latinos/as comprise the largest ethnic minority in the United States, they constitute only about 3%-4% of characters featured on prime time television. Additionally, Latino/a characters are usually depicted as comics, criminals, law enforcers, and sex objects. These stereotypical portrayals show Latinos/as in low-status jobs and service positions, not requiring intelligence or education. However, the important change being observed is the fact that Latinos/as are increasingly seen in major rather than background roles (Mastro et al. 2). Furthermore, the longstanding immigration trends and the growing numbers of Hispanics born in the USA have prompted other changes in the television industry, increasing the number of Latino-oriented TV networks. The status of Latinos/as as the largest minority group in the USA has enhanced their economic value for a television industry which tries to appeal to the Hispanic audience (Piñón & Rojas 129).

The protagonists of *Tortilla Soup*

The film *Tortilla Soup*, which was inspired by the Taiwanese-American movie *Eat Drink Man Woman* (Ang Lee, 1994), belongs to a number of US food films constructing a tourist experience of cultures outside of white middle-class America through celebratory images of ethnic food traditions. Whereas Lee's movie depicted a family adapting to changing times within its own country, Ripoll's film shows a family struggling with issues of assimilation. In *Eat Drink Man Woman*, food preparation symbolizes the maintaining of traditional values of Chinese culture as well as of the culinary arts. Both Lee and Ripoll use the idea of the Sunday dinner ritual that brings the whole family together. "However, Ripoll overturns traditions when it comes to matters of national cuisine and cultural homogeneity" (Bower 9).

The main characters of *Tortilla Soup* are the Mexican-American Naranjo family living in Los Angeles in contemporary times. The father, Martin (Hector Elizondo) is a widowed chef who has lost his sense of taste and smell since the death of his wife. The other family members are his three daughters: the eldest, Leticia (Elisabeth Peña), is a chemistry teacher; the middle, Carmen (Jaqueline Obrados), is a successful business executive; the youngest, Maribel (Tamara Mello), has vague plans about going to college. Other characters of the film include: Martin's close friend, Yolanda (Constance Marie); Yolanda's eccentric mother, Hortensia (Raquel Welsh); and Martin's best friend, a Cuban chef named Thomas Gómez (Julio Oscar Mechoso), who tastes samples of Martin's dishes.

Contemporary Latina stars, like Jennifer Lopez, are often portrayed with tropicalizing tropes of hypersexual, exotic otherness. The Mexican characters of *Tortilla Soup* embody a sort of hybridity that is both ethnic and appealing to the white mainstream audience. All three Naranjo daughters, together with Yolanda, are fair-skinned and present Eurocentric standards of beauty. Even Martin himself, although speaking with a Mexican accent, has fair skin and blue eyes. Only the minor character of Leticia's husband, the dark-skinned Orlando, looks Mexican. At the same time, the female characters confirm ethnic stereotypes concerning Mexican women: Carmen is hypersexual, Leticia religious and Maribel expresses anger by smashing dishes on the kitchen floor (Lindenfeld 312).

The first scenes of the film introduce the viewer to a world that is both familiar and 'other'. We hear the Caribbean sound of bongos, a bass, a guitar, and steel drums. With this musical background the viewer sees Martin gathering fresh tomatoes and peppers in the surroundings of tropical plants, which look colourful and exotic, suggesting the pan-Latino/a narrative. Then Martin is shown entering his middle-class kitchen and starting Sunday dinner preparations. Although the kitchen is equipped with modern conveniences, there are numerous ethnic accents, like painted vases, providing Mexican flair. Martin is depicted while slicing the vegetables, which he does with the skill of a highly trained cook (Lindenfeld 309). He is portrayed as a respected professional from the American middle-class who cultivates his ethnic traditions and Mexican cuisine. The movie challenges the common stereotypes concerning Mexican-Americans, who are often portrayed as "lazy 'greasers' and 'bandidos', fiendish sex and dope addicts" (Renner 7). *Tortilla Soup* depicts Latino/a characters as members of the American middle-class living legally in the USA, educated, intelligent and speaking English.

Mexican foodways and family

American 'food films' "invite the tourist gaze to experience ethnic 'others' and their food cultures, fulfilling a questionable ethnographic function for white audiences" (Lindenfeld 304). The main concept in the film *Tortilla Soup* is the food that is used to represent ethnicity and culture in a Latino family. In the opening scene the viewer sees the movement of hands picking vegetables, grilling, frying and performing other activities concerned with food preparation. We can guess that these are the hands of a person with culinary talents. Then we discover the identity of the cook – the Naranjo family patriarch, Martin – who is preparing a magnificent Sunday dinner for his three daughters. He is trying to hold his family together with the bond of carefully prepared meals and breaks the stereotype as it is women who usually cook in a typical Mexican family.

Sunday dinner is the time when the Naranjo family talk about issues concerning both family and professional life, share news and make announcements. Although these discussions are often emotional, the conflicts are quickly resolved over the dinner table laden with delicious food.

Sunday dinners at the Naranjo family are spectacular feasts to which family friends are also invited. The shots of food preparation have some sensory beauty and artistry. In the opening scene, the viewer sees fruit and vegetables typically associated with Mexican cuisine: tomatoes, peppers, avocados, prickly pear cactus, nopalitos, purple onions, and corn tortillas. Both in his home kitchen and in his restaurant, Martin uses a lot of fresh fruit and vegetables, with ordinary corn as well as the more sophisticated octopus. Those typically Mexican ingredients are also used when Martin secretly prepares packed school lunches for his friend's daughter. Dinner at the Naranjo home typically starts with either squash flower soup or tortilla soup. The Mexican heritage is also emphasized by the traditional containers, baskets and knives used for food preparation as well as by distinctive cooking techniques such as roasting vegetables and baking in parchment.

The movie depicts tensions between a first-generation immigrant and his daughters who are acculturated to the USA. The American setting is clearly visible when the characters start talking. The daughters speak a mixture of English and Spanish. Martin objects to the usage of 'Spanglish' and says "English or Spanish, one or the other!" He is a cultural purist who clearly does not like the mixing of either languages or food ingredients. Carmen prefers a fusion of ingredients and is fond of 'Nuevo Latin' cuisine. Her cooking is spicier than Martin's and she likes to experiment with new ingredients. Martin's three daughters present a certain level of acculturation to the American way of life. Two of them have jobs and break the stereotype of Mexican women staying at home. The film depicts the fusing of culture as an inevitable aspect of acculturation to the American mainstream.

The foodways presented in the film serve functions of basic nutrition and as a representation of love. Although Martin's daughters do not always act according to his expectations, he clearly takes pleasure in cooking for his daughters and watching them eating meals prepared by him. The plentiful food also symbolizes wealth and abundance such as many American middle-class families can enjoy sitting at tables and being served with nutritious and lavish meals. Additionally, the Naranjo family's dining room and tableware are presented in an elegant way. The fancy table setting, including china and silver, clearly indicates the family is well off. Food is also used as the medium to show pride in cooking and express creativity and talents. Carmen is good at mixing unusual ingredients and preparing 'Nuevo Latin' dishes and Martin is able to save overcooked food

and turn it into a new dish which he calls by a French name. Both Carmen and Martin are excellent cooks but express their talents in different ways (Balthrope 107-111).

All Martin's dishes represent traditional Mexican cuisine. However, the choice of the dishes is limited to certain types of food that are accepted by the majority of American consumers. Thus, the Mexican food depicted in the film reflects the types of dishes selected for the mainstream consumer in US Mexican restaurants. Yet, Martin's cuisine is presented as authentic in contrast to Carmen's 'Nuevo Latin' cuisine. "In its presentation of Carmen's Latin fusion cuisine, the film homogenizes Latinidad into a post-ethnic identity against the specificity of Mexican cooking and culture" (Lindenfeld 310).

Although Martin's sense of cultural continuity is often disrupted by unexpected announcements made by his rebellious daughters at the dinner table, the delicious food facilitates communication among family members and conflicts are soon resolved. The first announcement is made by Carmen, who plans to move into her own condominium; then she changes her plans drastically and decides to run a new company in Barcelona. Martin has to face the fact that his acculturated daughters are pursuing independence. One announcement is particularly dramatic, namely when Maribel says she wants to postpone college. When Martin does not accept that decision, she decides to move in to her Brazilian boyfriend's flat. Leticia breaks the most surprising news when she announces she has just married Orlando, who is a baseball coach at her school. Also at the dinner table, Martin announces his marriage proposal to Yolanda. When he falls in love, it helps him to accept the shifts in his daughters' lives.

Carmen, whose childhood dream was to become a chef, is a talented cook and prepares delicious meals for her boyfriend. Despite great career prospects she decides to turn down her business promotion and stay in Los Angeles with her family. While cooking a meal for her father, she changes the traditional recipe. It turns out that Carmen's culinary talents cause Martin to regain his lost senses of taste and smell. "In this movie, the daughter's version of a standard recipe represents a necessary renewal of culture through artistic variation and generational change" (Bower 9). The last scene depicts Carmen fulfilling her childhood dream and becoming the chef of a new restaurant serving 'Nuevo Latin' cuisine. Her hybrid, post-ethnic identity is visible in the way she combines Latin fusion culture with American white mainstream culture. At her restaurant the whole family hear the announcement from Martin's pregnant wife that their baby is going to be a girl. This scene implies that generational change is unavoidable (Lindenfeld 310).

Conclusion

Tortilla Soup depicts the emergence of transnational identities in the US-Mexican borderlands and the hybridization of contemporary metropolitan life. Martin Naranjo, as a cultural purist, not only tries to stop the merging of both languages and cultures, but also wants his daughters to keep the Sunday dinner ritual as a symbolic continuation of tradition. He also shows clear contempt for American fast food, as when Orlando invites him to a baseball match and hotdogs and Martin replies: "You take care of the tickets, and I'll take care of the food." However, the final scene of the film emphasizes the necessity of change; even if Martin's attitude remains the same, the next generation of Mexican-Americans will not be able to stop the fusion of culture. The Naranjo sisters present a high degree of acculturation into American urban life, "yet they too remain cultural hybrids, synthesizing the values of their geographic origin and those of contemporary California" (Keller 172).

Although *Tortilla Soup* does not reduce Mexican food to tacos and burritos and presents the culinary richness of Latina/o cuisine, the food presented in the film is an assimilated version of traditional Mexican cuisine for the American audience. The film commercializes Mexicanness while also affirming white middle class values. "Thus, *Tortilla Soup* reaffirms hegemonic ideologies about Latinos/as that privilege whiteness and contain ethnic 'otherness,' and food in *Tortilla Soup* reaffirms long-standing ethnic tropes" (Lindenfeld 304). The film privileges not only fusion cuisine but also the hybrid identities of the characters who are acculturated to US middle-class norms. By positioning fusion cuisine over traditional Mexican dishes, the film suggests Mexicans will be more acceptable to Americans if they blend their ethnic culture with the US mainstream.

Latino/as who cross international borders for political, economic or social reasons leave a mark on the places they left behind and change the culture of the receiving community as well; thus their migration results in the transformation of both the place of their origin and their destination. By starting the process of incorporating Latinidad into the American mainstream, Hispanics enrich American culture with elements of their Latino/a heritage.

Works Cited

Balthrope, Robin. "Food as Representative of Ethnicity and Culture in George Tillman Jr.'s *Soul Food*, Maria Ripoll's *Tortilla Soup*, and Tim Reid's *Once upon a Time When We Were Colored.*" *Reel Food: Essays on Food and Film.* Ed. A. L. Bower. New York and London: Routledge, 2004. 101-113. Print.

Bower, Anne L. "Watching Food: The Production of Food, Film, and Values." In *Reel Food: Essays on Food and Film*. Ed. A. L. Bower. New York and London: Routledge, 2004. 1-13. Print.

Candelaria, Cordelia Chávez, Peter J. Garcia and Arturo J. Aldama, eds. *Encyclopedia of Latino Popular Culture. Volume II*. Westport, CT: Greenwood Press, 2004. Print.

Kalcik, Susan. "Ethnic Foodways in America: Symbols and the Performance of Identity." In *Ethnic and Regional Foodways in the United States: The Performance of Group Identity*. Ed. Linda Keller Brown and Kay Mussell. Knoxville: University of Tennessee Press, 1987. 37-65. Print.

Keller, James, R. *Food, Film and Culture: A Genre Study*. North Carolina: McFarland & Company, 2006. Print.

Lindenfeld, Laura. "Visiting the Mexican American Family: *Tortilla Soup* as Culinary Tourism." *Communication and Critical/Cultural Studies* 4.3 (September 2007): 303-320. Print.

Mastro, Dana E., Elizabeth Behm-Morawitz and Maria A. Kopacz. "Exposure to Television Portrayals of Latinos: The Implications of Adverse Racism and Social Identity Theory." *Human Communication Research* 34 (2008): 1-27. Print.

Morán, Elizabeth. "Constructing Identity: The Role of Food in Mexica Migration and Creation Accounts." *SECOLAS Annals* 52 (2008): 15-27. Print.

Piñón Juan, and Viviana Rojas. "Language and cultural identity in the new configuration of the US Latino TV industry." *Global Media and Communication* 7.2 (2011): 129-147. Print.

Portes, Alejandro. "The New Latin Nation. Immigration and the Hispanic Population of the United States." *Du Bois Review* 4.2 (2007): 271-301. Print.

Renner, Sofie. *The Film 'Tortilla Soup' in the Context of Mexican Life in USA and Type and Stereotype of Chicanos and Latinos in Film*. Germany: GRIN Verlag, 2003. Print.

Rinderle, Susana. "The Mexican Diaspora: A Critical Examination of Signifiers." *Journal of Communication Inquiry* 29.4 (October 2005): 294-316. Print.

Stroman, James. *Down Home Texas Cooking*. Maryland: Taylor Trade Publishing, 2004. Print.

Valdivia, Angharad N. "The Gendered Face of Latinidad: Global Circulation of Hybridity." In *Circuits of Visibility: Gender and Transnational Media Cultures*. Ed. Radha Hegde. New York: New York University Press, 2011. 53-67. Print.

Part Five: Sustainability

"Steam-driven cannibals … claim us flesh eaters,– wish we were": Black Sustainability through the Voice in African American Poetry on the Middle Passage

Jerzy Kamionowski

The title of this article merges quotations from two poems on the Middle Passage: the former part comes from Amiri Baraka's "So the King Sold the Farmer," whereas the latter is taken from Kevin Young's "Doxology," which belongs in a series of monologues performed by Cinque, the Amistad rebellion leader. Both use the trope of cannibalism – according to Alan Rice, a conspicuous ingredient in the discourse of the literature of the Black Atlantic - and signal, in the most condensed form, its metaphysical and political aspects. This trope reveals mutual fear, resulting in stereotyping and hostility between the Africans captured for transportation to America to be consumed by the "steam-driven" economic system and their Euro-American enslavers paralysed with fear of being devoured by not-so-noble savages. This results in the stigmatization of the Other(s) and situating Them outside of the realm of OUR non-anthropophagic culture and perhaps even outside the category of humanity. Zygmunt Bauman suggests that the culture of Modernity is "anthropoemic" as opposed to the "anthropophagy" perceived as its antithesis. If anthropophagic cultures "internalize" their Other(s) by eating them, anthropoemic ones "externalize" them, which may reduce the Other(s) to the level of Agambenian "bare life." Apparently, the transportation of Africans across the Atlantic is a journey into the world of anthropoeia, which is also signalled by the deprivation of the voice of blacks.

I want to briefly explore the tension – and possible interdependence – existing between anthropophagy and anthropoeia in selected poems on the Middle Passage by African American poets. My purpose is to demonstrate how these poems help regain the voice of the Other as a means of black sustainability in confrontation with dehumanizing Modernity; arguably, it is the human voice of the enslaved Africans that manages to resist the hidden impulse of the cannibalistic desire of the insatiable anthropoemic culture of the West. The asymmetrical juxtaposition/complementarity, on which the relationship between anthropophagy and anthropoeia is founded, brings to mind Emmanuel Lévinas' concept of the Other and the *dire* versus *dit* distinction, which emphasises the role of the personal voice as opposed to public discourse with regard to communicating the experience of Otherness and its truth.

In his discussion of the discourse of cannibalism in the literature of the Black Atlantic, Rice identifies the "figure of the cannibal" and the motif of anthropophagy (both literal and metaphorical) as key components of Africans "respond[ing] to stereotyping" (106). Nonetheless, among the many examples he quotes to support his thesis, Rice does not mention any poetic works at all. The omission seems to be symptomatic, as it reveals a characteristic uncertainty about the epistemological usefulness of poetic utterance as contrasted with history and prose. Making selective use of Rice's observations, it is worth emphasizing the "counter-hegemonic" (106) potential of poetry on the Middle Passage. Along with the abovementioned poems by Baraka and Young, I will make reference to Robert Hayden's "Middle Passage," Elizabeth Alexander's "Amistad," Clarence Major's "The Slave Trade: View from the Middle Passage," and ultimately concentrate on Sonia Sanchez's "Improvisation." These titles underscore how important poetic representation of the trauma of the Middle Passage has been for the last half a century. However, I am not interested here in the historical evolution of "the Middle Passage poem" as a sub-genre, but rather in its ability to break through "Eliot's shell" of literary discourse and probe both the "original" experience of being reduced to the level of "bare life" and the ascension to "full humanity." From this point of view "Improvisation" represents a climax in terms of being a "spontaneous" expression of this experience.

As C. Richard King (111) observes: "the consumption of human flesh elsewhere (a) is problematic, (b) produces categorical distinctions (such as good/bad, us/them, civilization/savagery), and (c) as such has significance for the moral, if not political status of peoples, practices, and precepts here and there." Thus, "critical understandings of others as cannibals have justified colonial projects, sanctioned the recreation of indigenous peoples after Westerners, and promoted the fabrication of imagined communities." Similarly, W. Arens talks of anthropophagy as a phenomenon providing a border between human and non-human, culture and nature. He says that "eating human flesh implies an animal nature which would be accompanied by the absence of other traits of 'real' human beings who have a *monopoly on culture*" (109). Thus, the label of cannibalism has always been *used* by various communities for pragmatic purposes, especially to guarantee physical safety and protection (for themselves) and as a moral excuse for defining other groups as inferior or degrading them completely.

The cannibal equals the Other, both in political and metaphysical terms. Paul Shankman observes that cannibalism is "one of the nastiest things that can be said about others. People who are feared and distrusted are frequently ascribed a general syndrome of disgusting behavior of which cannibalism is a part" (59). To support his general claim, Shankman provides field-study evi-

dence from different regions of the world and data about various cultures which indicates how widespread and complex this universalism of stigmatization is. The purpose of Shankman's examples is to demonstrate that cannibalism has always functioned more as a metaphor than a real practice known from first hand observation or experience, and has been extensively used in order to stigmatize the Other.

Nevertheless, the situation changes dramatically in the case of black and white racial relationships during the slave trade, where we cannot find even relative equality or symmetry in terms of access to power which characterizes the uses of anthropophagy mentioned by Shankman. It is essential that we notice and understand this difference before looking at some examples of how the trope of cannibalism manifests itself and functions in African American poetry on the Middle Passage.

During his fieldwork in postcolonial Africa W. Arens discovered that many contemporary Africans believed Europeans to be cannibals or vampires. The title of Arens's book/report is *Man-Eating Myth*, which emphasizes the symbolic and metaphorical character of cannibalism suggested above. In this case the metaphor of cannibalism is deeply rooted in African experience of the Middle Passage, so deeply that it transcends strictly factual historiographic communicability. At the rhetorical level, taking Africans away by brutal force from their cultural and physical environments in the "belly of ships" can be perceived as an "equivalence to the barbarism of cannibalism" (Rice 113). As William D. Piersen has concluded: "As a mythopaeic analogy it does not seem farfetched to portray chattel slavery as a kind of economic cannibalism" (12). Colonialism and American plantation slavery actually *consumed* millions of Africans in the literal sense of the verb.

The myth of the white man as cannibal, uncovered by Arens, may be rooted in the African collective memory of the slave trade. Piersen says:

> Few of the new captives imagined themselves going west to become agricultural laborers; instead, they suspected they were to be cooked and eaten. From the seventeenth century onward, people in West and Central Africa from the Senegambia to Angola commonly explained the prodigious appetite of the Atlantic trade for human cargo in terms of the white man's barbaric cannibalism. (5)

Arens, King, Piersen and Rice provide a substantial number of examples of how and why this myth appeared, and give reasons for its extensive circulation among Africans. Their findings may be summed up in four essential points which explain why Africans took whites for cannibals:

1. The white ships took their captured relatives away from home and made them disappear into the unknown. When the human "cargo" was loaded into the vessels, both the slaves already on the deck and those standing on the land nearby could see huge cauldrons full of hot water, which they took for clear signs that they would be cooked and eaten, as testified by Eloudah Equiano (31) in his narrative. In fact the cauldrons were used to keep the fires burning in order to reduce the risk of epidemics of "African fever."

2. During the crossing of the Atlantic, the crew force-fed those who refused food in order to "protect" their valuable "cargo" from weakening and dying. Yet, force-feeding was believed by the transported slaves to be done for the purpose of fattening them in order to eat them after arrival.

3. The crew were well-aware of the slaves' fear and maliciously used this knowledge to make direct threats and cruel jokes; for instance, Eloudah Equiano says at one point in his narrative that "the captain and people told me in jest they would kill and eat me, but I thought them in earnest." This was a possible reason for the Amistad rebellion as "the cook told them [i.e. the slaves] that when they reached land they would be all eaten" (Rice 112).

4. Arab slavers spread rumors about black and white cannibalism to maintain their monopoly over the slave trade in the region of the Congo. As Arens explains: "They warned whites away from the area telling them that many of the peoples there were supposed cannibals; at the same time they dissuaded these Congolese from helping white traders by warning them of white cannibalistic practices" (88).

Arguably, the key "universal" function of perceiving the Other as cannibal is to cope with one's own fear and uncertainty in confrontation with the (imaginary) anthropophagous Them. Also, it is important to emphasize once again in the examples provided above the conspicuously rhetorical character of cannibalism: hard evidence for the hideous *practice* of anthropophagy turns out to be less important (or virtually insignificant) compared to the *verbal act of stigmatizing* the Other(s) with this label and situating them outside of polis, culture and humanity. However, there is a striking asymmetry in the mutual perceptions of whites and blacks as "cannibals": whereas the Africans become inferior when stigmatized with this degrading label, whites are perceived by blacks as superhuman, resulting from their power to enslave and their readiness to use violence in the process. Thus, both black and white "cannibals" are dangerous, but the peril they represent is qualitatively different.

Therefore, to use the possible distinction, however tentative, between metaphysical and political motivations for accusing the Other(s) of cannibalism, we

can say that Africans' suspicion that white slavers may be cannibals is of a metaphysical nature, even though it has quasi-empirical roots. Simultaneously, it must be remembered that extreme stigmatization of the Other(s) with the label of "cannibalism" usually had a pragmatic purpose: the rationalization of hostility, frequently expressed in violent and cruel forms; pragmatism makes such stigmatisation political rather than metaphysical. As a result, this concept of "cannibalism" could assist more disciplined, systematically organized, rationally planned, ideologically-cum-economically motivated, idealistically/morally supported large-scale enterprises such as the "emergence of an international economy that created a nearly insatiable demand for cheap labor in the Americas" (Piersen 3). As King observes:

> Administrators and adventurers, capitalists and Christians, have not simply advanced cannibalism to dismiss, judge, or otherwise devalue unfamiliar, exotic, and indigenous peoples; instead, they have invoked cannibalism as a social problem or as a marker of social problems, while advancing strategies to rectify them. Thus, observations and assessments of cannibalism have prompted and legitimated Occidental intervention. (109)

Also, when pointing out the importance of metaphysical and political dominants in the concept of cannibalism, when discussing it in the context of the trans-Atlantic slave trade, we must not overlook the fact that it has had its own history and has undergone a long process of transformation. As Klarer puts it:

> The concept of pre-agrarian, precivilization cannibalism is intricately interwoven with ancient theories of cultural evolution. The Neolithic revolution, that is, the transition of man from hunter-gatherer to peasant, was generally explained as a substitution of anthropophagy for agriculture. This concept does not end in antiquity but continues in various forms in cultural history. (393)

An awareness of this fact seems to be of capital importance for understanding the implementation of the stigma of cannibalism in the discourse of European colonisation and the trans-Atlantic slave trade, as well as in the counter-discourse of African American poetry on the Middle Passage. As pointed out at the beginning of this article, Bauman juxtaposes the "anthropophagic" culture(s) of the pre-Modern era with the "anthropoemic" culture of Modernity, arguing that the latter externalises its Other(s) in three interconnected modes: "hostilisation," "elimination," and "objectification." If anthropophagic societies eat their

ancestors and enemies, Bauman says, we "*vomit* ours. Our way of dealing with
the Other (and thus, obliquely, of producing and re-producing our own identity)
is to segregate, separate, dump onto the rubbish tip, flush down into the sewer of
oblivion" (131). Nonetheless, the act of vomiting depends inherently on the pre-
vious act of devouring and the eventual incapability of digesting – a point to
consider in the case of African slaves transported across the Atlantic. One can-
not vomit something that one has not swallowed, a trope present in African
American literature: does not the protagonist's grandfather in Ralph Ellison's
Invisible Man say, "let 'em swoller you till they vomit" (17)? Perceived from
this angle, Bauman's binary opposition turns out to be inherently asymmetrical
since the "anthropoemic" culture of Modernity has anthropophagy inscribed in it
as its necessary *pre*-condition, whereas the "anthropophagic" culture does not
imply "anthropoeia" as its inevitable *post*-condition.

Hypothetically, the "steam-driven cannibalism," the enforced transportation
of Africans from the state of anthropophagy to the state of anthropoeia, is related
to, or even founded on, depriving Africans of their own voice with which they
could tell their part of the story. In the situation when history is written by the
conquerors, winners, and oppressors rather than the conquered, losers, and op-
pressed, it can be argued that the production of difference depends on control-
ling the narrative and regulating access to discourse in terms of what sort of ex-
perience can be expressed and what forms of expression are allowed for this
purpose. Piersen says:

> the victims of the slave trade rarely left written records documenting their under-
> standing of their victimization. Few African slaves had the autonomy to produce
> such artifacts, and almost all lacked the literacy to do so. In fact, the idea would
> have come to very few of them, since among the African peoples involved in the At-
> lantic trade traditional wisdom and experience were passed on by word of mouth
> from narrator to narrator, not by the written word. (3)

This has far-reaching consequences since "[t]he oral histories of African peoples
were communal products, the results of a series of interchanges between narra-
tors and their audiences" (3-4) who believed that "truth had both a narrow literal
meaning and a broader, more dynamic, symbolic dimension ... Truth is not al-
ways in the facts, sometimes it is in the meaning" (5) of the events themselves.
The problem is that we "know" and "learn" about the trans-Atlantic slave trade
mostly through scholarly "cold, after-the-fact rationalizing [which is] a product
of our own secular, scientific, and business-oriented era; it does not at all sug-
gest how the Africans and African Americans who experienced enslavement

interpreted this same brutal commerce" (3). We know "roughly what they thought because the ephemeral oral narratives they passed down were occasionally frozen into the written records" (3). Those constatations give rise to various important questions, such as for instance:

1. How to get to the level of event(s) and experience of the Middle Passage rather than simply talk about facts?
2. How to restore the abovementioned communality of historical testimony?
3. How to "defrost" written records and preserve the quality of orality in the written text in order to reconstruct the experience of the enslavement?
4. How to regain the lost / non-existent record that would contain grains of traditional wisdom and communicate the original experience?

Necessary as factual information is, by rationalizing the matter it separates us from the original event and experience of what it must have been like for the transported Africans to be reduced to the level of "bare life." It is worth at least considering such a possibility, comparing the scholarly-cold precision of factual data with the undisciplined, irrational, trance-like "account" provided in Beloved's interior monologue:

there will never be a time I am not crouching and watching others that are crouching too I am always crouching the man on my face is dead his face is not mine his mouth smells sweet but his eyes are locked some who eat nasty themselves I do not eat the men without skin bring us their morning water to drink we have none at night I cannot see the dead man on my face... (Morrison 211)

Arguably, historical research into the trans-Atlantic slave trade, by analyzing documents and statistical data, concentrates on things external to the experience of the people enslaved and transported, thus leaving out its internal human dimension. Perhaps it is precisely this practical impossibility for historical accounts to break through the barrier of established facts and reach to the level of the events and experiences of the transported Africans which literary treatments of the Middle Passage demand. One can say metaphorically that only poetry or – more precisely – lyrical discourse (this category includes the extract quoted above) makes an attempt to let the "cannibal" speak, whereas more purely historiographically-oriented discourse objectifies the "anthropophagi" as objects to be defined and used.

As has already been stated, the trope of cannibalism is one of the recurring and central motifs in African American poetry on the Middle Passage. Nonetheless, its application and intensity differ substantially from poem to poem. Sometimes cannibalism is directly mentioned and taken literally, whereas in other poems it is only alluded to, implied, taken metaphorically or even "unspoken." In all cases, however, this trope is closely connected with access to discourse and power, enslavement and freedom, being devoured by the rational language-cum-economy of Modernity and the black sustainability that opposes it.

Cannibalism is mentioned most frequently in Kevin Young's quasi-epic collection *Ardency*, which deals with the *Amistad* rebellion and makes an attempt to restore the voice of the "cargo" through the means of polyphonic utterance of the traumatic experience of the transported African slaves. In Young's poem this frequency results from the fact that a cannibalistic threat made by the cook may have been a catalyst for the rebellion. In "New Haven," a poem written in the form of a letter addressed to John Quincy Adams (who defended the Africans), a slave signed as Kin-na states it directly: "Cook says he kill, he eat Mendi people; / we afraid; we kill cook. Then captain kill one man with knife, and lick / Mendi people plenty. We never kill captain, he kill us..." (36). There are further references to factual knowledge about the events that took place on *La Amistad*. For instance force-feeding, which had cannibalistic connotations for the transported slaves, appears in "Processional" ("the rice our people / for generations / grew – forced / down our gullet") (60), only to gain vehemence in the bitter irony of "Rice Song": "How / could we not / believe in heaven / having swam / thro hell? Forced to eat rice till vomit" (102). Quite significantly, these facts are uncovered not by legal documents but through the "incorrect" voices of the black witnesses, especially the personal voice of Cinque, the leader of the rebellion. Moreover, in several places the treatment of cannibalism is openly metaphorical: for instance in "Catechism," where it stands for what Marilyn Frye calls the "arrogant gaze" – the gaze that appropriates and deprives of identity and subjectivity ("Savaged, ravaged / by the cannibal eyes of the cruel – / by those who could call themselves / *master* or *senor* or *Christian* / or all three – their eating eyes – / their *thou shalt not* / Then they turn us chattel") (124); in "Prayer," where a Christian prayer becomes distorted so that its devouring nature is revealed ("standing in the eve of prayer" is transformed into "standing in the eaten prayer") (39); or in "Processional," in which the West's Satanic appetite is pointed out ("How many the sea / swallow'd – I could / not say – see – / Ah was not of the Lawd") (60). But in Young's volume the act of speaking itself allows the black subject to reject in "Doxology" the role of passive victim and dream of a cannibalistic role-reversal based on a kind of mimicry:

They claim us flesh

eaters, – wish

we were and then

could have done to them

what Cook promised

awaited us –

(80-81)

Similar strategies are implemented also in other Middle Passage poems. In Elizabeth Alexander's "Translator," a part of the "Amistad" sequence in *American Sublime*, the fear of white "cannibalism" taken literally is first among the atrocities mentioned by the slaves to James Covey – an African shipyard worker in New Haven, who spoke Mende and was employed as an interpreter: "*We killed the cook, who said he would cook us. / They rubbed gunpowder and vinegar in our wounds. / We were taken away in broad daylight.*" (39) In Clarence Major's "The Slave Trade" the trope of "cannibalism" appears as Modernity's insatiable, economically motivated greed for "ivory, gold, land, fur, skin, chocolate, cocoa, / tobacco, palm oil, coffee, coconuts, sugar, silk, / Africans, mulatto sex, 'exotic' battles, / and 'divinely ordained slavery'" (301) and as a projection on the Other of the Enlightenment's repressed anthropophagic drive ("And Hansel to Gretel: / 'I'm afraid to go / to Africa because cannibals may / eat me / as they do one another.' / Little Red Riding Hood to her grandmother: 'Dig, what makes your mouth so big?'" (312-313). Baraka's "So the King Sold the Farmer," by referring to the Middle Passage as the "original western / holocaust" (265), establishes the anthropoemic dominant of the culture of Modernity, only to immediately reveal a concealed anthropophagy as its pre-condition: "They threw / our lives / a way / Beneath the violent philosophy / of primitive / cannibals / Primitive / Violent / Steam driven / Cannibals" (266)

However, not every poem on the Middle Passage openly uses the trope of cannibalism. For example, neither Robert Hayden's now classic "Middle Passage" nor Sonia Sanchez's "Improvisation" mention cannibalism directly, which, arguably, does not mean that the trope is completely absent in them. In the former poem its absence is quite conspicuous, especially when it is read in the light of the poems quoted above, written much later. Apart from a passing remark about the "*butchered* bodies of … true Christians" (Hayden 53; italics mine), which can be classified as a discreet allusion to cannibalism, there are no other references to it in the text. Even the incident with the cook is not mentioned, despite the fact that Hayden's poem is rooted in painstaking research conducted by

its author into the *Amistad* case, which makes "cannibalism" *present* as a taboo topic in the text. Sanchez's "Improvisation" is a different matter: it also does not introduce the theme of "cannibalism" directly, but the trope is strongly encoded in the sequence of phrases dispersed in the text: "coming across the ocean" (75) "packing of all of us in ships" (76) "standing on auction blocks" and "giving birth ... / [e]very nine months" (77), which points to the commodification and consumption of Africans by the economic system of Modernity.

Whatever strategy is used in individual works by Alexander, Baraka, Hayden, Major, Sanchez and Young, their lowest common denominator is to restore the communal voice of the African witnesses/victims of the Middle Passage. Whether this is attempted by means of a scrupulous study of historical facts and documents (Hayden), a jigsaw-puzzle technique of putting lyrical and concrete details together (Alexander), a polyphonic combination of letters, testimonies and libretto (Young), the superhuman speech of a trickster-like ghost (Major), cool observations-cum-outbursts of panic (Baraka), or inspired, trance-like improvisation (Sanchez), the purpose is to communicate the original experience of enslavement and the Middle Passage. Apparently, this cannot be achieved successfully without challenging the stereotype that an African equals a "cannibal" and focusing on the anthropophagic practices of the anthropoemic culture of Modernity.

Arguably, the most successful creative attempt to recover the African collective voice and make the experience of the Middle Passage accessible to a reader is provided by Sonia Sanchez's poem "Improvisation" from her 1995 collection *Wounded in the House of a Friend*. In that poem Sanchez found a powerful artistic means to confront her readers/audience with the experience of the atrocities of the Middle Passage, and communicate – to quote Piersen again – "a broader, more dynamic, symbolic dimension" of truth about it.

The first striking feature of Sanchez's chant-poem is that it represents a conspicuous example of the "destruction of the text" – a term which stands for the "relegation of the printed poem to the status of a 'musical score'" (Henderson 61). Sanchez's poem should be perceived as a perfect illustration of her skill in using the jazz idiom to achieve the original rhythm-and-flow of her poem. "Improvisation" is a five-page long poem consisting of approximately sixty words used in a way similar to scat-style singing. The printed poem is a transcript of Sanchez's improvised verbal performance at the Painted Bride Art Center in Philadelphia with the assistance of percussionist Khan Jamal: the performance

chronologically predates the graphic form.[1] Joyce Ann Joyce finds this reversal significant and maintains that "[f]ollowing the tradition of the chanting African oral performer, [Sanchez] relives the experience of Black people taken from Africa through the Middle Passage to a land full of oppression" (155). In this way "Improvisation" meets the essential criterion for placing it within the African tradition of oral poetry whose one distinguishing feature is that "an oral poem is not composed *for* but *in* performance" (Okpewho 68), which creates an opportunity for immediate and spontaneous spiritual interaction between performer and audience.

Frenzella E. De Lancey emphasizes the originality of Sanchez's approach to the subject of the Middle Passage, pointing out that "[i]n projecting her poetic vision with blues/jazz elements, Sanchez raises the issue of compatible forms for expressing the collective psychic grief of thousands of diasporan Africans, particularly African Americans" (73). De Lancey perceives Sanchez's effective usage of the medium of jazz as

> [b]oth unique and quite ordinary, for if blues/jazz are classic African/American forms, why not insist upon their efficacy for telling our story? ... In effect, Sanchez's use of these forms presents a new look at the psychological toll of this crossing, which is, as Morrison describes, unspeakable. It is this unspeakableness that Sanchez conveys in her "Improvisation" (73).

But Sanchez goes further in her attempt to save the communal voice of the transported Africans from the cannibalistic practice of Modernity. It is necessary to notice her virtuosic implementation of the pronoun *I* in such a way that the chanted first-person confession must be simultaneously felt as an utterance made by the African American collective subject. As Lauren Frances (59) informs us, the role of this particular usage of the personal *I* as a preserver and exponent of the deeper truth of collective experience in the discursive practice of the African American community was emphasized by Bernice Johnson Reagon, a singer and scholar specialising in African American oral performance and protest traditions.

Sanchez's purpose in "Improvisation" is to create a "legitimately universal"[2] version of the original experience of the people shipped to the Americas' planta-

1 Interestingly, since then Sanchez has performed the text of "Improvisation" as "Middle Passage" with various musical lineups (see: Sonia Sanchez, "Middle Passage" on youtube).

2 The term "legitimate universalism" was coined by George Kent in reference to universal claims which result from experience rather than abstract speculation.

tions. In order to achieve such "legitimacy," the poet foregrounds the specific experiences of women, which is of great importance as the cannibalistic drive of the economic system of the West seems to be strictly connected with sexual exploitation and reproduction. Some atrocities mentioned in the text pertained to all Africans transported across the Atlantic, regardless of their sex. However, the most emotionally saturated extracts in the poem explore and express the fate and affective experience of the African women going through the horrors of enslavement:

> it was the raping that was bad
> it was the raping that was bad
> it was the raping
> it was the raping
> it was the raping that was bad
> (...)
> Don't don't don't don't don't don't don't don't
> don't don't touch me
> don't don't don't don't touch me
> don't don't don't don't don't don't don't touch me
> please please please please please
> ah ah ah ah ah ah ah ah ah ahhhhhhhhhhh
> ahhhhhhhhh Olukun Ayo Olukun
> (...)
> It was the giving birth that was bad
> It was the giving birth that was bad
> Every nine months, every nine months
> Every nine months, every nine months
> Every nine months, every nine months

In this way Sanchez expresses the horrors of sexual abuse experienced by black women, who were defined *by and within* the discourse of anthropoemic culture as objects for sexual consumption and as females expected to reproduce for the economic benefit of the plantation owner. Sanchez highlights the continuity between their slave-ship and plantation experience, and demonstrates the depth of

their carnal vulnerability in the hands of their cannibalistic oppressors who reserve for themselves the position of, to use Toni Morrison's term, "definers." The most shocking aspect of black female experience in the above-quoted extract is linking the motif of regular birth-giving that takes place during the shortest possible time interval and rape, whose mechanistic character also allows us to read it metaphorically as a meat-processing factory line. Even though it can be said, as Joyce (155) does, that the poem as a whole talks about physical and psychological survival in dramatically inhumane conditions – hence the affirmative statement: "I am, I shall be, I was, I am" (Sanchez 77), in the above excerpt emphasis is put on the sexual-cum-economic devouring of Africans, which started during the crossing to realise its full dehumanizing potential within the institution of (American) slavery.

Thus, in Sanchez's poem the Middle Passage must not be perceived only literally as the transportation of human "cargo," but as a *rite de passage* – a journey from the innocent state of (imagined) African anthropophagy to the objectification and institutionalized exploitation by the anthropoemic Modernity which was/is concealing its own cannibalististic drive. As suggested before, for the Africans being devoured and "flush[ed] down into the sewer of oblivion" (Bauman 131) by the New World economy equates with losing touch with their own collective memory and the lack of language to communicate their traumatic experience. In "Improvisation" the African collective "I" meditates on the interdependence and contradictions involved in the dynamics between remembering and forgetting:

> Whatever
>
> I remember I forget
>
> Whatever I forget I remember
>
> Whatever I don't want to remember I forget
>
> Whatever I want to forget I remember
>
> I remember
>
> (Sanchez 79)

An affirmative aspect of Sanchez's chant-poem is that it relives the transAtlantic voyage also in terms of reclaiming the forgotten language of those deprived of access to the dominant discourse, the only linguistic form that makes it possible to communicate the immediacy of the Middle Passage experience through the voice of the Africans.

This motif of regaining the forgotten language as the only means of communicating the truth appears also in *Beloved*. In Morrison's novel the narrator informs the reader that Sethe remembers the truth through the meaning (and not the actual words) of what Nan told her about her mother, because "she used different words. Words Sethe understood then but could neither recall nor repeat now...What Nan told her she had forgotten, along with the language she told it in. The same language her ma'am spoke, and which would never come back" (62).

One essential feature of Sanchez's poem, which helps regain the voice of the transported slaves, is its orality, manifested in the device of repetition. James A. Snead argues that for African American artists repetition is not merely a rhetorical device, but a "figure of black culture" whose most distinguishing feature is improvisation. Snead (68) observes that "[w]ithout an organizing principle of repetition, true improvisation would be impossible, since the improviser relies upon the ongoing recurrence of the beat." Okpewho (78) points out that the "oral performer cultivates repetition both as a means of achieving auditory delight in listeners and a convenient framework for holding the distinct elements of the composition together." However, Sanchez seems to have at least one more intention: to move beyond the barrier of written poetry, and, through chanting the pain and hope of the transported slaves, to communicate the original experience, and in this way to save them from being reduced to the level of "bare life" and – by extension – to resist Modernity's cannibalism.

"Improvisation" is rooted in what Robert Stepto calls "pregeneric" sources, i.e. "texts not consciously taking form from the cultural language institutionalized in literary genres" (Werner 71) such as personal diaries, slave narratives, folk songs and tales, and oral performances. As Craig Werner (71) points out, those crude original forms and their literary progeny provide us with "the most direct possible access to the 'pure' vocabularies" of the people left out of the official discourse, in this case the transported Africans. It also allows Sanchez to confront listeners/readers with the Other and their truth in its "original" shape and form, making quintessentially ethical demands on them to look into each Other's "face" (in Lévinas's sense of the term) and work towards proximity by appreciating the differences. As a result, Sanchez's chant situates itself within the boundaries of *dire*, the term used by Lévinas in reference to a living and forever open speech which both avoids being locked within pre-existing formal categories and represents a gesture towards the Other. *Dire* stands in binary opposition to the realms of utterance referred to as *dit*, something that is accepted in a given culture since it has already been petrified in a normalized form which regulates the conditions and rules of speaking, something whose very mechanism makes it support the existing order.

Undoubtedly, the ways of perceiving a given culture's Other(s) are deter-
mined by the shape of the dominant language, rules of speaking, and access to
the discourse. Therefore, in the context of the subject matter of this article, *dit*
may be understood as a powerful tool for anthropoeia to make efficient use of
millions of Africans-turned-into-slaves by the demands of the Euro-American
economy; one example of how *dit* works in practice is the stigma of cannibalism
that expresses subconscious fears, satisfies the appetite for sensationalism typi-
cal of the popular imagination, and eventually allows the reducing of "Them
cannibals" to the level of "bare life." But, as argued above, African American
poetry on the Middle Passage, by challenging the permissible limits of linguistic
expression, attempts to situate itself in the realm of *dire* and, by regaining
a black collective voice understood as a means of black sustainability and coun-
ter-discourse to dehumanizing Modernity, manages to unmask the "steam driven
cannibalism" of anthropoeia.

Works Cited

Alexander, Elizabeth. *Merican Blue. Selected Poems.* Highgreen: Bloodaxe Books, 2006.
 Print.
Arens, W. *The Man-Eating Myth: Anthropology and Anthropophagy.* Oxford: Oxford UP,
 1979. Print.
Baraka, Amiri. *Transbluesency. The selected Poems of Amiri Baraka/LeRoi Jones (1961-
 1995).* New York: Marsilio Publishers, 1995. Print.
Bauman, Zygmunt. *Mortality, Immortality, and Other Life Strategies.* Stanford, California:
 Stanford UP, 1992. Print.
De Lancey, Franzella Elaine. "The Language of Soul Beneath Skin: Sonia Sanchez's Jazz and
 Blues Improvisations." *BMa: The Sonia Sanchez Literary Review* 2.1 (1996): 69-94.
 Print.
Ellison, Ralph. *Invisible Man.* 1947. Harmondsworth: Penguin, 1968. Print.
Equiano, Eloudah. *The Life of Eloudah Equiano.* New York: Cosimo, 2009. Print.
Frances, Lauren. "Sonia Sanchez's Common Cause: Grounding with the Brothers." *Bma: The
 Sonia Sanchez Literary Review* 1.1 (1995): 52-65. Print.
Frye, Marilyn. *The Politics of Reality: Essays in Feminist Theory.* Trumansburg, New York:
 Crossing Press, 1983. Print.
Hayden, Robert. *Collected Poems.* New York: Liveright, 1985. Print.
Henderson, Stephen. *Understanding the New Black Poetry: Black Speech & BlackMusic as
 Poetic References.* New York: William Morrow, 1973. Print.
Joyce, Joyce Ann. *Ijala: Sonia Sanchez and the African Poetic Tradition.* Chicago: Third
 World Press, 1996. Print.
Kent, George. *Blackness and the Adventure of Western Culture.* Chicago: Third World Press,
 1972. Print.

King, C. Richard. "The (Mis)uses of Cannibalism in Conteporary Cultural Critique." *Diacritics* 30.1 (2000): 106-123. Print.

Klarer, Mario. "Cannibalism and Carnivalesque: Incorporation as Utopia in the Early Image of America." *New Literary History* 30.2 (1999): 389-410. Print.

Major, Clarence. *Configurations. New & Selected Poems 1958-1998.* Port Townsend: Copper Canyon Press, 1998. Print.

Morrison, Toni. *Beloved.* New York: Plume, 1998. Print.

Okpewho, Isidore, *African Oral Literature: Backgrounds, Character, and Continuity.* Bloomington: Indiana UP, 1992. Print.

Piersen, William D. *Black Legacy: America's Hidden Heritage.* Amherst: U of Massachusetts P, 1993. Print.

Rice, Alan. "'Who's Eating Whom': The Discourse of Cannibalism in the Literature of the Black Atlantic from Equiano's 'Travels' to Toni Morrison's 'Beloved'." *Research in African Literatures* 29.4 (1998): 106-121. Print.

Sanchez, Sonia. *Wounded in the House of a Friend.* Boston: Beacon Press, 1995. Print.

Shankman, Paul. "Le Rôti et le Bouilli: Lévi-Strauss' Theory of Cannibalism." *American Anthropologist* 71.1 (1969): 54-69. Print.

Snead, James A. "Repetition as a figure of black culture." *Black Literature and Literary Theory.* Ed. Henry Louis Gates, Jr. New York and London: Methuen, 1984: 59-80. Print.

Werner, Craig. "New Democratic Vistas." *Belief vs. Theory in Black American Literary Criticism.* Ed. Joe Weixlmann and Chester J. Fontenot. Greenwood, Florida: Penkevill, 1986: 47-84. Print.

Young, Kevin. *Ardency.* New York: Alfred A. Knopf, 2011. Print.

Thoreau and the Indians, or a Crisis of the American Ideals of the Wild and Wilderness

Laura Suchostawska

The American model of life in the wild was problematic from the very beginning, as the gradual conquest of the wilderness by white settlers finally led to its disappearance. Henry David Thoreau's writings exhibit the contradictions inherent in the idea of the wilderness, of which most of his contemporaries were not aware. Thoreau's life and views are in turn evoked in Arnold Krupat's novel *Woodsmen, or Thoreau and the Indians* (1979), which demonstrates that the ideal of living in the wild has become even more unfeasible in contemporary America. The crisis of the past models of life "in the woods," whether of Thoreauvian or Native American origins, revealed by Krupat in his novel, demonstrates the necessity of abandoning the myths of life in the wild and looking for new, more sustainable and socially just ways of life and of land use.

Thoreau's concept of the wild and the wilderness

Greg Garrard argues that wilderness is a notion specifically characteristic of the New World, where settlers from Europe encountered vast areas of land which, in contrast to Europe, had not been significantly altered by human activity (60). Another idea closely related to that of the American wilderness is that of the West or the frontier. The combination of "two imperial ideals – 'the West' and 'the Wilderness' – has framed, plotted and empowered a landscape of expansion and development over the course of North American history" (Chisholm 67). The myth of the West appeared at the time when the frontier had already disappeared, and its beginnings are associated with Frederick Jackson Turner's influential paper "The Significance of the Frontier in American History" (1893). Although Turner was not critical of the western expansion of the American nation, even he noted some of its destructive aspects. The fast exploitation of natural resources, first of the game and timber and then of the soil in recently occupied areas, drove the Americans still further west in order to exploit new areas until finally they reached the Pacific Ocean. Turner observed that the existence of "the unexhausted, cheap, and easily tilled prairie lands" tempted them "to go west and continue the exhaustion of the soil on a new frontier." In other words, the practices of the white settlers, their use of the land and other natural resources, were, to use contemporary terminology, totally unsustainable, as they required endless expansion. The vastness of the sparsely populated continent,

with its seemingly limitless possibilities, encouraged short-sightedness, waste, and the degradation of the environment. Apart from the land, the West appeared to offer another benefit to the pioneers – independence. As Turner sums up his analysis, "the demand for land and the love of wilderness freedom drew the frontier ever onward."

Lee Clark Mitchell points out that what happened in the West was perceived as marginal and quite insignificant by the majority of Americans, who lived in the Eastern, civilized states. It was only when the frontier ceased to exist (and perhaps because of its disappearance) that the myth of the West gained popularity, giving rise to an enormous number of books and movies celebrating an idealized vision of the history of the West, far removed from reality (Mitchell 5-6). Westerns presented the frontier as a place offering "the opportunity for renewal, for self-transformation, for release from constraints associated with an urbanized East" (Mitchell 5). The mythical, idealized figure of the cowboy, the main character of westerns, achieved the status of a national hero. He became a symbol of "the freedoms that others have sacrificed for the security of civilized life. . . . the cowboy represented a nostalgic dream of escape from middle-class obligations, and in particular from family ties" (Mitchell 26-27). Even though in reality the West was settled by both men and women, by whole families, the vision of the frontier portrayed in westerns is that of a wilderness inhabited mainly by single males.

A related myth characteristic of America is the pastoral ideal, as defined by Leo Marx. The pastoral ideal reflected a wish "to withdraw from the great world and begin a new life in a fresh, green landscape. And now here was a virgin continent! . . . With an unspoiled hemisphere in view it seemed that mankind actually might realize what had been thought a poetic fantasy" (Marx 3). Thus, the American pastoral ideal was related to "the myth of America as a new beginning" (228), of the newly discovered continent unspoiled by civilization, where people could undergo a transformation and start a new, better life. The early American version of the pastoral was also inspired by the idealized figure of the Indian, the "Noble Savage," who functioned as a counterpart of the European "good shepherd" (101).

Marx enumerates examples of the ubiquity of the pastoral ideal in contemporary American culture, such as the trend of moving from cities to the countryside, the popularity of spending free time outdoors, the "devotion to camping, hunting, fishing, picnicking, gardening" and "the wilderness cult" (5). In his view, that "yearning for a simpler, more harmonious style of life, an existence 'closer to nature'" (6) is particularly characteristic of the Americans.

The wish to abandon the complex world of civilization and to find refuge, peace and happiness in the wilderness or at least in a rural landscape is also re-

flected in American literature, where we encounter numerous versions of "the theme of withdrawal from society into an idealized landscape" (Marx 10). One of such examples is *Walden*, where Thoreau describes his own "experiment in transcendental pastoralism. The organizing design is like that of many American fables: *Walden* begins with the hero's withdrawal from society in the direction of nature" (Marx 242). However, even at that time, the place where he built his cabin could not foster the illusion of an escape from civilization and progress, as the presence of the recently constructed railway next to Walden Pond suggests (253).

The area which Thoreau inhabited was indeed much closer to the rural land-scape of the traditional pastoral than to the American wilderness. In fact, Tho-reau's relation to the myth of the wilderness of the Western frontier is complex. He might be seen as its predecessor and nowadays may be associated with it be-cause of his love of the wild and the wilderness. However, Thoreau's connec-tions with the West are slight. For him, the wild(er)ness was not associated spe-cifically and exclusively with the American West. He never emigrated to the West nor wished to do so, preferring his home town in the civilized East, and most of his writings are devoted to the eastern states of New England, where he lived and traveled. As James A. Papa points out, even Maine, the wildest of the states Thoreau visited, was in fact no longer a real wilderness due to the inten-sive activity of loggers, and its Native American inhabitants had already aban-doned their traditional lifestyle and had adopted white people's way of life.

The theme of the West occupies a prominent position only in Thoreau's es-say "Walking" and it is this essay that might have contributed to some extent to the later development of the myth of the West. In "Walking" Thoreau explicitly associates wildness and freedom with the West, which for him becomes synon-ymous with the wild: "The West of which I speak is but another name for the Wild" (*Wild Apples* 75). The charm of the western frontier tints even his percep-tion of his everyday walks in the vicinity of Concord: "It is hard for me to be-lieve that I shall find fair landscapes or sufficient wildness and freedom behind the eastern horizon. . . . And that way the nation is moving, and I may say that mankind progress from east to west. . . . we go westward as into the future, with a spirit of enterprise and adventure" (69-70).

Even though Thoreau shared the nation's enthusiasm about the westward progress, he was aware of the fact that the process of settlement of new lands inevitably led to the disappearance of the very wilderness that so captured his imagination. Americans' attitude to the wilderness was contradictory in itself, combining a fascination with virgin land and its destruction. In contrast to the pioneers conquering the West, Thoreau valued the wilderness and believed that

at least some portions of it should not be civilized but preserved intact for future generations.

Robert F. Sayre's detailed historical study *Thoreau and the American Indians* is a testimony to Thoreau's keen interest in Native Americans and to their influence on him and his writings, both through his library research and personal contacts with them. Thoreau's lifelong fascination with the indigenous inhabitants of America prevented him from seeing the wilderness as virgin land to be settled and civilized. Even writing his first book, *A Week on the Concord and Merrimack Rivers*, he was already fully aware that seeing the American earth as wilderness was possible only from white settlers' point of view, while for Native Americans such a notion would be inconceivable: "to the white man a drear and howling wilderness, but to the Indian a home, adapted to his nature, and cheerful as the smile of the Great Spirit" (*A Week* 210). Similarly, later he would call the primeval forests of Maine "the home of the moose, the bear, the caribou, the wolf, the beaver, and the Indian" (*The Maine Woods* 38). As James McKusick rightly observes: "The inclusion of 'the Indian' in this catalog is not intended to denigrate these indigenous inhabitants, but rather to acknowledge their status as wild denizens of the forest, at home in their ancestral dwelling place" (166).

According to Botkin, Thoreau understood wildness as "a *spiritual state* arising from the relationship between a person and nature," while wilderness was for him "a *physical state of nature*" (121), a condition of a particular area in which it is easy for people to "experience wildness" (122). Thoreau did not avoid the term *wilderness*, but he seemed to prefer the more inclusive and universal concept of wild/wildness, because it "suggests a more fluid quality, less localisable and in part a function of human attitudes" (Clark 33). A watchful observer will discover wildness anywhere, not only in uninhabited areas unspoiled by civilization, because wildness is the general quality of any being "resistant to human control, prediction or understanding" (33). One of the lessons Thoreau can teach us today is "that a person can experience wildness, with all its spiritual, religious, inspirational, and creative benefits, even in a small area in which the effects of human actions are quite apparent" (Botkin 156).

In *The Maine Woods*, a book relating his experiences in the primitive forests, the word *wilderness* occurs 61 times and the word *wild* 46 times (plus *wildness* 6 times). In contrast, when writing about his experiences in areas that had already been civilized by the time he was born, Thoreau uses the term *wilderness* mainly when he refers to the past of the region and prefers the more flexible term *wild(ness)*. In *Walden* the word *wild* appears 49 times (and *wildness* 5 times), whereas the word *wilderness* occurs only 5 times. Similarly, in *A Week on the Concord and Merrimack Rivers* the word *wild* is used 30 times

(and *wildness* twice), while the word *wilderness* occurs only 13 times (excluding 5 quotations from historical sources).

Thoreau did not idealize "wild" people, such as Indians, hunters, lumberjacks, or pioneers. Neither was he an unconditional lover and admirer of the wilderness. Somewhat unexpectedly for a lover of wildness, after a trip to the primeval forests of Maine he came to the conclusion that the familiar, pastoral landscape of his home town was superior: "it was a relief to get back to our smooth, but still varied landscape. For a permanent residence, it seemed to me that there could be no comparison between this and the wilderness" (*The Maine Woods* 71). Even though he attached great significance to the revitalizing experience of wilderness, it was enough for him to encounter it only occasionally: "the poet must, from time to time, travel the logger's path and the Indian's trail" (72). Fascinated as he was by wildness and simple, primitive ways of life, then, he did not actually wish to live in the wilderness himself.

Thus, the popular myth of Thoreau as a person who renounced society and civilization to live alone in the wilderness has no foundations even in his writings, not to mention in biographical facts. He did not romanticize the wilderness as a beautiful, peaceful sanctuary of nature. After his trips to the Maine woods, he was well aware of the hardships of traveling, living and working in the wild. Nor did he idealize the life of the inhabitants of the wilderness, whose main occupation, as he saw, was hunting animals or cutting down forests, which did not leave much room for a love of nature or for personal development. In addition, he was fully aware of the fact that the wilderness was not nobody's land. Wherever the white people went, they followed in the steps of the Indians, and their settlement meant the others' displacement.

A contemporary crisis of the ideals of living in the wild

In 1979 Arnold Krupat, one of the leading scholars in the field of Native American studies, published the novel *Woodsmen, or Thoreau and the Indians*, a fictional story of a professor of literature who, inspired by Thoreau's Walden experiment, decides to build a cabin in the forest. In the woods, he encounters not just Indian relics, such as the stone arrowheads that Thoreau used to collect, but the Indians themselves, a small tribe that claims the land he bought from the state is actually theirs. It turns out that neither the professor nor the Indians are able to continue the lifestyles of their predecessors, Thoreau and their ancestors respectively.

Finding refuge in the wild may be seen as a response and at the same time a solution to various types of crises, whether professional, personal, or spiritual. However, trying to follow in the footsteps of another person living in another

century is difficult if not impossible. In the opening chapter of *Walden*, Thoreau cautioned his readers: "I would not have any one adopt *my* mode of living on any account; for . . . I desire that there may be as many different persons in the world as possible; but I would have each one be very careful to find out and pursue *his own* way" (*Walden* 46). Ironically, Thoreau, the self-reliant individualist who urged his readers to be independent and to realize their own dreams, casting aside old beliefs and customs, a century later himself became a cultural icon, with various individuals trying to follow the model he described in *Walden*. Thus, the escape from conventions became a convention itself, a new tradition of moving into the wild. Ironically, only when one stops trying to be exactly like Thoreau, does one actually get closer to achieving his ideals of independence and self-reliance.

Nevertheless, the main character of the novel, a professor of literature, one day tells his friends that he wants to go and live in the woods, like Thoreau before him. From the very beginning, it is clear that his attempts to follow his model as closely as possible are bound to fail: "The woods were in Walden, he said. Walden, New York. And there was a river. But no pond" (*Woodsmen* 3). The location is different and Walden is not the name of a pond; in fact, there is no pond at all. There is a river, but it seems quite unlike the Concord River: "It does not seem a river much good for lazy drifting, said Anna. I think of the young Henry Thoreau and his brother and their week on the river" (12). It is obvious from the start that it would be difficult to reenact Thoreau's activities in that place.

Even to his understanding friends, the professor's efforts to become like the writer he admires appear at times ridiculous: "Then he said, My name is Henry. We paused at that. It was absurd. His name wasn't Henry" (4). Seeing his friends' astonished, perhaps alarmed or concerned faces, he smiles and reassures them: "Of course I know my name isn't Henry" (4). Adopting another person's name and imitating his actions, if not the result of madness, appears to be not much different from children's games, in which they play roles, pretending to be someone else.

The professor's plan is simple: "I'd like to try and build a little house. Like Thoreau. Live up in the woods for awhile" (5). Nevertheless, as his friends point out, the experiment cannot be repeated in exactly the same manner, because the circumstances are different too: "Two pails a paint and a brush, said Hope, that's about all you can get now for the amount of money it took Thoreau to build his whole house" (6). When a friend asks him: "So who's your Emerson . . . who supplies the land for this house?" (5), the professor's answer exposes one more mismatch between the two men. He had bought the land a few years before, so

he is his own Emerson. Unlike Thoreau, the independent spirit who never had much work or money and never purchased any acres but enjoyed all the land that he could walk through and admire, the professor has a regular job, money and land.

After his arrival, he unexpectedly encounters serious obstacles to his plans. The Poquosset, a small Native American tribe, claim that the land the professor bought from the state is actually theirs and ask him to give it up. The chief of the tribe explains: "The State had no right to sell you that land because it did not belong to the State. . . . Like many a whiteman before you, you probably blundered into something you knew nothing about. . . . it will help enormously if you cede us the land to which you now have title" (19).[1] To make matters worse, some developers bent on acquiring the area for their investments try to make him sell the land to them, first by tempting him with a good price and then, when he refuses to sell, by threatening him and the Indians. The dream of building a cabin in the woods is thus shattered and, not knowing what to do in the new situation, the despairing and confused professor helplessly complains: "It's ridiculous . . . Thoreau never had to deal with all this crap" (17). The simple, peaceful life in the woods is not so easy a goal to achieve.

Another issue which leads to further complications is the fact that the professor, unlike Thoreau, has a wife and two small children. His wife does not like the idea of moving to the woods: "She didn't want to go to the woods to live. . . . she felt locked in enough without volunteering for the tighter melodrama of The Wilderness Wife" (8). She believes life is hard enough with all the benefits of civilization and, moreover, she fears loneliness and social isolation, because she is not able to relate meaningfully to nature. According to her, "those fine trees did not speak back when spoken to; the white snow was clean and pure and also blank" (8).

The professor's friends, probably influenced by the omnipresent myth of the western frontier perpetuated in literature and movies, in which most characters are single males, associate Thoreau, a single man living in the woods, with that myth. As they observe, the idea of the frontier with its freedom and new opportunities is still alive in the American society: "Maybe we did weep when we reached the Pacific, land's end. But not even God could close the Frontier on us. When we ran out of continent to conquer, we set out to conquer the world. . . .

1 Even though the story is fictional, there have been very similar lawsuits in the 20th century history, for example, the court case of Mashpee Wampanoag, a small tribe from Cape Cod, discussed by James Clifford in the last chapter of his book *The Predicament of Culture* (299-370).

Commitment cuts down on infinite possibility, narrows free choice. . . . There's no excitement in what's settled. Beginnings, that's what we want, the new! the new!" (36). In their imagination, the West was conquered and peopled mainly by independent, unmarried white males, especially young ones, immature, with no duties and obligations and, as a result, they perceive Thoreau as a representative American: "In these regards, we said, even your beloved Thoreau was a typical American. He advised that we live free and uncommitted for as long as possible" (36). They seem to overlook the fact that in reality there were many pioneers and settlers who went to the West as whole families and, consequently, they come to the conclusion that it is impossible to combine a love of nature and wilderness with family life. In the masculine myth of the wilderness adventure, wildness and freedom seem to disappear when men get married, so a man must choose one or the other, a woman or nature. This seemingly unavoidable choice is obviously reminiscent of Thoreau, who declared in his journal on April 23, 1857: "All nature is my bride."

The professor, who is so eager to follow Thoreau in all other respects, cannot accept the idea that it may be impossible to realize his dreams as a family man. He cannot imagine living in the woods alone, without his wife and children, despite his friends' arguments: "And remember Thoreau never married, we said, he never had children. He went to the woods alone. Not even Thoreau could manage to have woods and wife at once. But our friend still wanted both" (36-37). However, the professor's selfish insistence on building a cabin in the woods and later the attention he needs to devote to the problems with the ownership of the land, the Indians and especially the developers, precipitate a crisis of his marriage. Feeling neglected, his wife enters into an affair and makes him leave the house, inviting her lover to move in and take his place. Thus, the professor loses everything: his dreams and his family; he "had wanted woods and wife and now had neither" (89).

Later, however, his friends begin to realize that their vision of life in the wilderness is one-sided. The West was also inhabited by Native Americans, for instance, whose lifestyle was a different one from that of white single cowboys: "we had failed to take Indians into account when we spoke of the lesson of our history. . . . Who were we to say that Indians were not available as an American model? All the great chiefs were married men who had performed their life adventures . . . as grown men, not even young, their wives and children close by them. Certainly they had never separated wife and woods" (93).

They are aware of the fact that it is impossible to copy the lifestyle of nineteenth century Native Americans exactly, but perhaps it can serve as a general guideline: "So Indians, if they could not be blueprints, might be models. Only

they had not, as Indians, survived" (93). Much as one can admire and appreciate the traditions of Native Americans, the fact remains that they were forced to abandon their traditional lifestyle and had to adapt to the white world: "The only trouble was the Indians hadn't managed to live that way and still to live" (87). So it appears that the Indian model is no longer available in the modern world, even to Native Americans themselves: "anything they would achieve was bound to be no longer just Indian but some new synthesis of white and red. Theirs might be a future informed by the past; it could not be again what it once was. Never again could Indians be a people living within the hoop, in an unbroken circle, in harmony with their world" (93).

Like the professor trying to reenact Thoreau's life, the Poquosset Indians attempt to revive old ways of life, but, like him, they are bound to fail. Unlike the professor, though, the chief of the tribe is aware from the very beginning of the limitations of their endeavors to restore the traditions. First of all, the tribe, which was never numerous or powerful, nowadays consists of about twenty surviving members. As the chief explains to the professor: "We aren't even recognized as a tribe by the Bureau of Indian Affairs because we never concluded a single treaty of our own as a separate tribe. . . . [Our history] does not include any famous battles we won or lost . . . there is no one you might call a hero . . . Our history . . . doesn't have the sort of high spots your culture stops to admire" (57). Since the Poquosset were a small, peaceful tribe, they failed to attract white people's attention and capture their imagination, unlike some numerous and powerful tribes led by great personalities, such as the Lakota, who entered American history and the legend of the West.

Even the Poquosset traditions appear to have been forgotten and lost. When the chief tells the professor about their spiritual life, he does so in very general, vague terms, referring to the stereotypical idea of the importance of land and nature to the spirituality of Native Americans. He does not allude to any specific myths, beliefs or rituals, but sounds more like a white "wannabe Indian":

> Because we were a pre-technological people, a primitive people – or, as some of your young people think, because we were a singularly wise and advanced people, the spirit of place informs our sense of things at every point. The rocks on the land you mistakenly bought, the trees, the special quality of the light at any moment of the day, these are important factors in what we think, what we do, who we are, how we heal and pray. (32)

Nevertheless, the chief is aware of the fact that there is no return to the past and frankly admits that they are not even certain about what to do to restore the traditional life: "It's not a question of turning back the clock. You can't do that, of course. I don't even know for sure what we'll do on this land, once we get it. But what's certain is that's where we have to start, with our land" (32-33). Just as the professor looks for a solution to his personal crisis by superficially following Thoreau's model through moving to the woods, the Indians, not certain about what to do, decide to reclaim their land and to erect a tipi on the same spot on which he intended to build his cabin. The chief explains to the professor and his friends:

> when we started getting some threats from those gangsters who call themselves developers, all the while various other members of our tribe were arriving, well, something had to be done, even if it was only symbolic. So we set up this tent on the land. Symbols are important to us, anyway.
>
> And here you are in your canvas wigwam catching pneumonia, said Hope.
>
> Only a slight cold, so far, John said. (40)

It is obvious that their actions are merely symbolic, a kind of performance. The contemporary Poquosset are not accustomed to living in a tipi. Unlike a group of Indians whom Thoreau visited, camping near Concord, they do not know how to make the tipi warm and habitable in winter.

Two young members of the Poquosset tribe whom the professor befriends may serve as a symbol of the Indians' future. The twin brothers "had identical faces. One wore a business suit and carried an attache case. The other wore long hair in braids and a fringed jacket" (56). The two young men can be treated as examples of two possibilities open to Native Americans: assimilation to the white world or clinging to past traditions. But because they are twins, they can also be seen as a symbol of the possibility of unifying the old and the new, the red way and the white way.

In the end, the professor realizes, like the chief of the tribe before him, that there is no return to the past. Both he and the Indians need to find new, creative ways of adapting to present circumstances. The past and traditions need not be rejected but can be reshaped and incorporated into something new. They would still be remembered and respected but they would no longer limit the freedom of individuals, who would not force themselves to reverently follow them as closely as possible.

Finally, the professor understands that there is no point in pretending to be someone else. It is far better to be honest with oneself and admit the impossibility of living in the old way, because at least it leads to authenticity and the establishment of true relations. In the closing scenes of the novel, the fake pomposity of the first visit to the woods is replaced by a relaxed, friendly atmosphere. When they first came to the site, the professor behaved in a solemn, reverent manner and urged his friends to act in the same way: "No drinking, he said. And, Ariel, if you possibly could, would you try not to smoke?" (13). If Thoreau did not drink or smoke, neither should they do so in that special place. Now the professor himself lights his friend's cigarette: "Ariel took out a smoke. Our friend struck the match that gave her a light" (124). The chief of the Poquosset goes to his pickup and brings cans of beer for everyone. The professor still remembers Thoreau's insistence on purity and temperance, but no longer imposes them on himself and others: "If we were doing things right, he said, what we'd be drinking would be water. That was Thoreau's drink. We agreed. No one switched" (130). The possible disillusionment connected with abandoning ideals is counterbalanced by the close, friendly relations between all the participants, the professor and his colleagues as well as the members of the tribe. All are reunited, the whites and the Indians, and even the professor's family.

Unexpectedly, the professor's dream of living in the woods is in the end made possible by the chief's offer to adopt him as a member of the Poquosset tribe. In this way, the land which he has given up and returned to the tribe would now be in a way his own again: "To help us, you've given up your right of property. I want to tell you on behalf of all the Poquosset that there's no way you can give up your right of use to this land in our eyes. These woods don't belong to any of us to own and keep. But I hope they'll be for us and you to use" (126-127). Thus, his generosity is doubly rewarded: with the land and with new community ties. And even though this new possibility of life in the woods is quite distant from Thoreau's solitary stay at Walden Pond, in a way the professor, by giving up land ownership, is a little closer to Thoreau than before because, as he observes, "the house he lived in at Walden Pond wasn't on his land either. He never owned it. But he made it his, in a sense anyway, by the life he lived there, by the use of it" (33), just like the Indians who lived there before him.

Perhaps hope for a better future, then, is in the art of synthesis, of overcoming dualism and creatively combining nature with civilization, the old with the new, the cultures of white Americans and Native Americans, Thoreau and the Indians. In the complexity of the contemporary world, there is no place for a single model to follow, especially if that model comes from another era. The past may serve as a rich source of inspiration, but it cannot be copied or repeated

in exactly the same manner. The crisis of past traditions which we face nowadays can turn into a beginning of a new lifestyle, building on the past but facing the present and the future.

Works cited

Botkin, Daniel B. No Man's Garden: Thoreau and a New Vision for Civilization and Nature. Washington: Island Press, 2001. Print.

Chisholm, Dianne. "Landscapes of the New Ecological West: Writing and Seeing Beyond the Wilderness Plot." The Journal of Ecocriticism 3-1 (2011): 67-93. Print.

Clark, Timothy. The Cambridge Introduction to Literature and the Environment. Cambridge, New York: Cambridge University Press, 2011. Print.

Clifford, James. Kłopoty z kulturą: Dwudziestowieczna etnografia, literatura i sztuka. [The Predicament of Culture: Twentieth-Century Ethnography, Literature, and Art.] Trans. Ewa Dżurak et al. Warszawa: Wydawnictwo KR, 2000 [1988]. Print.

Garrard, Greg. Ecocriticism. London, New York: Routledge, 2004. Print.

Krupat, Arnold. Woodsmen, or Thoreau and the Indians. 1979. Norman, London: University of Oklahoma Press, 1994. Print.

Marx, Leo. The Machine in the Garden: Technology and the Pastoral Ideal in America. London, Oxford, New York: Oxford University Press, 1964. Print.

McKusick, James C. Green Writing: Romanticism and Ecology. New York: Palgrave Macmillan, 2010. Print.

Mitchell, Lee Clark. Westerns: Making the Man in Fiction and Film. Chicago, London: The University of Chicago Press, 1996. Print.

Papa, James A. "Reinterpreting Myths: The Wilderness and the Indian in Thoreau's Maine Woods." Midwest Quarterly 40-2 (1999): 215-227. Print.

Sayre, Robert F. Thoreau and the American Indians. Princeton, NJ: Princeton University Press, 1977. Print.

Thoreau, Henry David. The Maine Woods. 1864. Stilwell, KS: Digireads, 2006. Print.

---. Walden; or, Life in the Woods. 1854. New York: Dover, 1995. Print.

---. A Week on the Concord and Merrimack Rivers. 1849. New York: Dover, 2001. Print.

---. Wild Apples and Other Natural History Essays. Ed. William Rossi. Athens: University of Georgia Press, 2002. Print.

Turner, Frederick Jackson. "The Significance of the Frontier in American History." 1893. Web. 20 Sept. 2013.

<http://www.learner.org/workshops/primarysources/corporations/docs/turner.html>.

Marching through Wilderness: Relating to the Environment in an Italian American Perspective

Francesca de Lucia

Born in 1951 in Waltham, Massachusetts, from a family that originated from the tiny Sicilian island of Filicudi in the archipelago of the Eolie, Anthony Giardina is one of the most significant representatives of contemporary Italian American literature, being part of a generation of younger Italian American authors who are detached from the group's immigrant origins and have a broader narrative focus than earlier writers. He can be considered part of what Fred Gardaphé has called the "third-generation renaissance" of Italian American writing, as he points out that

> Italian American writers of the third generation have found their natural place in American literature. Perhaps it is because, unlike Fante, Mangione and di Donato, [they] are free from the chains of the immigrants' memory and reality, and have had to rely on imagination—the fuel of true fiction—that their writing reaches into the more mythic qualities of the Italian American experience, thus creating a literature that transcends a single ethnic experience and reaches out to a wider audience of readers (82).

Giardina's novels, short stories and plays reflect various influences. The ethnic legacy is present in many of his works, which deal with the lives of upwardly mobile suburban Italian Americans in the second half of the twentieth century and the early twenty-first century (indeed the "recent history" that is the title of one of his books). At the same time, Giardina's writing is deeply rooted in its New England setting. With the exception of his second novel, *A Boy's Pretensions*, which mainly takes place in New York, Giardina's narratives are almost entirely set in Boston and its surroundings. From this point of view, Giardina may be considered as a New England writer: indeed, he has defined himself as a "Massachusetts writer" (conference at the University of Rochester, March 20th 2013). Furthermore, as shall be subsequently elaborated, he bears the influence of classic New England authors such as Henry Thoreau and Nathaniel Hawthorne. The aim of this essay is to explore how Giardina perceives landscapes and the environment in his work in the light of his diverse legacies.

The pastoral and the wilderness

In his seminal work, *Ecocriticism*, Greg Garrard compares and contrasts the notions of the pastoral and the wilderness.

> Wilderness narratives share the motif of escape and return with the typical pastoral narrative, but the construction of nature they propose and reinforce is fundamentally different. If pastoral is the distinctive Old World construction of nature, suited to long-settled and domesticated landscapes, wilderness fits the settler experience of the New Worlds [...] with their apparently untamed landscapes and their sharp distinction between the forces of culture and nature (66-67).

Furthermore, in his study *Pastoral*, Terry Gifford points out that the construction of a literary Arcadia centres, in the most general sense, around the description of a rural environment in contrast with an urban one. More specifically, since its origins in classical Greece, the literary pastoral has involved a contrast between "the town by the sea and the mountain country of the shepherd, the life of the court and the life of the shepherd, between people and nature, between retreat and return" (15).

However, within the Italian American collective imagination, the Arcadian image of the Southern Italian countryside becomes dramatically distorted and subverted. To summarize very briefly, the areas South and East of Rome, collectively known as the *Mezzogiorno*, were characterized, until Unification in 1861, by a weak central government and a social structure based on landless peasantry working for absentee landlords. The birth of the new state awakened the hopes of the Southern peasant class, who imagined that it would prompt a redistribution of the land that had previously belonged to the former government and the Church. Instead of improving, the problems of the South became exacerbated because of the extremely centralized structure of the new government, which pursued exploitative policies in the South, largely neglecting the problems of the landless peasants as well as carrying out sometimes very violent repressive campaigns. These circumstances would ultimately lead to the mass emigration of Italians in the period 1880-1920.

The rejection of an Italian Arcadia, possibly in favour of a threatening American wilderness which might however yield opportunities, is thus synthetized by Mario Puzo:

> The main reason for this enormous flood of human beings from a country often called the cradle of Western civilization was a ruling class that for centuries had abused and exploited its Southern citizens in the most incredible fashion. And so

they fled from sunny Italy, these peasants, as children in fairy tales flee into the dark forest from cruel stepparents.

Giardina subverts both the pastoral image of rural southern Italy and that of the conquered and colonized American context. Both in an article and in personal communications with me, Giardina has pointed to one major non-American literary influence, namely the Sicilian writer Giovanni Verga's 1890 novel *I Malavoglia*, translated into English under the title *The House by the Medlar Tree*. This text, which stages the downfall of a family of Sicilian peasants in the years following the unification of Italy, is a quintessential example of the literary current of *verismo*. This movement, somewhat parallel yet different from French naturalism, aspired to an ideal of truth (*vero*) and verisimilitude. In its focus on the harshness of social conditions in the Sicilian countryside *I Malavoglia* may be considered anti-pastoral according to the criteria indicated by Gifford (a rejection of idealization, an emphasis on social inequality, and a quest for realism).

While, according to Giardina himself, *The House by the Medlar Tree* influenced him "more than any American novel," as mentioned before, he also bears the influence of the New England tradition, in particular in relation to the theme of the wilderness. Perry Miller referred in *Errand into the Wilderness* to "the movement of European culture into the vacant space of the American wilderness" (vii). In a personal interview with me, Giardina identified the importance of what he calls the "elemental American story" represented, for instance, by Nathaniel Hawthorne's "Roger Malvin's Burial." For Giardina, this relatively little-known short story by Hawthorne, dealing with the themes of secrecy, guilt and fate on the backdrop of the early eighteenth-century Indian wars, expresses a profoundly American myth of the uninterrupted connection between civilization and wilderness. As noted by Andrew Light and John Rennie Short, within the traditional Puritan vision, the wilderness represents states of despair as well as the projection of fears and of the dark side of human nature. These elements appear in "Roger Malvin's Burial," along with the notion that it is vain to attempt to control the wilderness and the material and metaphorical danger it embodies. In Giardina's case, the struggle to control the wilderness manifests itself through the Italian Americans' endeavours to construct houses and communities. Similarly to Hawthorne's characters, however, their attempts are ambiguous. The New England woods become a locus of transgression, which, within Giardina's work, can go from the fairly mundane of (sometimes merely fantasized) adultery to murder.

Filicudi: pastoral and anti-pastoral

The archaic pre-immigration world that is akin to Verga's is more of a subtle influence than a concrete presence in Giardina's fiction. It is most prominent in Giardina's first novel, *Men with Debts* (1986), which significantly is the only of his novels to feature a first generation protagonist, named Jack Henna. Here the island of Filicudi appears unexpectedly in Henna's reminiscences, being sometimes described in lyrical terms, which would suggest an adherence to the pastoral, as indicated for instance by this passage: "Then, like a gift, he heard from a point not far away the trickle of water, light and uneven, a sound he could swear he'd only heard in the woods of Filicudi, the sound a salt stream makes as it flows over the high rocks on its way back to the sea"(84). This passage expresses an Arcadian dimension, as well as the common trope of the immigrant feeling nostalgia for an idyllic version of the old country. However, Giardina's representation of Filicudi moves away from these motifs. While Henna is a successful immigrant who is better off than Mrs. Adams, the impoverished WASP widow whose husband has committed suicide and with whom he interacts throughout the novel, references to Filicudi serve early on as a reminder of Henna's marginality as an immigrant and his incomplete Americanization. For instance he worries that he won't be able to teach his sons basketball since "it wasn't a game you played in Filicudi"(6).

Thus *Men with Debts* presents this pastoral or anti-pastoral dimension in its description of Filicudi, contrasting it with images of the American wilderness. At first, Giardina seems to evoke the notion of the conquest of the space of the New World, through the reminiscence of the explorer Cabot, as a way to express the immigrant view of America as the "land of opportunities." Henna reflects that:

> He could remember exploring every inch of wilderness on Filicudi, remembered especially the place where, it was said, his mother's sister had plunged to her death. A flat rock, shooting straight up the side of the island from out of the sea. She had been reaching out, the story went, to pick a flower growing out of a rock. The story's force hit him hard now, the fact that it might not have been true at all, just a convenient myth to keep the children from exploring. He thought of Cabot, the strong, brown, free-pissing explorer, and how myths were different here. Here you reached out for things and they came to you (135).

Here the "anti-pastoral" dimension of the description of Filicudi is the most prominent, with this apparently idyllic image of children exploring against an Arcadian background which not only turns out to have a darker dimension, but

is also used to illustrate the restrictive world view of the old country. At the same time, Giardina overturns the American myths he introduces. Paradoxically, it is the WASP Mrs. Adams who rejects the idea of claiming and dominating the American space: "we try to claim things in this country, and end up dying on rented land In Italy, at least your island was yours" (135).

Filicudi recedes even further in Giardina's subsequent works, eventually disappearing almost entirely. In *Recent History* (2001) on one occasion it is referred to simply as "the island," in an ironic deconstruction of the pre-immigration pastoral relation to Luca's aunts:

> Family lore had it that they were all unhappy women, but they never seemed that way. My father explained it to me: 'They came from an island, Luca. An island in Italy. You have to understand this. They were little girls, and they lived in Paradise. And then their father took them here And since, it's been nothing but complaints.' Then he always added, low, conspiratorial, not for me to repeat: 'Maybe it wasn't really Paradise, you understand? But let's keep that our secret' (9).

Men with Debts prefigures some of the motifs that will recur in Giardina's subsequent narratives. It is significant to observe that Giardina's later novels focus on second and third generation Italian Americans (as well as descendants of other 1880-1920 immigrant groups) and explore how people of ethnic origin who are further removed from the immigration period establish suburban communities and experience the changes in American life in the late twentieth century. In this context, the wooded space of New England contrasts with the construction of suburbs.

Conquering the suburbs

David Teague points out that "for all their shortcomings suburbs in [America] remain landscapes of promise and are ideal in many ways-the American version of pastoral" (157). The problematization of the suburb as an "American pastoral" emerges prominently in *Recent History* and *White Guys* (2006). *Recent History* centres on the relationship between the narrator, Luca Carcera, and his father Lou. The novel starts in the early 1960s, with a significant scene where twelve-year old Luca is brought by his father to visit a plot of land where their extended family is building a group of houses:

> "That, over there, you see those sticks with the little orange flags? They mark our lots. Of course it's only trees now, but they're going to build a road up here. Everything you see..." Here he hesitated again. "They're going to blast away. The rocks

and..." He gestured with his fist. "Make houses That's where Uncle John's house is going to be. We're starting a neighbourhood, you could say. The family. The Italians."(4).

By taking possession of wooded uninhabited space through the act of construction, Giardina's characters almost evoke Henry Thoreau with his declaration in the opening of *Walden*: "I lived alone, in the woods . . . in a house I had built myself." However in Giardina's view, this dimension is rendered in a communitarian rather than individualist perspective, centering on the ethnic community and the family. On another occasion, the notion of house-building as conquest, as well as personal self-assessment, is reiterated quite explicitly to describe the house of Luca's successful and assertive uncle, which "poked out of the wilderness like it was making some supremely confident announcement of itself." The idea of control is expressed through the use of the words "poke" and "wilderness." In *Recent History* the suburb represents a kind of American, or possibly Italian American pastoral, where both the place and the historical period are romanticized, in spite of Luca's protestations to the opposite: "[t]he fall of light in a suburban neighbourhood early in the reign of John F. Kennedy. I do not want to romanticize but here it was" (7). Thus Filicudi, and its possible romanticization as pre-immigration Arcadia, is abandoned for good, yet the New World suburban pastoral does not replace it but is also disrupted, implicitly by the unexpected and tragic ending of Kennedy's "reign" and more directly by Luca's father transgressing behaviour and Luca's apparent following of his father's footsteps.

Giardina's fourth novel, *White Guys*, also explores the relationship with the wilderness, the building of houses, the city and the suburbs. The novel traces the relationship between two friends, the Irish American narrator Tim O'Kane and the Italian American Billy Mogavero, from the 1960s to the 1990s, shifting from an ethnic working-class background to a white collar yuppie lifestyle. *White Guys* is rooted in a strong sense of place in its description of Boston which is threefold, encompassing the traditional New England Anglo-American aristocracy which is in decline and focuses on the past, the ethnic working class that is becoming gentrified, and lastly the image of prosperous corporate America. It is here that the Hawthornian theme of the woods is the most pronounced. From this perspective, it is reminiscent not so much of "Roger Malvin's Burial," but for instance of "Young Goodman Brown" where woods are very obviously associated with a process of damnation. In *White Guys* Billy recruits the narrator to hide in the woods the gun he has used to murder his wife. While Giardina might be playing with the tropes of mafia narratives, he is also suggesting a di-

mension where, as Young Goodman Brown "the devil himself could be at my very elbow" (15).

Moreover, interestingly, *White Guys* also contains a direct satirical deconstruction of environmental motifs, always in relation to the central themes of social ascent, family, and the construction on woodland. Indeed, on one occasion the narrator's patriarchal father-in-law places a "seemingly endless" string of Christmas lights between his house and Tim's in order to humour his young granddaughter's concern about driving everywhere. All the characters appear oblivious to the fact that this just implies replacing one waste of energy with another.

Environmental concerns also appear in relation to one of the novel's dominant imagery of houses, as well as its representation of Boston. In the course of their process of upward mobility, Tim's family establishes itself in a historical suburb of Boston, which is marked by the memory of nineteenth-century exploration and homesteading. From this perspective, the arrival of the gentrified descendants of 1880-1920 immigrants is perceived by the better-established but decaying local WASP community as a threat to the historicized environment. The narrator dismisses preoccupations with conservation by describing a protest against the construction of a soccer field on the site of a historical house thus: "[t]here was something absurd in the sight of these citizens, white-knuckled and patrician, climbing out of their burrows to insist on the rights of a ramshackle dwelling over what seemed to me, and to most others, the patently superior claims of our sons and daughters" (157-158). Throughout *White Guys*, the portrayal of this neighbourhood conveys an impression of pretentiousness and falseness, suggesting an artificial reconstruction of the past as well as an invasion of natural space:

> As more people have moved here, more of the woods have been cut back to make room not just for houses but for those little retail outlets you see in small, elegant towns. Each of the three mini-malls in Bradford is cut to an uniform design; shingled roofs, single stories, faux gaslights. The effect, surprisingly successful on a rainy night, is of stepping inside the eighteenth century (56-57).

As in the opening of *Recent History*, the narration alludes to the cutting down of woods, but while in the earlier book this anticipates the creation of a familial community, in *White Guys* it is associated with the expansion of the corporate world under a pretence of individuality and exclusivity.

Norumbega Park

The motifs that have been described so far are developed in a different direction in Giardina's most recent novel to date, the 2012 *Norumbega Park*. Norumbega, the etymology of whose name is unknown, is a mysterious entity related to the earliest European contacts with the New World, supposedly going back to possible Viking explorations of the continent. It is perceived as a kind of "Northern El Dorado," or possibly the site of a Viking settlement. Interestingly, Norumbega Park is also the name of a Boston amusement park of the first half of the twentieth century. Thus already the title of the novel and its epigraph, taken from the Wikipedia entry on Norumbega, suggests, albeit somewhat obscurely, both the mythology of the origins of the American nation and a notion of tawdriness and decline.

The novel which, as a departure from Giardina's previous restricted-third person or first-person narratives, focusses on the alternated third person point of view of the four members of the Palumbo family, is set off by the family's accidental discovery of the remote town of Norumbega, where Richie, the pater familias, will insist on moving the family. It is established early on that the town represents a kind of archetypal New World since: "[Richie] has heard the name [Norumbega] the old, unaccustomed Indian sound of it . . . like a town making a deliberate attempt to hide itself, or to claim its specialness" (8). Later, Richie's wife Stella muses about Norumbega as "the wilderness where he wanted to camp them all, the tree-darkened place whose name made her think of Indians" (13). So this brings back the Puritan/New England tradition, especially in the image associating Indians with trees and the wilderness (an early example of this aspect is visible for instance in Mary Rowlandson's captivity narrative, where the Indians and the trees in the forest appear to merge together). For Richie instead, Norumbega, and the house owned by a WASP family he becomes obsessed with, becomes a symbol of establishment in a quintessential America. A recurring symbol of the narrative is that of the lake, where early on Richie sees children skating, in a kind of Norman Rockwell-esque landscape, which he imagines will enable his children's integration. In the last scene of *Norumbega Park*, an older Richie indeed observes his children and grandchildren skating on this very lake. His dream appears to have come true but in an ambivalent and unexpected way (indeed, while Richie fantasized about merging with the traditional WASP elite, his son-in-law is Hispanic and consequently his grandchildren biracial). Nevertheless, the end of this narrative implies a form of redemption since Richie comes to fully embrace his daughter's hybrid and recomposed family, as shown for instance by the fact that he develops a closer relationship with his step-grandsons than with Jack's children.

Conclusion

The recurring themes in Giardina's work combine the legacy of an insular immigrant world with a quintessential classic American mythology in its way of relating to the landscape and environment. His fiction encompasses the rejection of the Arcadian imagery of the Old Country as well as a problematization of the myth of the conquest of the wilderness. He thus reinvents the notions of the pastoral and anti-pastoral as well as endowing some of the most typical themes of New England literature with an Italian American twist. Moving away from the predominantly metropolitan environment that characterizes earlier Italian American narratives set in the world of the inner cities, Giardina represents a milieu of more prosperous and integrated suburban people of ethnic origins, whose intimate struggles are projected against the powerful and intensely symbolic backdrop of the Massachusetts woods.

Works Cited

Bennett, Michael and David Warfield Teague. Eds. *The Nature of Cities: Ecocriticism and Urban Environments*. Tucson: University of Arizona UP, 1999. Print.

de Lucia, Francesca. "Anthony Giardina as a Representative of the 'Renaissance' of Italian American Writing." *Writing America into the Twenty-First Century: Essays on the American Novel*. Newcastle UK: Cambridge UP, 2011. 111-123. Print.

Gardaphé, Fred. "Italian American Fiction: A Third Generation Renaissance." *MELUS* 14.3-4 (1987). 69-85. Print.

Garrard, Greg. *Ecocritcism*. New York: Routledge, 2004. Print.

Giardina, Anthony. E-mail interview with Francesca de Lucia. 25 August 2008.

---. *Men with Debts*. 1984. New York: Dell Publishing Co., 1986. Print.

---. *Norumbega Park*. New York: Farrar, Straus and Giroux, 2012. Print.

---. Personal interview with Francesca de Lucia. 29 July 2010.

---. *Recent History*. 2001. New York: Random House, 2002. Print.

---. *White Guys*. New York: Farrar, Straus and Giroux, 2006. Print.

Gifford, Terry. *Pastoral*. New York: Routledge, 1999. Print.

Hawthorne, Nathaniel. *Young Goodman Brown and Other Short Stories*. Mineola NY: Dover Thrift Editions, 1992.

Light, Andrew and Jonathan Smith. *Space, Place and Environmental Ethics*. Lanham MD: Rowman and Littlefield Publishers, 2007. Inc.

Miller, Perry. *Errand into the Wilderness*. Cambridge MA, Harvard UP, 1956.

Thoreau, Henry David. *Walden*. 1854. Rpr. *Walden and Civil Disobedience*. New York: Norton, 1966.

University of Rochester. Neilly Series Lectures: Giardina (20 March 2013). Online videoclip. *Youtube*. Youtube. March 20th 2013. Web 2nd January 2014.

Between Taste and Interest: Reading Asian American Literature in the Age of Food Literacy

Dominika Ferens

"Food literacy," as many hip internet sources explain, means understanding the impact of people's food choices on their health, the environment, and their communities. Along with such notions as "sustainable agriculture," food literacy is becoming an important political goal for ecologically conscious Americans. But judging by the literature promoted on food literacy websites, some readers treat food literacy as a continuation of their more traditional interest in cookbooks, food autobiographies, and a host of other texts classified as "food writing." Since its publication in 2004, *The Book of Salt* by the Vietnamese American author Monique Truong, has won several prestigious awards[1] and become a staple on food literacy reading lists. Declared a veritable aesthetic and gourmet feast, *The Book of Salt* is a fictional first-person narrative of a gay Vietnamese cook employed by the famous American expatriates Gertrude Stein and Alice B. Toklas in Paris. This paper juxtaposes *The Book of Salt* with an earlier Asian American novel, *The Coffin Tree*, written by Wendy Law-Yone, which happens to explore similar themes: exile, food, appetite, and queer desire. Published by Knopf in 1983, *The Coffin Tree* initially hovered at the bottom of the *New York Times* bestseller list but, failing to arouse popular and critical interest,[2] it quickly went out of print. Both novels were authored by accomplished stylists who continue to write for a living. Yet on the amazon.com website *The Coffin Tree* has just 5 amateur reviews while *The Book of Salt* – 53. To explain the different reception of the two novels, I explore the interrelated themes of food and affect,

1 *The Book of Salt* won the PEN/Robert W. Bingham Prize, Young Lions Fiction Award, and ALA Stonewall Book Award. To get a sense of this novel's phenomenal popularity visit Monique Truong's homepage which lists reviews and translated foreign editions. Literary critics have been slower to respond. See: Wenying Xu, *Eating Identities: Reading Food in Asian American Literature* and Deborah Cohler, "Teaching Transnationally: Queer Studies and Imperialist Legacies in Monique Truong's *The Book of Salt*."

2 *The Coffin Tree* was reprinted by Penguin in 1985 and by an academic press in 2003, but these editions also failed to draw the attention of literary critics. A notable exception is David Cowart, whose analysis brings out the aesthetic sophistication of *The Coffin Tree*. However, Cowart's study of immigrant fiction is problematic in its insistence that immigrants (unlike American-born writers) rightly contrast their "unlivable" homelands with America as a land of opportunity. In this respect Cowart distorts the cultural critique contained in *The Coffin Tree*. For an examination of Cowart's *Trailing Clouds* see Dominika Ferens, pp. 129-134.

particularly, interest and shame. Using a combination of reader response analysis and affect theory, I hope to demonstrate that the lesser-known novel *The Coffin Tree*, about cheap food in "the Land of Plenty," is as important a contribution to food literacy as *The Book of Salt*, about delicacies in Paris.

Food and Ethnicity

Food literacy has become a major cultural, political, and academic concern in post-industrial societies. It is seen as particularly urgent in the U.S., where agriculture, food processing, food distribution networks, and the media which popularize certain foods and lifestyles, have become heavily monopolized. As a result, Americans are encouraged to choose unhealthy foods with a high content of substances that are cheap to produce and have a long shelf life, such as sugar, starch, and fat. Furthermore, due to the scarcity of grocery stores in some districts, the urban poor have limited access to food in general. Those who cannot afford good quality unprocessed food, and who have no time to cook because they work long hours, end up eating at the ubiquitous fast-food chains. "Researchers believe we have two generations of Americans who do not know how to cook," states one food literacy website (*California*). Raising food literacy, a form of political consciousness raising, is seen as a way to ward off the health crisis. It is referred to as a "mission" by ecologically-conscious communities, nutrition experts, and even caterers, for instance at Harvard, where the dining services operate an educational website and offer food literacy courses in addition to advertizing the healthy meals served at campus canteens (*Harvard*). According to the caterers' website, the educational mission "focuses on four integrated areas of food and society: sustainability, nutrition, food preparation and community. Ultimately, the project goal is to promote enduring knowledge, enabling consumers to make informed food choices." Raising consciousness about food also takes place in academic courses offered across curricula at American universities, from medical science to creative writing.

Such consciousness raising also goes on daily in all walks of life. Food co-ops network with organic farmers to deliver crates of seasonal produce to individual homes in cities.[3] Farmers markets are being established with the support of local authorities, and welfare recipients are encouraged to shop there. Doctors write subsidized fruit and vegetable prescriptions. Long-established community recipe websites, blogs, countless professional and amateur cookery videos insist on wholesome ingredients and healthy cooking techniques. The old-fashioned

3 The documentary *The Real Dirt on Farmer John* (Dir. Taggart Siegel, 2005) shows how a traditional farm in the Chicago hinterland evolved into a cooperative and now supplies Chicago households with organically grown fruit and vegetables.

slow-cooker has come out of the closet and become the pride of home cookery videos. Book-of-the-month clubs and food literacy groups discuss "food writing." On the *New York Times* food website Melissa Clark prepares dishes according to recipes picked up at "old-country" restaurants in New York and adapted for home use.[4] On youtube, a grandson presents a series of cookery lessons by his Italian American grandmother Clara Cannucciari who learned to cook during the Depression Era.[5] On camera, Clara prepares austere meals out of plain ingredients: lentils, rice, lettuce, and veal sliced so thin that half a pound can feed a family of six. What marks many of these cultural practices is that the recipes (and often the cooks) are "of foreign extraction" – markedly "ethnic" or "old-country." While the turn away from "all-American" food began in the multicultural 1970s, the "foreign" has never been domesticated with such determination.

To think about food and appetite in the context of racial/ethnic minorities is important for a number of reasons. Eating is the most basic way in which foreign matter enters the body. Everyone eats, but what food is considered appetizing, what food has high symbolic value, who does the cooking, and who gets to eat out, is complicated by ethnicity (not just gender or class). In fact, as James W. Brown points out, "appetite attests to and even comes to symbolize the space existing between subject and object, between 'me' and the 'world'" (qtd. in Wong 18).

Eating ethnically-marked food is sometimes mistakenly read as a sign of respect for ethnic minorities, not just in the U.S. but also in Poland. For instance, Tomasz Pietrasiewicz, who has been instrumental in uncovering much of Lublin's Jewish history, recently observed that the municipal authorities were unreceptive to the idea of an Isaac Bashevis Singer festival, but they warmed to the project of a festival of Jewish cuisine. Pietrasiewicz wryly commented this fact: "getting to know and accept the other is somehow easier on the gustatory level" (Stasiński, my translation). In the U.S., too, dining out at ethnic restaurants is viewed by many as a sign of openness to difference. Yet the disproportionate number of Asian restaurants attests to the fact that the labor of cooking is unevenly distributed across hegemonic and subordinate groups. Until the Civil Rights era, Black people in the American South were kept out of most lines of

4 Melissa Clark's cookery videos are posted in the "Dining and Wine" section of *The New York Times* (nytimes.com).

5 The videos, shot by Christopher Cannucciari, were uploaded on http://www.youtube.com between 2006 and 2009. Each one begins with the words, "Hello, welcome to my kitchen. I am Clara and I am 91/92/93-years old." See: "Depression Cooking: The Poorman's Feast" (2009). A commentary left by one of the 448,222 viewers who visited the site reads: "better take note, you may have to cook this way in the next year or two."

work, but Black cooks and other domestics were the norm in white homes.
Likewise, people of Asian descent were actively kept out of most occupations
but tolerated as cooks and laundrymen. As Sau-ling Cynthia Wong eloquently
argued in her 1993 study *Reading Asian American Literature: From Necessity to
Extravagance*,

> the ability to obtain food (of varying degrees of desirability and availability) is relat-
> ed to the ability to work around the terms set by powerful others. The powerful con-
> trol resources, the powerless must devise means to maximize their resources by ei-
> ther overcoming necessity or submitting to it. But successful eating often occurs at
> the expense of spiritual integrity. (Wong 55)

If one's body or the food one was raised on has an exotic cachet, one can try to
sell both. Wong points out, however, that such valorization of the exotic is de-
ceptive, for in order to appeal to the dominant group, the "foreign" has to be
"domesticated, 'detoxed,' depoliticized, made safe for recreational consump-
tion" (55).

The two Asian American novels discussed below address the issues of food
and ethnicity in provocative ways and are equally powerful as fictional narra-
tives. But their different reception begs the question: Why did American readers
find one text so much more interesting than the other? To answer this question
we may refer to sociological and psychological theories of interest.

Interest and Shame

Since it is impossible within a few paragraphs to do justice to all the approaches
to interest produced within the social sciences in the last century, I shall merely
gesture towards several that seem relevant to this project.

Sociologists see interest as a major force in social life and assume that it is
always social. Though Chicago School sociologist Albion Small wrote that the
individual already has a number of interests before entering society, sociologists
tend to focus on the effects of socialization on interest. Arthur Bentley, for in-
stance, claimed that "there is no group without its interest. . . . We may also
speak of an interest group or of a group interest" (qtd. in Swedeberg 367). Since
groups define themselves in relation to other groups, "their interests are . . . also
defined in terms of other interests" (Swedeberg 368). Max Weber discussed in-
terest-driven behavior in terms of social class, and, importantly, argued that in-
terest may be stimulated by ideology: "'ideas' have, like switchmen, determined
the tracks along which action has been pushed by the dynamic of interest" (qtd.

in Swedeberg 379). Much of Pierre Bourdieu's theorizing of culture has relied on the notion of group interest. Bourdieu felt obliged to lay out his ideas on interest in the essay "Is a Disinterested Act Possible?" (1998) by the angry reactions to his study *The Field of Cultural Production* (1983/1993) which questioned the disinteredness of individuals and institutions involved in producing highbrow art. He began by rejecting two reductionist assumptions: that we are "moved by conscious reasons" and that what motivates us is economic gain. As social agents, he argued, we engage in pursuits or "games" whose rules we rarely question once we have assimilated them. "Games which matter to you are important and interesting because they have been imposed and introduced in your mind, in your body, in a form called the feel for the game" (77). The rules of some "games" (such as academic scholarship, art, literature, or motherhood) reward disinterested behavior, enabling actors to gain symbolic capital or status (83-85). Thus, those who paint, write, read, or do academic research are not necessarily or primarily interested in material gain; in the process pursuing an interest they may, for instance, secure their position in a group.

Psychologists, by contrast, have investigated the development of interest in interactions between the infant and its mother, and its subsequent shaping within the family. They define interest as an emotion or affect much like happiness, the basic difference between them being that while happiness motivates us to repeat what we found enjoyable in the past and builds attachments to things familiar, interest motivates us to engage with new and complex aspects of the world (Silva 29). Daniel Berlyne identified four "collative variables" of interest: complexity, novelty, uncertainty, and conflict (Silva 33). In short, he argued that we tend to respond with interest to complex phenomena that elude familiar categories, as well as to information that goes against expectations or produces a sense of incongruity. Silvan Tomkins,[6] who conducted ground-breaking research in the 1950s and '60s, treated interest as an affect akin to excitement, activated by changes in the environment and new information. To interest he attributed our ability to stay focused long enough to perceive objects in detail and to analyze them in relation to other objects (Kosofsky and Frank 78-79). Interest, he argued, is crucial for human survival and development: if our perception lacked the support of interest, "acquaintance with objects would be greatly impoverished, with the further consequences of lack of commitment to the world and

6 I am deeply indebted to Tomasz Basiuk for pointing me to Silvan Tomkins's writings on shame and interest after hearing a version of this paper. I have also benefitted from his interpretations of Tomkins in *Exposures: American Gay Men's Life Writing Since Stonewall* (2013).

lack of development of general competence insofar as this depended on the development of perceptual skill" (76).

In Tomkins's constellation of affects, interest-excitement and pleasure can abruptly turn into shame when we encounter the indifference or disapproval of those around us (Kosofsky and Frank 133-178). Shame is a sense of being unworthy (of other's interest or love) rather than guilt (at having broken a rule). Shaming is commonly used as a sanction if we take an interest in what others perceive as inappropriate objects, or when we express interest-excitement in an inappropriate manner. In other words, the object of shaming is to make us conform to group norms. Once we have internalized shame, external reinforcement becomes unnecessary: we come to feel shame in certain circumstance whether or not anyone expresses contempt. Shame is more "toxic" than other negative affects, writes Tomkins – more so than distress or anxiety, for it leaves us feeling "naked, alienated, and lacking in dignity" (148). But since shame is a learned response or "script," it can also be unlearned when we come to understand its mechanism, and, perhaps more importantly, when we encounter the affirming gaze and uncritical interest of others in situations similar to those when shaming took place (Basiuk 77-81).

In the novels by Truong and Law-Yone discussed below, the interplay between interest and shame is thematically important. Their first-person narrators focus on a series of episodes in which they were humiliated as children in Asia and as adult exiles in the West, and those episodes affect their capacity for interest. But the two writers build radically different plots around these twin affects. Truong's *The Book of Salt* lends itself to interpretation through sociological theories of interest because the narrator is resilient to shaming, and because he occupies an ambivalent position in relation to several interest groups engaged in the production and legitimation of avant-garde art and literature. He is also a player in the game of gourmet cooking which the novel treats as an art form; Bourdieu's theories of interest therefore throw light on his narrative. Shame is a leitmotif in the novel but it takes second place to interest. By contrast, Law-Yone in *The Coffin Tree* seems far more concerned with the psychology of shame – particularly the way shaming blocks the characters' interest in the world around them. Law Yone also closely examines the possibilities of undoing the effects of shame. Thus Tomkins's work on affect seems particularly appropriate for analyzing *The Coffin Tree*.

In addition to thinking about interest as a literary theme, I also make forays into reader response analysis, to speculate about aspects of the two novels that may have evoked or turned off reader interest. These tentative speculations are based on amateur reviews of the novels posted on the web, as well as a few responses by professionals.

Interest over Shame in *The Book of Salt*

Until recently American publishers assumed mainstream readers would not be interested in books by Asian American writers unless they were stories of success. *The Coffin Tree* and *The Book of Salt* are both stories of failure. Both offer grim visions of the Asian fatherland (postcolonial Burma and colonial Vietnam respectively). Their narrators seek asylum in the West, but find that it withholds physical and emotional sustenance. Thus the novels refuse to trace the teleological trajectory from the "unlivable homeland"[7] to the democratic West which rewards hard work and merit – a trajectory characteristic for traditional immigrant autobiography and autobiographical fiction. While some readers may find these stories of failure refreshing and more in line with their expectations of highbrow literature, those whose reading experience led them to expect ethnographic accuracy and an upbeat message may be disappointed.

In *The Book of Salt*, a gay Vietnamese man named Binh tells us how he was trained as a cook in the kitchen of the French Governor-General of Vietnam, how he left his homeland to escape a sex scandal, and after wandering the world on board ships, ended up in Paris, cooking for Gertrude Stein and Alice B. Toklas in their famous rue de Fleurus home.[8] Binh's story unfolds through flashbacks, starting at the chronological end. Stein and Toklas, whom he calls "my Mesdames," are about to go on a lecture tour of the U.S., leaving him jobless and homeless once again on foreign soil. Ashamed of his inability to rise above the status of a dispensable domestic, Binh often complains about "repetition and routine. Servitude and subservience. Beck and call." But his shame is assuaged by the fact that he relishes being a "minor character" in the "daily dramas" (154) of his eccentric, self-indulgent, racist, yet charismatic "Mesdames."

The narrative alternates between a plaintive and a humorous tone, for Binh is a master of self-irony. Though he recounts many episodes in which Stein and Toklas treat him as a less important member of the household than their pet

7 I refer here to the notion of "unlivable homeland" used by David Cowart in *Trailing Clouds* (209). In this study Cowart valorizes immigrant literature for its sober assessment of life in the country of origin in comparison with the United States: "whatever America's shortcomings in the past or present, immigrants nearly always have an acute awareness (and often personal, firsthand experience) of social, political, and historical horrors on a much larger scale" (207). But both Law-Yone and Truong acknowledge the "historical horrors" of life in postcolonial Asia, although they also show the West as unlivable or barely livable.

8 As Truong explained in several interviews, the novel evolved out of a brief mention in *The Alice B. Toklas Cook Book* of two Indochinese cooks Toklas and Stein employed in Paris. See for example José Amador's interview with Truong.

dogs,[9] he finds compensation in the sense of one-upmanship: for instance, he makes a better omelet than Alice B. Toklas, a fact that "in a stark and economi-cal way separates you and me" (154). (These, of course, are Binh's thoughts, inaudible to Alice B. Toklas, for he speaks little French and no English.) To draw on Pierre Bourdieu's concept of "distinction," Binh builds his sense of self-worth on his participation in the game of gourmet cooking taken to the level of art – a game in which one can distinguish oneself by having superior taste. Since the game requires disinterested passion, Binh presents himself as always motivated by the love of his art, never base economic gain. He is always ready to squander his talents on undeserving others (though some, like Toklas, *are* de-serving on account of their refined taste). One could argue in line with Bourdieu (77) that Binh is so interested in the cooking "game" because he has internalized the rules of taste. Truong's readers, too, seem to be part of the game.

Based on the amateur and professional reviews of *The Book of Salt* – not all of them complimentary – it is possible to identify several features of the novel that interested the readers. Virtually all readers responded strongly to the central theme of food. *The Book of Salt* is a "delicious, sensual and rich novel of culi-nary and literary delights," as many attest. "Most of us would relish joining [Truong] at her table" (amazon.com). Published in times of heightened interest in "old-country food," the novel abounds in sensuous descriptions of the smells, tastes, and textures of food, as well as detailed recipes and tips that the narrator shares with the implied reader whom he treats as a confidante of sorts. The psy-chological theories that locate interest very close to pleasure or happiness sug-gest that Binh's nuanced descriptions of sensory experiences strike a pleasantly familiar chord with readers. An interest-raising effect is achieved by the fact that the recipes have French names and exotic ingredients. Readers' interest is also raised by the sense of incongruity or disjuncture, for instance when reading about the way in which Alice B. Toklas teaches Binh how to smother live pi-geons in order to keep their meat juicier than it would be if he slaughtered them in the conventional way. Like Patrick Süskind's *Perfume: The Story of a Mur-derer* (1985), *The Book of Salt* appeals to the emotional meanings attached to sensory perceptions, and it is not a novel for the faint-hearted.

Interestingly, *The Book of Salt* is also about "taste" in the sense Bourdieu explored in *The Field of Cultural Production*. Truong initiates the reader into the game of gourmet food, which has strong class connotations. Only those

9 On one occasion, when Stein and Toklas are cross with Binh on account of a drinking spree, they treat him as less important than a crate of vegetables: "Bin [*sic*], you will take the train tomorrow. GertrudeStein [*sic*] and I will take the vegetables with us in the au-tomobile" (Truong, *The Book of Salt* 141).

whose taste has been refined score points in the game. (For instance, Gertrude Stein and Alice B. Toklas often use food to put people in their place, or to distinguish visitors who are in the know from those who are not. Such fine distinctions, as Berlyne observed, arouse interest.) Binh's fictional autobiography is really an account of the refinement of his taste, from elementary-school age, when he chopped vegetables in his Vietnamese mother's kitchen, through high school at the French Governor-General's kitchen, where he learned to make high-status dishes, to university in Paris, where he studied under the solicitous eye of Alice B. Toklas. Here are two examples of exotic dishes that function in the novel as status symbols: Binh tickles Toklas's palate by making his "best Singapore ice cream" with milk in which "ten coarsely crushed peppercorns" were steeped "from morning to night" (186). Toklas in turn, teaches him to make *pré salé* lamb which requires no seasoning at all because the lambs have grazed on the salt marshes of northern France. Binh reflects on this dish: "The first bite is a revelation of flavors, infused and deep. The second bite is a reminder of why we kill and eat the young. The third allows the brain back into the fray to ask, But how is it possible? Not a visible grind of pepper, a milky grain of salt, not even the faintest traces of rosemary…" (178).

Superior "taste" in food goes hand in hand with the tasteful handling of language – a field in which Binh (or Truong) rivals Gertrude Stein. Binh's eloquence (which some amateur reviewers found unconvincing in a character who confesses that he speaks virtually no English) is what allows him to render not just tastes and smells but also the complexity of his life in all its fascinating and alienating queerness. But evidently not everyone who reviewed the novel had internalized the rules of "taste." As one resistant reader aptly put it, "*The Book of Salt* should appeal to readers with a taste for smart historical fiction, or foodies" (amazon.com). It is, perhaps, symptomatic that since the novel is so preoccupied with taste, some readers accuse it of being in bad taste: "overspiced," "smelling of artifice," or "trying way too hard to appear as haute cuisine" (amazon.com).

Readers' curiosity is evidently piqued by the fact that the indiscreet narrator takes them into the home of the most famous lesbian couple in history and reveals his own homosexual desire. Lesbians have not been the subject of much mainstream literature – certainly not exuberant, hedonistic, uncloseted ones – so this aspect of the novel is probably a source of interest to many readers. Binh not only discusses the daily rites of "his Mesdames" but he also eavesdrops on their lovemaking through the wall. His own relationships with male lovers are closeted, exciting, and brief (one ends in a scandal that forces Binh into exile, the other in betrayal), more in line with the literary tradition. Several of the amateur reviewers comment approvingly on the lack of explicit sex scenes; others ex-

press frustration at the inability to see inside the "Mesdames'" bedroom or the garret in which Binh meets with his male lover. One reader writes: "There isn't enough focus on Stein and Toklas: my expectations were falsely placed" (amazon.com). An academic critic is also disappointed, not so much by the insufficient focus on Stein and Toklas, but because the book, which could have been radically queer, ends up reinforcing homonormativity: Stein and Toklas are "described as so normal that [their relationship] no longer signifies transgression" (Xu 135). Finally, we are left with a disturbingly stereotypical image of a subservient Asian male who desires white men, and, worse still, acts as a double agent, somewhat like David Henry Hwang's M. Butterfly, spying on a biracial gay man to satisfy the curiosity of his lesbian "Mesdames."

Throughout *The Book of Salt* the erotic is displaced onto the culinary, and thus (to borrow Wong's phrase used in a different context) "domesticated, 'detoxed,' depoliticized, made safe for recreational consumption" (55). Several readers astutely note that in this novel appetite and queer desire are twin impulses of equal intensity. As critic Wenying Xu observes, there are two parallel "gastronomy structured relationships" in the novel, one involving Stein and Toklas, the other – Binh and his lover Lattimore (135). All the desiring/desirable subjects are insatiable eaters and/or gourmet cooks. Even Binh's most egalitarian, intellectually stimulating, non-sexual relationship with a fellow-Vietnamese exile in Paris is consummated in a restaurant over an exquisite meal prepared by a cosmopolitan Chinese cook.

Characters in *The Book of Salt* tend to be guided by group interest. The French Governor-General in Vietnam always imports head chefs from France, even though they could be replaced by their equally capable Vietnamese "sous-chefs." Stein and Toklas use Binh to satisfy their curiosity about Marcus Lattimore, an American expatriate they suspect of being a mulatto. While it is not clear whether they would snub him if he were, their desire to know suggests that they are serious about their own whiteness. That sense of white superiority is also present in their treatment of Binh, whom they hire only because he does not have to be paid as much as a French cook.

Interest in art and literature is also a group interest, one associated with symbolic and, occasionally, also material rewards. The "Mesdames" are mostly interested in each other and in art. We learn, for instance, that Gertrude Stein has severed relations with her brother Leo, among other things, because he "had allowed his interest in other people's art to surpass *their* interest in his. Over the years [Leo and Gertrude Stein] had distinguished themselves in [Paris] precisely for the interest that they showed in other people's art. At 27 rue de Fleurus, they collected paintings, artists, and a society of people who were interested in all three. The relevant three were the paintings, the artists, and the Steins" (Truong

207). Marcus Lattimore is so intensely interested in Gertrude Stein's poetry that he seduces her cook in order to access information about how she writes (and eventually to steal a manuscript). One could argue that his literary interest, rather than being purely individual, springs from being part of the group of young men who visit Gertrude Stein's salon to get a share of its cultural capital. The fact that Gertrude Stein opens its doors once a week to stimulating conversations about art and literature, and feeds the young men with French delicacies, is not calculated to bring financial gain, but neither is it disinterested: the salon helps to build Gertrude Stein's cultural authority, which eventually gets her invited on a lecture tour of the United States. By extension, those who read *The Book of Salt*, whether alone or with members of their book clubs, are aware of being part of a community of readers who expose themselves to ambitious, complex, and challenging literature. The act of posting semi-formal reviews of *The Book of Salt* on amazon.com and other websites is a way of reaching out to that interest group.

In sum, *The Book of Salt* balances a number of potentially interesting themes. In an earlier era, its focus on three queer protagonists would have probably relegated it to a small market niche, but not in the decade when the institution of marriage was opened up to gay people in several of the United States. That two of the queer figures are celebrities makes them seem eccentric rather than threatening. (The statue of Gertrude Stein in Manhattan's Bryant Park was the first monument of a woman to be erected in New York City and thousands of Americans pass by it daily.) The displacement of queer desire onto food also makes it less threatening. Finally, the novel is not designed to make anyone – white, Asian, or other – feel uncomfortable. An amateur review aptly expressed his relief: "Binh never welters in his own sense of persecution and loneliness. He rides above all that, a tough and compelling character, confident in his own culinary artistry" (amazon.com). Although Binh is exploited by his American "Mesdames" in much the same way as he was at the colonial governor's kitchen in Vietnam, he bears no grudge. On the contrary, he takes pride in the fact that he gets to savor exactly the same food as his "Mesdames": "Of course there is always a wall between us, but when they dine on *filet de boeuf Adrienne*, I dine on *filet de boeuf Adrienne*" (209). Finally, as the narrator Binh gets the satisfaction of satirizing all the characters who shamed him. The readers chuckle along with him and also experience a deep sense of satisfaction.

Shame over Interest in *The Coffin Tree*

Some of the same ingredients are also present in Wendy Law Yone's *The Coffin Tree*, yet they have a very different flavor. Eating is a recurrent theme here, too,

but the food is either insufficient or sickening. Queer desire is shown in this novel as a source of suffering rather than pleasure. The male protagonist conceals his queerness and quits his only American job, claiming to have been gang-raped by the men on his crew. Unlike Truong's Binh, neither of *The Coffin Tree*'s protagonists enter into erotic relationships. Also unlike Binh, these protagonists are neither resourceful nor resilient. They experience life in the United States as an undertow of humiliation, and only one of them survives to tell the tale.

An optimistic *Los Angeles Times* reviewer wrote in 1983 that anyone who reads *The Coffin Tree* "must move to exotic places, to Burma in the beginning, to New York squalor in the middle, to a mental ward for an affirmative finale. The reader must move almost without transitions but with bags of empathy, crammed full" (amazon.com). Contrary to this reviewer's predictions, market readers were not moved by what the reviewer called Law-Yone's "virtuoso performance." Readers expected immigrant fiction to have the clarity of ethnography and the chronological structure of autobiography; they may have found unsettling the fact that *The Coffin Tree*, like *The Book of Salt*, is narrated in flashbacks. Arguably, too, the foregrounded motif of shame, unalleviated by interest-raising exotica, made *The Coffin Tree* as difficult to read as highbrow fiction, requiring an effort few readers were willing to make at the time. It features no protagonists with special gifts, no well-known historical figures, no gourmet feasts, and mostly domestic settings (other than in a few scenes set in revolution-torn Burma). Had *The Coffin Tree* been published more recently, in the age of "food literacy," it might at least have received attention as a warning about what bad food can do to the human body, or as ammunition in the struggle for "food justice."[10] But the novel came out in the middle of the Reagan era, when empathy for the disadvantaged gave way to self-interest, manufacturing jobs went away to the Third World, and the government began to siphon money away from affirmative action programs.[11]

In the early chapters of the novel it is postcolonial Burma that fails to sustain its citizens. Civil unrest makes itself felt most acutely through food shortages. The protagonists' father, a rebel military leader, fails to look after his children, leaving them in the care of elderly relatives while he is away fighting for pro-

10 The organization Just Food defines food justice as "communities exercising their right to grow, sell, and eat [food that is] fresh, nutritious, affordable, culturally appropriate, and grown locally with care for the well-being of the land, workers, and animals" (qtd. in Alkon and Agyeman 5).

11 For an account of the way the Reagan administration's policies affected racial minorities see James Kyung-Jin Lee, *Urban Triage: Race and the Fictions of Multiculturalism* (2004), pp. xiii-29.

gress. In a series of flashbacks the narrator explains that she grew up cut off
from her father. "In the dark about his calling," she is shocked to find out what
he does from a flyer which had been wrapped around "lentil fritters" sold by
a street vendor. Instead of her father's attention, she gets the "oil-stained" wrap-
ping of someone else's meal imprinted with an ideological message.

When the father has to go underground, the narrator and her brother are sent
away to the United States. Pampered children of a once wealthy family, they
arrive alone in New York, with "no serviceable skills to speak of" (59) other
than good English, $500, and no winter clothes. For almost 40 pages the narrator
describes their attempts at scavenging and the cheap food they eat.

> We cooked whatever went on sale at the corner grocery store: dented cans of string
> beans or mushroom soup; a head of discolored cabbage; a packet of lentils. But the
> mainstay was rice. We had a pot of it daily as the base for the meager toppings. Oc-
> casionally, when dogs went on sale, there would be meat on the table: one sausage
> per meal, diced small, heavily camouflaged with curry powder and garlic, and mixed
> with the rice. [At a cafeteria] we attacked our greasy $1.25 specials of meat loaf
> with savage concentration, resuming our talk only when the last smudge of gravy
> had disappeared – and then regretting our haste. (51)

Of the two, only the sister seems capable of finding a job "that [pays] a pit-
tance," the main attraction of which is that "from the coffee room [she can]
smuggle out packets of hot chocolate, dried milk, coffee, tea, sugar, and saltine
crackers" (54). At home, the brother languishes, apparently traumatized by the
loss of status and his encounters with Americans. Once, when he tries his hand
at cooking, the top drops off the jar of garlic powder, and the soup becomes in-
edible. His sister recalls the incident:

> I took my first mouthful of garlic and gagged. The garlic had the potency of ammo-
> nia. I set the plate down. 'I can't eat this. A dog can't eat this.'
>
> 'There's nothing else,' he said in a small voice. 'I'll make you hot chocolate?'
>
> 'I'm sick of hot chocolate,' I said. 'I'm sick of crackers. I just wanted rice and soup.
> I've been starving.' (57)

Such alternating descriptions of starving and eating starch, sugar, and fat are
unique in minority literature, which tends to highlight family gatherings at tables
laden with sumptuous old-country food. Sentimentalized scenes of women
pounding aromatic spices (for instance in Audre Lorde's *Zami*) or cooking sa-

vory soup in family-sized pots (in Achy Obejas's *Days of Awe*) serve as coun-
terpoints for the hostile world outside the home. Law-Yone risks a departure
from this time-tried ethnic paradigm.

Shame organizes the narrator's memories of her Burmese childhood and her
young adulthood in the United States. Alternately ignored and shamed by their
father, as well as other caregivers, the narrator and her brother also experience
their American exile as humiliating. In the very first scene set in the U.S. they
are shamed when they try to bargain for a pair of sandals in a Fifth Avenue
store: "Red-faced, we abandoned the sandals and the store" (44-45). Too proud
to admit they are hungry, the protagonists eventually contact a Mr. Morrison
they once knew in Burma. Their first call for help results in an invitation to din-
ner on a date three weeks away – an interminable wait for the hungry Burmese.
Dressed in summer clothes on a winter night, they arrive at the Morrisons' in the
middle of a conversation about "the difficulty of flying in fresh salmon from
Alaska" (47). They sit awkwardly through the dinner and leave without ever be-
ing asked about how they are making ends meet. When they telephone the Mor-
risons again to ask if their father has sent any money from Burma, they are
shamed by the ice-cold voice of Mrs. Morrison (which the narrator calls the
"Voice of America"): "Mr. Morrison and I have not been involved with your
part of the world for many years now. We've had no contact, financial or other-
wise" (48). While the story is evidently an indictment of Americans' "sink or
swim" attitude towards immigrants, it is the protagonists' sense of humiliation
that comes across most forcefully.

The second white family the Burmese immigrants ask for help are the
Lanes, who allow the Burmese to live in the basement of their large house. Dur-
ing the day, the narrator goes job hunting, but at night she and her brother

> steal upstairs and raid the kitchen for a spoonful, a handful of leftovers that wouldn't
> be missed. One evening, when we had the house to ourselves, we gathered a bundle
> of raw pasta taken from half a dozen opened packages, cooked it hurriedly, and
> tossed it into an old pan with oil and butter in amounts that would escape inventory.
> Seizing the moment, we added a cupful of cooked rice and sprinkled over this unap-
> petizing mishmash a package of raisins which someone had thrown, unopened, into
> the garbage. . . . This concoction fed us for three nights running. We ate out of the
> pan which stayed under my bed. (60-61).

Starch, fat, and sugar – poor man's food – accompany them as they move to
Florida in an attempt at independence. Starch, sugar, and fat is what the sister,

now gainfully employed, feeds her brother, who stays home and descends into
mental illness:

> Food came to be the sum and substance of our days. When silence loomed, we could
> always turn to a discussion of the day's menu: what we would eat for the next meal,
> how it should be prepared, what it should taste like, and the satisfaction it would
> bring. In time, all my aspirations seemed to revolve around the pot on the stove, on
> the amount of food I could get him to eat. To compensate for the stinginess of my
> affection, I indulged him in his simpler cravings. I fed him all the starch and grease
> he wanted: mounds of glutinous rice swimming in oily stews; lumps of fatty pork
> fried in batter; unlimited helpings of ice cream; sodas, potato chips, and candy bars.
> (79)

It is not that the protagonists do not know any better: for entertainment, they
once wander through a grocery store filling carts with quality food they crave
but cannot afford – "cheeses and meats, caviar and canned asparagus, jams and
teas, melons and berries" – only to abandon their carts in the aisles and go home
in shame (79). Analyzed in terms of Tomkins's affect theory, this scene exem-
plifies the abrupt blocking of pleasure (evoked by shopping for good food) by
the realization that one is undeserving (cannot afford to pay). As a consequence
of shaming, the immigrant protagonists shut off their interest,[12] try to avoid fur-
ther shaming, and focus on basic survival. Lacking emotional sustenance, they
are seduced by the abundance of bad food which they treat as compensation.
Sugar, starch, and fat eventually kill the brother. The sister, plagued by guilt,
makes a suicide attempt, and finds herself in a psychiatric hospital, where the
second half of the novel unfolds.

The novel seems to indict the American ideology of self-sufficiency which
shames immigrants into hard work and humility. As one employer tells the nar-
rator when he dismisses her: "I hoped you'd be a kind of iron butterfly . . . but
you've turned out to be just a butterfly, flitting in and out" (56). Unlike Truong's
Binh, who *is* a self-ironic "iron butterfly," Law-Yone's Burmese immigrants
have no natural predisposition for drudgery. They act out in small ways against
an economic system in which immigrants must be resilient and hardworking but
can never earn enough to eat *well* – a system in which they, in fact, cannot earn
enough to do anything but eat. Mostly, however they punish themselves.

12 One exception is Shan's dream of finding the coffin tree, whose precious wood would
 make him rich overnight. Towards the end of the novel the narrator discovers that the
 coffin tree also had a spiritual meaning for her brother associated with an ancient Bur-
 mese myth (192).

The unlearning of shame takes place within the confinement of the hospital, where "life has to be consumed in safe doses and where what cannot be digested must not be bitten off" (97). Food is free. It arrives "on a trolley in stacked trays" (89) and is not interesting enough to merit description. Sustenance, Law-Yone seems to imply in the second half of the novel, comes from human contact and words rather than food. She does not idealize the community of patients, many of whom are self-absorbed, but she does suggest that communication among equals (unlike communication between the authoritarian hospital staff and the patients) can be sustaining and even healing. A patient named Paddy, who refuses to speak, writes the narrator long philosophical letters which he leaves on her "breakfast tray, tucked into the folds of the napkin" (126). She is not expected to respond and never does, but this and other odd forms of communication sustain her until she is declared fit to leave. "Eating and speaking," writes critic James W. Brown, "share the same motivational structure; language is nothing more than the praxis of eating transposed to the semiosis of speaking: both are fundamentally communicative acts by which man appropriates and incorporates the world" (qtd. in Wong 18). Law-Yone suggests that experiencing the interest and solicitous attention of fellow-patients allows the narrator to overcome her sense of shame and become interested in others.

The Coffin Tree offers a psychologically nuanced account of an underrepresented immigrant experience, which resonates with Tomkins's theory of shame as an affect that tends to punctuate if not completely extinguish interest. Unfortunately the effect this particular narrative seems to have on mainstream readers does not bear out Tomasz Basiuk's observation that shame, when performed in literature, can be contagious in a positive sense: it can evoke empathy on the part of the reader whom the performance interpellates as witness (Basiuk 78-79, 208-210). If we are to judge by the meager response of the American reading public, so far the performance of shame in *The Coffin Tree* has failed to interpellate mainstream readers. The most enthusiastic response to *The Coffin Tree* comes from a Burmese immigrant:

> I really couldn't put this book down! I was from Burma too, and the way that the author portrayed the people and the relationships between them, and the sights and smells and sounds really reminded me of home. . . . Perhaps because I do come from the country in the story, I do get it. I get all that craziness and what it all means, and how it impacts a person. . . . Most books I read, no matter how technically sound and artful . . . feel so void of the kind of emotion that evokes in this novel. It's been a while I've been moved this much from a book [*sic*]. (amazon.com)

Mainstream readers did not "get it," either because the intensity of the shame described in *The Coffin Tree* did not resonate with their own and they found little else in the narrative to sustain their interest, or because the novel brings the shame too close to home, rather than deal with it in a geographically and historically removed setting. Perhaps by exposing the insensitivity of the white middle-class towards immigrants, *The Coffin Tree* actually shames its white readers.

Conclusion

Speculating about what readers might find interesting is always risky, for even within a single nation there is a diversity of readerships. Nonetheless, when dealing with U.S. minority literatures, which often explicitly engage in discourses of race, gender, and sexuality, the risk seems worth taking. In order to bring about cultural change, books have to be read, so writers tend to use aesthetic strategies designed to appeal to large groups of readers. Arguably, Truong's subtle treatment of interrelated affects, with an emphasis on interest, contributed to the appeal of *The Book of Salt*. Its narrator Binh looks back at the embarrassing episodes in his life with a wry humor, poking fun at those who embarrassed him. Their acts of shaming do not stifle his curiosity about them as individuals, nor the passions he shares with them, including food, the art of cooking, language, and the exotic. Many readers clearly also share these interests, identify with Binh, and enjoy the novel. By contrast, the nameless narrator of *The Coffin Tree* refuses to be entertaining and insists on dwelling on her shame. Since most people read literature for pleasure, the interest they pursue is an emotional state similar to happiness evoked by things familiar, including variations on tastes and smells they have enjoyed in the past. *The Coffin Tree* denies them such pleasures, while its focus on negative experiences – hunger, humiliation, revulsion, and guilt – makes it a hard book to stomach.

But although readers did not "get it" in the 1980s, they might "get it" now, in the age of food literacy. Given that food literacy involves thinking not just about what we ourselves eat but also about other eaters whom we will never meet face to face, *The Coffin Tree* is a text worth reviving. In recent years, the problems faced by migrants in the global north, so poignantly articulated by both Law-Yone and Truong, have become aggravated. There is a growing insensitivity to the waves of migrants who spill across the globe to escape various natural and man-made disasters. As a result of Europeans' "sink-or-swim" attitude towards migrants, hundreds of human bodies are being dredged up from wrecks off the Italian island of Lampedusa. Food crises, which in the previous century mostly afflicted the global south, have begun to spread northwards and are pushing more people in the global north onto diets of starch, sugar, and fat.

In the fall of 2013, for the first time since World War II, 43 million Europeans could afford a meal a day (Gawlik), and the Red Cross started to organize large-scale food distribution in Britain ("Red Cross to Distribute"). At the end of 2003, the number of food stamp recipients in the United States had reached 48 million and the federal government yielded to pressures to cut funding for the program (McVeigh). Truong and Law-Yone have developed radically different yet very interesting aesthetic strategies for dealing with such difficult subject matter and both their novels belong on food literacy reading lists.

Works Cited

Alkon, Alison Hope, and Julian Agyeman, eds. *Cultivating Food Justice: Race, Class, and Sustainability*. Cambridge, Mass.: The MIT Press, 2011. Print.

Amador, José. "'History Is A Story': Seattlest Interviews Novelist Monique Truong." Seattlest. seattlest.com. 22 Oct. 2011. Web. 23 Aug. 2013. Web.

Basiuk, Tomasz. Exposures: American Gay Men's Life Writing since Stonewall. Frankfurt am Main: Peter Lang, 2013. Print.

Bourdieu, Pierre. *The Field of Cultural Production*. Ed. Randal Johnson. New York: Columbia University Press, 1993. Print.

---. "Is a Disinterested Act Possible?" *Practical Reason.* Cambridge: Polity Press, 1998. 75-91. Print.

California Food Literacy Center. californiafoodliteracy.org. Web. 14 Oct. 2014.

Cohler, Deborah. "Teaching Transnationally: Queer Studies and Imperialist Legacies in Monique Truong's *The Book of Salt.*" *Radical Teacher* 82.1 (2008): 25-31. Print.

Cowart, David. *Trailing Clouds: Immigrant Fiction in Contemporary America*. Ithaca: Cornell University Press, 2006. Print.

Ferens, Dominika. *Ways of Knowing Small Places: Intersections of American Literature and Ethnography Since the 1960s*. Wrocław: University of Wrocław Press, 2010. Print.

Gawlik, Paweł. „Europejczyków nie stać na jedzenie? Czerwony Krzyż będzie rozdawał żywność w Wielkiej Brytanii." *Gazeta Wyborcza* 12 Oct. 2013. wyborcza.pl. Web. 14 Oct. 2013.

Harvard University Dining Services Food Literacy Project. dining.harvard.edu. Web. 14 Oct. 2013.

Law-Yone, Wendy. *The Coffin Tree*. New York: Alfred Knopf, 1983. Print.

Lee, James Kyung-Jin. *Urban Triage: Race and the Fictions of Multiculturalism*. Minneapolis: University of Minnesota Press, 2004. Print.

McVeigh, Karen. "Demand for food stamps soars as cuts sink in and shelves empty." *The Guardian* 24 Dec. 2013. theguardian.com. Web. 14 Jan. 2014.

The Real Dirt on Farmer John. Dir. Taggart Siegel, Antidote Films. 2005. Film.

"Red Cross to distribute food to Britain's poor and hungry." *The Guardian* 1 Oct. 2013. theguardian.com. Web. 14 Oct. 2013.

Silva, Paul J. *Exploring the Psychology of Interest*. Oxford: Oxford University Press, 2006.

Stasiński, Maciej. "Bramkarz z Lublina." *Gazeta Wyborcza* http://wyborcza.pl/. 8 Aug. 2013. Date of access: 11 Aug. 2013. Print.

Swedeberg, Richard. "Can There Be a Sociological Concept of Interest? *Theory and Society* 34 (2005): 359-390. Print.

Sedgwick, Eve Kosofsky, and Adam Frank, eds. *Shame and Its Sisters: A Silvan Tomkins Reader*. Durham: Duke, 1995. Print.

Truong, Monique. *The Book of Salt*. Boston: Houghton Mifflin, 2003. Print.

---. *Monique Truong Homepage*. 2014. monique-truong.com. Web.10 Jan. 2014.

Wong, Sau-ling Cynthia. *Reading Asian American Literature: From Necessity to Extravagance*. Princeton, NJ: Princeton University Press, 1993. Print.

Xu, Wenying. *Eating Identities: Reading Food in Asian American Literature*. Honolulu: University of Hawaii Press, 2008. Print.

About authors

Paulina Ambroży is an Assistant Professor of American literature at the Faculty of English, Adam Mickiewicz University, Poznań, Poland. She has published articles on American poetry and prose and is the author of a book *(Un)concealing the Hedgehog: Modernist American Poets and Contemporary Critical Theories* (2012), which approaches American modernist poetry through contemporary critical theories. She held fellowships from the Fulbright Commission (Stanford University, 2002), John F. Kennedy Institute for North American Studies, Free University, Berlin (2001, 2008) and Corbridge Trust (Robinson College, Cambridge University, UK 2013-2015). She is a member of the European and Polish Association for American Studies, European Network for Avant-Garde and Modernism Studies and Wallace Stevens Society. Her research interests include modernist and contemporary American poetry, 19th century American literature, word-image relations and literary theory.

Tomasz Basiuk received his doctoral degree from the University of Warsaw in 1997, and his post-doctoral degree from the University of Gdansk in 2014. His research interests include contemporary American fiction and life writing, critical theory, and queer studies. He authored *Exposures: American Gay Men's Life Writing since Stonewall* (2013), a monograph on William Gaddis (*Wielki Gaddis. Realista postmodernistyczny*, 2003), co-edited three volumes of papers on queer studies: *Odmiany odmieńca / A queer mixture* (2002), *Paramety pożądania* (2006) and *Out Here* (2006), and a volume titled *American Uses of History* (2011). He also edited the "Gender and Sexuality" issue of *Dialogue and Universalism* (2010). He is on the editorial board of *InterAlia*, a queer studies e-journal (www.interalia.org.pl). In 2004-2005, he was Fulbright Senior Visiting Scholar at The CUNY Graduate Center. From 2005 to 2012, he served as director of the UW American Studies Center.

Zbigniew Białas is Professor of English, Head of the Postcolonial Studies Department at the University of Silesia, Katowice, Poland, and a prize-winning novelist. He was Alexander von Humboldt Research Fellow in Germany and Fulbright Senior Fellow in the USA. His academic books include *Post-Tribal Ethos in African Literature* (1993), *Mapping Wild Gardens* (1997), and *The Body Wall* (2006). His novel *Korzeniec* (2011) was awarded the Silesian Literary Laurels, won the title of Best Polish Prose of 2011, and was turned into

a successful theatrical play. The second novel, *Puder i pył*, was published in 2013. Zbigniew Białas has edited/co-edited twelve academic volumes and written over sixty academic essays. He has also translated English, American, and Nigerian literature into Polish.

Dominika Bugno-Narecka is a graduate student at the Department of English Studies, John Paul II Catholic University of Lublin, Poland. She holds an MA degree in English Studies and a BA in Culture Studies. Currently she is working on a doctoral dissertation concerning modern ekphrasis. Her work focuses on the dynamic relationships between word and image in the context of neobaroque, melancholy, theatricality and/or gender. When not working on ekphrasis, she attempts to read Thomas Pynchon. She has participated in numerous international conferences in Poland and abroad, which resulted in several publications. She is also co-editor of the volume *Automata and Robotics: Images of Artificial Children in Literature and Culture* (to be published in 2014/15 in the Studies in Literature and Culture series).

Aneta Dybska is an Assistant Professor at the Institute of English Studies, University of Warsaw, Poland. She teaches courses in American Studies, with a focus on the nineteenth- and twentieth-century American culture and social history. Those courses reflect her academic interest in the ideologies of the nation-building, class, race, gender, and sexual formation. Her recent work engages scholarly debates on urban revitalization and gentrification, theorizations of the "right to the city" idea, as well as grassroots struggles for the urban commons against privatization and surveillance—preoccupations that have dominated urban politics from the 1970s until today. Her writing is informed by insights into the use and production of urban spaces in American cities and metropolitan regions coming from scholars in cultural studies, sociology, geography and urban studies. She is currently working on a book project dealing with the spatial aspect of struggles for social justice in the 1980s and 1990s. This research builds on her earlier interest in 1960s urban ethnography on black communities, which culminated in the publication of *Black Masculinities in American Social Science and Self-Narratives of the 1960s and 1970s* (Peter Lang, 2010).

Dominika Ferens is an Assistant Professor at the Department of English Studies, University of Wrocław, Poland. She received a Ph.D. degree from the University of California, Los Angeles, in 1999, and a post-doctoral degree from the University of Wrocław in 2011. Her research interests include American minori-

ty literatures, ethnography, theories of race, gender and sexuality, travel narratives, and popular fiction. She is the author of two books: *Edith and Winnifred Eaton: Chinatown Missions and Japanese Romances* (2002), a study of early Asian American literature, and *Ways of Knowing Small Places: Intersections of American Literature and Ethnography Since the 1960s* (2010). Underlying the latter project is a curiosity about what happens when literature acts like ethnography, or is mistaken for ethnography, or when ethnography acts like literature.

Elisabeth Frost, a poet and critic, the author of a collection of poetry, *All of Us* (White Pine Press, 2011); two chapbooks, *Rumor* (Mermaid Tenement Press, 2009) and *A Theory of the Vowel* (Red Glass Books, 2013); and a critical study, *The Feminist Avant-Garde in American Poetry* (University of Iowa Press, 2003). She is also co-editor (with Cynthia Hogue) of *Innovative Women Poets: An Anthology of Contemporary Poetry and Interviews* (University of Iowa Press, 2006). In 2009-2010, she held a Fulbright Fellowship as a visiting professor at the University of Wrocław, Poland. Frost has received grants and residencies from the Rockefeller Foundation-Bellagio Center, the University of Connecticut Humanities Institute, the MacDowell Colony, the Ledig-Rowohlt Foundation, and Yaddo, among others. She is Professor of English and Women's Studies at Fordham University, where she directed the Poets Out Loud reading series for a decade, and where she founded and continues to edit the Poets Out Loud book series from Fordham University Press.

Anna Gilarek earned her Ph.D. from Maria Curie-Skłodowska University in Lublin, Poland, and her doctoral dissertation was devoted to utopia and dystopia in feminist speculative fiction. She teaches American literature at The State School of Higher Education in Sandomierz. Her academic interests include science fiction, feminist speculative fiction, alternate history, apocalyptic novel, gender studies, and utopian studies.

Veronika Hofstätter teaches American literature and culture at the University of Stuttgart, Germany. She has studied at Wesleyan University in Middletown, Connecticut, USA, and at the University of Regensburg, Germany, where she received a Master's Degree in American Studies and Comparative European Ethnology. In her thesis on Siri Hustvedt's *What I Loved* and Jonathan Franzen's *The Corrections* she applied hunger and eating as lenses to analyze literary representations of the contemporary U.S.-American family in the stated novels. She is currently working on her doctoral thesis on the cultural dimension and

representation of captivity narratives in colonial North America. Further research interests include contemporary U.S.-American fiction, visual culture, food studies, Digital Humanities, and methodologies of American Studies.

Agnieszka Kaczmarek is a Lecturer of American Culture at the University of Applied Sciences in Nysa, Poland. Her main field of interest is twentieth- and twenty-first-century American literature, with a focus on American travel writing. In 2013, Peter Lang published her doctoral dissertation entitled *Little Sister Death*, which is an analysis of William Faulkner's *The Sound and the Fury* in light of Max Scheler's, Martin Heidegger's, and Emmanuel Levinas' philosophies of death. She has also published articles on Charles Dickens, Harold Pinter, Thomas Merton, and Bill Bryson.

Jerzy Kamionowski teaches the history of English literature as well as courses on feminist and African American literary theory and practice at the Chair of Neophilology, University of Białystok, Poland. He is the author of *Głosy z "dzikiej strefy"* (Voices from the "wild zone") (2011) on the poetry of three women writers of the Black Arts Movement generation: Nikki Giovanni, Sonia Sanchez, and Audre Lorde. He has published articles on literature by women, African American writers, and postmodernists, often focusing on such issues as attitudes to literary and cultural tradition, the question of identity, and the ethical value of transgression. He also co-edited three volumes of critical essays on American women poets: *Piękniejszy dom od Prozy* (A Fairer House than Prose) (2005), *O wiele więcej Okien* (More numerous of Windows) (2008), and *Drzwi szerzej Otworzyć* (Superior – for Doors) (2011).

Justyna Kociatkiewicz is an Assistant Professor of American literature in the Department of English Studies, University of Wrocław, Poland. Generic and narratological aspects of the contemporary American novel have been the focus of her research. Her current project investigates the strategies and devices of conspiracy fiction. The broader scope of her academic interests includes gender problems in the nineteenth century European novel, the contemporary historical novel, as well as the theories of film narratives. She has published several articles on the contemporary American novel and film, and a study of Bellow's fiction *Towards the Antibildungsroman: Saul Bellow and the Problem of the Genre* (2007).

Zofia Kolbuszewska is an Associate Professor in the Department of English, John Paul II Catholic University of Lublin, Poland. The author of two books, *The Poetics of Chronotope in the Novels of Thomas Pynchon* (2000) and *The Purloined Child: American Identity and Representations of Childhood in American Literature 1851-2000* (2007) and articles on Thomas Pynchon, American postmodernism, American Gothic, ekphrasis, and neobaroque, as well as on American and Polish film, she edited a collection of essays *Thomas Pynchon and the (De)vices of Global (Post)modernity* (2012) and is currently working on a project concerning a neobaroque reading of Thomas Pynchon's works.

Marta Koval is a Professor of American Literature at the Institute of English and American Studies, University of Gdańsk, Poland. She received her postdoctoral degree from the University of Gdansk in 2013. Her academic interests include postwar American fiction and transformations of the historical novel in the late twentieth – early twenty-first century. She is the author of many essays on the twentieth-century American fiction. She published two books – *Play in the Novel, Playing the Novel: On John Barth's Fiction* (2000) and *"We Search the Past ... for Our Own Lost Selves." Representations of Historical Experience in Recent American Fiction"* (2013). In 2004-2005 she visited Michigan State University as a Senior Fulbright scholar.

Joseph Kuhn is a Visiting Professor in the Department of American Literature at Adam Mickiewicz University, Poznań, Poland. He is author of *Allen Tate: A Study in Southern Modernism and the Religious Imagination* (2009) and of critical essays on such subjects as the Southern Agrarians; Henry James and the sacred; Herman Melville and Hegelian aesthetics; Stephen Crane's fiction and the phenomenology of Emmanuel Levinas; and the baroque mode in twentieth-century Southern literature. He is currently working on a project concerning the fiction of Robert Penn Warren and Katherine Anne Porter in its relation to the politics of interwar Europe.

Francesca de Lucia is an Associate Professor at Zhejiang Normal University, Jinhua, China. She holds a PhD in American literature from Oxford University, a diploma in American studies from Smith College, Massachusetts, and a *licence ès lettres* from the University of Geneva. Her doctoral dissertation is entitled: *Italian American Cultural Fictions: From Diaspora to Globalization.* She has published articles on various aspects of ethnicity and American identity in literature, including: "The Impact of Fascism and the Second World War on Ital-

ian American Communities" published in *Italian Americana* 26.1 (2008) by Rhode Island UP, which was awarded the Geno Baroni Prize for the best historical essay in 2008; "Anthony Giardina as a Representative of the 'Renaissance' of Italian American Writing" (in the book *Writing America into the Twenty-First Century: Essays on the American Novel*, edited by Anne Marie Evans and Elizabeth Boyle, Cambridge Scholars [2010]); and "'An Abrupt Impression of Familiarity': Ethnic Projection in Arthur Miller's Work" (*Polish Journal of American Studies* 6 [2012]).

Małgorzata Martynuska works at the Institute of English Studies, University of Rzeszów, Poland. She received her MA from American Studies Center of Warsaw University and her PhD from Jagiellonian University in Cracow. Her publications include a monograph on female immigrants in the USA and a course book on the culture of Anglo-Saxon countries. She has published papers on the Irish and Italian diasporas in the US and multi-ethnic issues in American film. Currently she has extended her area of research onto Latina/o representations in the U.S. media. In 2010, 2012 and 2014 she co-edited *Studia Anglica Resoviensia*, published by the University of Rzeszow. The courses she has been teaching include American Society, Culture of English-Speaking Countries, Civilization of Anglo-Saxon Countries, and an MA seminar focusing on multiethnic issues in the US. She is a member of the Society for Multi-Ethnic Studies: Europe and the Americas (MESEA) and European Association for American Studies (EAAS).

Jacek Partyka is an Assistant Professor at the University of Białystok, Poland, where he teaches American literature. He received his Ph.D. from Adam Mickiewicz University, Poznan, in 2011. His research interests include modernist American poetry and prose, and American Holocaust literature.

Małgorzata Poks teaches courses in American literature and culture at the English Teacher Training College in Sosnowiec, Poland. In 2009 her monographic study *Thomas Merton and Latin America: A Consonance of Voices* received the biennial award of the International Thomas Merton Society for a publication that opens new perspectives in Merton studies. Her academic interests concern modern American poetry and prose.

Laura Suchostawska is an Assistant Professor at the Institute of English Studies, University of Wrocław, Poland. She holds a PhD in linguistics. Her research interests include ecolinguistics, ecocriticism, cognitive poetics and cognitive semantics. Her current research focuses on metaphor as a conceptual and rhetorical phenomenon and the writings of Henry David Thoreau. She is a member of the Polish Association for American Studies, the Association for the Study of Literature and Environment, and the Language and Ecology Research Forum.

Justyna Wierzchowska is an Assistant Professor at the Institute of English Studies, University of Warsaw, Poland. She holds a double MA in American studies and philosophy, and a PhD in American studies. She is the author of *The Absolute and the Cold War: Discourses of Abstract Expressionism* (2011), co-editor of *In Other Words: Dialogizing Postcoloniality, Race, and Ethnicity* (2012), and the author of numerous academic articles published in Poland and abroad. Her academic interests revolve around contemporary visual art, critical and politically engaged art, popular culture, and gendered readings of culture. She translates contmporary American fiction and art-related books into Polish.

Agata Zarzycka is an Assistant Professor of Literature at the Department of English Studies, WUniversity of Wrocław, Poland, where she is a member of the American Program as well as the Center for Young People's Literature and Culture. She has authored a monograph on role-playing games, *Socialized Fiction: Role-Playing Games as a Multidimensional Space of Interaction between Literary Theory and Practice* (2009). Her other publications deal with role-playing games, fantasy literature and participatory culture. Her current research project is devoted to Gothic influences on popular culture. She is also interested in remix, game studies, fandom and subcultures, as well as broadly understood speculative fiction.

Oskar Zasada is a doctoral student in the Institute of English Philology at the John Paul II Catholic University of Lublin, Poland. Having specialized in translation studies in the field of English and German philology, he received his MA degree from the Polonia University in Częstochowa in 2010. On completing a two-year extramural course, he acquired pedagogical qualifications, and went on to do graduate work in Lublin. An avid enthusiast of American popular culture, he enjoys learning new bits of trivia every chance he gets. Some of his current research interests include: the works of Thomas Pynchon and Hunter S. Thompson, the evolution of the Cthulhu mythos in relation to cultural and philo-

sophical posthumanism, utopian and dystopian themes in contemporary litera-
ture, and quixotic elements in superhero fiction.

Gdańsk Transatlantic Studies in British and North American Culture

Edited by Marek Wilczyński

The interdisciplinary series "Gdańsk Transatlantic Studies in British and North American Culture" brings together literary and cultural studies concerning literatures and cultures of the English-speaking world, particularly those of Great Britain, Ireland, the United States, and Canada. The range of topics to be addressed includes literature, theater, film, and art, considered in various twenty-first-century theoretical perspectives, such as, for example (but not exclusively), New Historicism and canon formation, cognitive narratology, gender and queer studies, performance studies, memory and trauma studies, and New Art History. The editors are leaving a broad margin for the innovative and the unpredictable, hoping to attract authors whose approaches will point to new directions of research as regards both thematic areas and methods. Comparative Polish-Anglo-American proposals will be considered, too.

Vol. 1 Mirosława Modrzewska: Byron and the Baroque. 2013.

Vol. 2 Andrzej Ceynowa / Marek Wilczyński (eds.): American Experience – The Experience of America. 2013.

Vol. 3 Marta Koval: "We search the Past...for Our Own Lost Selves." Representations of Historical Experience in Recent American Fiction. 2013.

Vol. 4 Tomasz Basiuk: Exposures. American Gay Men´s Life Writing since Stonewall. 2013.

Vol. 5 Klara Naszkowska: The Living Mirror. The Representation of Doubling Identities in the British and Polish Women's Literature (1846–1938). 2014.

Vol. 6 Urszula Elias / Agnieszka Sienkiewicz-Charlish (eds.): Crime Scenes. Modern Crime Fiction in an International Context. 2014.

Vol. 7 Justyna Kociatkiewicz / Laura Suchostawska / Dominika Ferens (eds.): Eating America. Crisis, Sustenance, Sustainability. 2015.

www.peterlang.com